The Early Public Garages
of San Francisco

The Early Public Garages of San Francisco

An Architectural and Cultural Study, 1906–1929

MARK D. KESSLER

McFarland & Company, Inc., Publishers
Jefferson, North Carolina, and London

The author wishes to acknowledge the enormous contribution
of Sharon Risedorph, whose photographs capture the beauty
of the buildings better than any words could

LIBRARY OF CONGRESS CATALOGUING-IN-PUBLICATION DATA

Kessler, Mark D., 1956–
The early public garages of San Francisco : an architectural
and cultural study, 1906–1929 / Mark D. Kessler.
p. cm.
Includes bibliographical references and index.

ISBN 978-0-7864-6681-8
softcover : acid free paper ∞

1. Parking garages — California — San Francisco — History — 20th century.
2. Parking garages — Social aspects — California — San Francisco — History —
20th century. 3. Architecture — California — San Francisco — History — 20th century.
4. Facades — California — San Francisco — History — 20th century. 5. Historic buildings —
California — San Francisco. 6. Historic preservation — California — San Francisco.
7. San Francisco (Calif.) — History — 20th century. 8. San Francisco (Calif.) —
Social life and customs — 20th century. 9. San Francisco (Calif.) —
Buildings, structures, etc. I. Title.
TL175.K37 2013 725'.38 — dc23 2013006960

BRITISH LIBRARY CATALOGUING DATA ARE AVAILABLE

Cover photograph: Detail, 1355 Fulton Street Garage, San Francisco
(photograph courtesy Sharon Risedorph)

Manufactured in the United States of America

*McFarland & Company, Inc., Publishers
Box 611, Jefferson, North Carolina 28640
www.mcfarlandpub.com*

To Cynthia

Acknowledgments

My deepest thanks to Sharon Risedorph, whose beautiful architectural photography enriches the book. Working on this project, Sharon and I rekindled a twenty-five-year-old friendship. I treasure our experiences traipsing through the city to shoot the garages — our encounters with curious San Franciscans, conversations with mechanics, and discoveries of decrepit beauty inside the structures. Her generosity, goodwill and moral support have been a great gift.

To my colleagues in the Department of Design at UC Davis, who have always believed in me and supported this research. To the design students who prepared architectural drawings, photographed archival material, maintained spreadsheets, located sources and reviewed articles: Tim Yu, Alissa Jones, Mel Blanchard, Nicole Pierce, Patrick Caughey, Sarah McDaniel, Nessa Fong, Sarah Chan, Haley Hubbard, Esther Kim and Nancy Mei.

To the librarians and archivists who, like detectives, unearthed articles, ephemera and archival photographs: Christina Moretta and the staff of the History Center, San Francisco Public Library; Dan Goldstein (Shields Library, UC Davis); Miranda Hambro (Environmental Design Archives, UC Berkeley); and, Tracey Panek and John Goepel (California State Automobile Association).

To Elizabeth Skrondal and Moses Corrette of the San Francisco Planning Department for guidance, support and sharing of information. Special thanks to Mark Luellen for working with my 2008 class devoted to the preservation of the garages.

To those who hosted photography exhibits devoted to the garages: Shawn Rosenmaas (San Francisco EcoCenter); and, Charles A. Fracchia, Kurt Nystrom and Christine Adams (San Francisco Museum and Historical Society).

To individuals and organizations who generously gave permission to use graphic and archival materials: Guy Johnson (GM Johnson & Associates), Rick Holliday (Holliday Development), Richard Ulffers and Russ Jones (International High School), the *San Francisco Examiner*, DDR and Joshua Cohn, Architect.

To Dr. Richard Hayes and the Board Knowledge Committee of the American Institute of Architects (AIA) for the generous awarding of a grant funding my early research. Thanks to both the AIA and the Association of the Collegiate Schools of Architecture for allowing me to include here material from earlier articles that first appeared in their respective publications.

To the individuals and families of garage builders and operators who graciously shared personal memories and old photos: Kaaren Tank and the Pasqualetti family, Shirl Buss, Jon Bartunek, Joan Anderson Weierman and the late Sterling Anderson.

To architectural historians Richard Brandi and William Kostura for their insights and knowledge of San Francisco history and architecture.

To Kathleen Courtney, Scott Edmondson and the members of the Russian Hill Community Association, who incorporated my research — and me — into their preservation efforts and continue to care deeply about the garages.

To Drew Detsch, for his friendship, counsel and immediate understanding of why this topic was important to me. To another friend, Andrew Anker, for his compassion and support, and for always bringing a camera on his pilgrimages abroad.

To Debbie, my sister, for her love and encouragement.

To Ce Ce and Max, whose love sustained me through all those years when I was parked at the desk.

Table of Contents

ACKNOWLEDGMENTS vi
PREFACE 1
INTRODUCTION 5

Part One: The Buildings
1 — The Dichotomous Garage: Basics and the Shed 17
2 — The Dichotomous Garage: Façades 32
3 — A Typology of San Francisco Garages 55

Part Two: The Significance of the Garage
4 — Eclecticism and the San Francisco Historicist Garage 137
5 — Dichotomous Architecture and the City Beautiful 154
6 — The Panama-Pacific International Exposition 182
7 — Parking, Congestion and the Garage 196
8 — Consumerism and the Limits of a Dichotomous Architecture 211
9 — What Is to Be Done? 246

CHAPTER NOTES 267
BIBLIOGRAPHY 275
INDEX 282

Preface

This book examines a collection of early twentieth-century commercial garages in San Francisco. My goal is to demonstrate that these utilitarian buildings are beautiful, significant, and deserving of protection. Unfortunately, the buildings are slowly disappearing. About half of the roughly 300 garages built before the Depression are either demolished or modified beyond recognition. Those that remain are vulnerable, as landowners pursue greater financial returns from their real estate.

The buildings' beauty and significance are closely related, but not synonymous qualities. Establishing these qualities encompasses two distinct modes of research: visual/architectural and historical. The first mode reveals that the buildings are provocative and well designed. The second, historical inquiry, confirms that the visual artistry is not an accident but the result of a strategy to promote and represent the automobile to the public. The organization of the book follows a hybrid approach, with Part One devoted to the physical aspect of the buildings, and Part Two to the historical factors influencing the design.

Architectural analysis and art photography are used in tandem to explain and illustrate the buildings' functional, structural and aesthetic properties. The point of architectural analysis is to arrive at a clear understanding of a building's underlying logic, as abstracted from the myriad parts and pieces that make up the entity. Photography illuminates the analysis, translating the discussion back into visual terms. Taking cues from the garage's elemental organization, the analysis focuses separately on the building shed and the façade. Once the observer grasps the relationship of shed to façade, he or she can "read" the organization of the building from the façade alone. As the building's representative to the public, the façade engages the observer in a consideration of visual motifs, either in isolation or in relation to other garages and building types.

The third chapter, "A Typology of San Francisco Garages," is the heart of the book. Here, 36 garages are individually discussed and assigned a place in one of nine categories. Each category is defined by a particular façade composition or historical style. While typologies typically facilitate a deep appreciation of architecture, this typology is additionally directed towards preservation. Throughout the book I argue that the relationships binding these garages together heighten the architectural significance of every constituent building. The chapter supports this argument in photographs, graphic architectural analyses and essays.

Wherever possible, archival and contemporary photographs of particular garages are juxtaposed. The aim is to illustrate the impact of neglect and to reveal the integrity that often lies just beneath the surface of the façade.

Sharon Risedorph's architectural photographs grace the entire book, but they come to the fore in the presentation of the typology. The decision to photograph the buildings professionally and artistically reflects my conviction — and Sharon's — that the garages are deserv-

ing of this attention. Moreover, the images do for us what we do not do for ourselves — look at the buildings.

The photographs — portraits — reframe the façades as autonomous aesthetic objects isolated from the context of the street and historic district. These are the spatial contexts within which architectural significance is considered, especially for good-but-not-great buildings. This chapter represents in consolidated form an urban typology that also establishes a spatial context. Like the street and the historic district, this context is also viable as a host of architectural significance. By bringing together the garages on the pages of the book, the real distance between the buildings is eliminated. This compression facilitates an efficient, direct comparison of structures. Considered holistically, the chapter conveys the collection's scope, in terms of distribution throughout the city and the depth of the architectural bonds.

On weekend walks, I first encountered and became aware of the garages. As a book project, the research mushroomed into an examination of Sanborn maps, Planning Department records, building permits, archival photographic collections, architectural and automobile magazines, and local newspapers. I conducted interviews with mechanics and family members of garage builders and operators.

Over a period of four years, Risedorph and I toured the garages, took photographs, requested permission to go inside, and spoke with our hosts. Under my direction, students from the Department of Design at UC Davis prepared the architectural drawings that appear throughout Part One. Most of the drawings are overlaid with a graphic analysis describing either the formal composition of the façade or the organization of the building structure.

Part One substantiates that the garages hold architectural merit and form a coherent collection. Anyone can verify these premises independently by visually inspecting the old garages on the street. Historical analysis and proof of cultural significance are not necessary in order to appreciate the buildings, a fact that should embolden San Franciscans to defend the garages against assertions of insignificance.

However, as the worthiness of the garages comes as a revelation to many, additional investigation is necessary to locate the source of the disparity between reality and our assumptions about the buildings. The most common assumption is that an old garage is an unimportant artifact of another time — that a building devoted to the storage and repair of automobiles is inherently limited as a site of cultural significance or aesthetic expression. While the prejudice is not at all surprising, it questions how the buildings became the focus of so much talent, skill and care.

My intention in Part Two is to place the garages in a historical and cultural context, and provide an explanation for the garages' unlikely beauty. This is distinct from a history or survey of San Francisco garages. The priority placed on the *architectural quality* of the buildings proceeds from the book's primary goal, which is to generate arguments in support of preservation.

This priority exerts considerable influence on the scope and nature of historical inquiry. I am primarily interested in the broad currents and events that factored into the architects' investment of great care in the design of buildings that — based narrowly on use — do not warrant it. Examples of these factors include the City Beautiful movement, eclecticism in architecture, the evolution of automobile design during this period, the impact of the automobile on San Francisco, the earthquake of 1906, and the world's fair of 1915. A consideration of the garage — based on these factors — reveals the ways in which the garage is extraordinary; i.e., it assumes a symbolic dimension that transcends its utilitarian use.

Also relevant to this examination is the subsequent erosion of symbolic meaning, a loss that contributes to the buildings' vulnerability today. Early on, the automobile and the garage were linked as rough, efficient, and machine-like tools. As the automobile industry matured and nurtured a society of consumers, the automobile became less of a machine and more of a domestic room on wheels. When comfort, privacy and interior design became properties of the automobile, the garage ceased to be its architectural embodiment. For this part of the book, the research focuses on the exploitation of gender stereotypes to sell cars to women, and the use of interior design to advance that promotion.

I am less interested in historical information that shows how garages, once designed and built, were integrated into the lives of those who opened them, patronized them or worked in them. Similarly, I do not provide a building-by-building chronicle of changing ownership or use. This information is of course relevant to a comprehensive understanding of the building type. However, this data does not shed much light on the designers' motivations and intentions.

In the course of researching the book, I found little critical discussion of the garages emanating from the architectural community — either building reviews or statements of intent from the architects or designers. These small commissions did not provoke that sort of commentary. From a research perspective, this paucity necessitated a roundabout approach. Assertions of cultural significance are often deduced from information pertaining to related utilitarian building types, the impact of the automobile locally and nationally, and the aesthetic context within which the designers practiced.

The research also involves the critical review of the visual and archival materials noted above. I conducted a visual cultural analysis of archival photos and ads representing both automobiles and buildings, usually juxtaposed in a San Francisco setting. This investigation yielded important insights, like the fact that the automobile and the Beaux-Arts–inspired monument were viewed on some levels as comparable design objects.

A clarification of terms: The garage façade organizes architectural elements and ornamentation derived from various historical styles into simple and traditional compositions. I use the word "historicist" as an adjective (historicist garage) that describes the historically derived content. By contrast, the term "historical garage" simply situates the building in the past, without reference to aesthetic intentions.

One definition of historicism, in a "chiefly derogatory"usage, is "(in artistic and architectural contexts) excessive regard for past styles."[1] This meaning links the aesthetic approach of the artist with the word user's negative assessment. In the context of this book I find the term useful because it implicitly acknowledges that our view of these buildings is retrospective, and that our vantage point postdates the modern movement's critique of "styles" in architecture. Regardless of whether one agrees that the stylistic overlay is "excessive," the appropriateness of this overlay onto the utilitarian garage is a question that permeates the discussion.

A note on the figures: Half of the figures appear in chapter 3 — A Typology of San Francisco Garages. However, references to these same figures occur throughout the text. Some readers may find it inconvenient to stop and locate these figures while engaged in the flow of the text. My advice is to peruse this chapter first, become familiar with the images, and decide later — while reading — whether to refer back to chapter3. To assist the reader, all remotely located figures are identified by chapter.

Introduction

While the preservation movement has made great strides in saving landmarks and historical districts, it is less effective in protecting good, not great, buildings. Development continues to threaten existing, adaptable structures that make significant contributions to the scale and character of the city. When older buildings are tossed away, material is wasted and architectural diversity is replaced by homogenization. A concerted effort to reverse this trend is essential, and the first step of that campaign is to raise consciousness about the existence and fate of certain types of vulnerable yet valuable buildings.

This book contributes to that effort through an examination of one notable example, the historicist garages of San Francisco. Built between the Great Earthquake of 1906 and the Great Depression of 1929, these structures are used for parking and/or the servicing of cars. While the early automobile age gave rise to ruggedly beautiful garages across America, San Francisco's collection is noteworthy for its concentration, cohesion and overall architectural quality. Collectively, these buildings constitute an architectural type.

Before the Depression, roughly 300 businesses were identified as garages.[1] These garages were disbursed throughout San Francisco. They appeared in response to demand, resulting in an uneven geographic distribution. In and around downtown, garages served drivers bound for offices, stores and entertainment venues. Public garages also materialized in middle- and upper-class neighborhoods with housing that did not include private garage space. Prior to the development of affordable closed cab automobiles in the early 1920s, these neighborhood facilities protected automobiles from exposure to San Francisco's moist overnight weather.[2]

The advent of the public garage reflects a specialization in auto-use architecture peculiar to large cities.[3] In smaller towns and cities, garages were more likely to include sales and service, in addition to storage. In major cities, sales establishments typically consolidated on a particular street that came to be known as Auto Row. While consolidation was convenient for sales, decentralization was convenient for parking and repair. Further specialization occurred within the realm of the public garage. Skyscraper garages of four or more stories were built on the fringes of the central business district, or sometimes in the district itself. These structures offered increased capacity where demand, land values and surrounding building heights were high.

In San Francisco, post-earthquake reconstruction roughly coincided with the initial rise of the automobile and its accessory, the public garage. As one small group of architects, engineers and builders assumed responsibility for a design effort spanning a relatively short period of time, the buildings — including the garages — exhibited an unusual degree of aesthetic unity.[4] Generally, these designers subscribed to the teachings of the École des Beaux-Arts, which endorsed the dressing up of buildings in architectural styles derived from history. When members of this group designed garages outside of the reconstruction zone, they applied the same aesthetic and utilized the same layouts and structural systems.

The specialization of auto-use buildings was already evident in the years after the earthquake and fire, when small showroom buildings shared Golden Gate Avenue — San Francisco's first Auto Row — with businesses devoted to repair, supplies, automobile specialties and storage.[5] Some auto dealerships grew in size and stature, and sought larger showroom buildings on Van Ness. As these more architecturally ambitious showroom buildings amassed along Van Ness around 1910, parking garages also established a distinct and distinguished identity. While the showrooms outpaced the garages in size and opulence, both building types displayed a tendency towards monumentality that continued through the 1920s.

Garages appeared with the greatest frequency in the Uptown Tenderloin, Lower Nob Hill, and the side streets east of Van Ness — areas leveled by the fire (Fig. 1). The hotels and apartment buildings constructed in the 1910s and '20s served white collar office and retail workers who walked or took public transportation to jobs downtown or in the Civic Center.[6] Generally, these buildings did not include garage facilities. Despite the ambulatory commute, many residents came to own automobiles, and the public garages served this population.

The Uptown Tenderloin was also an entertainment district, famous for its theaters, hotels, restaurants, bars, cafes and establishments of ill repute. Garages located on the district's eastern end served the financial and retail community by day, and the entertainment crowd at night. Many garages rented cars to tourists staying in nearby hotels.

In the late 1920s relatively few garages existed in the heart of downtown. The real estate was too valuable to be used for parking. Also by this time, garage facilities were often provided in the basements of new downtown office buildings. However, six garages were clustered across the street from the Ferry Building, providing parking for patrons of ferries, including auto ferries. Generally however, garages serving the financial district were located in adjacent districts to the west and the south — at the edge of the Tenderloin or just south of Market Street.

As downtown congestion worsened throughout the 1910s and '20s, San Francisco passed ordinances restricting street parking on particular downtown streets. Public garages provided one alternative for workers and shoppers, albeit an expensive one. Those capable of paying for private parking enjoyed the additional notoriety of driving their new status symbols through the fancy portals of garages. The increasing number of well-designed garages advanced the idea — promulgated by industry — that automobiles constituted a permanent and desirable addition to city streets.

Outside of the reconstruction area, the greatest concentration of garages occurred in the Western Addition — a middle- to upper-middle-class neighborhood containing hundreds of Victorians not yet retrofitted with private garages. Most of the garages serving this neighborhood have been demolished, with the exception of an important group on or just off Divisadero. A few garages on upper Divisadero accommodated the residents of Pacific Heights.

While other San Francisco neighborhoods sprouted garage businesses, the buildings were sited along district shopping corridors, streetcar routes and major arteries traversing the city. This pattern was typical in big cities, as the garage — like most any retail enterprise — benefited from exposure to passersby, shoppers, drivers and streetcar passengers. Also, many garages offered a drop-off and pick-up service to their customers, extending the

Opposite: **Figure 1. Map of downtown San Francisco with garages listed in the 1928 telephone directory (base map courtesy GM Johnson & Associates Ltd., 4562 Dawson St., Burnaby BC, V5C 4C1; overlay by Esther Kim and Nancy Mei).**

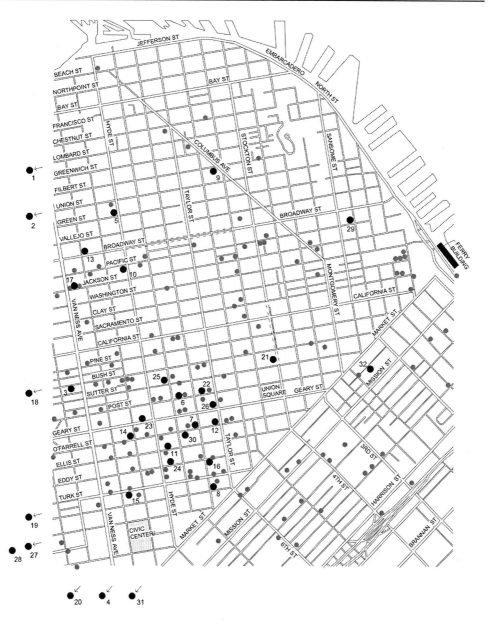

Addresses for Garages Included in Typology
(Black circles represent garages discussed in Chapter 3)

1. 2340 Lombard	9. 721 Filbert	17. 1641 Jackson	25. 818 Leavenworth
2. 1550 Union	10. 1419 Pacific	18. 2405 Bush	26. 530-544 Taylor
3. 1565 Bush	11. 541 Ellis	19. 1355 Fulton	27. 650 Divisadero
4. 4050 24th	12. 415 Taylor	20. 1661 Market	28. 1745 Divisadero
5. 1945 Hyde	13. 2120 Polk	21. 410 Stockton	29. 240 Pacific
6. 750 Post	14. 830 Larkin	22. 675 Post	30. 550-560 O'Farrell
7. 525 Jones	15. 550 Turk	23. 855 Geary	31. 66 Page
8. 64 Golden Gate	16. 265 Eddy	24. 460 Eddy	32. 111 Stevenson

geographic reach of the business deep into the interior of residential districts. This siting of garages became formalized in the 1921 Building Zone Ordinance, which prohibited new garage construction in residential areas while permitting it on shopping corridors zoned for commercial use. Thus, Valencia, Geary, Union, Divisadero and Pacific (and most streets in the Tenderloin) attracted garage construction in their respective neighborhoods.

An Urban Building Type

Garages from this era are infill buildings presenting a composed and ornamented façade to the street, and they are related to other commercial, utilitarian, popular and service-oriented buildings conforming to this template: banks, theaters, stores, power stations, car barns and warehouses. These are the buildings collectively referred to by historians Chester Liebs and Richard Longstreth as the architecture of Main Street.[7] Their façades employ the same historically based vocabulary and syntax as the exteriors of America's institutional and civic buildings, although in a more lighthearted and impure manner. Unlike museums and city halls, these buildings are not monuments of the City Beautiful, set back from the street, raised on a plinth and asserting a volumetric presence. They are, however, the monument's common cousins, the ground that supports the figural landmark. As such, the garages and their typological siblings on the street can be described as *lowbrow historicist* structures.

Why are these buildings worthy of consideration? By virtue of their age, scale, use, structure, material, composition, style, and ornament, lowbrow historicist structures possess character—and not just *any* character. These structures exhibit the physical properties that define the street in the modern city. They are the datum, the reference point against which new construction asserts its newness. To say that these buildings possess *irreplaceable* character is simply to acknowledge that—like old movies or cars—they are engaging, artful, and communicative expressions of an era. Try as we might, we cannot reproduce the circumstances that will yield authentic artifacts of a bygone age.

Unlike most infill buildings, the garage is a transportation building, having its roots in bicycle shops and livery stables. Many San Francisco stables were converted to garages as the automobile increased in popularity and superseded the horse. Indeed, garages and stables provided analogous services to their respective clients.

To its promoters, the automobile was an exciting new technology that offered individuals an unprecedented control over travel. Although just a stable for cars, the garage required an architectural identity that represented this positive view to the public. To a generation of architects trained to solve new problems through the adaptation of precedent, the train station offered an appropriate imagery for development. The station provided a set of signs and symbols associated with mechanized transportation, and a practical means of separating the public realm from the industrial. Architects found inspiration and source material from local transportation hubs—like the Ferry Building (Fig. 2) and the later Southern Pacific Third and Towsend Street Station (Fig. 3)—and European and American railroad stations built over the previous fifty years. This lineage helps to distinguish the garage from more generalized types of lowbrow historicist architecture, like warehouses and the retail blocks known as "taxpayer strips."[8]

Following the elemental organization of the station, the garage encompassed two distinct components: architectural front and transportation shed. Relative to the station, these components were compressed and simplified to the point of caricature. Still, the garage

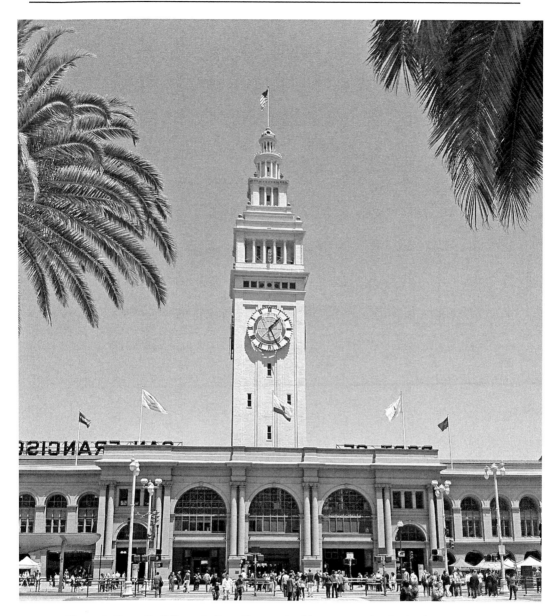

Figure 2. Ferry Building. A. Page Brown, Architect, 1898 (author's photograph).

façade — like the head building of the train station — utilized a traditional architectural vocabulary to communicate the civic and commercial pride underpinning the enterprise. The shed was a utilitarian enclosure of exposed structure and unfinished enclosing surfaces.

Many garage façades, mimicking the exterior forms and historical style of the station, exert a monumental presence on the street. Most are symmetrical and employ classically derived elements to emphasize or elaborate upon the center. Those that present a central portal to the street recall triumphal arches and establish connections with similarly endowed transportation building types. In San Francisco, the list includes the head buildings of piers (Fig. 4) and subway stations, major transportation terminals, car barns and firehouses. Also

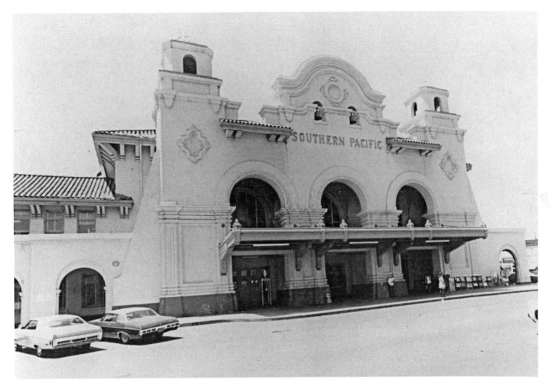

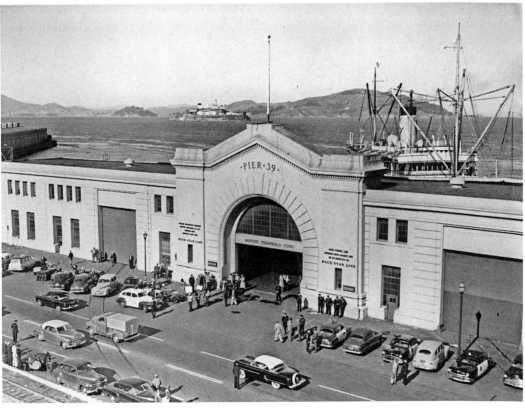

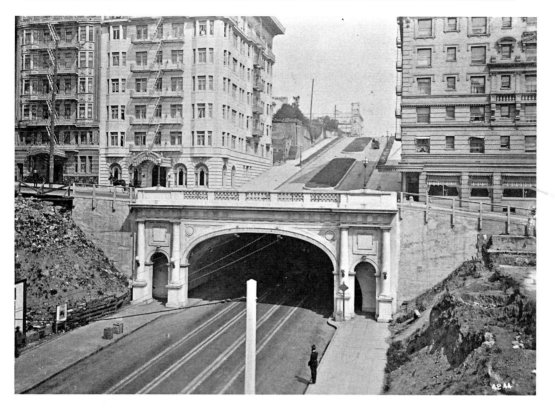

Figure 5. Stockton Street Tunnel, 1914 (San Francisco Department of Public Works Albums, San Francisco History Center, San Francisco Public Library).

relevant are public engineering projects, including the West Portal and Stockton Street tunnels (Fig. 5).

Of course, portaled façades are not unique to transportation buildings. On larger-scale highbrow buildings — schools, libraries, museums and government buildings — the triumphal arch motif often appears as an architectural signpost to announce both entry and civic importance. The difference is that the garage's appropriation of the portal is not just a generalized invocation of a glorious past, but a specific inheritance from an aging, immobile parent — the train station.

The garage's dichotomous organization of historicist façade over industrial shed is the basis of relationships formed between any one garage and outside buildings with the same schematic. These relationships vary in terms of the distance between the buildings and the substance of commonality. When the continuity is architecturally shallow, i.e., limited to superficial aspects of the façades, it is reinforced by proximity — the street. When the continuity is deep — encompassing the dichotomous architectural organization — the connection must overcome gaps introduced by time and distance in order to become etched into our minds.

We are accustomed to considering context as a function of physical adjacency and the

Opposite top: Figure 3. Southern Pacific Third and Townsend Street Station. SP Architectural Bureau, Architect, 1917 (San Francisco History Center, San Francisco Public Library). *Opposite bottom:* Figure 4. Pier 39 in 1953 (San Francisco History Center, San Francisco Public Library).

amalgam of facts the senses perceive in a given moment; this is the context of the street and
of firsthand experience. This notion of context underpins the *historical district*, which refers
to "a definable unified geographic entity that possesses a significant concentration, linkage,
or continuity of sites, building, structures, or objects united historically or aesthetically by
plan or physical development."[9] The garages contribute to the lowbrow historicism that
blankets these districts. Also, the garages are small in scale, while adding to the mix of
building uses on the street. Indeed, the large majority of garages located within San Fran-
cisco's historic districts are deemed to be "contributory resources," in acknowledgment of
these assets.

We are, however, less conscious of a more conceptual notion of context that encapsulates
the entire city and exceeds the scope of what can be perceived in a glimpse. This form of
contextualism focuses on related buildings that are distributed throughout the city. The
observer relies upon memory — instead of vision in real time — to affirm architectural rela-
tionship. A typological approach to the architecture of the city classifies according to criteria
that may not be predicated on physical proximity. It anticipates links between buildings
located miles apart and in different districts.

Beyond the context of street, garages are linked to a set of urban utilitarian buildings
that share its combination of historicist façade and industrial shed. These include car barns,
power stations, and firehouses. Larger-scale buildings conforming to this schematic organ-
ization include exposition buildings and train stations. The government agencies, utilities
and private companies sponsoring these structures exploited the opportunity to represent
themselves, through design, as powerful entities that harness technology for the public good.
The exteriors deliver the message of civic importance while the interiors house the equip-
ment. Building types vary according to the precise message to be conveyed and the acces-
sibility of the technology to the public.

With the exception of the generally older brick car barns, the same design professionals
who rebuilt the city also designed the post–1906 firehouses and power stations. Elite members
of this clique organized the Panama-Pacific International Exposition and designed many of
the buildings. Among these types, the garage is noteworthy for its inexpensive construction,
commercial purpose and lack of civic credentials. Still, it is a full participant in this typology
of urban dichotomous buildings.

Most importantly, the lowbrow historicist garage encompasses an internal typology
within the limits of San Francisco. Unlike the more generalized typology encompassing all
buildings with historicist exteriors and industrial interiors, the garages can be classified
according to more specific criteria. This is possible because the garages already share the
fundamental attributes associated with the use. As the typology is interpreted here as a form
of contextualism, the emphasis and the basis of classification reverts back to the garage's
most visible and public feature, the façade. The garage façades exhibit patterns based on
easy and accessible features, like a conspicuous arch, a symmetrical composition or an overt
reference to historical style. However, a holistic appreciation of the entire building underpins
the classifications.

Organizing the buildings in this manner helps to lift them out of anonymity. While
the garages are striking and typically designed by well-known architects and builders, they
are anonymous in the way that all infill buildings blend into the streetscape. Another
factor that contributes to anonymity is a popular assumption about the value of a garage
based entirely on its use. To many, a garage is a common utilitarian building with an inhos-
pitable interior, a sufficient basis upon which to consign it to oblivion. In order to counter

these forms of anonymity, we must learn to *see* these buildings and not mindlessly pass them by.

The typology places all of the buildings into a generalized relational and spatial context — like the assemblage of colored rectangles in Mondrian's *Broadway Boogie-Woogie*.[10] This contextualization precedes assessment on an individual basis. Then, the act of classification requires the interrogation of each building, an analysis of its parts and how they interrelate. This scrutinization, devoted to a single collection of buildings, can bring forth more in-depth critical evaluations than the descriptions and numerical grades one encounters in government-sponsored building surveys.

The analysis reduces anonymity and fights against that vague sameness that results from the reduction of a building to a word: *garage*. It also establishes *relationship* as a criterion of merit, a category that lies outside the conventional notion that merit is a function of an individual building's aesthetic quality or historical significance. This raises the possibility that good buildings falling short of landmark status may nevertheless require protection. The possibility follows from the notion that irreplaceable urban character often resides in undervalued lowbrow structures.

A Symbol

The lowbrow historicist garage captivates in part because it unapologetically presents itself as a vulgarization of the highbrow. The garage at 1355 Fulton illustrates this point (Fig. 78 in chapter 4). Literal and derivative in its references, the triple gable is an adaptation of a train station motif favored by leading American architects influenced by the École des Beaux-Arts. Designed by prominent San Francisco architect Mel I. Schwartz, the garage is not anonymous by attribution. The building demonstrates Schwartz's facile grasp of history, the academic design process, and the power of architectural signs. Urbane and clever, the façade establishes easy ties with the Ferry Building, the long-gone Panama-Pacific International Exposition, and the garage at 1240 Post, designed by Schwartz's peer, Sylvain Schnaittacher. As an assertion that the garage is a miniature train station adapted to cars, the design is direct and unequivocal.

At the same time, 1355 Fulton renders its architectural quotations in broad strokes, undercutting its highbrow pretensions. Historical elements are two-dimensional — simple statements of unadorned profile. The façade is flat and cheap, and like a billboard, it overloads our senses. However, the lowbrow nature of the façade in no way implies an architectural failure. Schwartz winks at his audience, letting us in on the secret that if the garage is indeed a station for cars, it lacks the scale and civic purpose of the train station. He gleefully communicates the absurdity of reducing great architecture to advertising, of invoking the Baths of Caracalla in the design of a storage shed. In its bold acknowledgment of goals in a state of contradiction, the façade is riveting.

Designed as a metaphorical station, the garage façade achieves a stature that transcends the building's prosaic use, as highlighted inside. To the contemporary observer, the shrill monumentality may be perceived as a benign incongruity. However, the monumentality of the garage façade cannot be dismissed as a quirk of history, or more precisely, as the designer's reflexive application of a design process learned in school. The opposition between the façade and the shed is strategic and deliberate, a positive act of design that ironically borrows from the unselfconscious architecture of the vernacular.

In discussing the dramatic evolution of the residential garage to a position of relative prominence, J.B. Jackson posed the question, "What is vernacular?" He concluded,

> It is the visible result of a confrontation between the aspirations of the occupying family and the realities of the environment — natural, social, economic. There is no permanent solution to the conflict; there never will be.[11]

As a commercial building most often designed by members of an architectural elite, the public garage may not qualify as either vernacular or anonymous. However, Jackson's definition informs our understanding of the lowbrow historicist garage, in particular its highbrow pretentions. His insight into the garage extends beyond the suburban house, in part because the automobile functions as a residential satellite, carrying with it the baggage of hopes and dreams underlying the purchase of the automobile. The lowbrow historicist garage reflects and expresses the confrontation between "aspirations" and "realities." In this way the garage is characteristic of the American vernacular, despite its provenance.

Garage architects strived to simultaneously represent the social status aspirations of the garage's clientele while accommodating the less glamorous challenges of automobile storage and service. The dichotomous solution facilitated the dual and contradictory aspects of this challenge. Through the appropriation of the historical portal, architects brought to bear an arsenal of symbolism to the act of driving, to car ownership and to the garage itself. Much of this symbolism derived its authority from the City Beautiful movement, in particular the notion that resplendent architectural gestures are both uplifting and unifying. At once, the historicist façade conferred status on the client, as a respectable member of an urban elite; the proprietor, as a proud contributor to the rebuilt city; and the garage, as an architecturally appropriate addition to the street and skyline.

The garage architects also drew upon and manipulated the City Beautiful interpretation of the station as city gate and centralized civic monument. In the great urban station, the architects discovered a foil for the small and ubiquitous garage. Indeed, after an initial phase in which it was regarded as a rich person's toy, the automobile came to be grasped in relative terms as an advance over the railroad, with its centralized stations, fixed schedules and communal accommodations. By treating the garage as a small-scale station — one that would reproduce itself where needed — architects called attention to the relative convenience and privacy of the automobile. The lowbrow historicist garage achieved its greatest symbolic potency when the difference between travel by automobile and rail was a novel and serious consideration.

Parking and repair were accommodated in the industrial shed, a fitting environment for the machines. However, the absence of a finished architectural interior limited the garage as a sales tool (and today as a candidate for architectural preservation). Originally the dichotomous garage was an apt symbol for the automobile. Both objects deployed a thin outer skin to engage and seduce the public while concealing a grimy, efficient, machine-like interior. Lacking finished architectural interiors, both objects disappointed as destinations and providers of comfort and repose. As the automobile maintained visual and functional ties to its predecessor the train, the garage perpetrated similar connections to the train depot. The front elevations of automobiles and garages featured classical compositions, symmetrical and balanced, with hierarchical focus on the centers.

By the early 1920s, interior design assumed a higher priority in automobiles and showrooms, a trend that continued throughout the decade. The affordable closed cab enhanced the architectural credentials of the automobile, facilitating enclosure, privacy, interior-grade

finishes and functional conveniences. The showroom interior assumed more opulence and splendor, especially in ornamentation and finish. Both of these developments played a role in the marketing of automobiles to women, who were assumed (and pressured) to regard interior design as a discipline falling within their sphere of familial duties and expertise.

The bond between the automobile and the garage eroded as the car realized its potential as a mobile architectural object — aesthetic, comfortable, reliable and fashionable. The garage, with its unaccommodating interior and association with cars in disrepair, lost resonance as a symbol of the automobile. Spurred on by these improvements in design and technology, an automobile culture took root, establishing an autonomous identity requiring no comparison to the train for legitimacy or understanding. As the train station lost relevance and significance, so did its likeness on the façade of garages. The showroom building, the majestic portals of which welcomed consumers instead of automobiles, superseded the garage as the architectural embodiment of the automobile age.

In post-war San Francisco, new and existing city homes incorporated private garages, resulting in the conversion of most neighborhood parking garages to repair facilities. Downtown, new modern garages, utilitarian inside and outside, superseded the lowbrow historicist garage. As a result of these shifts, the significance of the early garage drifted away from public consciousness.

Today the garage façade — with the exception of those few that have been restored — exudes a tired nobility. The cracks in the large expanses of stucco, the layered paint that obscures the profile of ornament, the stains and discolorations — all of this neglect imparts a premature antiquity to these classical compositions. The disparity between the perfection of their original symmetries and the imperfections wrought by time and cheap modernization presents a symbolic narrative of patience and long-suffering endurance. These qualities epitomize lowbrow historicist structures and are a major source of their charm and vulnerability.

The dichotomous nature of the garage continues to influence our response to it. As the aspirations originally communicated by the façade no longer resonate, the reality of the type's utilitarian use becomes dominant. Developers take advantage of this shift in understanding, characterizing the garage as common, insignificant and dispensable. However, by reconnecting with the garage's architectural quality and the cultural significance underpinning that quality, we can reject such assertions and act to preserve these buildings.

Part One: The Buildings

Chapter 1

The Dichotomous Garage:
Basics and the Shed

Finally we shall argue for the symbolism of the ugly and ordinary in architecture and for the particular significance of the decorated shed with a rhetorical front and conventional behind: for architecture as shelter with symbols on it.[1]— Venturi, Scott Brown and Izenour, *Learning from Las Vegas*, 1977

Program

Architecturally, garages are simple buildings: a rectangular enclosure provides shelter for automobiles, mechanics/attendants and clients. An interior with open space, generous ceiling heights and a minimum of columns facilitates parking, circulation and service. The flexibility of these buildings — their adaptability to shifting automotive uses and to a multiplicity of new uses — lies in the combination of rational structure and raw space.

A garage is a building dedicated to the storage of automotive vehicles. J.B. Jackson has written that the word "is related to the English 'ware' as in warehouse."[2] In 1910, the San Francisco Building Code defined a *public* garage as "a building where automobiles are kept and stored by the public; where automobiles are rented out to and hired by the public; where a charge is made for the use of or for the storage and keeping of automobiles."[3] The term "garage" has been used to describe buildings accommodating parking, service and sales, or any combination of these functions. The profile of a particular garage program, i.e., its mix of these three primary uses, is determined by several interacting factors, including location, era, size and demand. Over time, the relative importance of these factors shifts, and the garages adapt accordingly. Many of the garages in this study have alternated in use, typically between repair and parking.

Garages evolved from bike shops and livery stables in the early years of the twentieth century. Liebs described a process by which "livery owners began repairing cars in addition to boarding horses; bicycle and carriage shops became makeshift auto showrooms; and stores began selling gas along the sidewalk."[4] When business owners adapted their facilities and businesses to serve automobiles, they simply followed economic opportunity. In 1913, the *Call* reported, "The liveryman who sold his old broken down nags and started a garage is making more money than he ever dreamed was in the livery business."[5] In San Francisco, early print ads for garages appeared side by side with those for bike shops. Building owners secured permits to convert stables to garages as late as the early 1920s, and several of the garages in this study were built as stables.[6] The garage at 1336 Grove, for example, was converted to garage use following a transitional period during which the building housed horses,

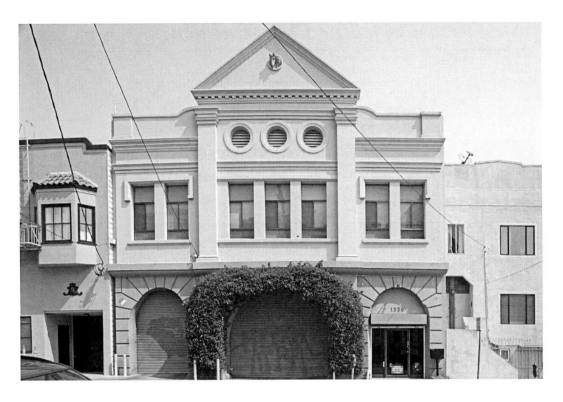

Above: Figure 6. Garage at 1336 Grove Street. Restored by architect Conrad Meusdorffer after the 1906 earthquake (Sharon Risedorph). *Below:* Figure 7. Garage at 1776 Green Street, 1914 (Sharon Risedorph).

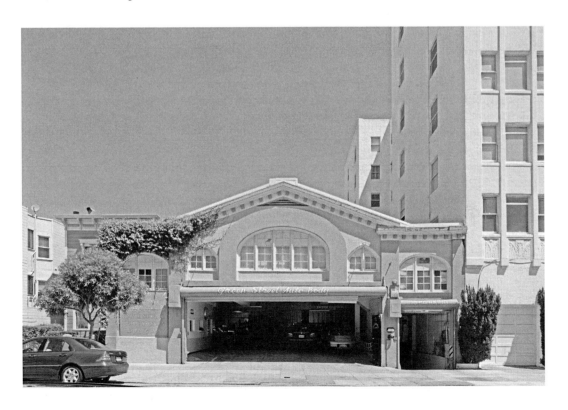

carriages and automobiles (Fig. 6).[7] Other converted stables included in this study are 1776 Green (Fig. 7) and 721 Filbert (Fig. 68 in chapter 3). Their façades — all of which have been altered — anticipate the proportions, composition, and historicist overlay of later buildings designed exclusively for cars.

San Francisco's first Auto Row, established before the earthquake, was situated on Golden Gate Avenue between Market and Van Ness Avenue. This street offered high visibility to the well-heeled target audience, members of which drove "pleasure horse-driven vehicles" from downtown San Francisco to Golden Gate Park.[8] Early on, a single garage business might sell one or several different brands of electric, gasoline or steam powered automobiles. Although "makeshift auto showrooms" were referred to as garages, they bore little resemblance to the large and monumental showroom buildings erected in the mid–1910s and 1920s. The later Auto Row buildings included garage-like industrial interiors for service and repair departments, situated above or behind the fancy showrooms. The large majority of interior space was unfinished, yet concealed from view. As a decorated shed, the rhetorical aspect of the front entailed the showroom and building exterior working in tandem to impart a false sense of opulence.

These buildings did not look like garages, and the term was for the most part dropped in favor of identifications based on brand or dealer. Thus, we have the Pierce-Arrow Building (1915) and the Don Lee Building (1921). Automobile dealers encouraged this shift, as they did not appreciate having any department housed within their increasingly monumental edifices associated with the small, dirty and possibly disreputable garage. They preferred the term "service station" to describe the repair department.[9] Disdain for the small independent repair garage was related to the larger marketing campaign that targeted women.[10] Borrowing from the Progressive Era trope requiring women to wage war against dirty, dusty and therefore morally deficient interiors, motordom decried the slovenly garage as unfit for female patronage. Trade publications launched a campaign in the early 1920s to clean up the premises and the reputation of the garage.

The ambiguity surrounding the profile of services offered by the garage extends at least back to 1920, when several automobile writers sought to clarify the term. In *Motor Age*, journalist Tom Wilder acknowledged the variety of auto-use building programs all referred to as garages: the "service station," "uncontaminated sales room," "combined sales and service garage," and "public garage."[11] However, the "pure, unadulterated garage ... performs the same function for the motor car that the livery stable of the past did for the horse." Specific services include parking for monthly clients and "transients," car washing, provision of oil and gas, but little or no repair work. No sales function is mentioned.

Most of the buildings in this study are public garages, identified by Wilder as a "big city specialty." The following discussion examines a number of garages from a programmatic perspective, noting how particular architectural accommodations or services — many of them unknown to us today — developed in relation to the times or the context.

The Golden Gate Garage, an early lowbrow historicist building, was a public garage (Fig. 60 in chapter 3). Three of its six arched bays were glazed — one serving as office window and the remaining two as storefront displays for a modest retail business. Parking was the most profitable use for the Golden Gate, given its proximity to the downtown business district, the Tenderloin entertainment district (theaters, restaurants and hotels), and adjacent apartment buildings. The small notice in the *Chronicle* that announced the imminent opening suggests that in 1910, when most businessmen employed chauffeurs, the notion of a downtown garage was something of a novelty that required explanation:

An interesting feature of this building is a clubhouse intended for the exclusive use of chauffeurs. The building ... is peculiarly adapted to the housing of autos while the owners are downtown. Instead of having the machines stand in the streets they will be sent to the garage, and the chauffeurs will have the benefits of billiard and card rooms, reading-rooms, etc., as in a clubhouse while waiting the call of their masters.[12]

A common feature in garages of the 1910s, the "clubhouse" amounted to servant quarters for chauffeurs who lay dormant along with their "machines." While the reference to "masters" confirms that drivers occupied a relatively lower caste, the chauffeur indeed enjoyed a special status in the household, attributable to "his daring, his mechanical genius and his style."[13] Typically, the chauffeurs' lounge was perched on a mezzanine built into the front structural bay of the garage, just above the entrance. Up against the façade, the drivers gained access to natural light and much needed ventilation.

Many garages in this study originally included repair departments in addition to the basic services and storage provided by the pure garage. The Jerome Garage (1914), with seven times the floor area of the Golden Gate, was better able to accommodate the increased services (Fig. 8). This garage had two floors and a basement, with stalls on all three levels. The ground floor accommodated live storage (short-term parking), the basement housed dead storage, and the second floor handled repairs. With eight mechanics and six car washers, the Jerome ran a fairly large operation. Repair departments were commonly relegated to the rear of a single-story structure or to an available second story. A well-stocked repair department from this era might include a blacksmith shop, machine shop, vulcanizing area, tire "apparatus," tool room, and stockroom.

Occupying a corner site on Polk Street — the major shopping street at the foot of Russian Hill — the Jerome enjoyed considerable exposure to passersby. The facility maintained a retail business, and promoted its wares — "tires, lamps, horns, spark plugs" — in the shop windows forming the corner. An office, also up against the façade on the ground floor,

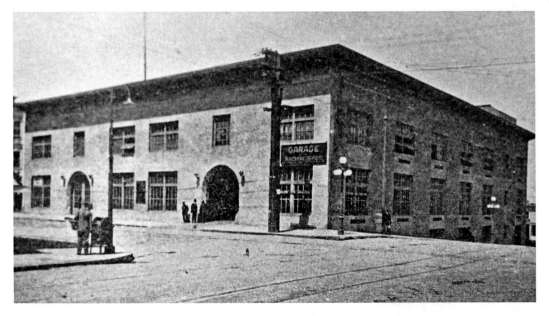

Figure 8. Garage at Jackson and Polk Streets. From *Horseless Age*, 1919 (San Francisco Public Library).

housed an administrative staff consisting of the president, day manager, two bookkeepers and a stenographer.

While public garages like the Jerome often sold accessories, an "uncontaminated sales room" was unnecessary. New car sales were accommodated in the Auto Row showrooms, and the garages were dedicated to parking and/or repair. Also, most garage façades were too narrow to accommodate a broad showroom window in addition to vehicular access, office and a small retail display. (The garage at 1641 Jackson is a notable exception [Fig. 73 in chapter 3].)

Like the Golden Gate, the Jerome offered a lounge for chauffeurs, as many car owners still did not drive their own vehicles in 1914.[14] Management also developed a security system that tracked the comings and goings of the cars, as restless chauffeurs were tempted to take their employers' cars out for a spin. The lounge was upstairs in the rear, its rooms carpeted, neatly furnished and "equipped with phone and a library of works on mechanics."[15]

Other amenities and organizational strategies of the Jerome responded to the fact that most cars in 1914 were open to the elements. The distinction between live and dead storage reflected many car owners' decision to store their vehicles during San Francisco's rainy season. Every parking stall was outfitted with a locker, allowing owners to put away clothing and accessories required for open-air motoring.

The 1919 Century Garage (Fig. 86 in chapter 3) represented itself as an upscale parking facility, and was "proclaimed by many to be the finest and most modern garage west of the Mississippi river."[16] In addition to sporting the latest in oil pumps and gas buggies, concrete parking blocks and vacuum cleaners, the Century offered "elaborate rest rooms for women, smoking rooms for men, lockers for owners, and the maintenance of personal service of high degree for all patrons."[17] The management of the Century sought to redefine the character of the garage through the introduction, on a limited basis, of interior design. While respecting the basic architectural schematic of the garage — historicist façade over industrial interior — the architect added discreet decorative elements into the shed: a sculptural winding stair, neo-Gothic column capitals, and a symmetrical double stair with marble trim. The program did not include a showroom, and the garage shed — while particularly lofty and bright — remained an expression of raw structure, rationally engineered.

The Century is important for its use of interior design as a factor in branding and promotion. Pandering to a status-conscious clientele, the design offers well-appointed lounges commensurate with well-appointed vehicles. Particularly noteworthy is the promotion of the garage to women on the basis of management's commitment to cleanliness and the provision of an "elaborate" restroom and lounge. As in the example cited above, the assumption that women insist upon a clean and well-designed interior draws upon a restrictive stereotype emphasizing a woman's duty to maintain a "pure" domestic environment. Through the appropriation of these domestic features into the program of the garage, the Century seeks to mediate and soften the strictly utilitarian character of the garage interior.

The Union Street Garage was originally a pure public garage, built exclusively for parking in 1923 by Joseph A. Pasqualetti (Fig. 34 in chapter 3). With frontage limited to fifty feet, this garage functioned as an efficient machine for parking. Open twenty-four hours a day, the facility was not equipped with doors to secure the premises. The wide middle bay of the ground floor was kept clear for circulation; cars were parked in marked stalls that stretched along either sidewall. Names of "live" monthly clients were written in chalk on the concrete beam that bypassed every stall; a sign stenciled onto a prominent wall cautioned clients to park only in his or her designated space. If original, this signage suggests that by 1923 car owners, unaccompanied by chauffeurs, were driving directly into the facility. How-

ever, as Jon Bartunek recalls, the garage also offered a customer drop-off and pick-up service (see below). In part, this service reflects the residential character of the neighborhood surrounding Union Street.

History of the Union Street Garage

Jon Bartunek

The garage building at 1550 Union Street was built during the summer of 1923. This is what my father had always told me, and one of the reasons he remembered that was because he was born in the summer of 1923. The building was originally built as a 24-hour neighborhood parking garage. There were no gates and along with a very small office was a small radio repair shop and a small bathroom. I was told that at the time the building was built, it was against the law to park a car on the street overnight in San Francisco, so these buildings were built to park cars off the street. They also provided drop-off and pick-up service for their customers. The charge was $2.50 per month!

I am not sure who the original building owner was, but I do know that in 1940 a man bought the building and gave it to his son. His idea was that if the son took care of the building, the monthly rental he collected would provide income for many years. And as of 2012, his family still owns the building.

In 1928, Leroy DeMarta took over the business. He continued the parking business and also washed cars and did mechanical repair, body repair and accessory sales and installation. The area around the garage had a large concentration of auto-related businesses. You name it, and if it had anything to do with an automobile, you could find it on Van Ness Avenue, on Lombard Street or on many of the side streets.

During Prohibition the garage was used (along with the legitimate garage business) as a transfer station for distributing booze throughout the area. My father would tell me that the night man was making a lot more money with the booze than Mr. DeMarta was with the garage. They also had a small room upstairs that they used as a gambling parlor.

Along with the auto-related businesses, Mr. DeMarta sold Doodle-Bugs, a strange little contraption like an early mini-bike. The kids were racing them all over, a real hazard. And they also made door mats out of old tires. Once, during a clean up of an old storage area, I found some odd shaped metal pieces left over from the door mat production.

The business remained consistant — repairs, accessories, parking and washing — throughout the 1930s and the 1940s. Soon after World War II the business slowly transitioned into an auto storage and shipping business. The Union Street garage building was used as the main office for storing and shipping cars mostly across the Pacific. At that time the U.S. had a huge occupation force in the Orient (as they called it at the time). Apparently, the armed service personnel who were being transferred overseas were allowed to take their cars with them. In most cases the army paid the shipping costs.

During the 1950s and the 1960s, 1550 Union Street was a hub of activity. They had over 600 cars in storage (using a number of warehouses) and they were sending about 10 to 30 cars a day back and forth to the docks. The repair shop, for the most part, took care of the cars that were being stored or shipped. They also serviced cars for neighborhood customers. As a teenager I remember helping my dad. I have a lot of memories from that time period, all those cars, all those characters.

My father bought the business from Mr. DeMarta in 1966 and eventually the shipping business split off to the branch office at Travis Air Force Base. We continued to store cars in three warehouses, including 1550 Union Street. Gradually, we got rid of the warehouses. Real estate in San Francisco commands a lot more money than you can get storing a car.

We now promote the business as an old-fashioned neighborhood repair garage. I bought the business from my father in 2003 and every day I feel fortunate to run a business out of such a wonderful space with its unique history.

Gasoline pumps were mounted on a curb just inside the entrance, served by storage tanks buried beneath the sidewalk — a code requirement in San Francisco and most major cities. A small administrative office was located opposite the pumps on the other side of the vehicular entrance. Washing racks occupied the rear of the middle bay. A second story, accessed by a ramp, accommodated long-term storage. Over the years, the building retained its basic garage function, but the exact nature of the activities performed on the premises changed again and again (see sidebar). The flexibility is typical, and illustrates the continued use of the term "garage" to refer to parking, repair and sales facilities.

San Francisco's skyscraper garages, built in the early to mid–1920s are later examples of the building type. Two skyscrapers, 265 Eddy and 111 Stevenson, are included in chapter 3 of this study. While much larger than the one- and two-story garages that form the heart of this study, skyscraper garages are closely related to these smaller garages. Typically, the façade of a one- or two-story garage is incorporated as the base of a neo-classical skyscraper — a tri-partite composition of base, shaft and celebratory top. Indeed, the short garage's parapet is dispatched to the top of the skyscraper. The incorporation is no accident, as the architects and owners of the skyscraper garages all designed smaller garages, often concurrently.

The skyscraper garages, as the label suggests, are designed to blend in with their surroundings. They are contemporary with the monumental showroom buildings on Auto Row, and share with them — the Don Lee Building, in particular — the simulated appearance of an office building. While showroom buildings incorporated garage facilities, and while many garages maintained a modest retail presence, the fundamental difference between the two related types is the nature of the ground floor interior and its presentation to the street. The garage presents a historicist façade over an industrial interior, while the showroom building presents a stylistically integrated interior and exterior.

While the showroom building appropriates the appearance of the office building in order to communicate a comparable prestige, the skyscraper does so in order to be a good neighbor among real office buildings. While the showroom building extends the office-building metaphor by offering its entry portals to people, the skyscraper garage presents its portals to cars. This contrast reflects motordom's purposeful manipulation of architectural design in buildings hosting the sale of new cars.

The "uncontaminated sales room" had existed for some time, but in the early 1920s the San Francisco showroom became grand — in some cases, majestic. In its augmented form, the showroom forged a symbolic link with the evolving automobile, which rapidly embraced architectural qualities like style, enclosure and interior design. Meanwhile, the garage — in particular its industrial interior — recalled the automobile of the past: in constant need of repair, uncomfortable, and machine-like. As the automobile developed, its symbolic connection to the lowbrow historicist garage waned. This theme will be elaborated upon in chapter 8.

Building Sheds

The lowbrow garage is an infill building in which a façade — based on historical precedent — provides vehicular access to an industrial interior. Like most lowbrow historicist structures, garages are *decorated sheds*, as famously described above by Robert Venturi, Denise Scott Brown, and Steven Izenour. The rhetorical content of the historicist garage front is expressed through the informal and caricatured assemblage of historically derived elements (arched openings, applied pilasters, cornices, discrete ornaments) into simple, symmetrical

compositions. The interior is conventional in the reduction of architectural development to the ordered and efficient disposition of heavy and unfinished materials for structure and enclosure — a raw building shell. The contrast between façade and interior is fundamental to the building type, and is referred to in this book as the *dichotomy*.

While both garage and freestanding decorated sheds exemplify "architecture as shelter with symbols on it," the garage shed is typically concealed from view. The façade represents the commercial enterprise while the interior — exposed to view through gaping openings — represents the building shell. In most retail infill buildings, the rhetorical content of façade and interior can achieve parity or unity, depending on the tenant's aspirations and budget; in the infill garage, the contrast between cavernous interior and rhetorical façade is inherent to the use and not contingent upon interior design.

In the service of a commercial venture, the garage façade assumes the thinness and communicative potential of a billboard. Rather than attempt to create unity by treating the front as simply the fourth side of the industrial box — as a modern-movement architect might do — the designers of these buildings revel in the opposition between inside and out and celebrate the public nature of these façades.

The dichotomy in the treatment of the outside and inside can be framed as a series of oppositions:

Outside	*Inside*
Historicist	Industrial
Public	Private
Light	Dark
Planar	Spatial
Solid	Void
Semiotic	Tectonic
Composed	Engineered
Finished	Unfinished

Many architects, critics and observers of the time would have interpreted the dichotomy as the difference between *architecture* and *building* (while objecting to the notion that architecture is two-dimensional). The proposition that these are distinct expressions has a long and controversial history, dating back to John Ruskin's assertion that ornament is the key distinguishing feature that separates architecture from mere building. In its blunt presentation of opposites, the historicist garage brings together the properties of architecture and building in a single organized tectonic expression.

From the psychological standpoint of the contemporary observer, the dichotomy juxtaposes the welcoming with the intimidating, and the transparent with the mysterious. The portal beckons, yet it welcomes cars — not people. Inside, no provision is made for pedestrian safety, circulation or way finding. In most garages, clients walk up and down the vehicular ramps, a routine originally reserved for parking attendants and mechanics. (Stairs, when provided, are usually steep and remotely situated.) Whether the interior boasts a nave-like center aisle or merely an area of refuge adjacent to the office, pedestrians appear out of place in this rough environment. The garage is also threatening and dangerous, as cars come quickly down ramps, barrel through façade openings and emerge suddenly out of the dark. Efforts to encourage a reassessment of these buildings are complicated by the alienating quality of the interiors.

Garages lots are deeper than they are wide, and primary structural elements span laterally from sidewall to sidewall. Rational expressions of engineering, the space is divided into rectangular, equally spaced, structural bays (Fig 9). Thus, a garage that is 137' deep

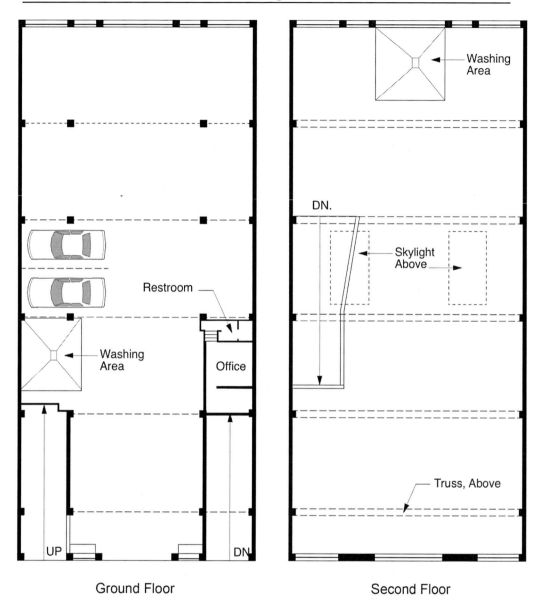

Ground Floor Second Floor

Figure 9. Plans, garage at 66 Page Street. O'Brien Bros., Architects, 1924 (drawing by Sarah McDaniel and Esther Kim).

divides into six bays just under 23 feet, a dimension that comfortably accommodates two cars parked side by side. With just a few exceptions, the garage sheds fall into one of the following five categories:

1. One-story brick buildings without mezzanine
2. One-story brick buildings with mezzanine
3. Narrow two-story concrete buildings, 50–70' wide
4. Two-story concrete buildings wider than 70'
5. Concrete frame skyscraper garages

These subtypes are broad, and subdivide the collection on the basis of a few key parameters: material, height and width. Sheds function as armatures supporting the façades, and each category of shed brings together the façade and the industrial interior in a distinct fashion. While the typology presented in chapter 3 classifies on the basis of façade — which encompasses architectural composition and historical style — the shed underpins the façade by dictating basic proportions and structural material.

The first two shed categories describe the earlier garages from the 1910s, with or without basements. (The Jerome Garage, an early reinforced concrete garage, is a notable exception.) These buildings feature wood or metal trusses that support wood-framed roofs (Fig. 10). Most brick garages include a mezzanine and belong to the second shed type. The mezzanine spans across the building, and fills up the front structural bay between the façade and the first truss.

A few brick boxes occupy wide lots. The sheds respond to the increased width by depressing the height of the truss, which in turn limits the height of the façade. Also, interior wood posts are introduced posts to break the span. The garage at 64 Golden Gate exemplifies this treatment (Fig. 11b).

The concrete frame buildings, categories 3–5, became typical in the 1920s, when unreinforced masonry fell into disuse. Roofs assumed a variety of profiles and support systems. On narrow buildings, a clear span truss — wood or metal — rested on sidewalls or concrete pilasters. Wide garages typically received flat roofs supported by deep concrete beams.

Figure 11 shows diagrammatic cross-sections of garages representing the first four shed categories. (Reference is also made to the façade types as designated in the typology chapter.) A comparison of the sections reveals the remarkable variety achieved in these primary struc-

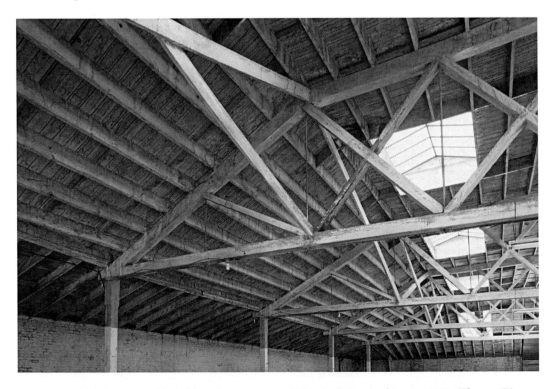

Figure 10. Garage at 64 Golden Gate Avenue. Crim & Scott Architects, 1910 (Sharon Risedorph).

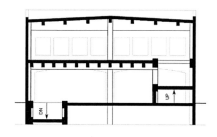

(a) 550 Turk, (Twin Arch Category), Width = 68.5'

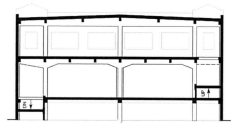

(e) 855 Geary, (Palazzo Category), Width = 82.5'

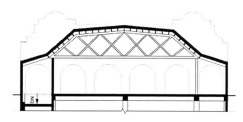

(b) 64 Golden Gate, (Arcade Category), Width = 82.5'

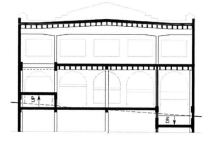

(f) 1945 Hyde (Arcade Category), Width = 70'

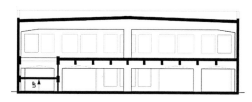

(c) 1745 Divisadero, (Wide ABCBA Catergory), Width = 87.5'

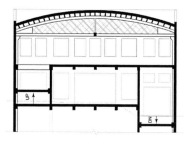

(g) 1565 Bush, (Narrow ABCBA Category), Width = 64.5'

(d) 1550 Union, (Narrow ABCBA Category), Width = 50'

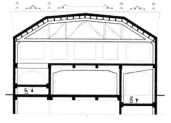

(h) 460 Eddy, (Palazzo Category), Width = 57'

Figure 11. Diagrammatic sections (drawing by Esther Kim, Sarah McDaniel and Haley Hubbard).

tural expressions. Both trusses and rigid concrete frames are regularly spaced events that mark one's procession through the garage, and are experienced as repeating echoes of the initial crossing through the façade.

The sections reveal patterns, including the sidewall positioning of ramps, and the independence of the parapet profile from that of the roof. Exposed trusses dovetail with the roof profile; two of the examples illustrate the bowstring truss and barrel-shaped roof profile

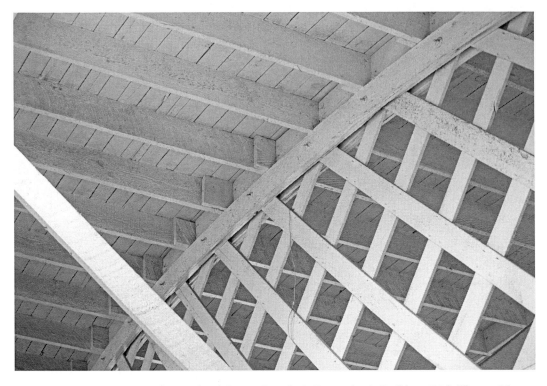

Figure 12. Garage at 2340 Lombard Street. Joseph A. Pasqualetti, Builder, 1924 (Sharon Rise-dorph).

employed by Joseph A. Pasqualetti (Fig. 11d, 11g, 12). Among the flat roof structures, the wide span is always subdivided into two, three, or four bays.

The cross-sections also show the impact of site width on the façades, and ultimately on façade composition. These buildings are one or two stories in height, and as the height of a single-story building with a shed roof approximates that of a two story building with a flat roof, building height does not vary as dramatically as width. Site depth also does not vary much, and serves as a relative constant in comparisons of buildings of different widths and cross-sectional proportions.

As owners built to their property lines, lot geometry and dimensions determine the floor plate. The garages featured here vary in width from 50' (Fig. 34 in chapter 3) to 126' (Fig. 75 in chapter 4).[18] A typical garage lot is 68' 9" wide × 137' 6" deep, a double square that is a sub-division of a standard San Francisco block. This general size and proportion is well suited to both one- and two-story parking structures, and it underpins some of the more efficient and compact façade compositions in the collection. A width of around 70' is used here as the dividing line between "narrow" and "wide" garages. At a certain critical width of about 80' and a more or less constant height, the garage assumes a broad and low presence, while the façade composition subdivides into a greater number of bays. Beyond 100', the garage appears horizontally attenuated, and the sense of axial procession through the façade less focused.

Throughout the 1910s and 1920s, on a national basis, garages having second stories and/or basements were outfitted with ramps or elevators to access these levels. In San Francisco, ramps — or *runways* — predominated. The elevator and turntable arrangement was typical in skyscraper garages (see below), but rare in two-story buildings (the Jerome Garage

notwithstanding). The relative merits of the elevator and the ramp elicited considerable discussion at the time in *Motor Age*, a magazine that discussed garage design. One 1919 article declared, "It is mainly a question as to whether the space given up to a ramp could earn a large enough return on the investment to pay for the up-keep [sic] and operating expense of an elevator."[19] A second article favored the ramp, calling it faster and cheaper, with a "capacity [that] is almost unlimited."[20] Ramps were an efficient choice for garages limited to three levels (including basement), with sufficient frontage to accommodate up and down inclines in dedicated bays directly accessible to the street.

As will be discussed in greater detail below, ramps play a large and influential role in the exterior aspect of the garage, both in terms of façade composition and the building's engagement with the street. Ramps are always situated towards the front of the structure — usually right on the property line. Simple rectangular slabs on an incline run perpendicular to the façade along one or both of the sidewalls.

This arrangement has several advantages: First, when garages are located on a sloping grade — and in San Francisco, this occurs frequently — ramp lengths can be minimized by locating the basement ramp on the low end of the façade and the second floor ramp on the high end. Second, the ramp, a concrete structure, can easily gain structural support from the available sidewall. Third, if the structure has both a basement and a second floor, the two ramps — located on either end — flank and frame the major ground floor entrance in the middle (Fig. 9 earlier in this chapter).

While the ramp derives support along its outside edge from the adjacent sidewall, the inside edge drops its load onto the concrete frames that span laterally across the building (Fig. 50 in chapter 3). As illustrated in Fig. 11 earlier in the chapter, these frames are always subdivided such that post locations coincide with the exposed inside edge of ramps. The width of structural end bays is therefore determined by the width of the ramps they serve, a constant dimension of 11–12 feet. Like bookends, the end bays remain constant regardless of the space in between and the overall width of the garage.

Skyscraper garages present a more complex circulation challenge. Typically vehicular openings in the façades provide clear access to elevators placed against the rear wall. Turntables, located in front of the elevators, rotate automobiles 180 degrees and preclude the necessity of backing out of the facility. Of course, these are vehicular lifts and not passenger elevators. Vehicles are parked and retrieved by parking attendants, a programmatic narrative suggesting that the garage interior is the domain of the staff, not the car owner. This circulation system is still in operation at 265 Eddy (Fig. 33 in chapter 3) and 111 Stevenson (Fig. 67 in chapter 3).

The North Central skyscraper garage at 355 Bush Street, now demolished, was atypical and progressive in its engineering and empowerment of the customer. Instead of vehicular elevators, it utilized the d'Humy Motoramp System, in which the floor plates are split in half and staggered at half-levels.[21] The length of ramps is reduced because the vertical distance traveled between adjacent slabs was only a half-level. At the same time, a *passenger* elevator enabled drivers to quickly descend to the street after self-parking, or to access their cars to leave. Variations of this circulation system are still in use today.

Interiors

The interiors are rugged, dirty, and dark, and the top story is vast. With the exception of a few isolated areas — offices, retail areas and chauffeurs' lounges — garages were not finished

for human habitation. Overwhelmingly, visible material is structural. As the number of interior columns is minimized to increase efficiency and flexibility of layout, spans are relatively long, spanning elements deep, and columns (especially concrete) substantial. Exposed and unfinished, structural elements express tectonic power.

The quality of these raw interiors is largely a function of proportion, material (color and texture), and light. The earlier brick boxes present a single immense space, 50 to 100 feet wide, 137 feet deep and at least 20 feet tall at the apex. Those with mezzanines offer the visitor a compressed transitional or preparatory zone between entry and the experience of the cavernous shed.

A dramatic feature of these single-story interiors is the contrast in material between wall and roof structure. In the lower half of the space, the brick holds sway—its dead weight, surface texture, coursing, stains and degradation—is a source of rugged expressionistic beauty. This contrasts with the upper half of the space, which presents an ordered sequence of lighter, linear elements that span and spring. Truss chords, cross bracing, planking and metal hardware intersect to form layered, abstract compositions. To the observer, the horizontally bifurcated room is striking, not only for its raw strength, but also for the visual accessibility of its simple and efficient structure.

Natural light enters the space through skylights and the façade. There may be windows in a rear or sidewall, but this is unusual in single-story infill buildings. A few garages back onto alleys, and have rear façades with door and window openings. The ratio of glazing (or openings) to the volume of enclosed space is very small relative to the smaller scale spaces we typically inhabit. During the day, the pure geometry of discrete rectangular skylights — and the pattern they form in the ceiling plan — is highlighted by an intense glow that contrasts with adjacent dry and dark surfaces. Walls of light-absorbent red brick are darker and cooler than those of concrete or painted brick. Occasionally, as at 1355 Fulton, an abundance of natural light emanating from the upper reaches of the space highlights the roof structure and animates its linear elements (Fig. 13). Typically, however, the overall lighting level is low, which contributes to the antinomy between façade and interior.

Two-story garages present a qualitatively different experience. The ground floors are quite dark, despite the large voids in the front wall plane. Proportionate to building depth, the ceiling heights of these ground floors are low, around 12 to 13 feet. (As most two-story garages were built for parking, these heights were adequate.) These deep, dark spaces with natural light visible at one end are distinctly cave-like.

Pedestrians (and automobiles) access the second floor of a garage directly from outside, walking up the ramp that begins at the street, at one end of the façade. As a result, circulation to these levels does not involve an axial procession through a central portal, as often happens in ground floor access. The visitor arrives in the center of the plan (depth-wise), along one sidewall (Fig. 9 earlier in this chapter). Nevertheless, the more monumental two-story garages, like 525 Jones Street, offer an upper floor with the spaciousness and austere beauty of the one-story brick shed—as if the one-story structure has been raised on a pedestal.

Indeed, those upper levels crowned with trusses are far more dramatic than flat roofs resting on concrete frames with interior columns. Either way, however, the upper levels benefit from skylights and a greater likelihood of window exposures on two or more sides. The second floors are invariably lighter than the spaces below—both in terms of the physical weight of structural elements and the illumination level.

From a preservation perspective, the garage interiors are not regarded as the repository of the building's significance. Setting aside the argument that holistic pieces of architecture

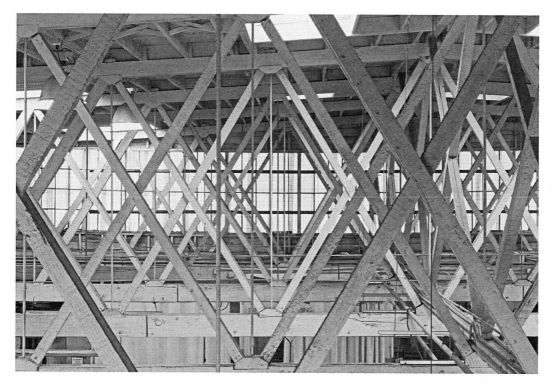

Figure 13. Garage at 1355 Fulton Street. Mel I. Schwartz, Architect, 1923 (Sharon Risedorph).

cannot be divided into significant and insignificant parts, many of these interiors are worthy of protection in their own right. The fact that they are common, raw and old is the source of their power and beauty. They envelop us in a combination of extraordinary properties that lift our spirits: clear, open space small enough to take in but large enough to expand our vision; heavy structure that orders the space, creates patterns and expresses its tectonic role; massive materials revealing texture, density, joints, and hardware, all in a state of deterioration; and, isolated glowing rectangles of gridded white light that provide contrast more than ambient light, a circumstance that draws even more attention to the vast parameters of the space. The industrial interior of the garage is an architectural refuge for anyone dissatisfied with a commercial environment bounded by sheet rock, acoustical tile, carpet, and aluminum windows.

Chapter 2
The Dichotomous Garage: Façades

The garage façade mediates between the public and private spheres, between the representation of the building to the street and the building's inner workings. Designers deployed grand portals on their façades to celebrate the passage of automobiles and the buildings' participation in a triumphant automotive culture. Promotional emphasis did not focus on the specific use — parking or repair — so much as the buildings' affiliation with the coveted status symbol. The façades represented the class aspirations of the clients more than the functions performed within, while the interiors reversed the symbolic priorities. As white-collar compositions superimposed onto a blue-collar use, the façades fulfilled a rhetorical mandate to invest the garage with a glamour that could not be generated around its use. Thus, the garage looks better than its use would suggest. The resultant architectural dichotomy — historicist façade over industrial shed — affirms J.B. Jackson's idea that the essence of a vernacular architecture resides in a "confrontation" between social aspirations and realities.

The automotive garage was a new building type devoted to a transformative new industrial product. While the type may have evolved from the livery stable and the bike shop, these antecedents served as transitional hosts for the garage. The older types were limited because they did not reflect the automotive pioneers' particular mix of confidence, idealism and entrepreneurial spirit. When the lowbrow historicist garage established an independent identity, the building type captured the civic and mercantile pride of the nascent industry.

The urban train station proved to be a better precedent for the garage, due to its role as city gate and transportation hub. With an architectural head building facing the city and an engineered train shed behind, the train station offered a convenient architectural organization, easily adapted as a garage façade and car shed. The organization affirmed the idea that the façade bears an autonomous civic role that is responsive to the public — regardless of the character and use of the shed behind. Just as important, the station served as a useful foil for highlighting the relative benefits of the automobile over the train. As tiny depots spread over the entire city, the garage expressed the unprecedented convenience and personal autonomy offered by the automobile.

The façade is the locus of the designer's artistry and ability to adapt historical precedent and style. Much of the meaning of the garage as a miniaturized train station and symbol of the automobile resides in the façade. At the same time, the façade reflects the designer's training and inclination to find order in simple compositions characterized by symmetry, balance and hierarchy. To varying extents these compositions represent a building structure that, despite possessing an analogous simplicity, is regarded as too inelegant for direct exposure. Historically derived style and composition achieve a mutually accommodating convergence, as the composition is itself symbolic of a traditional notion of architectural order, while the historicist overlay is disposed to highlight the composition.

In this book, the façade is the basis for the organization of the collection of buildings

into a typology. Façades are classified according to a particular composition or historical style. This chapter introduces the physical attributes, formal compositions, historical styles and stylistic elements that inform the later classification and discussion of individual buildings. Using the conventional nomenclature of architectural analysis, simple letter sequences are used to describe façade compositions and building structures, as subdivided into adjacent bays. (For clarity, compositional bays appear in regular type; structural bays are shown in italics.[1])

Proportions

As are one- and two-story buildings on lots wider than 50 feet, the garage façades in this are oriented horizontally. Even most skyscraper garages are wider than they are tall. Due to sloping parapet profiles above, and hilly San Francisco streets below, elevation heights are rarely constant across the width of a façade. Generally however, garage fronts — excluding skyscrapers — rise from 25 to 35 feet above grade.

The mid-block garage lot is considerably deeper than it is wide, a fact that runs counter to the impression formed on the basis of the façade alone. From the street, the horizontal proportions of the façade, the modest height (relative to multi-story buildings) and the inability to perceive depth in the dark interior suggest shallowness. The façade appears to be fronting the long side of the building rather than the short end of a long shoebox.

Materials

Garage façades are constructed of the same material as their associated side and rear walls — either brick or concrete. A brick façade fronts a single-story brick garage from the 1910s, with or without a mezzanine. Similarly, a concrete façade — with few exceptions — fronts a two-story garage built in the 1920s. However, as the brick may be faced in stucco, one can't assume the structure of the garage from the building front (Fig 73 in chapter 3). Stucco was likewise applied to concrete façades.

Since the front wall is a heavy self-supporting plane (and not weightless infill), the façade cannot be an abstraction divorced from tectonic considerations. The weight, means and methods of construction and the spanning capacities of the material must be considered. Hence, the brick façades tend to exert a more massive and wall-like presence, with a greater ratio of solid to void than their concrete frame counterparts (Fig. 14). The collection's most dramatic arched portals are rendered in brick, representing an ideal confluence of structure, material, composition and symbolism. Masonry details — like the brick *voussoirs* and imposts at 2405 Bush, for example — articulate the composition and animate the façade (Fig. 75 in chapter 3). Inset terracotta moldings, diamond shapes, and relief panels introduce polychromatic effects that likewise articulate centerlines and parapet profiles.

Façades of reinforced concrete are generally boxier than their brick counterparts and more likely to have flat parapets. In form, they resemble the urban *palazzo* with *piano nobile*, and contrast with the gabled or arched front of most monumental brick façades. The concrete surface, usually stuccoed and painted, is abstract and without texture. These façades reflect the vertical and horizontal lines of the structural frame behind, and present a grid of solids and voids. Ornament is usually appliqué, constructed of plaster, precast concrete or galvanized metal.

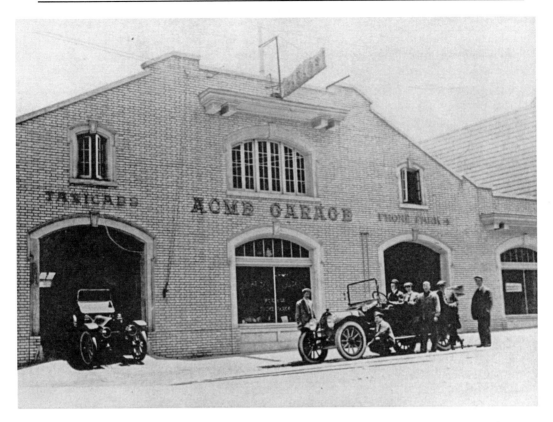

Figure 14. Garage at 624 Stanyan Street. Crim & Scott, Architects, 1911 (courtesy Joan Anderson Weierman).

While the garage façade is dimensionally and materially a small part of the building, it carries a disproportionate functional load. As originally conceived, most of the unique programmatic events occur on the façade or within the front structural bay: entry, vertical circulation (ramps), gasoline service, administrative office, lounge, store and retail display. These events vie for space along a limited street frontage, and the consolidation contributes to the impression that the façade constitutes the long side of a shallow building.

One feature that distinguishes a garage from its residential or commercial neighbors is the scale of its entry openings, which are sized to accommodate automobiles, not people. The lack of a standard door or opening — one scaled to a human being — distinguishes the garage from most other building types on the street. While adjacent shops, apartment buildings and theaters may also offer overscaled portals to invite entry, those compositions ultimately frame a conventionally sized door.

A standard door was never provided. Doors were functionally unnecessary because the wide vehicular opening did not preclude pedestrian passage. Standard doors, as complements to garage doors, may have been avoided to preclude the possibility of mechanics and attendants occupying or operating an inadequately ventilated enclosure. The health risk posed by garage fumes was well known at the time, as exemplified in the following excerpt from a 1926 article in *Architect and Engineer*: "The present concentrated drive by government officials, health authorities and physicians against the carbon monoxide peril in motor car garages offers an important item for the consideration of all contractors and builders."[2] To

admit light, air and customers, the doors (if there were any) remained open when the business was open. This procedure is still followed today, when many openings have been retrofitted with metal rollup doors.

The substitution of oversized openings for standard doors is a specialized feature that garage designers integrate into their academic compositions. In some cases, these entrances appear as punched out openings in a solid wall; in others, large adjacent voids dematerialize the façade at the street level (Fig. 58). Over the years, this dematerialization has been accelerated by the widening of existing openings, which has generally occurred at the expense of bays containing glazed display or office windows (Figs. 43–44 in chapter 3).

Compositionally, dematerialization results in a horizontally bifurcated façade, with a heavy solid wall floating above a continuous void. The suggestion of weightlessness was frowned upon by Victorian architects, who criticized multi-story buildings with glazed storefronts as ill-conceived inversions of classical order and good taste.[3] The prejudice continued into the 1920s, as evidenced in journalist Irving Morrow's review of garages designed by Bay area architect Charles W. McCall. "He [McCall] has fully recognized the necessity for huge yawning openings in such buildings, but at the same time has overcome the appearance of emptiness and structural inadequacy generally so obtrusive."[4]

The large, void but framed opening is an important identifying feature of the garage. It facilitates an unusual accessibility, inclusive of both the bright exterior and dark interior. This accessibility is unique to those building types, including firehouses and parking garages, which are — or used to be — always open for business and dedicated to the passage of vehicles.

Of course, garage façades also included glazed openings. On the ground floor, offices and retail operations were represented by windows and storefront displays. These elements provided designers with a much-needed source of visual and compositional flexibility. In the opposition of solid and void, glass offered a third possibility, an intermediary between framed open voids and opaque wall. Depending upon sill height, the relative size of glazing to surrounding material, and the role suggested by the composition, the ground floor window could function as a solid, a void or something in between. Given the amount of street frontage devoted to vehicular access, the representation of the window as a solid was often the primary means by which the designer could limit the dematerialization of the ground floor (Fig. 42 in chapter 3).

Some narrow garages built as pure parking structures did not require a display window, as the proprietor did not conduct a retail business. Administrative offices were often perched above the descending basement ramp and recessed from the façade altogether. This handling of the office, together with the absence of a storefront, enabled the street frontage to be monopolized by vehicular access.

The upper half of a two-story façade is a source of natural light and ventilation. (The same holds true for a one-story façade with a mezzanine.) Typically, discrete windows appear as punched-out openings in the wall. Whether regularly spaced or clustered into groups, the windows reinforce the major compositional subdivisions. As in factories, each window is subdivided into smaller rectangular panes. An operable panel composed of a group of these panes may float in the center of the window.

Promotional signs and graphics appeared on historicist garage façades from the beginning of the building type. As is true today, signage might include the name of the facility, the services provided, a particular brand of automobile (a house specialization), and sundry logos and trademarks representing the products used or sold within. The most prominent signs were blade signs, oriented horizontally or vertically, that were cantilevered off the face

of the building. Intended to capture the attention of potential customers driving by, the signs usually highlighted the word "GARAGE" and not the business name. Painted signs on wood or metal panels were attached to wall surfaces, often inserted into available recessed transoms. Letters were painted directly over stucco or stenciled onto glass. In one noteworthy example, signage contributed significantly to the architectural character of the façade and was not an after-the-fact superimposition (Fig. 70 in chapter 3).

In rare cases, care was taken to coordinate signage and façade composition, with blade signs and restrained graphics centered above key architectural events (Fig. 14 earlier in this chapter). Much more commonly, signage was aggressive in size, character and location, reflecting a proprietor's preference for maximum impact over architectural sensitivity. Also as a practical consideration, blade signs required structural support and were mounted on piers usually located off the centerline of the façade.

Garage signage and graphics emphasize the commercial aspect of the business and the building's engagement with the street and its activity. As a totality, the signage appears as an additive promotional element, common and shrill. It plays a major role in framing the garage as a lowbrow enterprise, a judgment that easily transfers to the host building. This influence continues to this day, and it serves to legitimize assertions of blight and squalor.

Composition and Structure

Garage designers relied upon traditional, academic principles of composition to organize and reconcile the conflicting demands made upon the façade by its didactic and functional program. The façades of the lowbrow historicist garage are stable, balanced set pieces. When the façade is treated as a wall with punched-out openings, order is usually achieved through symmetry and hierarchy about a strong center (Fig. 90 in chapter 3). When the façade is treated as a gridded elevation, emphasis shifts towards alignment and the articulation of bays and levels (Fig. 34 in chapter 3). Almost always, the designer strives to frame around the overscaled entrances with solid material. Given the programmatic need for windows and openings on the street, this was often difficult to achieve.

Compositions are compact and basic in their bay configurations: AA, ABA, ABBA, ABCBA, AAAAA and ABA/ABA. These arrangements reveal symmetries composed of an odd or even number of bays. In a few instances, subtle, syncopated rhythmic patterns are overlaid onto a basic composition through the ordered manipulation of finer-grained elements: operable sash, cornice projections, parapet inflections and individual ornaments. Simple classicizing façades — like the Main Street storefront topped with a western-style parapet — are staples of lowbrow historicist architecture, garages included. The thinness and semiotic power of these fronts are complementary properties of the architectural sign. However, while the San Francisco garage façade engages in its fair share of cheap and easy signification, its simple compositions cannot be dismissed as arbitrary or unhinged from the building behind.

The regulating lines of a garage façade are closely related to structure. Vertical lines subdivide the façade into compositional bays that loosely mirror the primary structural system behind. Horizontal lines reflect a second floor or mezzanine directly behind. (A mezzanine enables the architect of a one-story garage to design the façade as if it were a two-story building — a deception that amplifies the scale of the building as perceived from the street.)

The ties between the façade and the building structure behind are unusually exposed, despite the implications of a barrier suggested by the notion of a dichotomous architecture.

Large framed openings provide easy visual access to the interior. As discussed in the previous chapter, the primary structural event is a truss or concrete frame, regularly spaced, and imbued with substantial architectural presence. (Variations of these events are illustrated in Fig. 11 earlier in this chapter.) An ascending ramp, when it occurs, triggers a subdivision of the structure supporting the second floor and the introduction of columns supporting the ramp's inside edge. The façade reflects and represents this structure and can be interpreted as its introductory expression. For this reason, façade compositions fall into patterns that reflect the shed categories introduced in the previous chapter.

Shed Category 1: Single Story Brick Box

This shed affords the designer the most compositional freedom, as the primary structural event — a clear span truss — offers few lines within the perimeter of the cross section that can be projected onto the façade. Compositional restraints are imposed by the structural properties of brick, most notably in the spanning of wide openings. The signature motif of this shed is a monumental arched portal positioned at the center of the façade. Soaring up towards the apex of the roof behind, the arch appears to flaunt the absence of a mezzanine or second floor to interrupt its vertical reach. As rendered in brick, the arch is structural. The dramatic garage at 1641 Jackson features this motif, although its structural logic is revealed only on the interior (Fig. 73 in chapter 3).

Shed Category 2: Single Story Brick Box with Mezzanine

Façades over these sheds form two basic groups. In the first, the mezzanine serves as a horizontal dividing line between smaller residential-type windows above and larger commercial-use windows and openings below. This treatment distinguishes between the lounge function of the mezzanine and the business functions on the ground. The garage at 3536 Sacramento illustrates this approach (Fig. 90 in chapter 3).

The second group incorporates fenestration at the mezzanine level into large-scale openings extending down to the ground. When a central archway is employed, the arch springs off the mezzanine floor, the end of which is covered by a transom bar. The rectangular opening beneath the mezzanine serves the ground level. The garage at 1776 Green (which also includes small residential windows above the mezzanine) exemplifies this design motif (Fig. 7 earlier in this chapter).

When brick boxes have no basement (and therefore no ramps), storefronts and office windows are easily integrated into the composition. Windows simply flank the central portal in a symmetrical ABA configuration. For garages with no stores or offices, similarly situated windows provide much needed light to a dark interior. Many excellent garage façades employ this classic, straightforward composition. The garage at 1419 Pacific — a brick box equipped with a mezzanine — utilizes this template (Fig. 72 in chapter 3). For brick boxes *with* a basement, the designer balances the ramp on one side of the portal with the window on the other, achieving a somewhat compromised symmetry (Fig. 7).

On those few brick boxes occupying wide lots, the façades expand from three bays (ABA) to five (ABCBA) or six (AAAAAA, ABAABA). When unencumbered by a basement ramp, the wide ABCBA solution calls for matching vehicular openings in the "B" bays, both of which access the ground floor. These openings frame a center bay that contains the office window. The end bays are likewise glazed, and usually accommodate retail displays. Composi-

tionally, the vehicular openings are voids and the glazed bays are "solids," creating an alternating pattern. While 242 Sutter (Fig. 106 in chapter 5) and 650 Divisadero (Fig. 42 in chapter 3) appear to be very different buildings, they are united by this underlying composition.

Shed Category 3 and 4: Two-Story Concrete Frames

The structure of concrete sheds exerts a more explicit impact on façade composition. There are several reasons for this, the most basic of which is the increased number of linear structural events that manifest on the façade as regulating lines. The second floor and the interior columns are the primary elements that project onto the façade as a grid that influences composition.

Almost always, two-story façades are designed as stacked levels with a solid horizontal separating ground floor and second story events. As a result, vehicular openings are single-height events with flat or shallowly arched headers. Paradoxically, these mundane square voids function as centerpieces — singly or in pairs — of elaborate compositional symmetries. A straightforward expression of the frame does not take the form of a grand central portal, as it does in the brick box. Other devices are utilized in order to aggrandize the entrance.

One alternative is illustrated in the garages designed by Joseph L. Stewart. His façades are atypical in presenting super-scaled portals encompassing both levels of a two-story garage (Figs. 15–16). These façades achieve a heightened monumentality, the result of Stewart's adaptation of the central arched portal to these taller buildings. In order to adapt this motif, Stewart had to confront the fact that the "true" vehicular entrance only extended up to the second floor, and that the arch is just a non-structural cut out. In one design for a skyscraper garage, Stewart refrains from a portal extending the full height of the building,

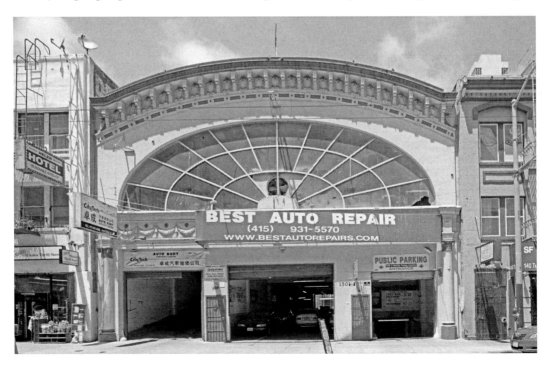

Figure 15. Garage at 150 Turk Street. Joseph L. Stewart, Architect, 1922 (Sharon Risedorph).

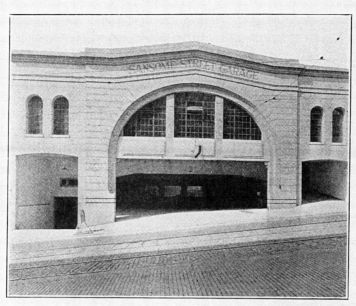

Figure 16. Ad from *Architect and Engineer* showing the garage at 825 Sansome Street. Joseph L. Stewart, Architect, 1921 (San Francisco History Center, San Francisco Public Library).

and the stacked result is quite awkward (Fig. 17). While he employed the arched portal, the results lack the simplicity and integrity of those gracing the fronts of the earlier brick sheds. (Stewart's building at 1661 Market is discussed in chapter 3 [Figs. 78–79 in chapter 3]).

However, the strong impact of structure on these façades is not solely attributable to the stacking of levels (a characteristic shared with the mezzanine garages) and the simple projection of frame elements. It is also due to the ramps, and especially the ramp up to the second floor. Visually, ramps function as bridges that span from the façade to the concrete frame behind.

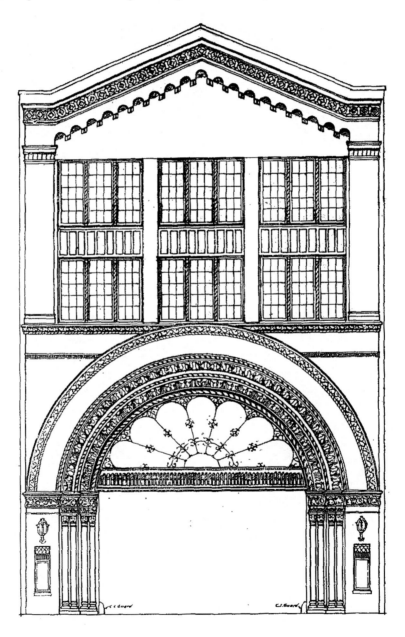

Figure 17. Elevation, 145 Fourth Street (demolished). Joseph L. Stewart, Architect, 1921, from *Architect and Engineer*, 1920 (San Francisco History Center, San Francisco Public Library).

Together, façade, ramp and structural frame form a three-dimensional construction. The coincidence of ramp width, structural bay, and compositional bay (on the façade) is exposed to view and intuitively grasped. At the Post-Taylor garage, for example, the layering of façade and structure is visible through the voids along the street (Fig. 50 in chapter 3). Also illustrated is the dual aspect of the front wall as tectonic plane and decorative façade. (As so often happens, architectural intentions are better illustrated in archival photographs, because contemporary photographs document subsequent modifications that obscure these intentions.)

There are two primary approaches to incorporating ramps into the façades of frame structures (only one of which is exemplified by the Post-Taylor garage). In one, the façade presents two identical arched openings, each one sufficiently wide to accommodate two cars (Figs. 18, 27–28 in chapter 3). The ramps are recessed a few feet, and are not represented on the façade as dedicated compositional bays. Behind the façade and between the ramps, the ground floor is continuous. (Gasoline pumps were often positioned behind the pier separating the two openings.) This arrangement results in a syncopated rhythm between a two-bay façade (AA) and the trio of events right behind: ramp/ground floor/ramp (*ABA*). As the AA façade is ubiquitous and easily recognizable, it is designated as a classification within the typology presented in chapter 3.

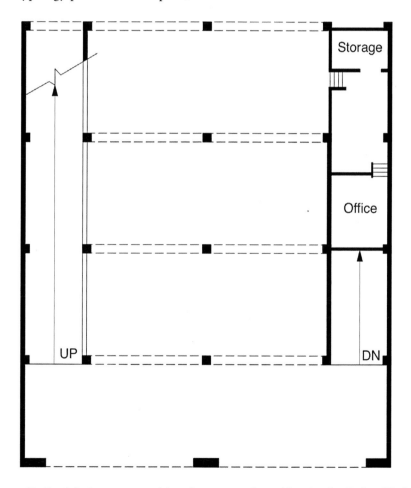

Figure 18. Partial plan, garage with twin entrance bays (drawing by Esther Kim).

Another solution, much more common, involves two-story garages with three or more façade bays. Ramps are served by dedicated wide-bay openings of matching width. The incline begins at the front property line. A common composition for a two-story building with basement (and therefore two ramps) is an ABA façade, with a squat center arch providing access to the ground floor, flanked by narrower openings devoted to ramps (Fig. 84 in chapter 3). Directly behind this façade is a concrete frame with the same *ABA* subdivision (Fig. 11h). One of the clever deceptions of the façade symmetry is its projection of equality onto the two ramps, since they are framed by identical architectural openings. While equal in width and singular in purpose, the divergent ramps do not adhere to the implication that they arrive at the same level — like symmetrically disposed mezzanine stairs in a movie theater.

Ramps and the Street

All of the garages with ramps appropriate the public sidewalk as a flat landing. Starting the slopes right on the property line was a crafty means of minimizing the internal area committed to circulation, and maximizing parking capacity. While aggressive, the thrusting of vehicular circulation onto the sidewalk increases the vitality of these structures on the street. The disadvantage is the danger and disruption to pedestrians walking along the street. Addressing this hazard, the city passed a traffic ordinance, which — as described in the *Chronicle* — forbade cars from "darting across sidewalks from alley or garage without making a complete stop when reaching the sidewalk."[5]

The positioning of the ramps at the property line effectively extends the reach of the garage's vertical circulation system beyond the sidewalk and into traffic. Imagine the path of a car traveling from the basement to the second floor in relation to an ABA (or ABCBA) façade with ramps occupying the end bays (Fig. 19). The car engages in a spiraling rotation around the middle. Emerging from the basement ramp on one end of the façade, the car executes a U-turn in the street, and disappears into the identical opening on the opposite end of the façade. The scenario crystallizes attention on the façade as a thin membrane separating inside and out. While this particular excursion may only occur rarely, it nevertheless illuminates an opposition between a stable, symmetrical two-dimensional elevation, and a dynamic, asymmetrical circulation pattern. In the relationship of circulation to façade (and the enclosed space behind), the lowbrow historicist garage reveals some qualities that are surprisingly modern and machine-like.[6]

As noted above, savvy garage designers also exploited San Francisco's hills to increase efficiency and capacity. By positioning the basement ramp at the low end of a sloping façade, and the second floor ramp at the high end, the vertical distance to be bridged is minimized — as is the length of the ramps. If we apply this condition to the vertical circulation loop described above, the appropriation of the street intensifies and becomes more dramatic. When the grade is flat, the façade sits squarely on the street; the two elements are in balance and neutral with respect to the asymmetrical ascent of the moving vehicle. However, when the grade is sloped, the street breaks its fealty with the façade and *becomes* a garage ramp. This metamorphosis wreaks havoc on the ABA or ABCBA façade, the symmetry of which is distorted by balanced ramp portals springing from different elevations. Most designers dealt with this circumstance by introducing strong horizontals — parapet profiles, cornices and stringcourses — to stabilize the façade and isolate the slope at the base (Fig. 16 earlier in this chapter).

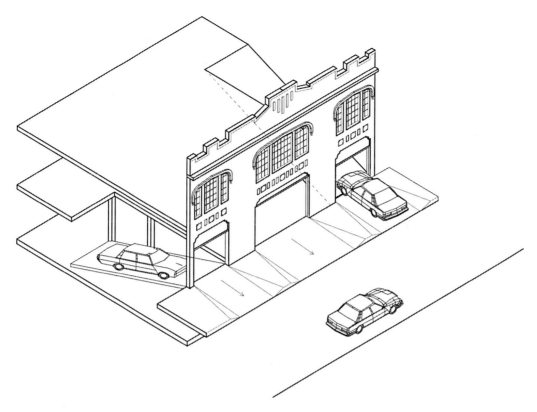

Figure 19. Axonometric, garage at 66 Page Street. O'Brien Bros., Architects, 1924 (drawing by Esther Kim, Sarah McDaniel, Haley Hubbard and Nancy Mei).

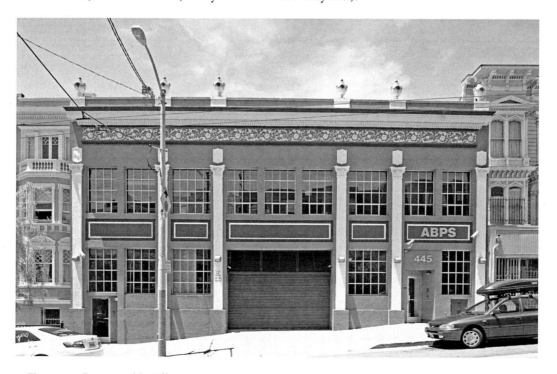

Figure 20. Garage at 445 Fillmore Street. Joseph A. Pasqualetti, Builder, 1924 (Sharon Risedorph).

Composition as an Expression of the Concrete Frame

As discussed above, the façades of concrete garages represent and reinterpret the structural frame behind. Structural end bays are determined by ramp width, and in most cases, the structural bay appears on the façade as a compositional bay. However, the relationship between structure and frame becomes more complex in the center, i.e., the broad middle in between the end bays.

The most common structural frame for narrow concrete garages is a simple *ABA*, as illustrated in Figure 11h. While the end bays remain constant, the center B bay varies as a function of a garage's lot width. Due to this variation, the middle structural bay supports considerable variety in façade composition. In its most literal representation, the façade assumes the same ABA composition as the structure, with a ground floor entrance occupying the middle bay. Thus, the entire ground floor is devoted to vehicular access, with bays serving either the ground floor or a ramp. The garage at 460 Eddy exemplifies this solution (Fig. 84 in chapter 3).

A more common solution is the superimposition of a five-bay ABCBA façade over a three-bay *ABA* frame (Fig. 11d, 11g). In this instance, the middle BCB portion of the façade is backed by a single, wide structural B bay. Through this subdivision, architects increase the complexity and flexibility of the grid that supports the composition. One option, for example, is to render the B bays as solid wall, establishing a pattern of solid and void across the façade, while avoiding dematerialization at the base. The Narrow ABCBA Façade is a category within the typology and is discussed more fully in chapter 3.

This compressed form of ABCBA works well for façade widths up to around 65'. Wider lots can sustain an expansion of the structural middle bay to accommodate three or four large compositional bays, each one as wide as the end bays serving the ramps. This results in an arcade of five or six equal bays (AAAAAA) that front an *ABA* ground floor frame. Arcades are an effective means of masking the ill effects of ground floor dematerialization, as the form implies structural support for the volume above. They can also impose order and regularity on the disparate functions that demand street frontage. Thus, at 64 Golden Gate (a brick building), the programmatic sequence of office/opening/storefront/storefront/opening/ramp is easily assimilated into the six arched openings on the street (Fig. 60 in chapter 3). The arcade garage is also a classification within the typology.

At the extreme end of the spectrum are lots that are so wide (over 85') that the distance between the two end bays is too great to span in a single structural bay. Through the addition of a single column placed on the centerline of the building's overall width, the structural frame grows to an even number of bays and assumes a configuration of *ABBA* (Fig. 11c, 11e, 11f). Joseph A. Pasqualetti built a series of garages in which a five-bay ABCBA composition is superimposed on this four-bay *ABBA* ground floor structure (Figs. 43–44, 46 in chapter 3). In these garages, open B bays provided vehicular access, and framed a storefront in between. As these buildings had no basements, a single ascending ramp required integration into the symmetrical composition. Thus, a ramp opening on one side was imperfectly balanced by an office on the other.

Pasqualetti's solution proved to be problematic, as the entrance bays were too narrow for bigger vehicles. In most cases, the problem was remedied through the removal of the middle storefront and a widening of the entrance bays. A new pier, placed on the centerline of the façade, provided support for the widened entrances. This change united both ground floor structure and composition in an ABBA sequence. However, the ground floor is now

dematerialized, and the rhythm between ground-floor and second-floor events is bizarre (because the second floor retains its ABCBA arrangement). The garage located at 1745 Divisadero exemplifies this composition in both in its original ABCBA form, and as modified to ABBA (Figs. 43–44 in chapter 3).

Composition and Historicism

Before considering the ornament that is so central to these façades, it is important to note the traditional nature of the approach to composition. The architects strived to organize the disparate programmatic requirements affecting the street frontage into balanced, symmetrical façades. In doing so, they applied time-honored models of architectural order to accommodate this new, utilitarian building type.

One of the ways in which architects mediated between the public and private spheres was by giving priority to these notions of architectural order over either pure structural or functional expression. The superimposition of a five-bay composition over a three-bay structure is but one example of the preference for a composed façade over a "pure" expression of frame and infill. However, as the example demonstrates, the ABCBA composition simultaneously acknowledges and represents structure. Throughout the typology, façades abound in subtle recognitions of structure, often deploying the insubstantial parapets to regroup façade subdivisions into sections that reassert the structural configuration behind (Fig. 62 in chapter 3).

One cliché of academic eclecticism is "you may decorate your construction but never construct your decoration." The idea is that structure is primary, ornament secondary, and the role of ornament is to articulate and call attention to structure. If we regard the façades as more responsive to traditional notions of order than to pure structural expression, the façades assume a formal aspect, one slightly detached from structure. However, because the composition also represents structure, as filtered through academic design principles, it can be interpreted as an ornamental device that obeys the formulaic mandate to "decorate your construction." Façade and structure enter into an agency relationship, such that the façade represents structure to the public, making it palatable and pretty for mass consumption. Car manufacturers proved to be very sensitive to the marketing potential of this form of representation, and took steps to extend it to the interior — when sales were at stake.

The assertion of a strong relationship binding structure and façade does not compromise the notion of a dichotomous architecture. If anything, the assertion reinforces the dichotomy by offering a rationale for the thin historicist façade that can perhaps survive the pejorative critique of the modern movement. This critique would condemn the façade as a hypocritical simulation of style and the original structural system associated with that style. However, if the historicist content of the façade is not taken too seriously, and is instead regarded as an articulation of structure, the dichotomy becomes plausible in academic terms, if not modern. This point is illustrated at 550–560 O'Farrell, where buttresses are decoratively applied to the façade to signify Gothic, while they also represent "real" structural uprights behind (Fig. 63 in chapter 3).

One means of isolating that portion of façade composition and design that is exclusively attributable to aesthetic intention is to compare, when available, front and rear elevations. Those garages extending to back alleys offer shadow façades with the same dimensions, while accommodating fewer programmatic requirements. The design criteria are identical to those applied to the industrial interior: utility, ease of construction, and budget. As exte-

rior correlates to the interior, these elevations provide a glimpse into the outward appearance of a lowbrow utilitarian — as opposed to historicist — garage.

At 66 Page Street, both front and back share the ABCBA composition, but only the front receives the Neo-Tudor treatment of shallow-pointed arches, crenellated parapet and medallions (Figs. 21, 62 in chapter 3). The rear façade offers a more industrial appearance. Compositional features of the front are transformed on the rear. For example, the vertical

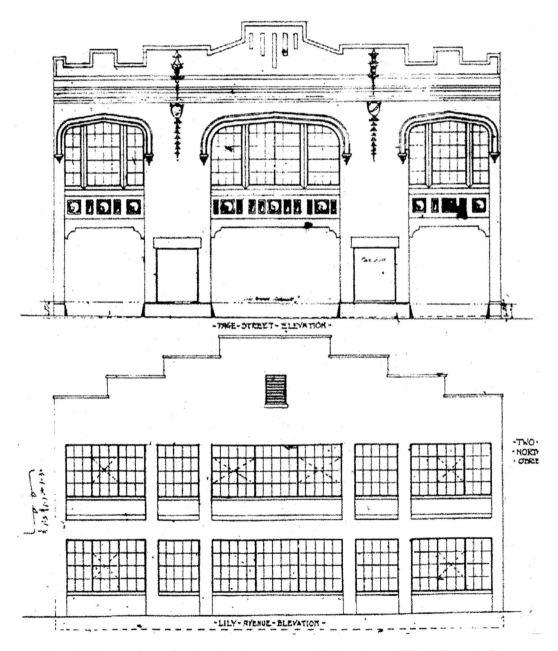

Figure 21. Front and rear elevation drawings, garage at 66 Page Street. O'Brien Bros., Architects, 1924 (courtesy French American International School).

orientation of bays and the alternation of solid and void give way to the horizontal orientation of windows and spandrel panels, expressed as infill in an articulated structural frame. The front elevation has high shoulders that conceal the shed profile and truss behind. On the rear, the shed is approximated as a stepped profile. While the rear façade is top heavy, it centers on a vent — a celebration of mundane circumstance that might have been celebrated in *Contradiction and Complexity in Architecture*, by Robert Venturi.

In essence, the rear elevation anticipates a factory aesthetic that was deemed to be inappropriate for the San Francisco street — despite the elevation's harmony with the interior. The difference between front and back confirms that the façade — despite the projection of structure — is primarily responsible for communicating a message to the public that would not be delivered by a straightforward representation of the industrial building behind. A dichotomous approach facilitated the independence of the façade,

The garage designers exercised aesthetic choice on the façades, but it was not between academic eclecticism and modernism. Their choice was between academic design and utilitarian expression. Indeed, utilitarian building, often executed without the benefit of architectural expertise, was known, discussed, and reluctantly admired in some quarters. Dozens of such buildings existed in San Francisco. If architects had taken this approach, interior and exterior would have enjoyed a unified architectural character. Architects' decision to engage the academic process reflected a shared conviction regarding the meaning of the garage in the context of San Francisco. This conviction encompassed an idealism surrounding post-earthquake reconstruction, a dream of a city built along the principles of the City Beautiful movement, and an interpretation of the garage as a symbol of the automobile. The academic process was a trusted vehicle relied upon to develop that interpretation and the design. Firm believers in the idea that design "evolves" from the past, architects accessed the academic process in part because it led them to consider the problem at hand as an adaptation of precedents. These and other factors that exerted influence over the garage designers are considered in chapters 4–6.

Garage architects strived to adapt a large-scale precedent, the train station, to this much smaller new building type. The vocabulary, syntax and historical allusions of various station types were lifted and translated to the garage. However, because the garage offered such a limited canvas as a host for such an ambitious appropriation, the imagery underwent an extreme compression. This compression resulted in monumental gestures overscaled to the host façade (Fig. 80 in chapter 3), and the reduction of entire architectural epochs to mere signage (Fig. 62 in chapter 3). Today, the overwrought quality of these façades lies at the heart of their exuberance and lowbrow nature.

All of the façade compositions mediate between structure, program and historical style. The subdivision of the façade into adjacent bays, symmetrically disposed, was at once amenable to all three elements. This organizational structure offered a formal integrity and flexibility capable of accommodating any of the stylistic references that architects chose to plug in. Here, the formal compositions constitute one basis of classification, as they define a set of easily identifiable garage types. This approach favors form over content, structure over sign and symbol, and the typical over the idiosyncratic. Once the observer is made aware of these underlying compositions, their reappearance in differently styled buildings becomes conspicuous. For example, while the façade of 530 Taylor (Fig. 48 in chapter 3) is Spanish Colonial and one at 66 Page is Neo-Tudor (Fig. 62 in chapter 3), they both exemplify ABCBA compositions. This insight binds the buildings together, while making people aware of the arbitrary, yet memorable, quality of the historicist overlay.

Arches and Parapets

However, not all elements that contribute to historical reference can be dismissed as arbitrary. Many of the historicizing details in the earlier façades of exposed brick are expressions of masonry building technology and craftsmanship. While brick is a source of continuity between façade and shed, the exclusive use of fancier brown brick and historicizing detail on the façade asserts the independence of the public face (Fig. 90 in chapter 3). The most tectonic historicizing element is the arched portal or window, used to invoke the symbolic power of the triumphal arch by way of the train station (Fig. 75 in chapter 3).

The triple arch is another motif that cements the tie between the garage and the train station. Both 1220 Valencia (Fig. 22) and 1355 Fulton (Fig. 78 in chapter 3) are monumental garages that use the grouped arch to align with Mission and Burnham style stations across America, and with the Ferry Building and Southern Pacific depot, locally. Arcade garages feature repetitive arched openings, either lining the street or positioned beneath the parapet (Fig. 23). The arcade at 64 Golden Gate references a common feature of both Mission churches and Mission-style train stations (Fig. 60 in chapter 3).

Arched windows in many varieties — round, stilted, segmental, depressed, lancet, Venetian, and Tudor — are sources of style (Fig. 24). Shallow basket-handle and shouldered arches are used over the vehicular openings of multi-story concrete garages to invoke style without exposing the concrete beam immediately behind (Fig. 27).

Aside from the arch, the parapet is the most effective means of imposing style. Every façade includes a two- to three-foot parapet that liberates the top profile of the façade from the shed profile behind. There are three major types of parapet profile: flat-topped, bowed, and gabled. Mission-style and/or Main Street–style parapets are hybrid variations that string

Figure 22. Garage building at 1220 Valencia Street, 1890 (Sharon Risedorph).

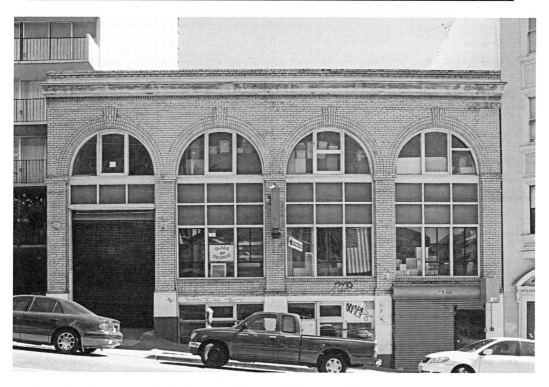

Figure 23. Garage at 1267 Bush Street. William Helbing, Builder, 1917 (Sharon Risedorph).

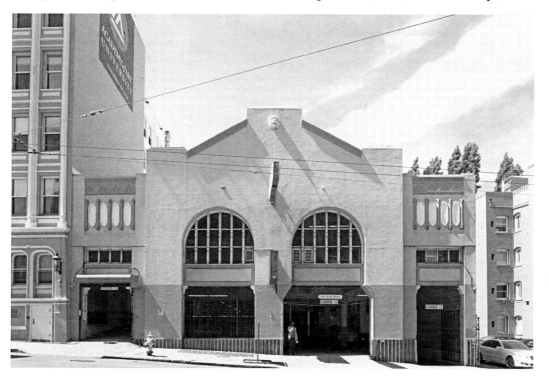

Figure 24. Garage at 840 Sutter Street. O'Brien Bros., Architects, 1918 (Sharon Risedorph).

together flat, inclined and arced segments, all in the service of an overall symmetry that peaks at the center or frames the center.

The form and profile of the parapet is not determined by structure or programmatic requirements. Garage architects exploit this circumstance, utilizing the parapet to assert the independence of the façade and reshape the building as perceived from the street. The parapet may closely follow the roof profile, loosely interpret it, or disregard it altogether. Often, that determination is a function of stylistic affectation, or an arbitrary centering device that augments the building's stature. At 66 Page, the crenellated parapet serves both purposes (Fig. 62 in chapter 3).

The single-story garage is more likely to express its shed roof while the two-story garage is more likely to suppress it. The combination of expressed shed and central arch results in a classic gabled front (Fig. 71 in chapter 3). In a variation of this motif, a celebratory pediment or arch breaks through an otherwise flat parapet that serves as a datum (Figs. 39, 73 in chapter 3). Sometimes the parapet assumes the profile of a basilica or monitor front, presenting the center as an interruption of a sweeping gable (Figs. 138, 140 in chapter 9). All of these examples illustrate profiles that acknowledge the shed behind, and which are based on precedents in train stations.

Parapets often suggest architectural volumes that are not present. This deceit occurs most commonly over the end bays of wide, multi-bay façades, where it is used to superimpose an ABA configuration over the entire width of the building. At 2535 Clement, tower-like volumes frame a lower, flat center portion (Fig. 25). The parapet at 1355 Fulton promises, but cannot deliver, three vaulted bays like those atop the waiting room of Penn Station (Fig. 78 in chapter 3).

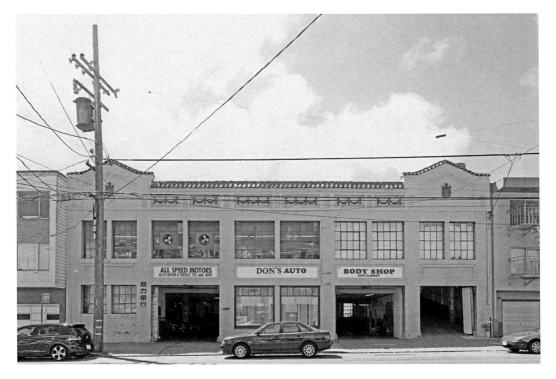

Figure 25. Garage at 2535 Clement Street, 1923 (Sharon Risedorph).

Commonly, the parapet is treated as an attic above a strong horizontal cornice. While the horizontal firmly establishes a flat profile, the parapet terminates the façade in a crowning gesture that regroups the bays into a summary composition (usually ABA) and adds a stylistic flourish. For example, 66 Page Street (Fig. 62 in chapter 3) and 4050 24th Street (Fig. 39 in chapter 3) exemplify this use of the parapet.

Earlier, the point was made that a formal approach to the classification of the façades, i.e., one that grouped buildings by underlying composition, exposes the arbitrary quality of the historicist overlay. While physically flimsy, decorative and arbitrary, the parapet — a significant contributor to that overlay — is nevertheless a powerful source of character and identity. The crowning aspect of the parapet invests it with a unique authority to preside over the abstract gridding of the composition below, and to absorb the bay structure into its own conclusive, historicist interpretation.

Ornament

The garage façades abound in recessed and surface mounted-ornaments, a collection too large and diverse to catalog here. However, while the selection of a particular ornament may be arbitrary, its placement and function in the composition are not. Indeed, patterns in the disposition of discrete historicist elements are another source of underlying continuity that cuts across any specific historic style.

Ornamental and stylistic elements are deployed to visually reinforce composition and structure. The major vertical lines of a composition are accentuated with pilasters medallions and shields. At 150 Turk (Fig. 15 earlier in this chapter) and 1661 Market (Fig. 80 in chapter 3), Joseph L. Stewart used engaged Corinthian columns to support monumental arched windows. Joseph A. Pasqualetti marked the grid lines of his flat-topped ABCBA façades with urns resting on the parapet (Figs. 26, 37). (In most cases, these gestures do not survive.)

Most flat topped two-story garages feature a strong cornice or full entablature that extends straight across the façade. These horizontals unify the composition by placing a cap on the subdivisions below (Fig. 34 in chapter 3).

The articulation of the second floor varies considerably. In some cases, it is simply unacknowledged by ornamental treatment (Fig. 56 in chapter 3). When double-height verticals run uninterrupted from grade to parapet, panelized transoms may span between the verticals at the second-floor level. These can be highly decorative (Fig. 58 in chapter 3) or simple frames around a recessed panel (Fig. 29). An emphatic sill course at the second-floor level sometimes contributes to the interpretation of the ground floor as a base for a *piano nobile* (Fig. 30). At 265 Eddy — a skyscraper garage — a strong sill course establishes the fourth floor as an attic (Fig. 33 in chapter 3).

In addition to articulating the compositional grid, ornament is employed to emphasize active parapets, pediments and grand arches. At 770 North Point (Fig. 140 in chapter 9) and 1641 Jackson (Fig. 73 in chapter 3), the outlining of the top profile of the façade enhances the impact of a central, monumental event. At 1355 Fulton, the cornice and dentil moldings break their horizontal path to suggest gables over the three central arches (Fig. 78 in chapter 3).

To varying extents, a garage façade is identifiable as an adaptation of one of the following styles of architecture: Gothic, Renaissance/Baroque or Mission. These adaptations are at least a few iterations removed from original sources, as these styles had already been represented as train stations, fire stations, car barns and other precedents. As noted above, the extreme

Figure 26. Garage building at 445 Fillmore Street. Joseph A. Pasqualetti, Builder, 1924 (Sharon Risedorph).

reduction of architectural vocabularies to the two-dimensional garage façade results in caricature. Individual historical elements taken out of context serve as signs for an entire epoch.

Composition, parapet profile, and ornament interact to communicate style. Ornament, as described at the time by A.D.F. Hamlin, double-functions as a delineator of composition and a stylistic sign.[7] Garage ornament varies considerably in the balance struck between its separate roles. Some ornaments and profiles are more effective as signs, others as delineators. For example, at 64 Golden Gate, the attached Spanish tile eave supported on brackets is evocative of style (Fig. 60 in chapter 3). Conversely, the circles and rectangles contained within the spandrels at 66 Page are generic and difficult to ascribe to any particular style (Fig. 62 in chapter 3). In between these extremes is a host of shields, medallions, moldings and scrolls that appear to be evocative, but are not sufficiently specific to "push" the façade in a decisive stylistic direction.

At the same time, the designers liberally and routinely assemble ornaments and profiles from different epochs in a single composition. At 550 Turk (Fig. 27 in chapter 3), a Renaissance frieze coexists with Gothic-inspired spandrels. As this frieze appears on many Pasqualetti garages, it may be that off-the-shelf availability took precedence over stylistic rigor.

The task of designing a garage façade did not exactly demand stylistic purity or historical rigor. Nor was purity much in vogue during this period of eclecticism. However, the absence of stylistic purity does not detract from the buildings. The selection of style was arbitrary anyway — why would one garage be Tudor and another one Mission? These ornamental overlays, regardless of style, fulfill their basic purpose: to transform front walls into façades that celebrate the affiliation of both the building and its clients with the emergent automobile culture. Caricatured or imprecise evocations of style are symptomatic of a popular lowbrow architecture that seeks to entertain as well as fulfill the City Beautiful mandate.

The lowbrow character of the façades was also amplified by manifestations of the industrial use. Examples include multi-pane steel sash windows, large open voids across the front, and promotional signage and graphics. While these elements curtailed any highbrow aspirations, they in no way determined that the façades would be poorly designed or unsightly. At 830 Larkin, for example, the historical and industrial elements achieve a mutually enhancing balance (Fig. 30 in chapter 3).

The architects were neither threatened by nor resistant to the application of academic skill to the industrial garage. They were not contemptuous of industrial elements infiltrating the façade or of the lowbrow nature of the enterprise within. Arguably, they approached these commissions with a mannered sense of humor. At 550–560 O'Farrell, for example, applied hood ornaments (griffons) double-function as gargoyles in a fantastic Gothic collage of flattened arches, buttresses and a diminutive Romeo and Juliet balcony (Fig. 63 in chapter 3). At 66 Page (Fig. 62 in chapter 3), the small-pane industrial windows, now gone, also signify the leaded glass analogues of the Tudor vocabulary. These elements invigorate the façades by injecting alien yet compatible materials into a traditional syntax that is already hopelessly compromised. The contemporary eye, now accustomed to seeing the juxtaposition of the industrial and the historical, is perhaps jaded to the oddness of the bedfellows thus assembled.

On the one hand, the two fundamental components of the lowbrow historicist garage — façade and interior — can be described as a series of oppositions. On the other hand, the façade and interior are deeply woven together through structure, circulation and program.

These interpretations may appear to be irreconcilable. However, the proposition that these elements are dichotomous does not imply mutual autonomy, in the sense of two unrelated architectural forms, responsive to different criteria, simply pushed into juxtaposition. The dichotomy is meaningful precisely because the two constituent elements are so interactive. In this way, the garage is like a device or product, the external casing of which renders it usable, marketable and consumable.

Chapter 3
A Typology of San Francisco Garages

Note: Passages in the following chapter first appeared in the following article written by the author: "Educate, Preserve, Reuse: The Good (Not Great) Garage Buildings of San Francisco," *AIA Report on University Research, Volume 4* (Washington DC: AIA, 2008). These passages are reproduced courtesy of the AIA.

The garages are anonymous as lowbrow infill buildings that blend into the urban fabric. Sight unseen, many of us associate garages with the utilitarian use and assume that *all* garages present the visual characteristics of the post-war version: industrial inside and out. Passersby observe dark, dirty interiors through gaping holes at street level. Unlike the ubiquitous apartment block from this period, the lowbrow historicist garage appears infrequently. In the absence of easy visual access to the collection, the layperson cannot be expected to become cognizant of relationships among buildings that are displaced from one another and are seen days, weeks or months apart.

This study organizes the buildings into a typology to counter the ill effects of anonymity indifference, and disbursal. Like any group of buildings constituting a type, the garages share essential properties, including siting, use, age, materials, and structure. Circumscribed within this commonality exists a rich diversity of designs, reflective of the unique circumstances surrounding each project. A typological approach fosters an awareness of the continuities and discontinuities among the examples.

Classification involves the assignment of every garage to one of several categories — each one defined by a distinguishing set of criteria. The process involves the critical interrogation of the building, first as an autonomous object and then in relation to the other garages. When assigned a category, the garage takes its place in an organizational matrix that includes all the buildings. The typology formalizes and documents the notion that the buildings engage in an architectural dialogue through us.

When describing the distinct social, economic and geographic context that led to Palladio's villa commissions, historian James Ackerman said, "The situation recalls the old saying, 'had he not existed he would have to have been invented.'"[1] Binding together the examples of a type are threads of continuity, attributable to the constant conditions that give rise to the impetus to build, and the backgrounds of the designers who interpret these conditions. The garage type is no different. All of the factors affecting the façades — context, size, program and structure — seem to converge and resolve in an improbable stateliness, as if well-composed façades are the inevitable result of these conditions. That different architects, engineers, builders and owners arrived at comparable solutions suggests that the designers influenced each other's work, and that fundamental aspects of those design solutions — like the disposition of the ramps — possessed undeniable logic.

The components of the dichotomy — façade and shed — are essential to classification. As

discussed in the previous two chapters, "façade" refers to the composition and stylistic overlay of the front wall; "shed" refers to the lot dimensions, material, structure, vertical circulation and number of stories. Façade and plan type are jointly developed in response to the program.

One means of classifying garages would be to identify every garage by the basic characteristics of its façade and plan type, as follows:

> *Façade Style:* Mission, Gothic, Italian Renaissance, Beaux-Arts, Station
> *Façade Composition:* AA, AAA, ABA, ABBA, ABBBA, ABCBA, AAAAA(A), ABA/ABA
> *Sheds:* One-story brick, One-story brick with mezzanine, Narrow two-story concrete, Wide two-story concrete, Skyscraper

Using this system, 66 Page would be identified as a Gothic/ABCBA/narrow two-story concrete garage. Although this approach encompasses the all-important relationship of façade to industrial shed, it is cumbersome in the amount of generic information used to classify buildings.

However, if the relationship of façade and shed is acknowledged and understood, we can employ a less burdened classification system that identifies each subtype by a conspicuous visual aspect shared by all of the façades in that group. The identifying link can be a particular motif, composition, historical style or architectural precedent. Thus, Twin Arch, ABCBA, Mission and Station are examples of named categories within the typology.

The proposed categories are not mutually exclusive. For example, a particular building might reasonably fall into two categories simultaneously, like "Mission" and "Station," precisely because many train stations were designed in the Mission style. Or, a garage may be classified on the basis of its historical style, even though it also meets the criteria for assignment to a category defined by façade composition. Despite the occasional ambiguity, the basis upon which buildings are grouped is intuitively clear and straightforward. The goal is not to pigeonhole buildings into rigid, mutually exclusive categories, but to lift them out of anonymity by highlighting visually accessible relationships.

The typology is one of façade, focusing on that half of the dichotomy that maintains a street presence. This is ironic, given the argument advanced here in favor of attaching architectural significance to both the façade and the interior. A similar irony was on the mind of Richard Longstreth when he organized the typology in *The Buildings of Main Street* on the basis of building façade:

> The façade is only a small portion of a building's fabric. To understand architecture fully, one must consider buildings as a whole, inside and out. One must also take into account the people who commission, design and construct buildings as well as external forces — economic, social political, cultural — that may have played a role in shaping the product. So why focus on the façade?[2]

Longstreth's answer, that "most commercial buildings were designed to be seen from the front," certainly pertains to the garages. Nevertheless, the buildings constitute *integrated* responses to the conditions that caused their construction, and the façades are inextricably linked to the sheds.

Here is a synopsis of the categories:

- *Twin Arch:* A pair of adjacent basket-handle arches is the primary motif of a base that supports a *piano nobile*. Second-floor windows form a row of discrete, deeply set, vertically oriented openings. Symmetrical compositions encompassing an even number of bays, the centerline coincides with a slender structural upright. Minor centers are developed around the apex of the arches. Roof profiles are flat.

- *Narrow ABCBA by Pasqualetti*: In a series of two-story concrete garages, Joseph A. Pasqualetti uses the ABCBA composition as a template. The buildings center on a square entrance flanked by narrow "B" bays. As variations on a theme, Pasqualetti explores the conflict between a traditional composition that frames the center and a more contemporary representation of the concrete frame structure. Ornamentation and stylistic elements are employed to articulate composition, and not to represent a particular historical era.
- *Wide ABCBA*: In the wider format, the compositions become more complex and varied, especially in the disposition of vehicular entry and ramps. Designers rely on strong center bays to stabilize façades subject to dynamic elements, including sloping streets and multiple entries.
- *Arcade*: This category features an arcade of five or six bays on the ground floor. Typically, the style is Mission and the openings are arched, although the Georgian-inspired 525 Jones Street is also included here. The arcade appears over all the shed types, becoming problematically compressed when fronting a narrow shed.
- *Gothic*: Displays one or more characteristic motifs: elliptical, Tudor or depressed arched windows and vehicular openings; "battlement" parapets of crenels and merlons; and, drip and label moldings. These are typically concrete buildings built in the 1920s. The Gothic garage is a close relative of the Twin Arch category. Related buildings with western or Main Street–type parapets are included here.
- *Mission*: Displays one or more characteristic motifs: a large arched portal centered beneath a cresting parapet of stepped and arced segments; ornamental eaves supporting clay tile roofs, applied directly to the façade; and, vertically oriented parapet projections simulating towers. The façades are symmetrical, usually composed of an odd number of bays. Reflective of a relatively early date of construction, this category includes a preponderance of brick box sheds behind the façades.
- *Station*: These garages assert an overt link to the great urban train station. A monumental arched portal, or portal group, is plugged into a symmetrical composition of three or five bays. While similar to the Mission type in composition, the stylistic reference is to Beaux-Arts or other European precedents.
- *Palazzo*: This category includes garages characterized by rectangular boxy façades of two stories and three to six bays. Typically the bays are outlined in pilasters that support an Italianate entablature.
- *Brick Pier*: This is a category of ABA façades in which four prominent piers articulate the three bays. The shed type is a single story brick box. In all the examples discussed here, the two interior piers are taller than the end piers, as the composition crests over the entry. These façades are essentially gatehouses celebrating vehicular entry and egress.

The classification latches onto visual aspects of the façades, giving priority to motifs that are easily perceived. As a result, the typology confers respectability on the seemingly arbitrary and shallow appearance of historically derived motifs or styles. Viewed retrospectively through a modernist sensibility (and a post-postmodernist sensibility), the historicist overlay is frivolous.[3] Arguably, the designers themselves signaled an awareness of the thinness of the historicist overlay by taking an over-the-top approach to the representation of three-dimensional forms on the two-dimensional façade. In some cases, they designed puns in which architectural elements function simultaneously in traditional and popular vocabularies.

However, whether they approached their commissions with a sense of humor or not,

the architects always dressed up the fronts of their garages. The overlay is the means by which these designers celebrated the street and the automobile, while exploiting the vanity of the status-conscious clientele. At the same time, architects relied upon these dressed up façades to meet an intertwined civic and professional responsibility to beautify their surroundings. The tenuous marriage of commerce and art is a hallmark of the lowbrow his-

FACADE TYPE		EXAMPLES
1	Twin Arch	• _550 Turk_ • _830 Larkin_ • 2120 Polk • _265 Eddy_
2	Narrow ABCBA	• _1550 Union_ • _1565 Bush_ • 2340 Lombard • 4050 24th Street
3	Wide ABCBA	• _650 Divisadero_ • _1745 Divisadero_ • 530–544 Taylor • _818 Leavenworth_
4	Arcade	• _750 Post_ • _1945 Hyde_ • 525 Jones • 64 Golden Gate
5	Gothic	• _66 Page_ • _550–560 O'Farrell_ • 240 Pacific • _111 Stevenson_
6	Mission	• _721 Filbert_ • _415 Taylor_ • 541 Ellis • _1419 Pacific_
7	Station	• _1641 Jackson_ • _2405 Bush_ • 1355 Fulton • _1661 Market_
8	Palazzo	• _855 Geary_ • _460 Eddy_ • 675 Post • 410 Stockton
9	Brick Pier	• _1545 Pine_ • _3536 Sacramento_ • 421 Arguello • _3640 Sacramento_

Table 1 (drawings by Sarah McDaniel).

toricist garage and the auto showroom building. In chapters 4–6, the architects' City Beautiful convictions and Beaux-Arts training are examined as factors that motivated the architects to develop the garage in this particular way.

When we allow style and precedent to influence the classification criteria, we accept the priority bestowed on this aspect of design by the architects themselves. We also acknowledge the strength of historical motifs and symbols to establish identity in our consciousness. This communicative potential does not depend upon a viewers firm grasp of historical styles. These buildings are eclectic and are memorable as images rather than comprehensive or consistent examples of historical style.

The typology is presented on a category-by-category basis. Each of the nine categories receives a brief introduction that identifies a category's distinguishing characteristics as well as the category's inherent formal design themes. The categories are represented by four stellar examples, each one of which is the subject of a brief essay with architectural analysis. Table 1 summarizes this structure.

1. Twin Arch Façades

— 550 Turk — 2120 Polk
— 830 Larkin — 265 Eddy

The Twin Arch category includes façades focusing on a pair of "basket-handle" arches on the ground floor. In two-story garages, the motif occupies the full width of a two-bay composition, and serves as a base for a *piano nobile* of vertically oriented discrete window openings. In skyscraper garages of four bays, the motif is positioned in the center, and helps support a multi-story grid of similar windows above. Capping the composition is a flat parapet, regardless of whether the roof behind is flat or sloping. The parapet is treated as an entablature or as an attic just above an entablature.

Each arch is sufficiently wide to accommodate two cars, providing access to a ramp (along the sidewall) and to the ground floor (towards the center). Praising the motif as it appeared at 111 Stevenson (Fig. 67 in chapter 3), *Motor Age* reported, "They are too large to be called doorways; there is absolutely no chance of blockades or delays on cars entering or leaving the garage and no danger of cars running into each other, as there is plenty of room to turn."[4]

A symmetrical composition encompassing an even number of bays is apt for a building type that does not celebrate the passage of people through the façade. These façades subvert

the anthropocentrism of Beaux-Arts composition, which typically used symmetry to enhance grand entrances or windows. Here, symmetry centers on structure — the middle pier separating the twin arches. The twin arch illustrates the adaptation of traditional composition to accommodate the non-traditional program and represents the conflict inherent in the notion of a historicist garage. The motif expresses and accommodates a contemporary condition — the dynamic, in and out movement of the machines. However, as rendered in traditional garb, the net effect is a boldly stated redundancy and irresolution, as if two autonomous structures were forced together.

In the trajectory of these four examples, designers grapple with this conflict. Through the manipulation of elements common to all four buildings, they produce façades that mediate between emphasis on the middle pier and emphasis on the local symmetry about each arch. In every instance, the façade and the central pier represent their respective cross-sections behind.

550 Turk

The garage at 550 Turk — a Pasqualetti production — is the finest example of the category. Structure, composition and ornament are integrated into a pure and unadulterated statement of purpose. This façade is resolutely divided into two identical and adjacent bays, as defined by three identical piers. The strong middle pier is key to this expression, as it denies horizontal continuity across the divide. This pier is structural, and represents the row of columns — on both levels — that occur regularly along the centerline of the plan (Figs. 27–28).

Dominant double-height events, the three piers modulate along their lengths to interact with lateral elements. The lower half of each pier projects slightly, and a drip molding at the top of this projection heads off the arch moldings. Arches and lower piers form a base that is surprisingly convincing and powerful given the small ratio of solid to void.

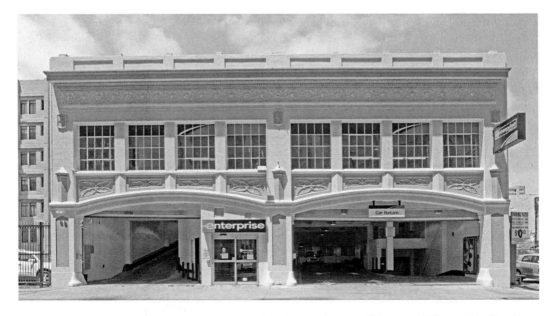

Figure 27. Garage at 550 Turk Street. Joseph A. Pasqualetti, Builder, 1924 (Sharon Risedorph).

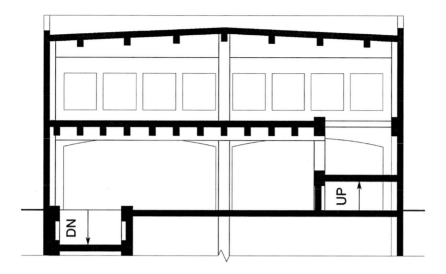

Figure 28. Schematic section, garage at 550 Turk Street (drawing by Esther Kim, Sarah McDaniel and Haley Hubbard).

Beneath a pier's drip molding, a recessed panel provides a minimal visual resting place. A gatepost ornament rises from the top of the molding, marking the midsection of the composition between the arches and the windowsills. The gatepost points up at a shield reminiscent of hood ornaments and car-company logos. All of these ornamental elements accentuate the centerline of the piers and the regulating lines of the AA composition.

Each bay presents four windows over one wide arch. Mirroring the composition overall, the even number of windows centers on a narrow vertical support. As a result, the eye is not invited to pause over the crown of the arches: focus reverts back to the overall center. The window spacing extends downs into the panelized transoms. Each panel frames an ornamental *fleur-de-lis*, and these motifs are visibly squashed in the two panels at the apex of the arch—a treatment that heightens the impression that the arches push up against an orthogonal grid.

Stylistically, the façade is eclectic, employing forms and ornaments from different eras alongside of industrial elements. However, the primary role of the Gothic arches, Renaissance entablature and stylized ornamentation is to outline composition, and not to evoke a specific historical era. The ornamentation and its application are typical of Pasqualetti garages. In particular, the frieze decorated with a *rinceau* of acanthus leaves is a key source of identity and continuity, appearing on his narrow and wide ABCBA compositions.

Due to its subdivision into articulated piers, panels and openings, the façade of 550 Turk appears rugged and muscular. The boldly stated piers lead the way towards an unapologetic and forceful endorsement of the even-bay composition and the contemporary in/out dynamic that it accommodates.

830 Larkin

The garage at 830 Larkin is clearly related to 550 Turk, despite significant differences in proportion, fenestration and ornament (Figs. 29–30). The exaggerated height of the sec-

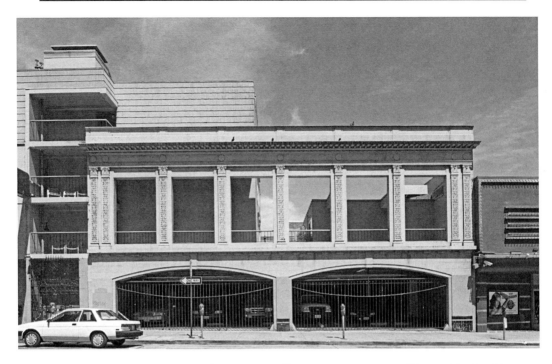

Figure 29. Garage at 830 Larkin Street. Bell Bros., Owners, 1928 (Sharon Risedorph).

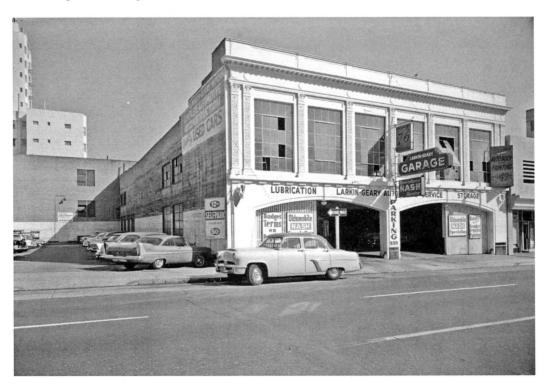

Figure 30. 830 Larkin Street in the 1960s (San Francisco Assessor's Office Negative Collection, San Francisco History Center, San Francisco Public Library).

ond floor relative to the ground floor imparts to the latter the quality of a squat pedestal base. A Renaissance-inspired order sits on a shelf at the top of the base, with Corinthian pilasters, entablature and attic. Six enormous openings are framed by these elements.

Larkin offers a contrasting interpretation of the twin-arch template, substituting horizontal continuity across the façade for vertical emphasis of the center. The shift is attributable to the differential treatment of the middle pier relative to the end piers. Upstairs, the center pier is integrated into the rhythm and vocabulary of the applied order. Pilasters are doubled up at the either end, a stately device more likely to grace the façade of an elite city club. The doubled-up extremities frame interior events into a single broad unit.

The Larkin composition also de-emphasizes the center by establishing a stable symmetry about either arch. Turk's four-over-one rhythm is replaced at Larkin by three windows over each arch. Stacked voids gather along the centerline of either arch, drawing attention away from the middle pier. Secondary design details reinforce the horizontal emphasis, too. At the base, the middle pier is narrower than its peripheral counterparts, weakening the center. Just above, the strong shelf underlines the sweep of the second floor and denies any vertical thrust. As a result of these manipulations, Larkin appears more amenable than Turk to the autonomy of its two arches from the center pier and from one another. Tension between ingress and egress yields to an easy and non-directional statement of accessibility.

Much of the compositional contrast between Turk and Larkin reflects differences in structure. At both locales, the ground-floor middle pier fronts a line of columns behind. Upstairs, the strong middle pier at Turk fronts a line of columns that supports the flat roof. Larkin, however, relies on clear span trusses to support its roof, a circumstance represented compositionally by the sweep of the second floor.

Compared to Turk, Larkin is less rugged but more refined. The ornament is elegant and elaborate for a garage, as best exemplified by the pilasters. Here, too, ornament and historically derived elements accentuate composition and structure. This façade successfully integrates historicist and industrial vocabularies into a single composition, as evidenced in the alternation of ornamental pilasters with large industrial-sash windows. The projection of the industrial interior onto the façade is one means by which garages relate to train stations and other building types employing these dual vocabularies. While this façade still stands, the industrial sash windows and the roof have been removed.

2120 Polk

This garage, built several years later than Turk and Larkin, employs subtle compositional layerings to resolve the tension between an overall symmetry that focuses on a pier, and the off-center but welcoming arches (Figs. 31–32).

Polk resembles Turk in the upper half of the façade, and in particular, the appearance of three major piers marked with medallions. Also as at Turk, the structural middle pier divides the façade into two adjacent bays. The pier denies the possibility of horizontal continuity across the upper façade, in the manner of Larkin.

On the other hand, Polk employs an odd number of windows over each arch, and — like Larkin — centers a window over the crown of the arch. In the service of emphasizing the autonomy of each bay, the designer deploys a uniquely widened window (four panes

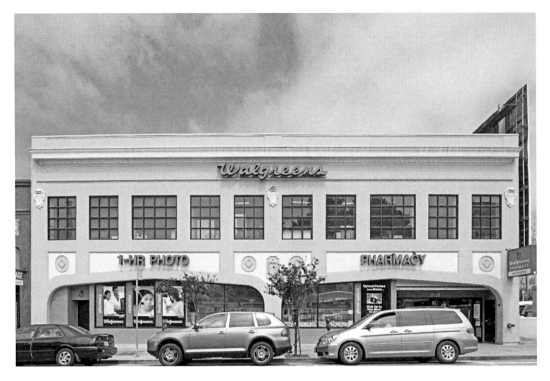

Figure 31. Garage building at 2120 Polk Street, 1931 (Sharon Risedorph).

wide) above the crown. Thus, Polk simultaneously and conspicuously calls attention to the centerline of the façade, and the centerline of the arches.

Mediating between the two interpretations that vie for dominance are the spandrel panels, located between the arches and the second-floor windowsills. The panels respond to events both below and above by assuming the geometry of the various adjacencies: they concentrically outline the arches along their lower profile, while presenting a horizontal line running parallel to the windowsills. While each panel is autonomous, the five panels act in concert as a continuous, if interrupted, band. Considered as separate entities, they tend to refer to events above; as a discontinuous band, they refer to events below.

Fig. 32 presents contrasting compositional analyses based on different readings of the middle panels. Fig. 32a takes its cues from the medallions at the top of the major piers. It presents the twin-arch motif in its basic form and acknowledges the AA composition. The analysis bisects the tripartite ornament above the middle pier, and demonstrates that both halves of this ornament enter into symmetrical relationships with similarly configured panels at the extreme ends of the façade. Adjacent panels work in concert to outline the arches.

Fig. 32b interprets the panels as discrete units. The analysis superimposes a more stable ABCBA composition onto the basic two-bay backdrop. Windows and panels work in concert to create equivalent symmetries about the two primary compositional events that vie for primacy — the center pier and the center of each arch. Unlike Fig. 32a, in which the middle panel is bisected, Fig. 32b celebrates the tripartite panel and allows it to expand into a viable C bay that is certainly more interesting than the middle pier at 550 Turk. It accomplishes this feat by "borrowing" the inside windows from both arched bays. While this

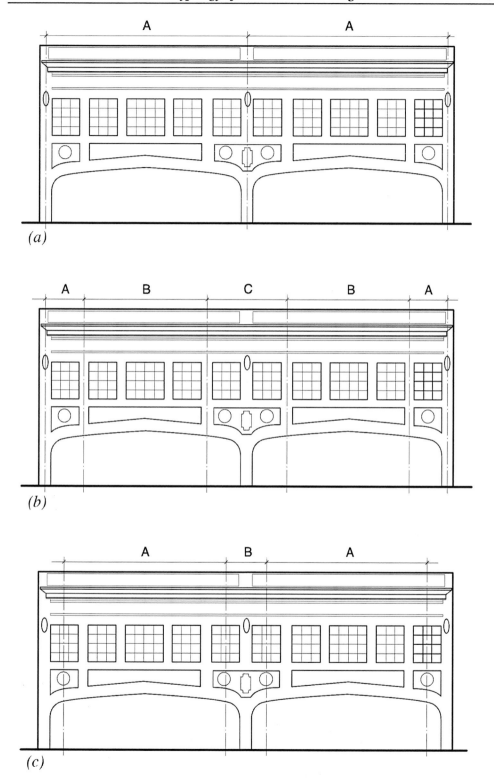

(a)

(b)

(c)

Figure 32. Elevations with analysis, 2120 Polk Street (drawing by Esther Kim and Alissa Jones).

analysis subdivides the arches, it maintains the key symmetry about the wide middle portion of the opening. Lastly, the peripheral A bays are revealed to constitute one-half of the center C bay.

Fig. 32c presents a variation of Fig. 32b based on the roundels that occur in only the middle and peripheral panels. Like the recessed panels, the roundels work individually to reference windows above while working in pairs to frame events below (arches or middle pier). The resultant composition, ABA, is similar to the ABCBA sequence in Fig. 32b in its consequences. It too superimposes a symmetrical sequence containing an odd number of bays onto the twin arch motif, simultaneously acknowledging the center of the entire façade and the two arches.

While it is more sophisticated in formal and abstract terms, Polk is today less satisfying than Turk on a purely sensual level. Overall, the façade presents a flat but composed wall to the street. Discrete ornaments, like medallions and roundels, identify major compositional lines; delicate moldings outline the arches and panels. In its present incarnation as a pharmacy, the building appears modernized and sanitized, which detracts from its original *gravitas*.

265 Eddy

This façade illustrates how a one- or two-story garage serves as the base for a multi-story skyscraper garage (Fig. 33). It also shows how the relatively small set of architectural

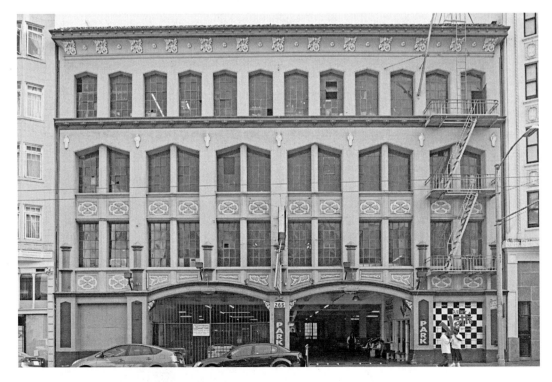

Figure 33. Garage at 265 Eddy Street. Henry C. Smith, Architect, Joseph A. Pasqualetti, Builder, 1924 (Sharon Risedorph).

elements utilized on the smaller garage can accommodate the much larger building without a sizable expansion of that set.

The vocabulary of 265 Eddy is almost identical to that of 550 Turk. While both buildings were developed and built by Joseph A. Pasqualetti of the American Concrete Company in 1924, only Eddy Street is attributed to architect Henry C. Smith.[5]

The Twin Arch motif is central to both buildings, accommodating entry and egress. (While Turk provides ramped access to floors above and below, Eddy has elevators on axis with the arched openings.) In general terms, Eddy becomes a skyscraper garage simply through the multiplication and stacking of elements existing at Turk. Storefront bays are added to either side of the twin-arch motif, transforming an AA façade into BAAB. The vocabulary and syntax of ornamentation from Turk reappears at Eddy: piers with recessed panels, *fleur-de-lis* spandrel ornaments that compress above the arches, and gateposts and medallions that mark the major piers.

Turk's second floor serves as the compositional genesis of the shaft of the Eddy skyscraper. The upper pier stretches vertically from one story to two, and the panelized spandrels are repeated between the second- and third-floor windows. The primary difference between Turk and Eddy involves the latter's grouping of the industrial sash windows in pairs, and the introduction of a new major pier rising from the crown of each arch. While these piers are unique in not extending down to the ground, their status as major compositional verticals is acknowledged through the addition of gatepost ornaments at their bases — launched, as it were, from the keystones. A lintel course at the fourth floor concludes the composition of paired window bays below. Above this course, the windows are decoupled and spaced equally across the width of the façade.

Thus, while Eddy is a larger, more complex building than Turk, the latter establishes a language of elements that also organizes the skyscraper. Consistent with the smaller building, Eddy assembles an even number of bays into a symmetrical façade that focuses on a structural pier in the center.

The arches at Turk seem to effortlessly lift their load, while those at Eddy work harder. Of course, the twin arches of Turk support one story while those at Eddy support three. However, contributing to Eddy's strain are the new major piers that drop their load on the crest of the arches. In the later discussion of the skyscraper at 111 Stevenson, we will look at a similar four-bay façade that refrains from this expression of load.

Conclusion: Twin Arch Façades

The buildings in this category unify around a specific motif. For this reason, the category is more coherent than those formulated around a general criterion — like historical style. This category in particular illustrates the power of a typological approach to lift buildings out of anonymity on the basis of relationship rather than traditional notions of architectural excellence. While all the buildings possess the iconic Twin Arch motif, they exhibit significant differences rooted in structure, function and architectural vision. The motif expresses a contemporary notion of mechanized movement and perverts the traditional anthropocentric goals associated with the arch. Each façade reveals a different point of view regarding the appropriateness and legitimacy of this representation.

2. Narrow ABCBA Façades
by Joseph A. Pasqualetti

— 1550 Union　　　— 2340 Lombard
— 1565 Bush　　　 — 4050 24th Street

In contrast to a Twin Arch façade, a narrow ABCBA model assembles an odd number of bays into an elaborate symmetry about a center entry bay. As a result of this more traditional focus, these façades assert a more static and balanced presence.

On the ground floor, the ABCBA composition fronts an ABA structural frame, as illustrated in the diagrammic sections and discussed in chapter 2. Wooden bowstring trusses support the roof, leaving the second floor column-free. With no structural pier to respect, windows can and do occupy the center bay, forming a triplet above the major entrance. Windows are grouped to reinforce the composition as infill voids spanning between solids. Modular, the windows permit a description of varying bay widths as a simple ratio — as in three windows (center bay) to two windows (end bay).

Joseph A. Pasqualetti, the builder of the twin-arch garages at Turk and Eddy, is responsible for all the examples in this category. The link becomes explicit in certain details, including friezes adorned with acanthus leaves, framed spandrel panels, and ornaments that mark the centerline of piers. This cross-pollination of composition and detail knits together the typology and introduces the possibility of parallel classifications — for example, a category devoted to all Pasqualetti garages.

Here, Pasqualetti investigates over several buildings the possibilities presented by a single compelling composition. He regards the ABCBA format as a flexible template capable of receiving different content. Focus centers on the disposition of the narrow B bay, and its pivotal role in either facilitating or denying formal continuities across the façade. The assertion that Pasqualetti regarded the garage front as a blank canvas for formal architectural investigations is supported by the quality of the work and the variety of imaginative solutions plugged into the template. A talented designer and builder, Pasqualetti manipulated structure, composition and ornament in a search for a valid and/or contemporary architectural expression.

1550 Union

This façade is perhaps the most conservative of the category — a distinction having little to do with the quantity or quality of historicizing ornament (Fig. 34). Rather, it is conservative in its interpretation of the ABCBA composition, fleshing it out to appear heavy and possibly wall-bearing. This appearance results from treating the B bays as solids that

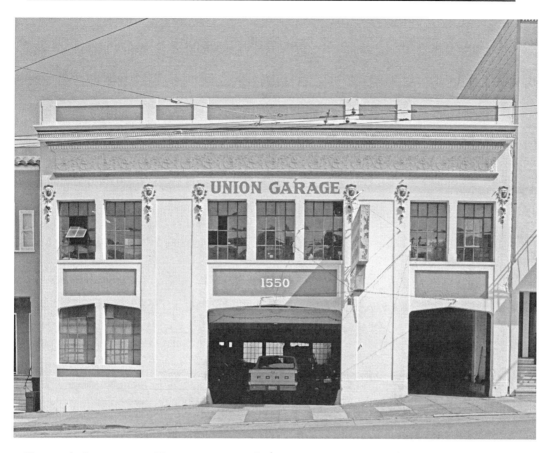

Figure 34. Garage at 1550 Union Street. Joseph A. Pasqualetti, Builder, 1924 (Sharon Risedorph).

simulate compressive towers (Fig. 35a). From a structural standpoint, the middle-entry bay is narrower than necessary, as the "true" structural span extends from end bay to end bay (Fig. 11d). The substantial minor piers that separate windows, and the beam-like spandrels that support them, are secondary devices that reinforce the load-carrying credentials of the solid B sections.

Treating the façade as a structural diagram of supporting and supported bays adds legitimacy to this interpretation of the ABCBA composition, which achieves formal balance as an alternating pattern of (supporting) solids and (supported) voids. That pattern amplifies the importance of the entrance, which benefits from the scale and weight of the flanking solids. Key to the creation of this hierarchy is the dominance of verticals over horizontals, and of monolithic bays over the linear or column-like elements that outline these bays.

This façade shoehorns a programmatic asymmetry into its formal symmetry: one end bay accommodates a ramp while the other accommodates office windows. This version of the ABCBA composition is less forgiving of these imbalances, because it relies upon the consistent alternation of solid and void for its efficacy. Here, the windows form an L-shape configuration that surrounds and isolates the two vehicular openings. The imbalance is sufficient to undermine the symmetry, although the shallow Tudor arches presiding over ramp opening and office window strive to overcome the inconsistency.

The positioning of the six medallions complicates the interpretation of the façade as

(a)

(b)

Figure 35. Elevations with analysis, 1550 Union Street (drawing by Esther Kim, Sarah McDaniel, Haley Hubbard and Alissa Jones).

a simple pattern of alternating solid and void rectangles. As in most Pasqualetti garages, vertical strips of wall are reinvented as major piers through the introduction of these ornaments, which function as applied capitals. At Union, the solid B bay — a flush frame surrounding a recessed panel — is revealed to include two major piers. The implication is that framed voids (window groups and vehicular openings) and framed panels are equivalent as infill bounded by structural piers.

Within the B bay, the medallions create the illusion of parity between one pier that does represent a line of structure (the peripheral pier) and one that does not (the inside pier). The proximity of these two piers to one another suggests redundancy, as if the structural member was cloned in order to interrupt horizontal continuity across the façade and frame the entrance. Fig. 35b documents a prior state in which all piers are structural and the inside piers serve "void" bays on either side. By contrast, Fig. 35a — the front elevation of the building — captures the sense that the B bays are visual spacers inserted to introduce balance and weight into a straightforward utilitarian design. The implication is that the garage is not a factory, and the passage of the automobile is an event requiring architectural enhancement (even if the means of providing enhancement are traditional and antithetical to the precision and functionalism of the factory-produced machine).

1565 Bush

This façade constitutes the first variation on the themes introduced at Union (Figs. 36–37). The major change is the transformation of the B bays from solid to void. At Bush,

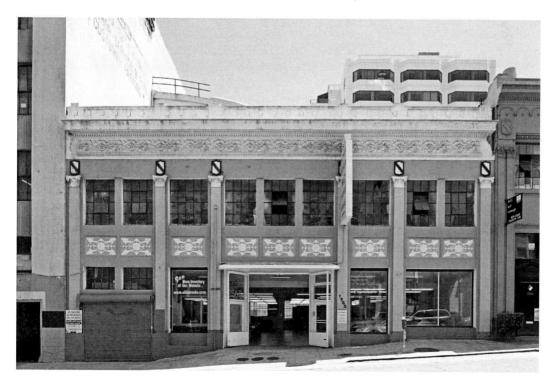

Figure 36. Garage at 1565 Bush Street. Joseph A. Pasqualetti, Builder, 1924 (Sharon Risedorph).

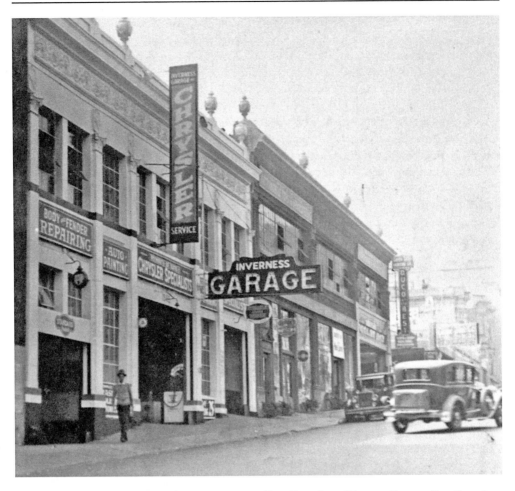

Figure 37. Garage at 1565 Bush Street in 1932 (San Francisco History Center, San Francisco Public Library).

the B bays are detailed like their end- and middle-bay neighbors. A related development is the superimposition of Corinthian pilasters over the major piers. This facilitates a vertical articulation that is independent of the wall behind and creates a more layered composition.

These modifications usher in an opposing interpretation of the ABCBA composition: linear gridding and horizontal continuity replace Union's emphasis on adjacent rectangular bays. The recasting of the B bays as voids isolates the vertical piers as thin, insubstantial strips, a potential problem addressed by the superimposed pilasters. Lighter, more abstract and less wall-like, this façade is less concerned with monumentalizing the entrance with traditional displays of compressive strength.

Secondary refinements reinforce the new interpretation. The ground-floor headers are flat and the spandrels are subdivided into modular panels. As a result, the spandrels are not simulated beams dropping their load on adjacent piers, as happens at Union. The spandrels simply float between openings above and below. Without major interruption, the spandrels form a ribbon that slips behind successive pilasters.

Bush is wider than Union (64.5' and 50' respectively), a circumstance that may under-pin the opening up of the B bays. While the B bay at Bush accommodates a single window,

that window is uniquely wide; the solid equivalent at Union is uniquely narrow — perhaps too narrow to support a window. However, even if the differential handling of these bays at Union and Bush is attributable to circumstance, the attendant detailing suggests that the formal issues assumed primary importance.

The blocky and solid quality of Union Street is abandoned in favor of a lighter, more contemporary expression of frame elements (whether truly structural or not). Ironically, the eclectic mix of historically derived elements — entablature, pilasters, shields and *fleur-de-lis* ornaments — finds unity and purpose in the service of articulating the lines of this more contemporary expression. The end product is a patchwork of solid elements that are linear and ornamental, and framed voids that are rectilinear and industrial.

Originally, both end bays of Bush accommodated ramp openings (Fig. 37). However, the balance that typically results from this fortuitous condition could not materialize, the possibility undermined by the steep slope of the street. Despite the *lateral* symmetry of the ABCBA composition, the overall symmetry was compromised by ramp openings meeting grade at substantially different elevations.

The basement ramp opening is cleverly isolated as a submerged element, i.e., a replica of its uphill counterpart that appears to have been pushed downward to meet grade. (An alternative treatment occurs at 530 Taylor [Fig. 48 later in this chapter], where the heads of both ramp openings align.) At the head of the opening, the elevation is so low that a pair of clerestory windows is inserted between the opening and the spandrel. To reach down to grade, the ramp opening violates the datum established by the base of the pilasters and the foundation wall.

The design posits a perfect and symmetrical composition, and then acknowledges the distortion that renders it imperfect. The ideal and the circumstantial simply coexist. At 818 Leavenworth, we will examine one architect's determination to integrate the sloping grade into the design, creating a balanced but asymmetrical composition.

2340 Lombard

The garage at 2340 Lombard Street is the most forward-looking of the four buildings, although it exhibits a striking similarity to Union, the most conservative (Fig. 38). As at Union, the major piers are vertical sections of wall marked by medallions pinned just below the frieze. Lombard also shares with Union the programmatic and compositional disharmony that results from balancing a ramp opening with a storefront in opposing end bays. While Lombard and Union streets are not perfectly flat, their slopes are sufficiently gentle to avoid the formal gymnastics on display at Bush Street.

Lombard, like Bush, has B bays containing framed glazed voids, and flat heads across its vehicular openings. While spandrels form a discontinuous ribbon across the façade (interrupted by the piers), they are not subdivided into modules as at Bush. Rather, they conform to the Union St. strategy of extending to fill the width of the bay.

What distinguishes Lombard is the elimination of minor piers separating windows into dedicated openings. Bays still include one, two, or three windows, as they do at Union and Bush, but adjacent units are linked by a metal mullion and are subsumed within a single opening. This change results in greater horizontal continuity of the industrial sash within each bay, and across the entire façade. Window openings and spandrels run parallel to one another and maintain identical widths.

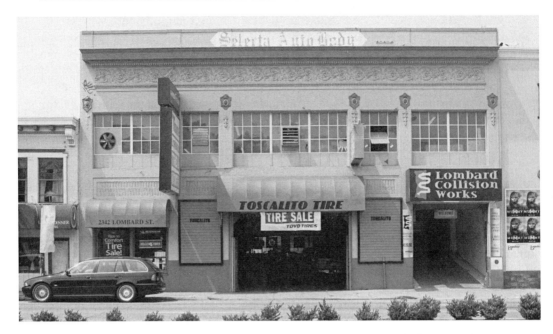

Figure 38. Garage at 2340 Lombard Street. Joseph A. Pasqualetti, Builder, 1924 (Sharon Rise-dorph).

Modularity is not abandoned, despite the elimination of the minor piers. Lombard is unique in utilizing a single four-over-four window unit throughout. Thus, the ABCBA façade can be expressed as a multiple of the window units, or 2:1:3:1:2.

Relative to Union, the ribbon of industrial sash shifts the imagery towards a factory aesthetic. Relative to Bush, the absence of minor piers and pilasters produces a less gridded and layered façade. While still not a pure representation of the frame, the façade does express the capacity of the beam above the windows to span across the wide center bay. However, despite these more contemporary expressions, the garage façade maintains its traditional footing, courtesy of the symmetrical composition, decorative entablature, medallions and fluted spandrel panels.

4050 Twenty-Fourth Street

This façade conspicuously abandons the entablature, attic and flat profile of the previous three examples in favor of an active western-style parapet (Fig. 39). The parapet regroups the five bays below into a tripartite composition by subsuming the three middle bays (BCB) into one composite frontispiece crowned by a gable (Fig. 40).

The façade has a width of 50 feet, matching the width at Union. In both façades, the B bays appear as solid walls, a concession to their narrow sites. As at Union Street, the solid bays are detailed as flush frames surrounding a recessed panel. However, at Twenty-fourth St., the B bays are too narrow to sustain the impression that the vertical members of the frames are all major structural piers. Medallions or shields are therefore left behind as implied capitals. Instead, three decorative recessed panels fill the zone above the second-floor windows. Reinforcing the compositional interpretation imposed by the parapet, the middle

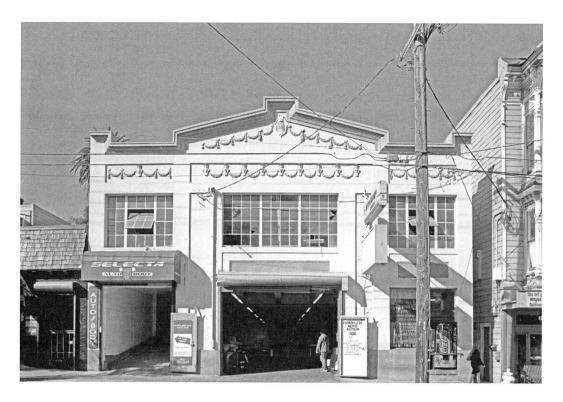

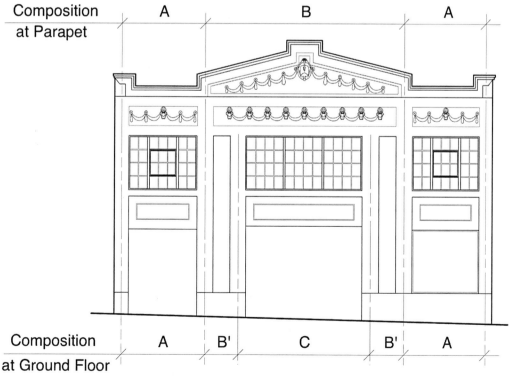

Composition at Parapet

A B A

Composition at Ground Floor

A B' C B' A

Top: Figure 39. Garage at 4050 24th Street. Joseph A. Pasqualetti, Builder, 1924 (Sharon Risedorph). *Bottom:* Figure 40. Elevation with analysis, 4050 24th Street, 1924 (drawing by Esther Kim and Sarah McDaniel).

panel presides over both the B bays and the entry bay. Panels gracing the side bays align with the openings below and the long parapet segments above.

As at Lombard Street, industrial sash windows occupy the full width of their respective bays. Slender metal mullions join adjacent window units, rendering minor wall piers unnecessary. However at Twenty-Fourth St., the industrial windows function differently in the composition than they do at Lombard, where horizontality is emphasized. Returning to the strategy implemented at Union, the windows reinforce the autonomy of separate vertically oriented bays. Thus, the composition reverts back to an alternating rhythm of solid and void — at least as perceived below the parapet.

The entablatures of the other examples in the category maintain a grand neutrality with respect to subdivisions below, even though the compositions are restated in the attic. These horizontals express no preference regarding the role to be played by the B bays in establishing hierarchy around the entrance bay. This aloofness afforded Pasqualetti license to treat the B bays as either solids or voids, and to generate variations over the ABCBA theme. As these examples demonstrate, the differential rendering of the slender bays exerts considerable influence over the character of the façade. When the B bays are treated as voids, horizontal continuity is ascendant and the composition appears more contemporary. When they are solid, the composition veers towards a traditional statement of hierarchy based on a strong frame about the center. However, by summarily capping over everything, the entablatures sustain a minimal level of ambiguity below, allowing the B bays to come forward and recede relative to the balance of the façade.

The Twenty-Fourth Street composition retreats from this neutrality — and the ambiguity it sustains — by utilizing a dynamic inflecting parapet to advance a single conclusive point of view. This façade compresses the five-bay format into an ABA composition and — as if concerned that the solid B bays will exert their independence — emphatically nails down the preferred interpretation. While the parapet lacks the subtlety of the flat profile, it is explicit in its intentions.

3. WIDE ABCBA FAÇADES

— 650 Divisadero — 1745 Divisadero
— 530–544 Taylor — 818 Leavenworth

The category includes two-story ABCBA garages occupying wider lots.[6] These buildings share key properties with their narrow cousins: building height, flat parapets, and windows

arranged as a discontinuous band across the second floor. Attention focuses on the distribution of the five bays to the wider canvas and the expansion of the B bays. As in the narrow category, the compositions build hierarchies around the center and organize bays into patterns of solid and void. These preferences result in façades of increased complexity, especially when the center is a solid, and the voids on either side are entrances. While the center bay is the symmetrical focus, it offers neither door nor axial procession. Tension develops between the "mute" center and the activity on either side. The two garages on Divisadero reflect contrasting strategies brought to bear on this theme.

San Francisco's hills are another source of compositional tension, one we have already encountered at the narrow ABCBA façade on Bush. Tension develops between a stable symmetrical composition and a destabilizing inclined grade. The façades at Taylor and Leavenworth, two buildings linked by their ornamental frontispieces, "discuss" how best to incorporate this conflict into the design and function of the garage.

Circumscribed within a traditional overall framework, the wide ABCBA façade composition anticipates the modernist concepts of balanced asymmetry and rotation about a fixed center. All of these examples reflect an exciting transitional moment that predates modernism by just a few years, when architects stretched to the limit an academic process predicated on the adaptation of existing forms to solve new problems. While their designs lack the conviction and passion of revolutionary expressions, these architects subtly capture their moment by allowing the automobile to loosen and even distort the inherited canon.

650 Divisadero

This is a classic wide garage façade, in which vehicular openings occupy the second and fourth bays of a five-bay composition (Figs. 41–42). Sandwiched in between is a glazed opening of equal width that serves as an office window and storefront. The open/glazed/open sequence in these middle three bays illustrates the treatment of glazing as a quasi-solid, i.e., an intermediate material poised between a framed void and an opaque solid.

The garage is, however, unusual in its massing: a two-story head building, just one bay deep, fronts a single-story shed. On the façade, the second floor is treated like an attic story over the ground floor. Inside, the second floor provides a small apartment and office and resembles the mezzanines of older brick box garages.

The programmatic demands on the façade are eased by the fact that the shed is a single story and ramps are not required. Each automobile entrance gives access to a circulation aisle that bypasses the office occupying the center bay. Behind the head building, the shallow shed is supported by a series of trusses, their spans bisected by wooden posts. The line of these posts form an informal boundary separating two rows of parking spaces, each one accessible from one of the two entrances.

Plain and devoid of ornament, the three middle ground-floor bays are nevertheless the compositional focus. The balance of the façade — end bays and attic — forms a large ornamental frame (an inverted U-shape) around the middle. Slightly projecting end bays are detailed as matching pavilions that bookend the composition. Between the pavilions, the attic articulates the three middle bays as groups of five windows separated by squat pairs of pilasters. Thus, while the attic serves as part of a decorative surround for the three-bay center, it also acknowledges the integrity of each bay.

The special status of the center bay hinges upon the glazing in the opening and the

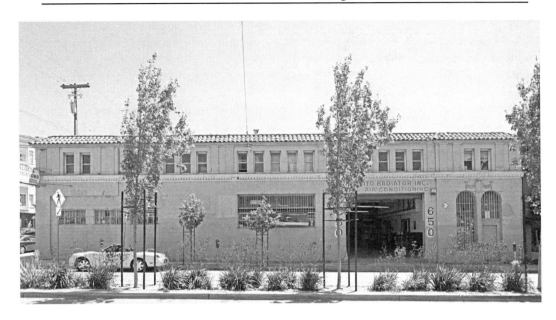

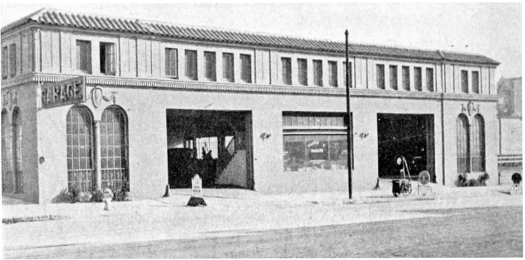

Top: Figure 41. Garage at 650 Divisadero Street. Baumann & Jose, Architects, from *Architect and Engineer*, 1922 (Sharon Risedorph). *Bottom:* Figure 42. Garage at 650 Divisadero Street in 1922 (*Architect and Engineer*, San Francisco History Center, San Francisco Public Library).

wall beneath the sill, as otherwise this bay is the same as those on either side. This storefront bay is pivotal, as it functions simultaneously in several related formal relationships. This bay (1) anchors the center of a wide symmetrical façade, (2) maintains the alternating pattern of solid and void across the ground floor, (3) maintains the integrity of the center three bays as a distinct entity, and (4) distinguishes itself within that middle entity as a solid flanked by void entrances.

These formal relationships constitute the means by which a traditional symmetrical composition is adapted to contemporary requirements. The composition creates a strong center but denies axial movement through that center. Pedestrian entrance along a centerline

is replaced by vehicular rotation about the center bay. Rotation is subtly encouraged by the refusal to build symmetries about the entrance bays; each entrance is not a static center of balance but a contingent part of a larger symmetry that revolves around the center. In this way, the composition accommodates and expresses the dynamic and asymmetric movement of the automobile within the framework of a balanced and conventional façade.

1745 Divisadero

This garage is easily identifiable as a Pasqualetti garage, presenting the full inventory of his architectural motifs: ornamented entablature, major piers accentuated by medallions, minor piers separating windows, spandrels with recessed panels, and pointed arches atop ground floor openings. There is also the telltale approach to composition: a rectangular canvas is subdivided into adjacent double-height bays composed of rectangular windows over void or glazed openings (Figs. 43–44). This façade closely resembles 1550 Union Street.

This ABCBA façade is compositionally the same as 650 Divisadero insofar as twin ground-floor entrances occupy the B bays and frame a storefront in the center. However, unlike 650 Divisadero, no attempt is made to group the three middle bays together. The center storefront is a unique event—the sole ground-floor bay with a flat window head. Also, this garage has a true second floor, which necessitates a ramp. As always, the ramp is accommodated in the end bay on the uphill side. This solution is awkward, both in the adjacency of vehicular openings, and in the balancing of disparate events in the end bays (ramp on one side, office on the other). The disposition of the end bays reproduces the condition at Union Street, with similar results.

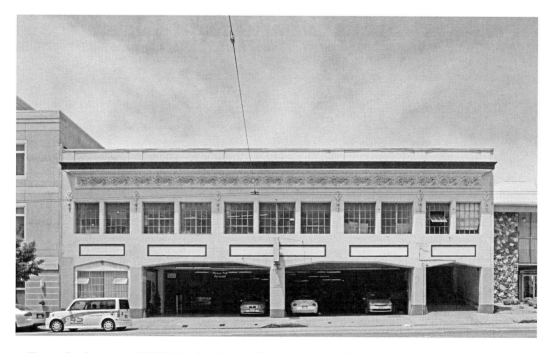

Figure 43. Garage at 1745 Divisadero Street, Joseph A. Pasqualetti, Builder, 1922 (Sharon Risedorph).

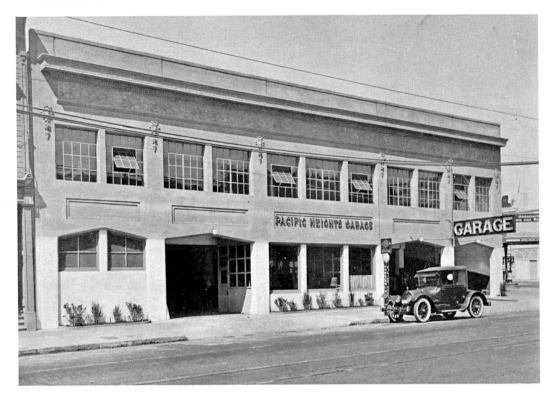

Figure 44. Garage at 1745 Divisadero Street in 1922 (courtesy the Pasqualetti Family).

In this composition, Pasqualetti pursues a theme that is also central to the Twin Arch category: the introduction of secondary local symmetries about the major vehicular (and off-center) openings. In both cases, the intention is to soften the impact of a symmetrical façade that does not center upon an entrance. In this category, the situation is less severe because the composition centers upon an entire bay and not — as in the Twin Arch category — a slender structural pier. While the grouping of the center three bays is schematically similar to 650 Divisadero, the emphasis is not on rotation about the middle, but on processional axial movement into either vehicular opening.

The desired emphasis is achieved by overlaying a secondary and subtler subdivision onto the basic ABCBA bay structure (Fig. 45). The locus of concern is the second-floor windows, and the overlay is created through the interaction of bay width, window width, and the number of windows in each bay.

Bays become incrementally wider from the periphery to the center: the A bays are the narrowest, the B bays are intermediate, and the middle C bay is the widest. The difference in width can be expressed in terms of the number of panes of glass within a window, the number of windows in a bay, and a combination of the two. Thus, the A bays contain two five-pane windows; the B bays contain two six-pane windows; and the C bay contains a triplet of windows, with two five-pane windows framing a single six-pane window.

Emphasis on the center bay is a function of its unique width and window triplet. The triplet enables the entire composition to center on an opening instead of a pier — the six-pane window in the middle. This is a paradoxical achievement, as the structural frame behind the façade includes a column along this centerline (Fig. 46). At the same time, each

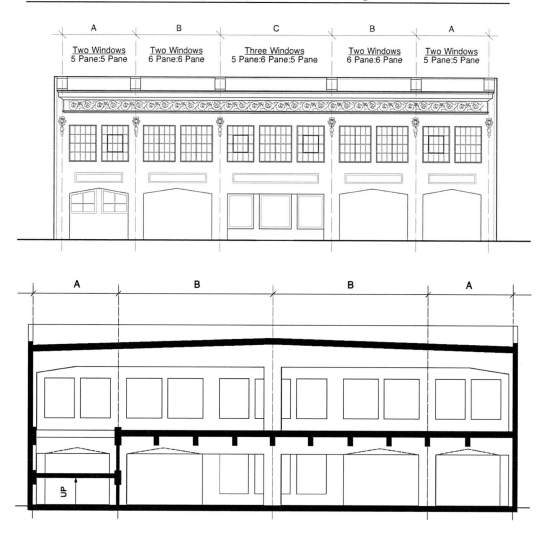

Top: Figure 45. Elevation with analysis, 1745 Divisadero Street. *Bottom:* Figure 46. Schematic section, 1745 Divisadero Street (both drawings by Esther Kim, Sarah McDaniel, Haley Hubbard and Alissa Jones).

five-pane window within the triplet engages its peripheral five-pane counterpart — the inside window of the end bay — in forming a local symmetry about either entrance (Fig. 47).

The intention is reinforced through the conspicuous placement of operable panels in certain windows (Figs. 44, 47). These panels only occur in those five-pane-wide windows that are involved in creating centers about the overall centerline of the composition, or about the two vehicular openings. In the archival photograph, the operable panels are open, suggesting that these manipulations are purposeful and deliberate. The symmetry about the vehicular openings assumes a clownish anthropomorphic quality, as the open windows are the eyes of a face that centers on the gaping mouth below.

As noted in chapter 2, Pasqualetti built a number of wide five-bay garages that adhere to this template. However, among surviving examples, 1745 Divisadero is unique in presenting the triplet of windows in the center bay; the other examples contain pairs of windows.

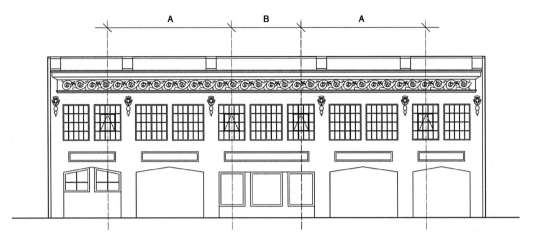

Figure 47. Elevation with analysis, 1745 Divisadero Street (drawing by Esther Kim, Sarah McDaniel, Haley Hubbard and Alissa Jones).

As the triplet is key to the establishment of multiple centers on the façade, 1745 Divisadero is the most ambitious and sophisticated of these related garages. Unfortunately, the widening of the vehicular openings and the elimination of the center storefront render unintelligible Pasqualetti's original design intentions.

Deceptively complex, the façade at 1745 Divisadero is more layered and nuanced than it first appears. The ABCBA composition and the ornamental overlay that highlight its regulating lines serve as a backdrop for more subtle and obscure manipulations. These manipulations, which involve minor changes in geometry and proportion, are the elements that lift this composition out of the ordinary.

530–544 Taylor

This façade, 60 feet wide, employs the same compositional formula as the Narrow ABCBA Façades category: a wide opening in the center accommodates ground-floor access, while narrower openings in the end bays provide access to ramps (Figs. 48–50). The B bays are intermediate zones separating the three openings. In this template, the formal center and the main entrance coincide, resulting in a relatively stable and straightforward façade.

Despite the common compositional formula and comparable width, 530 Taylor and the Pasqualetti garages exhibit contrasting visual emphasis. While the Pasqualetti façades are gridded and feature dominant vertical piers, 530 Taylor is wall-like, with horizontal articulation. Each window group is centered above a ground-floor opening, but the bay remains implicit; i.e., windows and ground-floor openings are not circumscribed within rectangular frames. Instead, a strong sill course divides the façade into base and *piano nobile*.

Glamorizing the center bay and the main entrance is the Churrigueresque frontispiece. The flourish accentuates the increased width of the central bay and the fact that it uniquely contains a triplet of arched windows. Ornamental pilasters separate adjacent windows in both odd and even groupings. In side bays, the pilasters mark the centerline; in the middle bay, they constitute the uprights of the frontispiece. Over a central entrance, the shift to a tripartite event is consistent with the more traditional focus of this template.

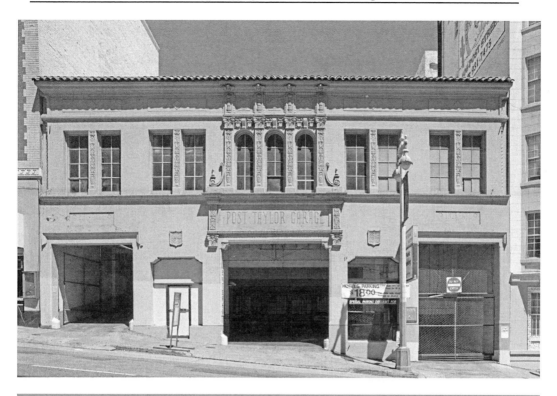

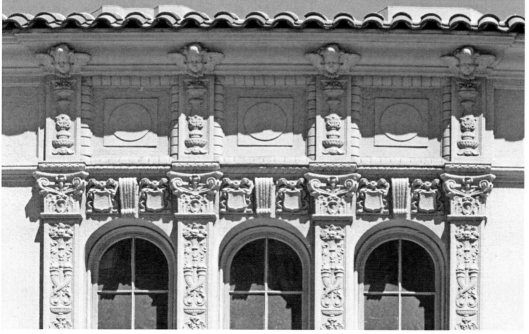

Top: Figure 48. 530–544 Taylor Street. Frederick H. Meyer, Architect, 1922. *Bottom:* Figure 49. Detail, 530–544 Taylor Street (both photographs, Sharon Risedorph).

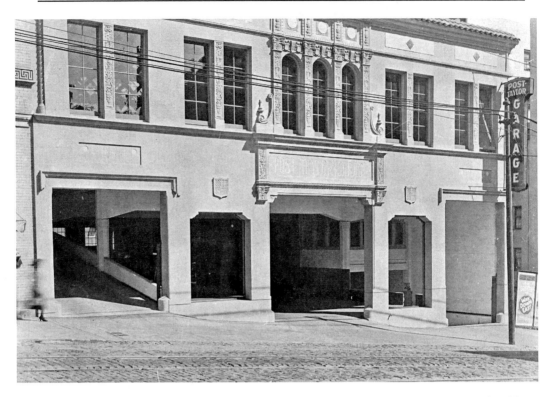

Figure 50. 530–544 Taylor Street, archival photograph (San Francisco Department of Public Works Albums, San Francisco History Center, San Francisco Public Library).

The narrow Pasqualetti garages also feature a triplet over the center entrance, and for the same reason. However, in his façades, the triplet is rationally expressed as an increased number of modular windows, and not as an invitation to celebrate. Instead of relying upon the figural, ornamental gesture to reinforce the center, Pasqualetti engages the B bays as a framing device.

Taylor, like Bush, sits on a steeply sloping street, and in both cases the incline undermines the symmetry of the façade. Both designers address the condition by isolating the downhill ramp opening as an aberration to an otherwise stable composition. At Bush, the ramp opening is treated as a sunken modular element. At Taylor, the analogous opening is presented as "normal" at the head, sharing the same elevation and label molding as its uphill counterpart. Then, the opening drops to meet grade, becoming vertically distorted. The main entrance, situated in the center and meeting grade at a pivot point, is a datum against which we can measure the modest compression of the uphill opening, and the more pointed attenuation of the downhill opening.

The relationship of stable compositions to destabilizing slopes is a recurrent issue. Typically, the solution calls for absorbing the slope into a local condition and trusting that the overall compositional order is sufficiently imposing as to overwhelm the anomaly. This strategy, never too successful, serves as a point of reference for the following example, which takes a more engaged approach.

818 Leavenworth

This façade presents an array of syncopated rhythms between events at different levels (Figs. 51–52).[7] The attic and ground story subdivide into four bays (Fig. 52[a]). The second floor breaks down into five, loosely defined by window groups of varying widths and configurations (c). In the center, a frontispiece incorporates a triplet of windows and dominates the façade. A stylized entablature divides into three, with a center segment that crowns the frontispiece (b).

The composition has an improvised yet balanced feel. Windows and vehicular entrances are punched-out openings in a wall that drifts between the misalignments that are the consequence of the syncopations. At the same time, vertical alignments do occur along the centerlines of the vehicular openings, and of the façade overall.

The frontispiece occupies a similar central position to the one at Taylor. However, rather than declare entry, the Leavenworth frontispiece serves to stabilize a composition that unfolds asymmetrically from the center to the periphery. This façade does not center on a ground-floor bay, either used as an entrance (Taylor) or as a storefront flanked by entrances (650 and 1745 Divisadero). Entrance is disbursed to either end of the façade, with ground-floor access on the downhill side (typically the site of a basement ramp), and the second-floor ramp on the uphill side. This wide separation maximizes the incorporation of the street *as a ramp* into the vertical circulation system of the garage.

A comparison of Taylor and Leavenworth illustrates the dramatic difference between a sloping street serving a garage with a second floor and a basement, versus one serving a garage with just a second floor (in addition to the ground floor). It appears as if the main entrance of Taylor migrates downhill to assume—at Leavenworth—the peripheral spot

Figure 51. Garage at 818 Leavenworth Street. W.J. McKillop, Builder, 1921 (Sharon Risedorph).

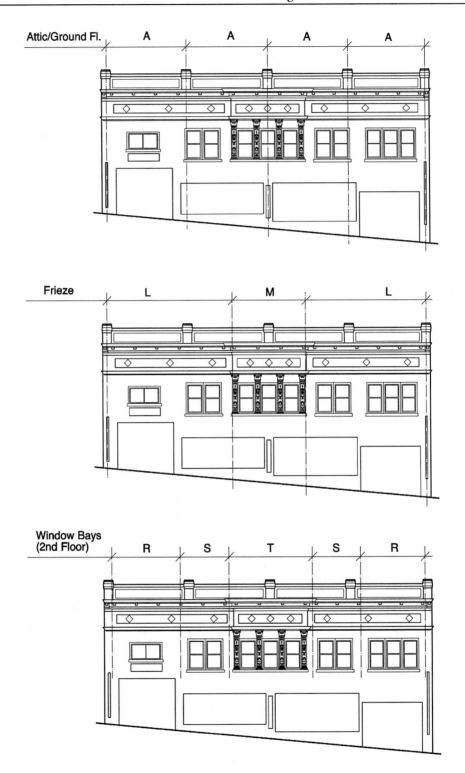

Figure 52. Elevations with analysis, 818 Leavenworth Street (drawing by Sarah McDaniel and Esther Kim).

usually occupied by the basement ramp. Leavenworth is more deeply embedded in the ground than Taylor, as a greater portion of the ground-floor height is concealed by grade. Although frontispieces mark the center of both façades, Leavenworth's is clipped at the base, as if to acknowledge the absence of anything beneath to celebrate.

In the design of the front elevation, the architect welcomes the slope as a major design element, incorporating it as a dynamic and generative force in a narrative that chronicles the distortion of a once stable and flat composition.

Except for the sloping street, the composition is relatively stable and symmetrical in the center, encompassing all events beneath the two middle attic bays. This interpretation isolates the end bays as variables and sources of instability. The two vehicular openings are identical but spring from opposite extremes of the sloping street. Using the two middle windows as a datum, it appears that the ramp opening is higher and the ground floor entrance is lower by about equal measure. Similarly, events along the centerline of the façade — pier, frontispiece, and attic pier — function as a visual fulcrum with regard to the vehicular openings on either side. The openings are like differentially weighted pans suspended from the center post of a scales of justice.

However, a more conspicuous imbalance occurs between the second-floor windows above their respective vehicular openings: a triplet of double-hung windows over the low opening corresponds to a single double-hung window over the high opening. Remarkably, this single window is oriented horizontally, rotated ninety degrees as if to avoid a collision with the ascending head of the ramp opening.

The rotation of this window, coupled with the "weighted" elevations of the vehicular openings, statically represent the end result of a dynamic process by which a flat street *becomes* sloped. The façade implicitly references a former state in which the street was flat and the window upright. We can speculate on which is the causal agent that influences the other: does the cataclysmic eruption of a hill cause the ramp opening to rise and the window to get out of the way, or does the rotation of the window cause grade to incline? Fig. 53

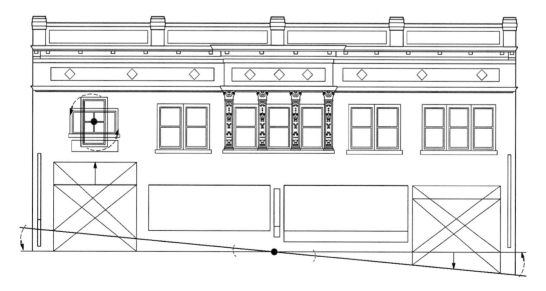

Figure 53. Elevation with analysis showing the dynamic rotation of the window and the street, 818 Leavenworth Street (drawing by Esther Kim and Haley Hubbard).

illustrates one interpretation of the narrative, in which the window is likened to a knob of a mechanical device, the turning of which sets the level street in motion, rotating clockwise about a fulcrum at the bottom center of the façade.

Regardless of which element sets the narrative in motion, the façade presents a once stable composition that is now in a state of disarray. The distortions are not arbitrary — they document the impact of a particular scenario. Sufficient evidence remains of the "original" state to easily reconstruct it upon visual inspection.

The designer exhibits a wry sense of humor in the development of this façade, and a game willingness to expose his Mannerist tendencies in downtown San Francisco. The solution may reflect a hyper-awareness regarding the deployment of one's sophisticated training in the service of the prosaic garage. Alternatively, the architect may have viewed the garage as a low-risk forum for formal experiments that might provoke criticism if attached to a highbrow commission. Regardless, the architect's integration of abnormality into the façade displays a prescient willingness to welcome circumstantial and idiosyncratic elements into design.

4. ARCADE FAÇADES

— 750 Post — 1945 Hyde
— 525 Jones — 64 Golden Gate

These garages present five or six bays of equal width to the street in a manner that suggests the uniform access and transparency of the public arcade. Three of the four examples emulate Mission arcades, as found in train stations and the accessory structures of churches. These are indeed Mission garages, but they are categorized separately due to the distinguishing formal characteristic of regular open bays on the ground floor. The fourth example features square bays and has distinct Georgian overtones, but it too represents itself as a type of loggia to the street.

As discussed in chapter 2, the arcade is an effective means of masking the dematerialization of the ground floor. With visible means of support, the upper level does not appear to float. Also, the repeating, articulated motif superimposes a formal unity on ground-floor events that are programmatically disparate. These compositions are less sensitive to inconsistencies in patterns of solid and void, particularly if glazed offices and retail fronts are recessed into their assigned bays.

Relative to the other categories in this typology, the arcade composition does not build hierarchies or frames about a specific opening or element. Attention is diffused across the

width of the façade, and there is a greater likelihood that major entrances will not occupy the center bay. However, above the ground-floor level, parapet profiles and historicizing detail introduce a central focus. These four examples vary to the extent that the ground-floor loggia is allowed to dominate the entire composition.

750 Post

This façade is imposing and bold in its simplicity: a ground-floor arcade supports a second story of rectangular windows (Fig. 54). The vocabulary is reductive, with just two main elements — arch and window — repeated six times. Although bays are not vertically articulated, arched openings and windows share the same width and are aligned.

The arcade dominates the façade and generates its formal order. No competing gestures challenge the abstract integrity of the grid or accentuate the center. Horizontal emphasis occurs at the second-story sill course and again at the projecting eaves. These lines, continuous and undifferentiated, reinforce the sweep across the façade.

The even number of bays also diffuses attention away from the center. Many six-bay garages subdivide into adjacent tripartite compositions, with vehicular entrance accommodated in the middle bay of each set piece (ABA/ABA). If the archival photo from the 1960s represents the original condition (Fig. 55), this strategy was ignored at Post Street. Vehicular openings occupy the second, third and fifth arches from the left side of the photograph. No pattern of solid and void is established, and no hierarchy is built around entrance. This

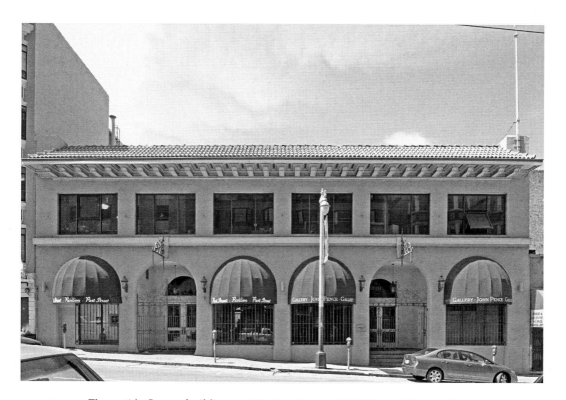

Figure 54. Garage building at 750 Post Street, 1914 (Sharon Risedorph).

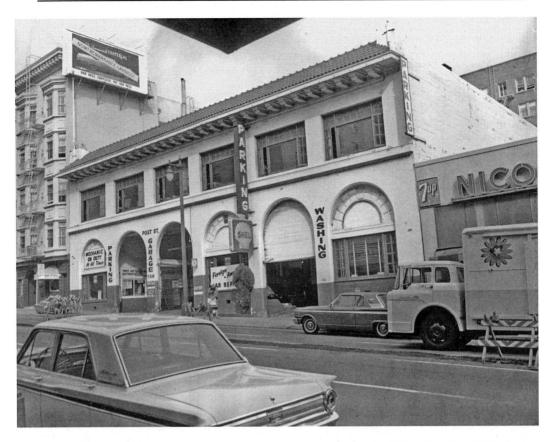

Figure 55. 750 Post Street in the 1960s (San Francisco Assessor's Office Negative Collection, San Francisco History Center, San Francisco Public Library).

informality in the programming of the bays exploits the architectural authority of the arcade to minimize the impact and visibility of discordant events.

A sloping street distorts the arches and the regularity of the arcade. The openings simply extend down to the street — the same strategy used at 530 Taylor. In an attempt to isolate the distortion towards the base of the façade, the sills of windows within arches align, establishing a level datum.

Composition and historical reference merge in the repetition of arched openings. The façade is precise and stark — its internal subdivisions do not require ornamental accentuation. While the overhanging eave is substantial and allusive, it remains compositionally neutral, offering no interpretation of events below.

1945 Hyde

Sitting on a quiet residential street in Russian Hill, 1945 Hyde rivets our attention with its size and focused composition (Fig. 56). Another garage with rectangular windows over arched openings, Hyde Street bears a strong family resemblance to Post. However, while the Post arcade is undifferentiated across the width of the façade, Hyde superimposes a central emphasis over its arcade.

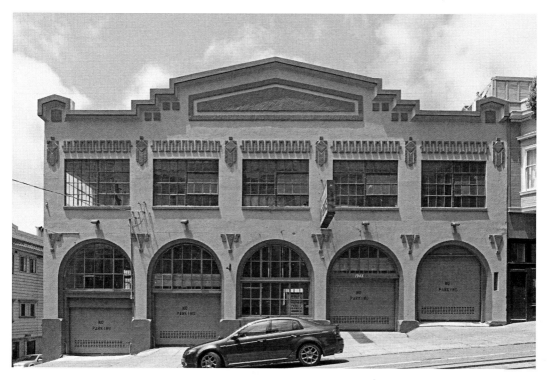

Figure 56. Garage at 1945 Hyde Street. August G. Headman, Architect, 1921 (Sharon Rise-dorph).

The emphasis over the middle is accomplished in ways both obvious and subtle. Relative to Post, Hyde's five-bay arcade is more amenable to centering gestures, as an opening — not a pier — occupies the middle. The western-style parapet, a conspicuous crowning gesture, recasts the five bays as an ABA composition. A central pediment claims the three middle bays, flanked by a single bay on either end.

Not merely an arbitrary formal device, the compositional overlay represents function and structure. The parapet represents the programming of the façade and the allocation of bays to serve different levels. Where Post employed an internal elevator to access the second floor, Hyde utilizes ramps. As always, ramps serving the second floor and basement are dispatched to the end bays in order to exploit the slope of the street and consolidate the ground floor over the center of the plan. The three center bays serve the ground floor, with a glazed storefront in the middle and vehicular openings on either side. Overall, the programming of the arcade is symmetrical and elegant: ramp/ground-floor access/storefront/ground-floor access/ramp. The parapet diagrams this arrangement, distinguishing between end bays (ramp) and center bays (ground floor).

Although the parapet profile does not parallel the slightly pitched roof, it does represent the concrete frame supporting the roof. The upstairs frame is an *ABA* structure, with two rows of freestanding columns separating the end bays from the broad center (Fig. 57). Fronting this wide structural bay is the false pediment. Over the ground floor the frame becomes a four-bay structure (*ABBA*), with a freestanding column at the centerline of the building. Upon closer scrutiny, the center arch is revealed to frame a view of the first in a row of centerline columns. Thus, somewhat paradoxically, Headman designed an arcade of

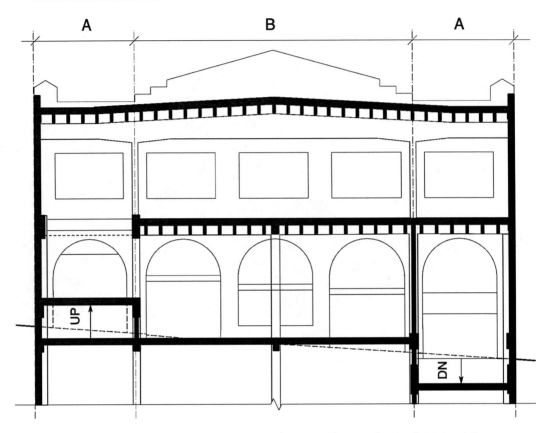

Figure 57. Schematic section, 1945 Hyde Street (drawing by Sarah McDaniel).

five bays to underpin a grand symmetrical composition that ultimately centers upon a slender but structural column. Arguably, the column undermines the arcade.

Headman devised an innovative strategy to incorporate the street slope into the façade without compromising the composition. He initiated a counterpoint between elements that follow the slope and those that defy it. On the one hand, door heads and transom bars, unglued from the springline of their respective arches, form a stepped profile that loosely follows the slope of the street. On the other hand, a foundation wall provides a pedestal for each pier, rising to a constant elevation that establishes a level base for the arcade. The intricate and ordered appearance of opposing lines animates the base of the building.

Ornament consists of brick appliqué that outlines and accentuates the major compositional lines. Beneath the parapet, brick is fashioned into stylized medallions, keystones and lintels. On the parapet — the source of compositional hierarchy — the brick sheds the intricate stylizations below to assume more importance. The pediment-shaped panel and surrounding frame add weight and visual focus to a parapet that might otherwise appear flimsy.

In a comparison of Post and Hyde, the latter's parapet and centralizing tendencies contrast with Post's flat profile and undifferentiated arcade. Hyde superimposes hierarchy onto its non-hierarchical arcade, and the façade is somewhat at odds with itself as a result. This formal conflict between the upper half and lower half of the composition parallels and represents an analogous conflict between the structural concrete frames above and below.

525 Jones

This Georgian-inspired façade is both regal and lowbrow (Figs. 58–59). The division of the 67-foot-wide lot into five equal bays, each one capable of accommodating vehicular passage, results in slender piers. The loggia is insubstantial, and a sloping street exacerbates this problem on the downhill side. However, despite this handicap, the façade possesses remarkable integrity, the consequence of formal manipulations and inspired detailing above the loggia.

As at Hyde, the AAAAA loggia is restated above as an ABA composition. Here, the regrouping is more convincing, as the subdivision involves more elements than just the parapet. The three middle bays form a temple-like frontispiece, with double-height Corinthian pilasters and segmental arches supporting a projecting entablature. End bays, which accommodate ramps, function visually as a backdrop. A discontinuous band of spandrels separating ground-floor and second-floor openings appear as festive mock balcony fronts. The three panels subsumed within the frontispiece are more ornate than the balustrades on either side.

Relative to Post and Hyde, Jones has little continuous wall surface and simulates a post-and-beam construction of pre-cast ornamental parts. The slight projection of the well-proportioned frontispiece interrupts horizontal flow. This articulation of the center contrasts with Post and Hyde, where the arcades spread out along the street. Jones appears lighter and more upright, like a building raised up on stilts.

The structure is typical of the narrower two-story garages: trusses support the roof and *ABA* frames support the second floor (Fig. 11d, 11h). On the ground floor, the frontispiece

Figure 58. Garage at 525 Jones Street. O'Brien Bros., Architects, 1924 (Sharon Risedorph).

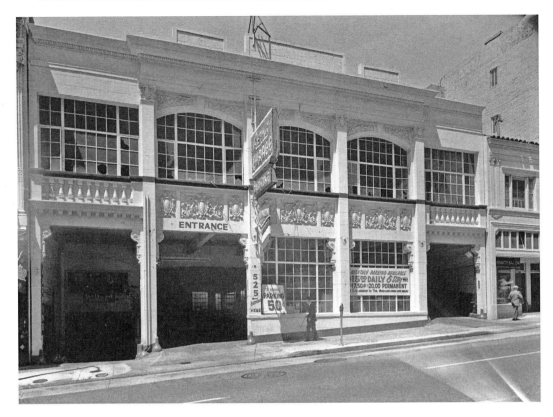

Figure 59. 525 Jones Street in the 1960s (San Francisco Assessor's Office Negative Collection, San Francisco History Center, San Francisco Public Library).

covers the wide middle structural bay, while the end bays are both compositional and structural. On the second floor, the ABA composition has no comparable link to the column-free interior. Similarly, the strong entablature denies expression of the shed, which is barely concealed by the three merlons at the very top.

This building captures the oxymoronic quality of lowbrow historicism, an informal application of formal architecture. It is at once elegant and clunky, powerful and insubstantial, historically allusive and utilitarian. The architect appears ingenuous in sharing with us the building's flaws yet confident of a masterful outcome despite these flaws. As in the example of Leavenworth, the prosaic nature of the enterprise affords the architect license to loosen the rules governing the adaptation of a historically derived architecture.

64 Golden Gate

This relatively early garage exemplifies the greater compositional freedom exercised by designers of the single-story brick box (Fig. 60). In the context of a one-story building, the arcade does not project upward to establish a grid with second-story windows. The reduced level of formal responsibility enables the arcade to function as a stylistic quotation within an overall picturesque Mission composition. Among the examples of this category, this façade is the least geometrically rigid and the most stylistically allusive.

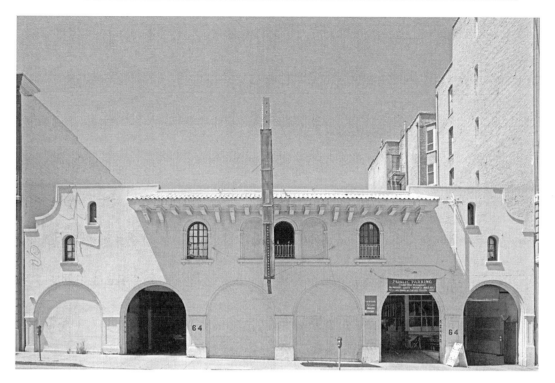

Figure 60. Garage at 64 Golden Gate Avenue. Crim & Scott, Architects, 1910 (Sharon Rise-dorph).

While eschewing the precise grid of windows and arcade openings of Post and Hyde, the Golden Gate façade is still organized and considered. The repeating arched motif imposes formal unity over an asymmetric programming of glazed and open bays. (As in many garages, a sole ramp opening occupying an end bay throws off an otherwise symmetrical patterning of solid and void.) Also, arcade bays fix the location of most of the smaller windows above, as illustrated by the vertical centerlines shown in Fig. 61.

In its composition, ornament and vocabulary of elements, the façade is primarily devoted to Mission-style signification. In addition to the arcade, Mission motifs include the tower-like silhouette of the parapets, the attached eave supporting a clay tile roof, and the free placement of roundhead windows of different sizes. Relative to the other Arcade category garages, this building is more evocative in its emphasis on the whitewashed wall, the large ratio of solid to void, and its solid attachment to the ground.

If the design seems surprisingly lyrical for a parking garage in the Tenderloin, it is largely because the significance of the lowbrow historicist garage is largely lost to us today. Also, the building has endured unfortunate modifications, including the hacking off of its flanking towers and the boarding up of its once-glazed bays (Fig. 135 in chapter 9). These changes make it that much harder to discern its meaning.

The façade is reminiscent of Mission train stations designed and built by the Southern Pacific railroad throughout California at about the same time (Fig. 3 in the Introduction). Crim & Scott adapted the volumetric forms of the freestanding train station to the two-dimensional façade, including the covered arcades that line the tracks, hipped Spanish-style roofs, and arched porticos with flanking towers. The result is a flattened Mission collage

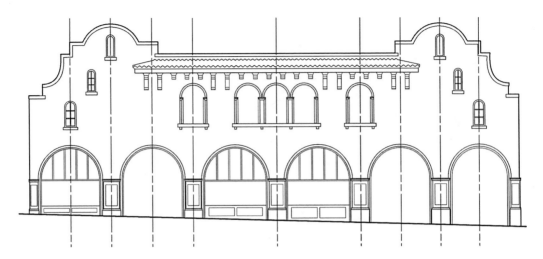

Figure 61. Elevation with analysis, 64 Golden Gate Avenue (drawing by Sarah McDaniel and Esther Kim).

that relies upon a continuity of imagery to assert that the garage is the successor to the train station,[8] and the car is successor to the train.

———————————————————————————————————————

5. Gothic Façades

— 66 Page 550–560 O'Farrell
— 240 Pacific 111 Stevenson

Identifying a category on the basis of style shifts the focus from façade composition to the historically derived and decorative overlay. These four garages possess different compositions, each one of which could serve as the basis for assignment to another category. The group includes a narrow two-story ABCBA garage, a wide version, a single-story ABA garage and a skyscraper. However, the goal is not to assert the mutual exclusivity of the categories, but to celebrate the rich interrelationships of all the garages, using a broad range of criteria. This group is formulated around a few representative motifs — depressed arches, battlements and buttresses — that are easily identifiable and establish an informal kinship. The reappearance of these motifs in buildings of different scales and complexity forms the

basis of a conversation between the structures, a dialogue that occurs through us. As these examples demonstrate, while the Gothic overlay is tectonically frivolous, it is essential to the related compositional and symbolic expressions of the façades.

66 Page

This façade is a narrow two-story ABCBA composition, and is closely related to Pasqualetti's narrow garages (Fig. 62). Page presents the typical features of the composition, including alternating solid and void bays, and tall B bays separating vehicular entrances. Also typical is the relationship of composition to structure: Clear span trusses support the roof and three-bay concrete frames support the second floor (similar to Fig. 11d).

A fortuitous set of circumstances relating composition, site and program results in balance and repose. With two ramp openings flanking the major entrance and a relatively flat site, the formal symmetry of this façade is uncompromised by either imbalances in the programming of bays or a sloping grade.

The main elements identifying this as a Gothic billboard are the crenellated parapet and second-floor windows. Tripartite windows are subdivided by piers and topped with depressed Tudor arches. The architect cleverly exploits the multi-pane industrial sash windows, incorporating them as leaded glass analogues into the double-height Tudor bays. There are additional ornaments of a more generic nature, including the cornice, medallions

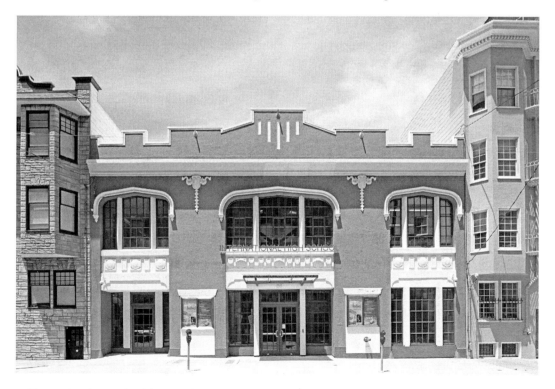

Figure 62. Garage building at 66 Page Street. O'Brien Bros., Architects, 1924. Adaptive reuse to Dennis Gallagher Arts Pavilion of the International High School by C+A Architects, 2009 (Sharon Risedorph).

(centered at the top of the B bays), and applied circles and rectangles (within the spandrels).

The Gothic parapet is especially engaged in interpreting the bay structure below: in the center of the parapet, three wide merlons (and connective inclined segments) form a crown uniting the middle three bays (BCB) into a single Tudor portal. In order to appreciate the parapet's regrouping of the bays, one must disregard the cornice, which encompasses all events beneath its broad sweep. Parapet and cornice function as gatekeepers to contrasting interpretations of the five-bay composition.

The major and minor portals of this façade vary in width, but are identical in the use and disposition of a small number of elements. In some cases, the difference in width is expressed in plastic terms, as a stretching (or compressing) of a given motif. This treatment applies to window drip moldings, shouldered arches above ground floor openings, and parapet merlons. In other manipulations, the difference is expressed in small-scale modular terms, as a number of units required to fill a particular length. This treatment applies to the number of panes of glass comprising the windows and the subdivision of the spandrel panels into circles and rectangles.

Pasqualetti employed similar devices to express these differences in width, although his manipulations generally involved larger-scale geometric subdivisions. For example, at 1550 Union, the increased width of the center bay (relative to the end bays) is expressed as the stretching of a blank spandrel panel and an increase in the number of large windows from two to three. The effect is mathematical and abstract, and relies minimally upon historical reference.

While the façades are fundamentally the same, Page alone manipulates its historically derived elements to elaborate upon the ABCBA template. Given the compositional similarity, the Page façade looks like Union with a stylistic facelift.

550–560 O'Farrell

This garage was designed by William H. Crim, whose firm — Crim & Scott — designed two early garages at 64 Golden Gate (1910) and 624 Stanyan (1911). Built as the Abbey Garage for the Mt. Olivet Cemetery Associates in Colma, the garage is reminiscent of a two-story medieval cloister, without the fine detail (Fig. 63).[9]

The composition is a variation of the wide ABCBA façade, with the center bay compressed to the width of a doorway (the door accessed a small office). This narrow bay centers on a line of structure that extends back from the façade — a line marked by the single griffon placed over the crown of the arch. Programmatically, the ground floor resembles 650 Divisadero.

As at Page, shallow Tudor arches preside over double-height bays. Additional Gothic elements include applied buttress supports, a parapet of blind quatrefoil panels, a preacher's pulpit and a row of attached griffons. Despite this overlay, the façade is bare. Casting the piers as buttresses completes a stylized Gothic representation of frame and infill, suggesting that the architect's intention was to evoke structural rationalism rather than Victorian embellishment.

Once again, the architect manipulates the Gothic motifs to articulate a central compositional theme — a symmetrical variation in bay width. Here, the arches are stretched over three different-sized openings — from the vertically oriented preacher's entrance to the

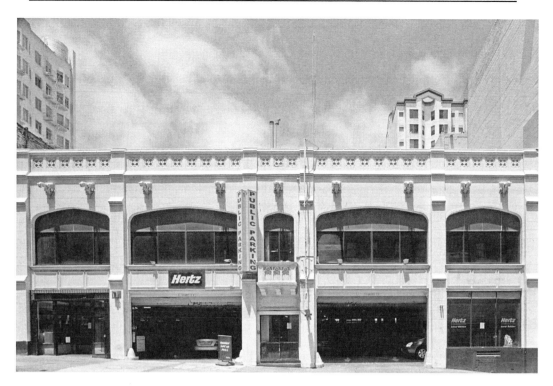

Figure 63. Garage at 550–560 O'Farrell Street. William H. Crim, Architect, 1924 (Sharon Rise-dorph).

squat, horizontal B bays. O'Farrell also rationalizes bay width as the multiple of a small-scale module. The entire composition is organized on the basis of one basic unit — the square quatrefoil panel that runs across the parapet.

Thus, the ABCBA composition breaks down into a ratio of 6:8:3:8:6, where each term represents the number of quatrefoil panels in a given bay. Spandrel panels equal the width of two parapet units. While the preacher's pulpit interrupts the band of spandrel panels, the pulpit elevation presents a triplet of small trefoil bays and supporting brackets corresponding to the three modular quatrefoils above.

Conspicuously poised between the elastic arches and the modular parapet are the griffons, which double-function symbolically as gargoyles and hood ornaments. They also double-function formally: on the one hand, the placement of the ornaments appears to be governed by the elasticity of the arches — pairs of griffons maintain a symmetrical relationship with respect to every arch (except the special case in the center). On the other hand, griffons are situated with modular consistency, always centered below the second panel inset from a pier. In other words, griffons are symmetrically disposed about inside piers.

The elastic interpretation of griffon placement supports the perception that the infill bays are dominant; that is, we first inspect the width of the arches to make sense of the irregular spacing of the griffons (Fig. 64, analysis above left side of elevation). By contrast, the modular interpretation emphasizes the buttress piers as primary (Fig. 64, analysis on right). Only the single griffon positioned along the centerline of the building and above the pulpit supports both readings simultaneously. Thus, the ambiguity in the placement of the griffons resolves in the center.

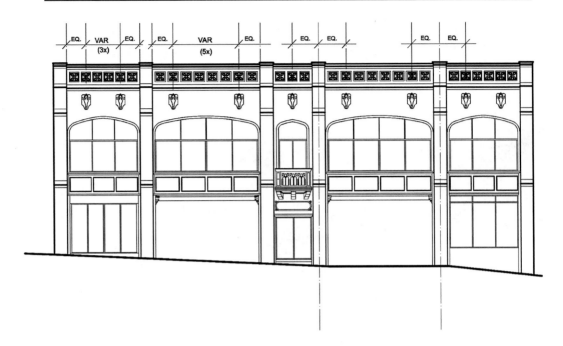

Figure 64. Elevation with analysis, 550–560 O'Farrell Street (drawing by Esther Kim).

As discussed in chapter 2, the reference of the griffons to both gargoyles and hood ornaments exemplifies the wry sense of humor employed by architects when adapting historical precedent to the garage. At the same time, the application of fairly sophisticated design strategies — as exemplified by the modular underpinning of the composition — is surprising, given the utilitarian nature of the building. The integration of hood ornaments into a modular system suggests the marriage of the sublime and the ridiculous. However, the centering of the composition on a preacher's pulpit — under the watchful eye of a single griffon — can be interpreted as an ironic comment on garage design, in particular the use of symmetry to frame the comings and goings of automobiles instead of people.

240 Pacific (demolished) and 111 Stevenson

The link between 240 Pacific (Figs. 65–66) and 111 Stevenson (Fig. 67) is analogous to that between 550 Turk and 265 Eddy. In both cases, a small-scale garage is deployed as a base for a skyscraper garage. In addition, the smaller garage's stylistic details and composition inform the design of the taller building above its base. Both Gothic garages were designed by the O'Brien Bros. and completed in 1921.

The Sacramento garage is like a prototype for the more sophisticated Stevenson garage. The façades employ the same Gothic details, although the vocabulary is significantly expanded to accommodate the greater scope of design conditions encountered at Stevenson. The most conspicuous element common to both garages is the depressed three-centered arch, with heavy drip moldings supported on foliated corbels. Another shared motif is the faceted window pier, although its application is far more consequential at Stevenson, where it divides window bays across the three-story shaft of the building.

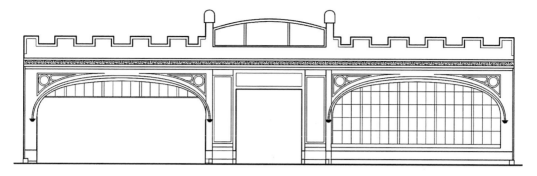

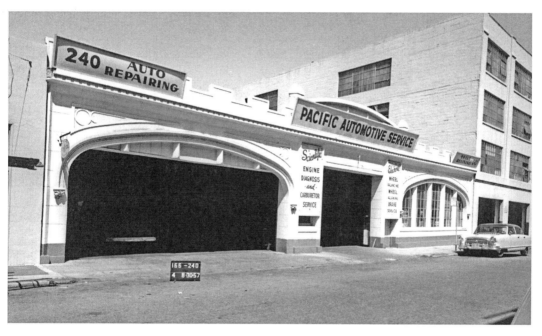

Top: Figure 65. Elevation, 240 Pacific Street (drawing by Patrick Caughey and Esther Kim). *Bottom:* Figure 66. Garage at 240 Pacific Street (demolished). O'Brien Bros., Architects, 1921 (San Francisco Assessor's Office Negative Collection, San Francisco History Center, San Francisco Public Library).

At Pacific, the simple ABA composition is not supported by a corresponding symmetry in the programming of the bays or a patterning of solid and void. The major openings overwhelm the façade, and the adjacency of arched and squared voids is a source of imbalance. (One successful detail — obscured in the photograph — is the crest of the parapet above the middle bay, which presents a miniaturized and opaque representation of the arched openings.

Stevenson, a much larger building, is taut and efficient by comparison. It mines Sacramento for motifs, and uses them as building blocks in a finer-grained and more balanced whole. The weight of the Stevenson façade creates a context and purpose for the arches, which function visually as part of a pedestal base that transfers the load to the ground. Dispensing with Pacific's square middle bay (along with the static symmetry it engenders), the architect moves the arches together and creates a twin-arch façade.

Figure 67. Garage at 111 Stevenson. O'Brien Bros., Architects, 1921 (Sharon Risedorph).

At Stevenson and Eddy, both skyscrapers, the twin arches are the centerpieces of a four-bay, ground-floor composition that centers on a structural pier. The arches are buttressed by flanking end bays that are narrow but solid at the base. At Eddy, the BAAB composition is abandoned above the base in favor of a regularized grid of six bays (Fig. 33 earlier in this chapter). The center pier is absorbed into the rhythm of undifferentiated uprights. However, at Stevenson, the four-bay composition projects upward, organizing the balance of the façade.

One major pier separates the twin arches and boldly asserts itself as the centerpiece of the extended skyscraper composition. Each arch supports one identical section of the shaft — a rugged grid of industrial windows bordered by piers, articulated sills and decorative panelized spandrels. Expressed as infill, the gridded sections span between major piers. The center pier is accentuated by a number of mutually reinforcing factors, including the overall symmetry of the façade, the convergent drip moldings at the base, and the strong distinction between structure and infill (Fig. 67). The building presents mirror images about a spine upon which both sides are visually (and structurally) dependent.

Stevenson exemplifies the popular approach to the vertical organization of tall buildings, with a tripartite stacking of base, midsection and top. (Pacific only has a base and a top, as if poised to accommodate Stevenson's midsection through the lifting up of its parapet.) While the composition is classic in its vertical organization, it is willfully peculiar horizontally: the lot is divided into an even number of bays, with redundant large-scale entrances centered on a structural pier.

Around the entrance there is signage — both old and new — indicating that one arch is for entry, the other for egress. In the relationship between a static façade and dynamic circulation, the designation of one-way traffic in opposite directions creates rotation about the central pier. While vertical circulation is not implicated, the rotation described here represents a variation of the chapter 2 discussion regarding the path of cars circulating from the basement to the second floor of a garage with a symmetrical façade (Fig. 19). In both instances, the car circles around the center of the composition.

Many garage architects see a potential for architectural expression in this rotation. Adapting the design to accommodate and highlight this rotation is one effective strategy for communicating that the building serves automobiles. Still, the integration of this idea into a compositional system that is traditionally anthropocentric creates tension and distortion about the center. At Stevenson, the impression is one of an abnormal condition — the horizontal organization — that is deeply embedded in a normal condition — the vertical organization and historicist detail of the Gothic skyscraper.

Normal and abnormal conditions also coexist at O'Farrell. In this instance, however, a statement of human defiance accompanies the tension that builds at the center. As discussed, the modular and plastic expressions on this façade resolve their conflict in the narrow bay — similarly the focus of an elaborate symmetry. This narrow bay centers upon a free-standing column behind, but unlike Stevenson, this line of structure is denied expression on the façade. Instead, the bay is conspicuously detailed at a human scale, with a conventionally sized doorway and a preacher's pulpit cantilevered over the street. What prelate, mechanic or aspiring Juliet can be expected to address the citizenry of the Tenderloin from this perch? Regardless of the stature or identity of the orator however, he or she fulfills an enormous symbolic role as one who restores human centrality to the garage façade. In this regard, Stevenson and O'Farrell approach dialectical opposition in how they adapt a traditional architectural vocabulary to accommodate the automobile. Unfortunately, and due

to the passage of time, we are desensitized to the design challenges implicit in this opposition.

— ·· — · — ·· — ·· — ·· — ·· — ·· — ·· — ·· — ·· — ·· — ·· — ·· — ·· —

6. MISSION FAÇADES

— 721 Filbert — 415 Taylor
— 541 Ellis — 1419 Pacific

While Mission Revival architecture was popular in the 1910s, the selection of this style for the garage was not only a matter of contemporary taste and regional pride. The California missions were promoted as tourist destinations, first by the railroads, and then by the local automobile industry. Transportation buildings designed in the Mission style advertised the notion of traveling to see these landmarks.

The Southern Pacific railroad built a series of Mission train stations along its lines, and did so with self-conscious reference to the "Old Missions."[10] On the automotive side, photographs of cars positioned in front of Mission churches appeared frequently in the automobile sections of local newspapers and in *California Motorist* (the magazine of the California State Automobile Association). Indeed, the cover of the premier issue of the magazine featured a car driving away from a romanticized image of a Mission church.[11]

The Mission-style garage draws upon the special link between transportation and Mission architecture, accessing the California missions by way of the train station. As always, the representation is reductive, as references to three-dimensional forms, including towers, waiting rooms and arcades, appear as flattened profiles on the façade (Fig. 61). The portaled façade is a common feature of both Mission churches and train stations, and it adapts well to the context, use and symbolism of the garage.

The examples in this category also break down into pairs: Filbert and Taylor, Ellis and Pacific. While the first two examples don't look anything alike, the compositional strategies are the same: stable end bays frame an ambiguous tripartite middle section. The parapets are a major source of character, while they also provide a conclusive interpretation of the composition below.

Ellis and Pacific present architecture stripped down to the fundamentals of entry and enclosure. The architectural mandate is to accommodate the entry sequence while investing these urban buildings with a dignity appropriate to the neighborhood and the growing stature of the automobile. As a result, the façades assume the singularity of purpose and

design characteristic of the triumphal arch or decorated tunnel entrance. The Mission overlay reinforces the association with western train stations and the transportation use.

721 Filbert

This brick structure was built as a stable in 1906 and converted to a garage in 1924 (Fig. 68).[12] A two-story head building just one bay deep fronts a tall and spacious shed. The second floor was originally a hayloft, and has since been converted to a commercial office space.

The Mission-style elements include an active, inflecting parapet that centers on an elliptical arched crest, attached clay tile roof overhangs, elliptical arched openings faced in gauged brick, and stout piers with pedestal bases and corbelled capitals. Brick detailing is a source of character, as exemplified by the window surround that forms a stepped band across the façade.

The garage is Mission-style, too, in its massiveness and expression of wall. Clinker brick is employed to expressionistic effect — its irregular facets add texture and glisten in the afternoon sun. While constructed out of a different masonry material, the façade exhibits some of the battered nobility of the Alamo. The exposed brick also evokes the California missions as they appeared in a romantically ruinous state, prior to renovations that covered exposed adobe brick in bright new stucco.

In a subsequent renovation, the second floor windows were enlarged by dropping the sill height from the elevation of the sill molding (still visible) to the stringcourse. Despite

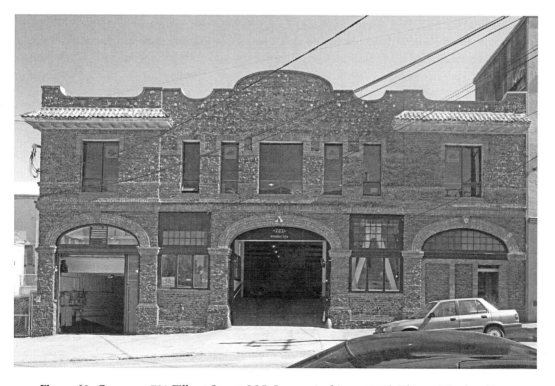

Figure 68. Garage at 721 Filbert Street. M.J. Lyons, Architect, 1906 (Sharon Risedorph).

the obvious benefits, the modification distorts the proportion of the windows and interrupts the continuity of wall surface.

The composition is organized around three arched openings, each with a large rectangular window above. Volumetrically, the composition is a simple ABA — slightly projecting end bays frame a wide middle frontispiece. However, the central portal is subsumed within this frontispiece — it does not occupy the entire width of the bay, as happens on either side. Instead, the central portal is the focus of a local tripartite division that occurs within the frontispiece. If the portal motif is assigned the status of a compositional bay, the composition expands to ABABA. Across the ground floor, the rhythm of open and glazed openings is similar to that found in narrow five-bay compositions, like 2340 Lombard (Fig. 38 earlier in this chapter).

Within the frontispiece, first- and second-floor windows are not in alignment. Instead, the windows form a semicircular surround about the entrance. That surround — visually dependent on the center arch — supports the perception of the frontispiece as a singular event and reinforces the three-bay interpretation.

This early brick façade is not informed by the rationality of the concrete frame. While similar in composition to ABCBA concrete garages of the 1920s, Filbert lacks the precise articulation of bays (66 Page) or alignment of openings (530–544 Taylor), characteristics of these later structures. The appearance of imprecision within an overall balanced façade contributes to the building's integrity and charm.

415 Taylor

Built in 1912, this is an early example of a two-story concrete garage (Figs. 69–70). Unique to this study, the second-floor slab and the ramps are supported by wood-frame construction, creating a fire hazard. This practice was subsequently abandoned. The Jerome Garage, built just two years later, is all concrete construction.

Taylor's façade composition is a wide ABCBA (75 feet), with twin ground-floor entrances framing a central storefront. The façade anticipates the wide ABCBA garages by Pasqualetti and displays the same imbalance in the programming of the end bays (Fig. 44 earlier in this chapter).

Remarkably, the parapet is the sole repository of Taylor's Mission-style identity (Fig. 70). Prominently featured are three flattened bell towers or frontispieces crowned with graceful handlebar profiles. The middle frontispiece is taller and wider, concealing the peak of the roof behind. A circular medal (that identifies the proprietor) is installed just under the apex, and a "GARAGE" sign of raised letters and frame underlines the arched flourish. These architectural graphics add a touch of western Main Street style.

The cresting parapet forms mimic the active silhouettes of Mission train stations and the churches that inspired those stations. Built a few years later, the San Francisco station illustrates the connection (Fig. 3 in the Introduction). The architect of Taylor puts little effort into perpetuating the falsehood that the references to three-dimensional Mission forms are anything but flat. For example, the possibility that the minor frontispieces are dormers is quickly dispelled by the verticality and thinness of the flanking simulated tile roof. The stylistic overlay is revealed to be a self-conscious exercise in caricature.

The compositions of Taylor and Filbert employ similar means to integrate a five-bay ground floor into a three-bay reading of the overall façade. In both cases, the compression

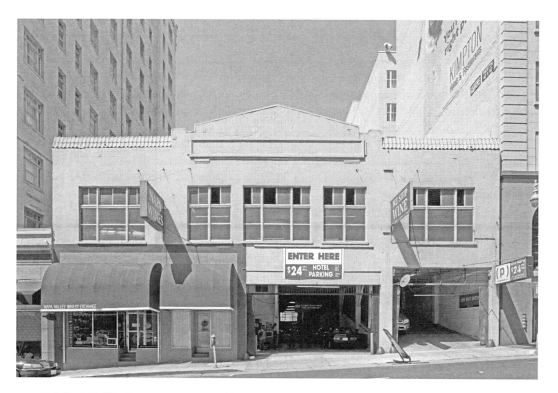

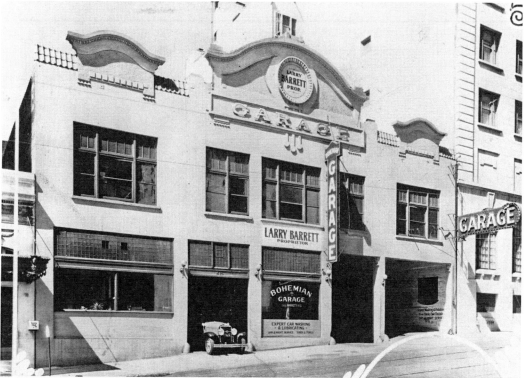

Top: Figure 69. Garage at 415 Taylor Street. William Helbing, Builder, 1912 (Sharon Risedorph).
Bottom: Figure 70. 415 Taylor Street in 1929 (San Francisco History Center, San Francisco Public Library).

occurs not in the end bays, but in an ambiguous middle section (BCB) that only resolves formally as a single entity symmetrically disposed about the center.

The wall beneath the flashy parapet is plain and unadorned. As at 2535 Clement (Fig. 25 in chapter 2), a virtual line extending across the base of the parapet divides the façade into utilitarian and ornamental realms. At Clement, clean lines and crisp geometries unite events on either side of the divide. At Taylor, the utilitarian base is oddly dependent on the parapet: the windows gather about the frontispieces like metal filings to a magnet. The effect is unsatisfactory, as the most tectonic aspect of the building front appears to be responsive not to its own internal logic but to the frivolous Mission cutouts above.

Today, the Mission parapet and ground-floor bay structure have been significantly altered. A comparison of the building as originally built and as it stands today reveals the extraordinary power of the parapet to impart character despite its lack of substance.

541 Ellis

An early concrete structure, Ellis maintains the basic parameters of the brick box garage: a single-story structure (plus basement), with a wooden shed roof supported by light metal trusses (Fig. 71). Thus far, Ellis is the first garage that brings together a grand entry portal and tall shed, symmetrically disposed about an axis of circulation. These garages are similar to single-room churches in the close correspondence of façade to interior, simple axial circulation, and quick revelation of the entire interior. The dignified Mission façade recalls the cemetery gateway at the Mission San Luis Rey, borrowing the motif of the round arched opening centered beneath the shallow arched crest of a curvilinear gable.

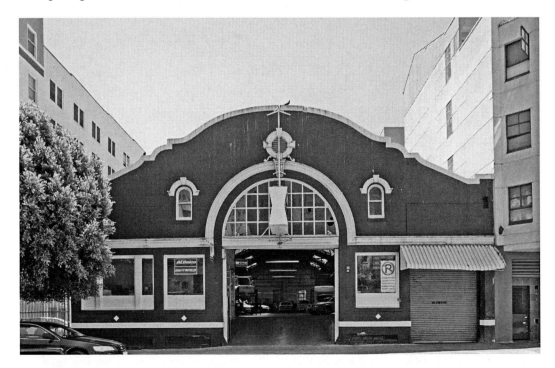

Figure 71. Garage at 541 Ellis Street. T. Paterson Ross, Architect, 1915 (Sharon Risedorph).

The designer makes efficient use of just a few elements and ornaments to reinforce the central portal while softening its blunt invitation and profile. A lower band course and upper stringcourse divide the façade into base, midsection with windows, and top section with cresting parapet. Fittingly, the entry portal interrupts the flow of these sections. The stringcourse reinvents itself, however, as a semicircular molding that surrounds the arch, amplifying the portal's scale and priority.

Three small Mission-style openings surround the arched transom: a vent, detailed as a stylized star window, and two flanking arched windows, detailed as miniaturized versions of the portal. Completing the halo surrounding the portal are two midsection windows, each one centered beneath the diminutive arched windows.

At the periphery, the taut composition collapses — an office window at one end is balanced by a basement ramp at the other. The disparate elements share a common width, but only the ramp opening extends down to grade and interrupts the band course at the base. Ideally, only the central portal would interrupt the horizontal banding of the façade, and avoid competition from its right flank.

While the façade strives to maintain fealty with its stylistic roots by emphasizing the wall, it must also open up to admit vehicles and light. As at 415 Taylor, conflicting demands are accommodated through the division of the façade into separate spheres: an upper area devoted to style and a lower area devoted to utility and function. Here, the stringcourse is the dividing line. Only the ramp opening — a functional necessity — derails the successful integration of the two areas into a unified whole.

This façade achieves its goals — the celebration of passage — through the establishment of hierarchy. The portal is prioritized by scale, position, frame and motif. As the silhouette of the façade closely follows the outline of the interior cross section, façade and interior are linked as positive and negative approximations of one another. Passage through the portal reveals that the interior is the dark spatial analog of the façade. This architectural sequence exists independently of style, and so Ellis — although categorized here as a Mission garage — is closely related to all those garages that employ the portal in this manner.

1419 Pacific

Like the previous example, this garage is a single-story brick box with a shed roof (Fig. 72). Here, too, an axis of circulation along the building centerline results in balanced processional movement through the entrance and into the interior.

There is, however, a mezzanine, which appears to have precluded the entry from taking the form of a grand glazed portal. Here, the entrance is just a shallow rectangular void beneath the mezzanine floor. In an effort to overcome this limitation and boost the scale and stature of the entrance, the designer incorporates the balance of the façade as a large concentric surround. Fortunately — from a formal standpoint — there is no basement and therefore no ramp opening to detract from unilateral focus on the middle.

Roughly following the sloping sides of the roof, the parapet steps up towards a grand segmental arched gable over the center. The entrance opening is integrated into a larger event that includes a triplet of mezzanine windows framed by a Spanish Colonial hood. Hood and gable work together as concentric frames to signal the importance of the entry. A volute and vent are strung along the centerline between the gable and hood, articulating

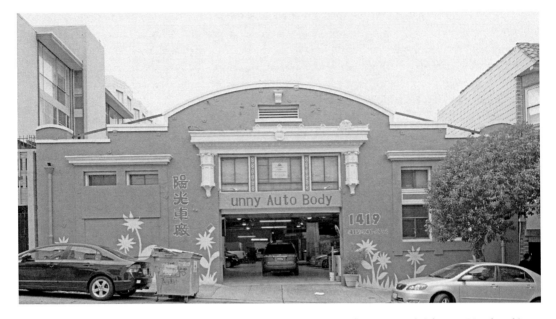

Figure 72. Garage at 1419 Pacific Street. O'Brien Bros., Architects, 1914 (Sharon Risedorph).

the alignment of the major framing elements. Flanking bay windows, smaller in scale and topped with modest cornices, help to establish the relative priority of the center.

At both Ellis and Pacific, the integration of the vehicular opening into a taller, vertically oriented event constitutes a strategy to enhance entry. While we have encountered this approach in two-story buildings (66 Page, for example), the effect is more dramatic in the context of a single-story façade that is horizontally attenuated. Here, the suggestion is that the entry bay pushes up against the rising parapet in order to accommodate passage.

— · — · — · — · — · — · — · — · — · — · — · — · — · — · — · — · — · —

7. Station Façades

— 1641 Jackson 2405 Bush
— 1355 Fulton — 1661 Market

The examples in this category are adaptations of the great urban train station. While all the lowbrow historicist garages maintain significant ties to the train station, these buildings

are set apart due to the overt nature of the representation. The façades epitomize the concept of the garage as a miniaturized train station, a depot for cars. Borrowing specific train station motifs and compositional strategies, the designers seek to appropriate for the garage the monumentality and civic grandeur of the precedents. A powerful metaphor, the garage-as-station offers a platform to express the significance of the automobile in relative terms, as an advance over the train. Decentralized and local (as opposed to the station), the garage represents the convenience, autonomy and mobility promised by the automobile. This theme is discussed in the chapter 5 section, "The Garage as Miniaturized Train Station."

The most common motif is a single grand arch — positioned at the center of the composition — or a triple portal that occupies the majority of the garage front. In the translation from train station to garage, these elements are reduced in scale, lifted out of context and executed inexpensively. The appropriation renders these monumental elements flat and shrill — one of the hallmarks of the lowbrow façade. There is the attendant possibility that the portals overwhelm their façades. The architects address this potential by creating a context for the grand gestures, framing them with well-defined subsidiary elements. One exception — a garage designed by Joseph L. Stewart — is unusual in that it impresses through sheer scale and not through the establishment of hierarchy.

1641 Jackson

This monumental garage is an eclectic mix of Art Nouveau, Richardsonian Romanesque, and Beaux-Arts inspired classicism (Fig. 73). The façade is based on Otto Wagner's Karlsplatz Stadtbahn station, a landmark of Jugenstil architecture built in 1899 (Fig. 74).

Like all of the garage façades, Jackson represents its historical references as a two-dimensional reduction of a three-dimensional architectural system. At Karlsplatz, Wagner's graceful arch fronts a barrel-vaulted central bay. At Jackson Street, the arch is a window and an architectural sign, but it is not a form-fitting cap over a barrel vault. Rather, the

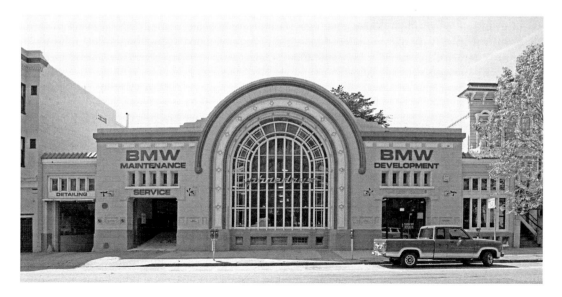

Figure 73. Garage at 1641 Jackson Street. O'Brien Bros., Architects, 1914 (Sharon Risedorph).

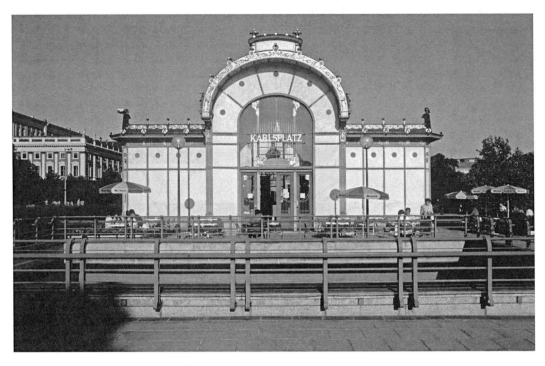

Figure 74. Stadtbahn station, Karlsplatz. Otto Wagner, Architect, 1899 (photograph by Andrew Anker).

arch masks a shed roof, the sides of which slope downward behind the entire façade. Where Wagner's arch springs lithely from an elevation established by the top of its flanking wings, Jackson's spring line is submerged several feet from the top of its square subsidiary bays, deeply embedding the arch into its host setting.

The central arch is not for entry but for display, yet it is detailed like a grand celebration of passage. Flanking bays suggest attached pavilions with autonomous compositions centered upon local entry openings. The central block is itself bookended by smaller implied volumes, slightly recessed from the front plane. One of these volumes accommodates the basement ramp, the other houses an office.

A brilliant device, the recessed volumes absorb programmatic asymmetries while framing an idealized tripartite center. This is a five-bay garage masquerading as a three-bay building with minor appendages on either side. The central block is sufficiently prominent as to divert attention away from the imbalance between ramp and office and the awkward adjacency of ramp and ground-floor openings.

Prior to a recent renovation that recast one of the ground-floor openings as a modern pedestrian entrance, the center block exhibited a remarkable correspondence of formal and functional symmetry. Effortlessly, the composition accommodates and coordinates two contrasting interpretations of the path of movement in and out of the garage: (1) automobiles approach perpendicularly to the façade, on axis with either one of the entrances; and (2), automobiles rotate about the middle, such that one opening is designated for entrance, the other for exit.

At 650 Divisadero and 1745 Divisadero, we have seen other formal strategies deployed to mediate between rotation and axial approach (Figs. 42, 44 earlier in this chapter). Here,

the clarity of the relationship between the arch and the flanking bays is key to a successful balance. The arch is central, but denies passage. The flanking bays are at once contingent — they are mutually dependent to complete the overall symmetry — and they are autonomous as individual pavilions. Their contingent status supports the notion of rotation, while their autonomy supports axial approach. Rotation is also suggested by the outermost arched molding; it gesticulates like the outstretched arms of a person who says, "You can go to my right or my left, but not down the middle."

Jackson presents center and side bays in a state of extreme contrast. While the arch is detailed as a portal worthy of a great city station, the flanking blocks simulate the solidity and mass of a Richardsonian Romanesque pile. The overall effect is monumental yet accessible. While the garage is crude when compared to Wagner's station, the Jackson Street garage shares with its prototype a presence that belies its small size. In part, this results from the incremental increase in scale that builds from the periphery towards the center, reaching its climax in the explosive arch.

This garage was built in 1914, when the Panama-Pacific International Exposition was taking shape just a few blocks away. The Exposition would present an exterior architecture of imperial grandeur that stood in opposition to its unfinished interior scaffolding (see chapter 6). Jackson exhibits a similarly extreme dislocation between exterior and interior. While many garage architects used composition and historical overlay to express the civic and commercial pride of the emergent automobile industry, the O'Brien Bros. injected extraordinary vitality into this representation. At the heart of this vitality is a willingness to fully embrace the dichotomous equation that underlies the garage, reinterpreting the brick box with shed roof as a monumental sequence of stepped volumes.

2405 Bush

This façade recalls the middle section of the Gare du Nord in Paris, Jacques-Ignace Hittorf's masterpiece of 1857–66. As at Paris, three majestic portals are subsumed within a colossal gable (Figs. 75–76). By necessity, the reference to Paris is schematic, and beyond the basic organization of elements, the building front is developed in a manner appropriate to its vastly reduced size and its use.

As at Jackson, the attainment of a convincing monumentality in the context of a small infill building relies upon the establishment of hierarchy, with minor elements serving as backdrops to the major event. Here, smaller arches that provide access flank a central monumental arch. While the basic composition — the centering of the big portal under the apex of the gable — does much of the work, the design employs subtle means of reinforcing the center.

The composition presents three overlapping Palladian motifs, each one composed of one arch and two flanking brick panels (Fig. 77a). The brick panels on either side of the central arch double-function in two Palladian motifs. While the Palladian motifs formed about the side arches are balanced and well proportioned, the motif about the center is distorted, as the arch is too tall and wide for its flanking panels. Thus, the composition establishes a normal condition that sets the stage for the abnormal, encouraging us to conclude that the center arch is not only bigger than its siblings, it is *exaggerated*.

We can rationalize the abnormal condition by recognizing that the center arch concentrically frames a smaller arch, the radius of which matches that of the side arches. This

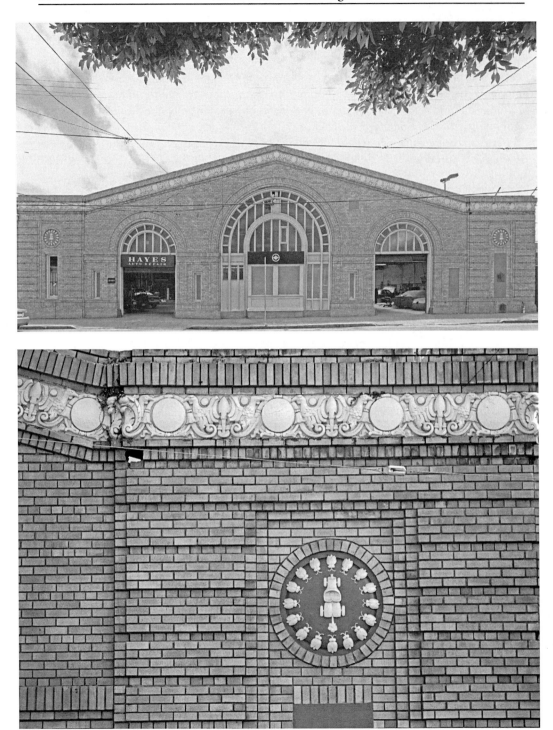

Figure 75. 2405 Bush Street. J.R. Miller, Architect, 1916. *Bottom:* Figure 76. Detail, 2405 Bush Street (both photographs, Sharon Risedorph).

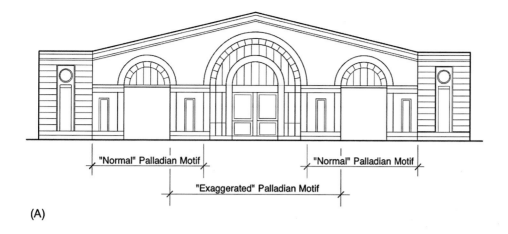

(A)

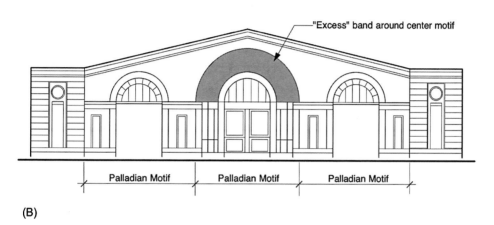

(B)

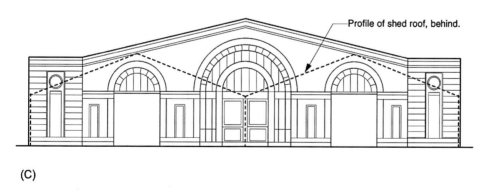

(C)

Figure 77. Elevation with analysis, 2405 Bush Street (drawing by Esther Kim, Haley Hubbard and Nancy Mei).

smaller arch combines with the glazed area beneath the wide transom bar to define a Palladian motif that is completely circumscribed within the larger arch (Fig. 77b).

New interpretations emerge: the façade presents, side by side, three equally sized Palladian motifs; however, the motif in the center is supplemented with a concentric band of glazing surrounding the motif's arch. This band can be interpreted as a benign halo that

successfully transforms a distorted Palladian motif into a larger version of the side arches. Alternatively, the band can be isolated as an excessive element that forces the larger arch into an awkward Palladian relationship with the adjacent brick panels. Either way, the design engages the observer in a consideration of a generative process — a means by which the center arch *evolves* from the side arch. The hierarchy is not one of blunt facts — big things and little things. It results from the development of stated themes.

The façade is deceptive in that it fronts two adjacent sheds, each served by a side portal (Fig. 77c). The gabled parapet unifies the composition and suggests a single shed behind. (Originally, structure along the centerline was held back from the façade in order to accommodate a central display.) As at Jackson Street, the composition emphasizes an element associated with passage, but denies entry. At Jackson, however, the contrast between the arch and the entry wings is so strong that it telegraphs the difference in function.

The cues given by Bush are more ambiguous because the similarity in the portals suggests a common use. If anything, the overall hierarchy implies entry in the center. An experiential sequence unfolds wherein the visitor first approaches the center portal (and appreciates the goods on display), and secondarily realizes that only the flanking arches give access. The interpretation of the center bay as excessive carries with it the connotation of something enlarged beyond its own usefulness, which is arguably the case here. Prioritizing promotional considerations over basic access, the composition may well reflect the owner's commercial aspirations. However, the architect also provides us with the means to deconstruct this priority and interpret the center arch as an exaggeration.

The garage at 2405 Bush adapts the imagery of the urban train station to the automotive garage, and appropriates the station's significance as a public building and civic landmark. The point is not to suggest that the garage really is a train station, but to leverage the meaning of the station to announce that the automobile is a transformative new technology that will overtake the train. Now, the building is a stunning example of the lowbrow garage as a flattened, miniaturized metaphor that maintains some of the monumentality of the precedent.

1355 Fulton

This garage is a billboard that refers to a classic Beaux-Arts motif found in train stations and exposition buildings: the triple portal with open gables above each arch (Fig. 78). Noteworthy precedents include Atwood's train station at the Chicago World's Fair, and the waiting room of Penn Station by McKim Meade & White.

The façade has a rich local history as well. At the 1915 Exposition, Ward & Blome employed the triple portal with gables for the façade of the Palace of Machines. A year later, Sylvain Schnaittacher adapted the motif to the San Francisco garage (Fig. 79). That garage, at 1240 Post, was demolished in 1983.[13] Fulton, built in 1922, is closely related to the Post St. garage.

The center pier on the ground floor was added when the peripheral arched bays were widened towards the center. (1745 Divisadero and many other five-bay garages were modified

Opposite, top: **Figure 78. Garage at 1355 Fulton Street. Mel I. Schwartz, Architect, 1923 (Sharon Risedorph).** *Bottom:* **Figure 79. Garage at 1240 Post Street (demolished). Sylvain Schnaittacher, Architect, 1916, from** *American Architect and Architectural Review,* **1921 (courtesy Holland and Terrell Libraries, Washington State University).**

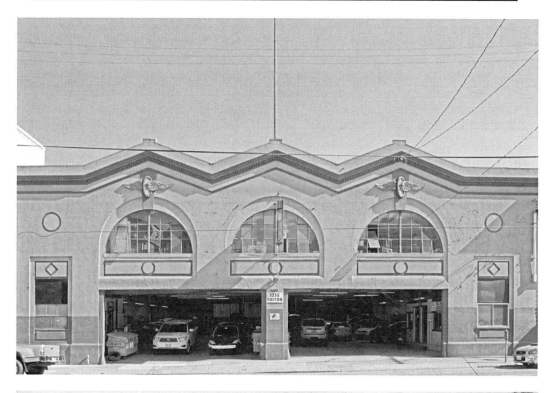

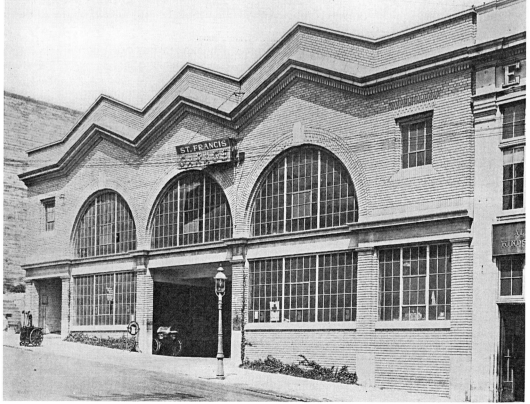

in this way.) The composition is ABBBA, although it is likely that an office window or storefront uniquely occupied the center bay, with vehicular openings on either side. If so, the composition approaches the ABCBA façade at 650 Divisadero.

As at Jackson and Bush, the parapet profile is determined by allusion to architectural precedent and not by fealty to the shed behind (Fig. 13 in chapter 1). At the same time, the architect has no intention of persuading us that the parapet is in fact the gabled fronts of three architectural vaults. The parapet has no relationship to events behind, whether real or implied, as the intention in quoting this imagery is semiotic — to appropriate for the garage the significance of the buildings that typically exhibit these motifs.

The architect employs caricature to disclose the fact that the appropriated motifs are signs, not to be mistaken for tectonic elements. For example, each arch presents two arced profiles as the extrados and intrados of a cartoonish Florentine arch with no *voussoirs* and no structural valence. While potent as images and symbols, the arches are no more convincing than the parapet as structure.

At the two flanking arches, a winged wheel ornament is superimposed on the oversized keystone. This wonderful icon has a long history of its own, as the logo of the Indianapolis Speedway. Locally, the motif appeared in posters promoting the Exposition and on covers of *Motor Land* (Aug 1927) and *Pacific Golf and Motor* (May 1917), magazines of the California State Automobile Association. The ornament's appearance links the garage to the Exposition and one of the fair's underlying themes — the inevitable march of Western progress from a glorious classical past to an exciting future driven by technology.

Winged wheels in tow, the Fulton façade delivers a simple message: this is Penn Station adapted for cars. The power of that message is not compromised by the failure to reproduce Penn Station or even a diminutive Beaux-Arts analog. The flattened symbol winks to the public, who share in the knowledge that the automobile spares them the necessity of getting to the train station. On residential Fulton Street in the Western Addition, the train station comes to them, recast as a depot for their vehicles.

The metaphor highlights the autonomy and freedom of movement provided by the car relative to the train — a change that constitutes a form of progress. The garage — smaller, decentralized, local and convenient — is the architectural embodiment of that progress. This façade reduces the station to caricature, but not in the service of a tongue-in-cheek dismissal. Rather, it celebrates the fact that the new transportation hub — the garage — need not be a tectonic masterpiece, precisely because it is the decentralized complement of the technology that it serves. That circumstance is itself a source of pride worthy of architectural representation.

1661 Market

This monumental garage presents a Beaux-Arts–inspired triple portal to the major thoroughfare of San Francisco (Fig. 80). The façade, with overall dimensions of 84.5 feet wide and 42 feet tall (2:1), is unusually tall and imposing.

At the ground floor, applied Corinthian half-columns support an entablature masking the second floor. Three round arches spring from the second floor, their profiles outlined in a concentric molding scored to simulate *voussoirs*. Across the top portion of the façade, there is a second entablature with a strong projecting cornice supported by block modillions. A light attic completes the composition.

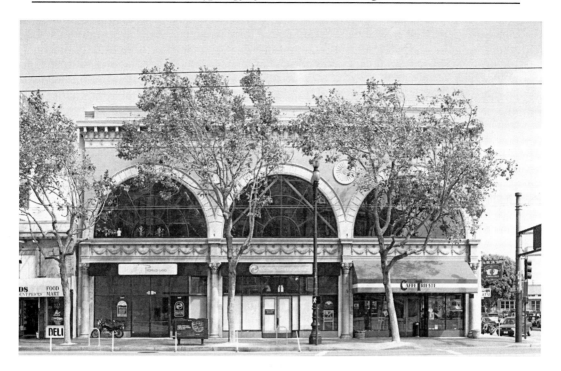

Figure 80. Garage at 1661 Market Street. Joseph L. Stewart, Architect, 1921 (Sharon Risedorph).

Stewart's façade balanced consolidated solids, glazed openings and voids (Fig. 81). As represented in the drawing, the arches were treated as fanlights with radiating metal sashes, while ground-floor bays presented a loggia to the street. The glazed arches contributed to the perception of the second floor as a substantial cubic mass supported by the four columns and lower entablature. This distinction between supported and supporting elements is fundamental to the design.

The Market Street façade is unique among the buildings in this category for the absence of compositional hierarchy. Specifically, Stewart does not introduce minor peripheral elements that frame and enhance a major central element. A comparison of the triple portal at Fulton and Market reveals the starkness that accompanies the lack of preparatory gestures. While the façade does not build to a crescendo, it impresses through sheer size and the boldness of its motifs.

The garage's appearance today compares unfavorably with the original conception. Most importantly, all openings are filled with tinted glass. The change creates a continuity of glossy darkness above and below the lower entablature. Visually, that continuity imparts to the entablature — and the implied structure behind it — a weightless, floating quality. The impact of the new glazing is exacerbated by the lack of compositional hierarchy because the scale of the tinted portals — no longer divided between glazed and unglazed areas — assumes gigantic proportions relative to the frame of the façade.

Stewart sought to catapult his garages into the sphere of public institutional buildings. While seductive, the drawing's depiction of open access and Beaux-Arts grandeur suggests a portico or an entry pavilion of a larger building (like the Ferry Building). Stewart's other extant garages, including 150 Turk (Fig. 15 in chapter 2) and 825 Sansome (Fig. 16 in chapter 2), display a similar tendency towards the monumental. While Turk is another Beaux-Arts–

Figure 81. Elevation, 1661 Market Street. James L. Stewart, Architect, 1921, from *Architect and Engineer*, 1920 (San Francisco History Center, San Francisco Public Library).

inspired garage and Sansome is Mission style, they both feature overscaled arched portals that push against the limits of the bounding envelope. The extreme contrast between the civic aspirations evident in Stewart's façades and the utilitarian use of the facilities reflects the excitement surrounding the ascendancy of the automobile — at least among those segments of society able to afford it or profit from it.

8. PALAZZO FAÇADES

— 855 Geary — 460 Eddy
— 675 Post — 410 Stockton

These garages present rectangular façades to the street, two stories in height, with an overlay of stylistic elements and ornamentation loosely based on Italian Renaissance or

Baroque precedent. Typically, the façades employ pilasters to articulate compositional bays, topped by ornate entablatures across the parapet. While these façades bear stylistic similarities to examples in the Station category, the compositions are developed with different goals in mind. The Palazzo façades strive for balance through the grouping of events into tripartite compositions, rather than through the creation of hierarchy about arched portals. Vehicular entrances are contained, single-height events conforming to the regulating lines of the grid. Entrance openings are not aggrandized through vertical extension into the higher reaches of the façade. In three of the four examples, the end bays are treated with special emphasis in order to frame a wider center area and achieve an overall tripartite division. In the fourth example, 675 Post, the priorities are reversed — a strong center loses focus towards the periphery.

855 Geary

Presently, this façade exhibits extreme disparity in the level of architectural development between the ground-floor and second-floor levels (Fig. 82). While the second floor is noteworthy for its Renaissance-inspired overlay of elements and ornament, the ground floor is conspicuous for dematerialization. The ground floor may have been modified to remove office or storefront bays and widen the vehicular entrances. With the ground floor reduced to five piers, the present façade looks like a single-story building lifted up on stilts, an effect reminiscent of the Jones façade.

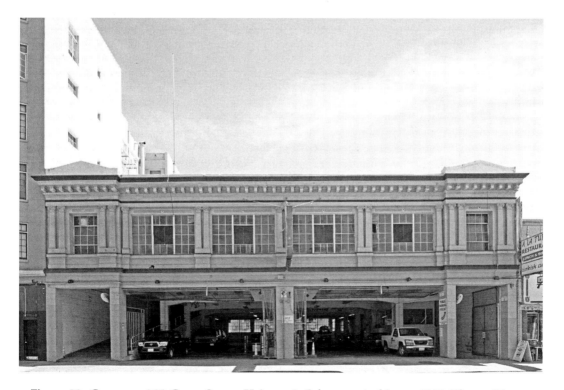

Figure 82. Garage at 855 Geary Street. Heiman & Schwartz, Architects, 1917 (Sharon Risedorph).

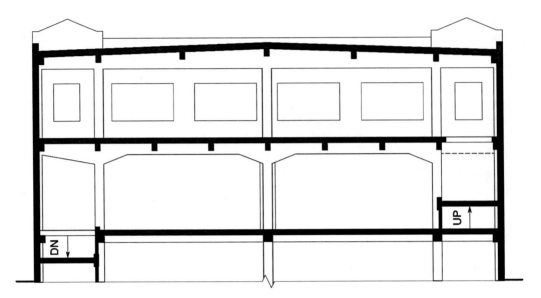

Figure 83. Schematic section, 855 Geary Street (drawing by Sarah McDaniel and Haley Hubbard).

The façade composition does, however, reflect the structural system (Fig. 83). A wide garage (82 feet), the distance between the ramps is too great to span in a single structural bay. With the addition of a centerline column, the frame assumes an *ABBA* configuration, as mirrored in the ground-floor elevation. The second-floor elevation shows windows alternating with paired pilasters, the latter appearing to receive the load of the secondary beams positioned up against the roof.

The upper half of the façade is quite embellished. In an involved stacking of support, the coupled pilasters sit on a shared pedestal resting on a podium supported by a lower cornice. Above, the pilasters carry a dignified entablature with block modillions holding up an overhanging cornice.

Narrow end bays frame the wide center section. Diminutive temple fronts, these end bays project forward, boast an autonomous classical order, and receive pedimented parapets. Vertically oriented, the end bays contrast with the horizontal orientation of the middle bays and the overall façade. These articulated bookends superimpose an ABA composition on the whole. The turning of the inside corner — where the wide middle section meets the projecting end bay — is one of the more elaborate ornamental events gracing any San Francisco garage.

Due to the extreme dematerialization of the ground floor, the façade appears in a state of irresolution similar to 1745 Divisadero and 1355 Fulton — garages that have been modified to widen the entry bays. Despite these issues, however, we can appreciate the upper half of the façade for its graceful detail, the integration of industrial sash windows into the Italianate vocabulary, and the use of temple-like end bays to frame a long, low composition.

460 Eddy

This garage employs a classic ABA façade composition, with two ramp openings framing a wide main entrance (Fig. 84). The major piers extend this composition up to the

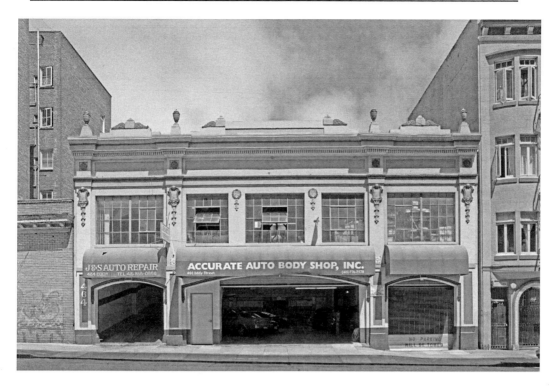

Figure 84. Garage at 460 Eddy Street. Norman Mohr, Architect, 1927 (Sharon Risedorph).

parapet, dividing second-floor windows into a center triplet flanked by single windows above the ramp openings.

In its cross section, this garage is similar to buildings in the Narrow ABCBA Façades category: a clear span truss supports the roof and an *aba* concrete frame carries the second floor (Fig. 11h). While ground floor openings express the frame, the top half of the façade conceals the slope of the shed and the trusses. The correspondence of ground floor openings to the structural frame is a remarkably straightforward solution, one that occurs with surprising infrequency. Its appearance here is facilitated by a modest programmatic load, specifically, the absence of an office or storefront. The primary benefit of this tradeoff is an adequate width for ground-floor access.

A comparison of Geary and Eddy illustrates the flexibility of the formula used to organize these two buildings and many other two-story garages with basements: by situating ramps in dedicated bays at either end of the façade, a center section of just about any width can be accommodated and framed. Eddy can be interpreted as a compressed, better-proportioned version of Geary.

Ornament is successfully deployed to highlight regulating lines and balance verticals and horizontals. Each major vertical is expressed as a decorated, articulated pilaster. The entablature and attic are among the most lively and allusive in the collection. A series of moldings — anthemion and lotus, bead and reel, dentil, leaf and dart — run in parallel across the façade and accentuate the entablature's projections around the pilasters. At the attic level, each of the three bays is crowned with a flourish of urns, pyramids, scrolls and stepped profiles (Fig. 85).

This façade is an excellent example of the elastic treatment of ornamental motifs to

Figure 85. Detail, 460 Eddy Street (Sharon Risedorph).

define bays of different widths. At the ground floor, the segmental arch of the narrow end bay is extensively stretched over the wide middle bay. Both end- and middle-bay arches present the same molding profile, corbel supports, and volute keystones. The appearance of these ornaments as constants in both narrow and wide versions of the arch supports the proposition that the arch is a pliable motif that expands or contracts to accommodate different conditions.

The expression of elasticity is repeated at the attic. Above the end bays, a pair of affronted scrolls converges on a pyramidal block, and the ensemble provides a localized crown to the composition. Above the wide center, the ensemble splits in two, with both halves displaced to opposite ends. In this expression of plasticity, motifs in the end bays appear well proportioned and normal; they attenuate to the point of extremity in order to accommodate the broad center.

The triplet of second-floor windows provides balance and stability to a middle bay that is otherwise stretched. Vertically oriented elements — the side windows and minor piers — counter the horizontal proportions. However, this triplet also constitutes a composition within a composition, a miniaturized ABA set within the larger façade. The window rhythm of narrow-wide-narrow mimics the rhythm and orientation of the bays. Similarly, the minor piers separating these windows mimic the major piers that articulate the bays. In this context, the center window of the triplet can likewise be characterized as stretched, relative to the "normal" windows on either side. If we mentally superimpose the interpretations of the overall façade and the window triplet as related ABA compositions in which the middle bays are stretched versions of end bays, the overall impression is one of dynamic movement away from the center.

While the garage is classified as Italianate, it is decidedly eclectic. The shallow basket handle arches above the ground-floor openings are Neo-Gothic, and could serve as the basis for reassignment to either the Twin Arch or Gothic category. The garage is assigned to this category due to the prominent Italianate entablature and the façade's affinity with other examples employing end bays to frame the center. While stylistically inconsistent, the ornamentation is successfully deployed to animate a simple and elegant composition reflecting both structure and use.

675 Post

This sprawling garage, located in the heart of the entertainment district, was marketed as a luxurious, state-of-the-art facility (Fig. 86). Well-appointed customer lounges and decorative interior details — a rarity — were offered as proof of the Century Garage's upscale qualifications. The car shed is particularly elegant, due to the tall ceilings, natural light, and undulating structural beams dipping down to meet the columns (Fig. 87).

This garage is among the widest in the study (124 feet). Located at one extreme end of the building is an administrative and customer service wing. Detailed like an attached storefront building, it reduces the apparent width of the garage.

Including the administrative wing, the composition subdivides into an ABCBA/D configuration. Vehicular openings at either end of the shed are sufficiently wide to accommodate both a ramp and ground-floor access. Sandwiched between these openings is a tripartite middle section (BCB) that does not coincide with structural bays behind. The centerline of the shed, a line of structure, is not expressed on the façade.

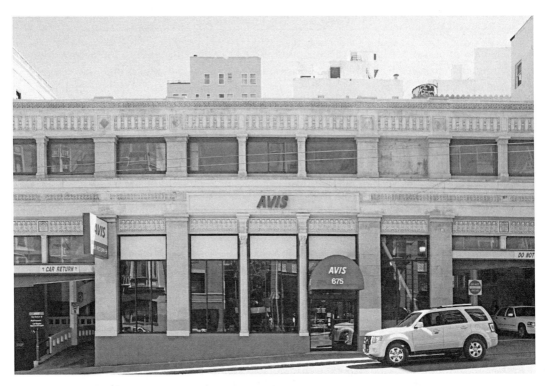

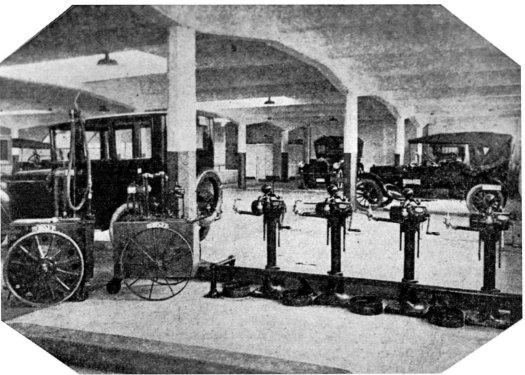

Top: Figure 86. Garage at 675 Post Street. August Nordin, Architect, 1919 (Sharon Risedorph).
Bottom: Figure 87. Interior, 675 Post St. August Nordin, Architect. From *Motor Age*, 1920 (San Francisco Public Library).

The shed façade is reduced to a grid of posts and beams detailed as an eclectic architectural order. Visually heavy, the horizontals are stacked bands of clunky ornamental precast moldings. These horizontals dominate the verticals, and reinforce the attenuated proportions of the façade. This is especially evident across the top, where squat attic story windows and uprights are squeezed between continuous entablatures.

Major compositional bays are framed in substantial and plain Tuscan piers. Minor verticals take the form of Corinthian half-columns below and fluted pilasters above. Major or minor, all verticals define a basic repeating module, most clearly stated at the attic level. Even though this module underpins all of the compositional bays, our ability to recognize it as a compositional building block is undermined by the variety of verticals that mark it.

The absence of wall appears intentional, even thematic. The design suggests a colonnade that represents a frame structure behind. However, façade composition has little relationship to this frame, instead feigning fealty to the simulated structure implied by the nine regularly spaced modules. Given the unusual elegance of the shed, the independence of the façade is ironic.

The distinction between major and minor piers implicitly ascribes structural purpose to the former. In fact, the distinction is a compositional device intended to group the nine modules into an ABCBA configuration. The compositional and structural implications of the façade design act at cross-purposes, resulting in a façade that is tenuous either as an ABCBA composition or a structural representation.

Still, while the façade never achieves a convincing balance between verticals and horizontals, or between composition and structure, it is an original and impressive conception. It appears to be an armature for bold ornamental moldings signifying opulence and power. In its dematerialized state, it makes sure to reinforce the vital message that car ownership is a source of status and prestige.

410 Stockton (Demolished)

This building was a dignified automotive palazzo (Fig. 88). In San Francisco, it is a rare example of a two-story garage without ramps (the second floor was accessed by an elevator positioned against the rear wall). Compositionally, this eliminates the challenge of balancing ramp openings with the ground floor entrance. Architecturally, it removes the mandate to establish a motif (like the arch at Eddy) that serves multiple vehicular openings. Instead, the entire composition can focus on a single ground-floor entrance, similar to the brick-box garage with mezzanine.

A recurring theme of this category is an emphasis on end bays that frame a center area encompassing the major entrance. This façade employs a variation of this theme, with slightly projecting end bays containing monumental two-story arched windows. The openings are outlined in a substantial molding emphasizing the double height; a spandrel panel conceals the second floor. A typical Beaux-Arts detail is the detailing of the semicircular window as a fanlight with radial mullions.

The façade presents an ABA composition in which there is greater vertical separation of adjacent bays and increased contrast in architectural detail between middle and end bays. Grandeur resides in the end bays, while the wide entry bay is a bridge that spans between twin towers. The entry opening beneath the span reads more as a vestigial void created by adjacent events than as a positive architectural statement.

Figure 88. 410 Stockton Street (demolished) in left foreground, 1915. Photograph from the 1940s (San Francisco History Center, San Francisco Public Library).

This composition activates the entire façade to frame passage, creating a giant inverted "U" around the entrance—like a triumphal arch. The three-bay composition mirrors the internal subdivision of the space in which two rows of freestanding columns extend from front to back. In addition to mediating entry, this façade announces a tunnel-like procession to the back, with axial movement through a series of concrete frames terminating in the elevator. The experience would have lacked the monumentality and natural light accompanying a similar circulation path through a spacious single-story shed. Nevertheless, this garage exemplifies the coordination of composition, historical overlay, and structure to facilitate a classic and simple circulation sequence, one that orders the relationship between the architectural façade and the industrial interior.

9. BRICK PIER FAÇADES

— 1545 Pine — 3536 Sacramento
— 421 Arguello — 3640 Sacramento

This type of façade is found throughout San Francisco in one and two-story garages and warehouses. Four brick piers organize the façade into a three-bay, ABA composition. The entire façade is summoned into a frame around entry, resembling a gatehouse. Typically, the two center piers are taller than those at the ends. The approach is related to those Mission- and Station-style façades that also build a hierarchy about a center entrance. In the context of a single-story brick box, the low-high-low adaptation of the ABA composition approximates the sloping sides of the shed behind. Three of the four examples feature an entry that is nothing but a framed void spanning between the two middle piers. In the fourth, 3640 Sacramento, a monumental arched opening affords more architectural definition (and vertical emphasis) to entry. Despite the straightforward template and easy hierarchy, these façades are invested with formal manipulations and ornamental details that lift these garages out of the realm of the commonplace.

1545 Pine

This building is one of the few remaining "temporary" structures quickly erected to serve the city following the earthquake (Fig. 89).[14] Originally a restaurant, it has been a garage for generations.

While a limited Art Nouveau influence is evident at 1641 Jackson and 2405 Bush, 1545 Pine is the only overt expression of the style in the collection. Uninterrupted piers define an elaborate tripartite gate. Compositionally, these piers are like bar lines in musical notation — regularly spaced markers organizing the fluid movement of melodic content.

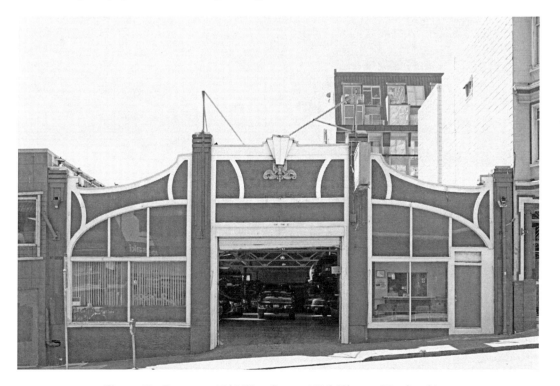

Figure 89. Garage at 1545 Pine Street, 1906 (Sharon Risedorph).

Indeed, fluidity characterizes the architecture at the top of the façade. Graceful half-timber arcs swoop from pier to pier, outlining the silhouette above and the storefront below. Against the sky, the profile loosely recalls the iconic elevation of a suspension bridge. Below, the profile defines a split elliptical arch, its pieces dislodged from the center in deference to entrance. Similarly, the double keystone appears to have been thrust upward from a previous position at the crown of the elliptical arch.

As at Leavenworth, a static composition narrates a story about the generative forces that acted upon it, resulting in the present — not original — condition. Appropriately, the subject of this narrative is the creation of entry — the opening up of the façade to facilitate the passage of automobiles.

3536 Sacramento

This medieval gatehouse also presents a rectangular entrance opening made important through the implied movement of surrounding events (Fig. 90). Like all the examples of this category, the composition deploys its four piers as slender towers defining three vertical bays. Horizontally, the primary compositional markers are the spandrels that cover the mezzanine floor. Occurring at a constant elevation, the spandrels serve as a datum line against which we can measure the various height differentials and plastic effects that distinguish the side bays from the center bay.

Between the major piers, narrower pilasters divide each bay into modules. Every pilaster

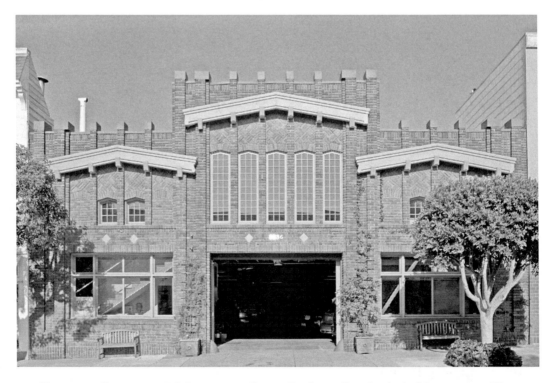

Figure 90. Garage at 3536 Sacramento Street. Banks & Copeland, Architects, 1917 (Sharon Risedorph).

breaks the horizontal profile at the top of the wall, suggesting a stylized battlement. The modules rationalize the ABA composition as a simple ratio of 4:5:4. In addition, the pilasters support cantilevered raking cornices, one per bay. Mimicking the low-high-low profile of the parapet, the cornices restate the tripartite division of the façade while gathering the windows beneath them into house-like gabled fronts.

Similar to Pine Street, the composition presents itself in plastic terms, as the calcified end product of a once dynamic process of organic growth. In addition to the modular representation, the difference in bay width can be expressed as a change, a stretching of the side bay to create the entrance bay. This is implied in the subtle positioning of the two diamond-shaped ornaments framed within each spandrel. In the center spandrel, the dimension between diamonds is larger than in the side panels, suggesting a physical stretching of the material.

The façade also expands vertically. Squat, pointed windows in the side bays blossom into the tall slender openings of the center bay. Windows and pilasters experience a growth spurt — one that lifts up the raking cornice. Hierarchy is established through an architectural sprouting.

As at Pine Street, all of the implied displacements — both vertical and horizontal — serve to highlight the most vacuous but important part of the façade — the entrance. Other façades of brick box garages celebrate entrance through the use of a singular, summary gesture — an arched portal beneath a gabled parapet. By contrast, the designer of this façade pursues a fine-grained regulation of proportion, composition and motif in order to achieve this end. This façade is remarkable for the aggregation of small-scale brick details into a unified composition that represents a simple cross-section. The brick detailing is charming and varied, dense and delicate. Small-paned windows, gauged brick lintels, corbelled verticals, and basket-weave infill impart to this façade a surprisingly convincing residential character. Located on a shopping street in a residential neighborhood, this building is contextual and striking.

421 Arguello

In this variation of a classic commercial building composition, a pediment that parallels the slope of the roof vies with four piers for dominance (Figs. 91–92). While the pediment unifies the entire composition in a single cresting gesture, it also yields to the projection and profile of the piers. These stanchions exude tectonic power, especially the inside piers standing guard over the entrance. All horizontally oriented elements extend from pier to pier: low walls, ground-floor openings, rectangular panels, and sections of pediment. Rounding out the composition are two brick courses, one that outlines the heads of the openings and another that closes the pediment. This garage front is elemental in its configuration, precise in its articulations, and muscular in its emphasis on structure.

In contrast to 3536 Sacramento, Arguello establishes authority through the interaction of a small set of basic, heavy building blocks. Yet like Sacramento, the façade derives grace, scale and artistic effect through brick detailing. While Sacramento creates ornamental effects by arranging a single brick type into various bonding patterns, Arguello relies on different colored brick. The brick lintels and stringcourses divide the piers into stacked sections, each one of which receives a distinct decorative pattern. Brick patterning also enhances the square vent opening just under the apex of the pediment.

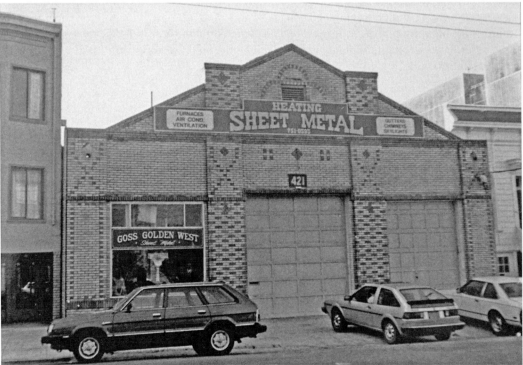

Figure 91. Garage at 421 Arguello Street, 1912 (Sharon Risedorph). *Bottom:* Figure 92. 421 Arguello Street in 1989 (courtesy San Francisco Planning Department).

As this book goes to press, the property is undergoing a conversion to residential use. The building, deemed a "historic resource" by the San Francisco Planning Department (SFPD), will remain. A new two-story addition is under construction, set back from the façade. The SFPD exempted the project from environmental review, as it "would not have a significant adverse affect on the historic resource."[15] While the saving of the garage is cause for celebration, it is unfortunate that this massive gritty wall will be divorced from its industrial past and utilitarian use.

3640 Sacramento

In the other examples of this category, the architect utilizes solid material to frame around the weakest but most important part of the façade — the void rectangle that is the entrance. The garage at 3640 Sacramento is unique in featuring a large arched opening (Figs. 93–94). The solid tripartite block that encompasses this arch possesses the presence of a scaled-down civic monument. Like the nearby garages at Arguello and 3536 Sacramento, this building utilizes masonry construction to express both tectonic weight and decorative patterning.

Despite its monumentality, the building is ambiguous in its assertions. We can interpret it as (1) a monumental portal supported by flanking bays, and/or (2) a monolithic three-bay block with a flimsy hat over the middle. The first interpretation favors vertical thrust, the second, horizontal continuity. Both readings hinge upon the formal role played by the

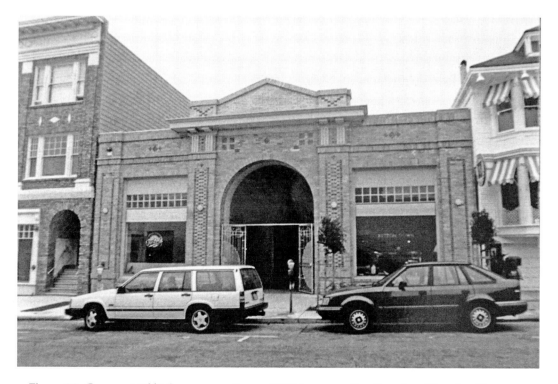

Figure 93. Garage at 3640 Sacramento Street, 1989 (courtesy San Francisco Planning Department).

Figure 94. Detail, garage at 3640 Sacramento Street (Sharon Risedorph).

two interior piers, which double-function in framing both a side bay and the more dominant center bay.

All four piers are identical from grade up to a stringcourse separating the main level from a blind attic story. The prominence and regularity of all four piers offers the strongest evidence that the building is a three-bay block. While the stringcourse runs across all four piers, it does not, however, span across the center bay. In this way, each segment "claims" an interior pier to complete the frame around a side-bay window, thus satisfying one of the piers' two formal roles. Insofar as this treatment emphasizes the autonomy of the side bays at the expense of the center bay, horizontal continuity is still implied.

Above the stringcourse, interior and peripheral piers are treated differently, permitting the interior piers to unite in framing around the center — thus satisfying the piers' *other* formal role. Pairs of stylized triglyphs and mutule blocks attach to the upper portion of the interior piers, serving as brackets that support the projecting cornice. The pedestal blocks that frame the pediment visually extend the piers. These manipulations support the second interpretation of the composition — a portal with flanking bays.

While monumentality is suggested by its central position and symbolic profile, the arch is almost upstaged by the subsidiary windows on either side. Relative to its sidekicks, the arch appears sunken. Were the stringcourse to run across the arched opening, this depressed quality would be highlighted. The architectural frame around the middle bay remedies the situation by isolating the arch within its own localized context. Completing the frame around the center, the cornice provides a visual divide that obscures the considerable amount of wall required to augment the status of the arch.

The ambidextrous role of the interior piers is a theme of this category, and each example employs a slightly different strategy to mediate the piers' divided loyalties between the side bays and the center. At 3640, the architect exploits the double-functioning piers as the means by which a potentially static and ponderous building achieves movement and animation.

Conclusion

Regarded individually, these buildings would not be seen as special or noteworthy. Some examples are better than others, a truism that today must take into account horrific modifications and benign neglect as well as original execution. The tendency to take these structures for granted results from the unevenness in the quality of individual examples, the prosaic, industrial nature of the enterprise, and the aura of anonymity that surrounds them.

When the buildings are reframed as a group, they assume an importance that transcends individual merit, becoming urban in scope. As examples of a type, the buildings refer to one another and to the elusive, abstract ideal. In the mind of an observer whose consciousness has thus been raised, a particularly mangled example transforms itself from urban detritus to a diamond in the rough, followed by a conceptual restoration that reinforces and enhances the complete set of buildings.

The notion of typology is incompatible with either the demolition of examples or their reduction to stage sets preserved only to maintain the visual continuity of the street. When a garage loses its connection to the past, it ceases to exist as an example of the building type. By contrast, when preserved — as a functioning garage or through an adaptive reuse that respects its industrial character — it maintains its connection to all of the other examples of

the type, citywide. The preserved building knits the fabric of the city together through the repetition of motifs that recall the city's transportation heritage.

While façade motifs are the most visible elements connecting the buildings to each other — and to us — the relationships run deeper than arches, crenellated parapets and ornamental friezes. These small monumental buildings, housing retail and light-industrial businesses, are the very essence of heritage and character.

Implicitly, the typological approach extends protections to anonymous buildings and works against their isolation. It substitutes relationship for attribution and/or architectural distinction as the source of value. A building may merit preservation not for its individual excellence, but for its continuity with other examples of the type.

The four narrow ABCBA buildings designed by Pasqualetti are a case in point. When approached from a traditional planning perspective, one that regards context as a function of street and neighborhood, these four buildings would not be compared to one another or assessed collectively. Although located within just a few miles of one another, they stand in different districts. A proposal to modify any one of these buildings would trigger an assessment of its architectural, cultural and contextual significance, but that effort would not necessarily uncover the existence of the three siblings. This leaves each example of the type in the position of "fending for itself," as its merit is considered in isolation. A building's worth is not enhanced by virtue of being an example of a category, as the existence of the category remains unrecognized. A typological approach is therefore an important tool in helping us to understand the value of a building as a function of its relationship to similar structures.

We may glean valuable insights into the collection as a whole, and into our history and heritage, through the preservation of the entire collection — and other collections just like it. Yet older buildings are every day threatened by bland new construction. If we "go with the flow" and abandon the past, we encourage the process by which our cities lose authenticity and all look alike.

Part Two: The Significance of the Garage

Chapter 4

Eclecticism and the San Francisco Historicist Garage

Part One of this book describes the properties of the building type, organizes the garages into a typology, and argues that the structures are architecturally worthy. That worthiness is surprising and begs the question, "Why did the designers labor to invest these structures with an aesthetically pleasing presence when the use — automotive parking and repair — suggests that a simple accommodation of functional requirements would suffice? Put simply, why do these buildings look so good?" Part Two provides some answers.

One of the central premises of this book is that the vulnerability of the garages is exacerbated by observers' tendency to take the buildings for granted, primarily because of their use. Passersby may not see the architectural quality that is obscured by events experienced at street level: the dark raw interior, aggressive signage and the intimidating appearance of automobiles violating the sidewalk. However, the indifference of the public is complemented and indirectly encouraged by a lack of critical appraisal on the part of the design community. The critical marginalization of lowbrow historicist buildings in the city — garages and other types of buildings — leaves a void. An intellectual argument is needed to justify the extension and expansion of legal protections. While the aesthetic merit of the buildings may provide a sufficient basis upon which to argue for preservation, a more substantial case is made when that unlikely quality is understood as a result of underlying historical factors.

Critical neglect of the lowbrow historicist garage is best understood as a form of collateral damage accompanying drivers' dissatisfaction with downtown America in the early twentieth century. With a dramatic increase in automobiles, cities became besieged with traffic, congestion and insufficient parking. In *Main Street to Miracle Mile*, Chester H. Liebs wrote, "By the 1920s, motor vehicles were not only more numerous, but faster and larger, and it became increasingly evident that Main Street was the invention of a bygone era and had not been designed for the automobile."[1] In response, retailers and real estate interests acquired potential store sites at the edge of the city and on the arterial routes leading to new or anticipated suburban development. Thus, "the evolution of the modern roadside shopping center originated with a discontent with Main Street that appeared after World War I. To a population rapidly succumbing to the opiate of high-speed travel down manicured highways, driving down Main Street with its stop-and-go traffic and bumpy pavement was becoming an annoyance."[2]

While the transformative impact of the automobile on American society and culture is well documented, Liebs' excellent book is especially relevant because it specifically relates that impact to architecture. He describes the early architecture devoted to serving the automobile — built in the city — as antiquated, adopting the stylistic norms of existing Main Street commercial architecture:

137

Ironically, most downtown garages, showrooms, and curbside gas stations, although built to serve a radical new machine that would eventually transform almost every facet of twentieth-century life, exhibited dutiful adherence to the cornice, wall, and storefront regimen.[3]

While acknowledging that the lowbrow historicism of early automotive architecture imparted an air of respectability to the new industry, Liebs concludes that this "conformism" did not serve the business interests of the merchants that commissioned it:

> These new entrepreneurs were unwittingly caught in the same dilemma that had confronted merchants for decades — Main Street architecture, while designed for civic propriety and current fashion, contributed far less to the other task for which it was intended: assisting in the process of selling goods and services.[4]

Just as the city was unprepared to physically accommodate the automobile, city architecture was stylistically unprepared to promote the invention that would change the world. Viewed from this perspective, it is easy to see how the lowbrow historicist garage would elude critical appreciation. In its historicism, the early garage was an ill-fated vestige of the past. Its public face expressed fealty to the urbane imagery of the city, rather than to an imagery representative of the technologically advanced automotive machine. In its small size and traditional composition, the building front responded to the slow pace of the pedestrian rather than to the speeding automobile. The building failed as an instrument of marketing.

For our own benefit, the lowbrow historicist garage should be assessed and appreciated as an artifact of its time — an early reflection of the automobile and the city that embraced it. The city garage is just as responsive to the city as roadside architecture is to the roadway. That the building type proved to be an evolutionary dead end — both locally and nationally — can be interpreted as an opportunity for analysis and set aside as a basis for marginalization.

In order to appreciate the significance of the lowbrow historicist garage of San Francisco, it's necessary to consider the factors that influenced the architecture, and in particular, the ubiquitous template of historicist façade and industrial interior. Some influences are unique to San Francisco while others are national in scope; in the latter case, the local experience serves to exemplify and affirm a broader trend. Factors that will be examined for their influence on garage design include (1) the theoretical underpinnings of a dichotomous approach; (2) eclecticism, historical precedent and the City Beautiful movement; (3) local events of profound architectural significance, including the earthquake and the Panama-Pacific International Exposition; (4) the emerging car culture and the marketing strategies of the automobile industry; (5) traffic congestion in 1920s San Francisco; and, (6) the automobile as a designed object that is both served and represented by the garage and its sibling, the showroom building.

The historicist garage façades exemplify an American eclecticism that designers employed as a matter of convention, training and the shared assumption that the style was generally appropriate for the city, no matter what the building use. However, the application of this eclectic approach to the problem of the garage façade still required the designers to interpret the significance and impact of the garage and the car. The preceding list of influences reflects this assumption.

Lowbrow historicist garages featuring Mission, Neo-Gothic and Beaux-Arts–inspired style stopped being produced by the end of the 1920s. Fortunately, much of them have survived and even thrived. Arguably, this work has gained value as an irreplaceable resource,

and its original limitations now perceived as assets. Today, the elitism implicit in the garage designers' historicism is devalued, and nobody cares that the designers may have missed the point when they favored historic styles over celebrations of technology. I believe that these misunderstood buildings must be integrated into a broader, more inclusive, historical perspective in order to ward off threats from those who would dismiss the garages based on use.

The Dichotomous Train Station

The contrast between the garage's historicist façade and industrial interior is a conspicuous and essential feature of this architecture. In chapter 1, the differences between inside and out were organized into a list of contrasting qualities, and summarized as an opposition between *architecture* and *building*. This opposition has its roots in the train station, composed of an architectural head building that fronts an industrial shed, often constructed of iron and glass. The head building represents the train station to the public, while the much larger shed is typically concealed on the exterior and experienced as an interior architecture.

Many utilitarian infill buildings are organized as façade and concealed shed, and generically resemble a compressed station. However, the garage is unique in that its appropriation of this dichotomous arrangement is informed by the fact that garage and station are transportation buildings. Each of the component pieces of the garage's dichotomy is enriched as a transformation of the analogous part of the station. The transformative process from station to garage encompasses shifts in scale, site condition, use, and symbolism. While this process may be arcane, the end results are not subtle. For example, the façades documented in the Station category trumpet the connection to the train station. In order to appreciate the "lost" significance of the garage, it is helpful to examine the train station as an example of dichotomous architecture.

In 1943, Nicholas Pevsner wrote, "A bicycle shed is a building; Lincoln Cathedral is a piece of architecture."[5] While this sweeping statement creates an all-too-easy opposition, it nevertheless provides an elegant formulation relevant to the garage. Both train station and garage are hybrid objects — part architecture, part building. Pevsner's distinction hinges upon the incorporation of artistry into the design and construction process, and it follows upon Ruskin's notion that Architecture—as opposed to Building—"concerns itself only with those characters of an edifice which are above and beyond its common use." Only Architecture is capable of eliciting an emotional response that contributes to a person's "mental health, power and pleasure." For Ruskin, ornament was central to the creation of beauty and Architecture.

Ruskin famously loathed the train station, not only as a building type, but also as a representation of contemporary urban life. As Julia Scalzo succinctly put it, "Ruskin disapproved of the whole structure of nineteenth-century society and its economic practices, which shop fronts and railroad stations symbolized."[6] He found industrial, capitalist society dehumanizing, and regarded the train station as that society's embodiment, "the very temple of discomfort." As the site of crowds rushing to and from, the train station did not offer the repose required for the "contemplation of beauty." To adorn a train station, to treat it as anything but a functional working building, was absurd.

The train station was just one of many new building types that developed to accommodate the dynamic growth of cities in the Industrial Age. Architects participating in this

development faced enormous pressures to adapt to new circumstances. According to historian Carroll Meeks, "The 19th-century architect had to work to a new kind of large scale necessitated by the vast urban crowds swarming through newly created buildings which were partly monumental, partly commercial — exhibitions, markets, department stores, railway stations — a scale which can be called demomorphic."[7]

Among these building types, the train station possessed a special prominence as the place in which people and machines routinely converged. Historian François Loyer has written, "Far more than the factory, the railway station is the symbol of industrial architecture, for two reasons: it is the place where machines are displayed to the public at large, and it is also the place to which the materials produced by industry quite naturally find their way soonest."[8]

In the train station, the architect confronted the new urban scale, and the challenge of generating new form and imagery for a single entity serving the disparate requirements of people and machines. A transportation terminal serving the people was to be majestic, sumptuous and imposing, representing the power and magnificence of the city (and the railroad company). The program for the machines answered more directly to function: the need to span large distances, admit natural light and resist fire. In the absence of a serviceable model, a pointedly dichotomous solution emerged in which head buildings and sheds were treated separately as high architecture and industrial building, respectively. As Kenneth Frampton observed, "The railway terminus presented a peculiar challenge to the received canons of architecture, since there was no type available to express and adequately articulate the junction between the head building and the shed."[9] Meeks describes the result this way:

> Often the architect's responsibility was limited to the station itself, while the shed was reserved for the company's engineers.... Some architects felt that the two elements were so discordant in character that unification was impossible, and that no relationship more subtle than contiguity could be attempted.... Whether or not the architect was concerned with both, the outcome was that a masonry forebuilding usually emerged victorious, with the alien metal shed hidden behind it, visible only from the sides.[10]

This discordance was personified in the conflict between the architect and the engineer. Engineers rose to meet the technical challenges posed by the shed, designing increasingly daring, soaring, and seemingly weightless examples of iron and glass. Architects, who claimed exclusive possession of the knowledge required to integrate tectonic mastery and high cultural expression, maintained design control of the head buildings.

This command over high culture is perhaps epitomized by Philip Hardwick's application of the portal motif to the station front in the 1830s, based upon his conviction that the "station was to the modern city what the city gate was to the ancient city."[11] Implicit in this appropriation is the adaptation of an existing cultural sign — the portal as a sign of ceremonial entry — to meet a new circumstance. It's an appropriation that lies beyond the dictates of structure and function — the assumed limits of the engineer's expertise.

The train station abruptly juxtaposes historicist, decorated architecture with exposed industrial structure. In the organization and function of head building and shed, the train station offers a template and precedent for the garage. Head building and garage façade represent the enterprise to the public, and the sheds — one light, one dark — provide shelter for machines. Architecture and Building co-exist.

The architect's appropriation and adaptation of precedent was characteristic of an aca-

demic approach to design, as taught in the École de Beaux-Arts and in American programs modeled after the École. Disciples of academic eclecticism studied the history of architecture to learn time-honored approaches to architectural balance, massing, composition, plan organization and circulation patterns. Descriptions of the process by which architects mastered the arcane and "universal" principles of design were shrouded in a self-aggrandizing obscurity. Sir Reginald Blomfield, for example, referred to "a sort of unconscious knowledge which gradually builds itself up in his [the architect's] mind as the result of years of patient study and innumerable observations."[12]

On a more practical level, history provided a sourcebook of prototypes and styles. The architect scanned the history of architecture in search of an appropriate precedent, which could be a particular building or historical style. Once selected, a somewhat open-ended and improvisatory process unfolded, the goal of which was the adaptation of the precedent to meet the challenge at hand. As William H. Jordy explained, the architect exercised several "freedoms," including choice of style, the eclectic combination of elements from different buildings within that style, the modification of details to suit present needs, and even the invention of new stylistic details.[13]

Steven Parissien has written that "Beaux-Arts theory had a profound effect on the design of railway termini from 1870 through to the beginning of the First World War, and beyond into the 1920s and '30s."[14] Within this time span, the automobile first appeared, developed into a sophisticated and reliable machine, gained widespread acceptance, and overtook the railroads. Given the Beaux-Arts mandate, it is not surprising that architects would interpret the garage as an outgrowth of the train station—a terminal for automobiles. While the academic process anticipated the transformation of relatively small precedents into new buildings of "demomorphic" scale, the same processes of transformation proved equally effective in the service of an extreme reduction in scale—from civic monument to infill building.

In the reductive process, certain essential patterns were maintained, like the relative positioning of Architecture and Building—identifiable as areas of stylistic treatment or exposed structure. Architectural theorists approached the difference between Architecture and Building as a function of the relationship and relative priority assigned to the constituent elements of the Vitruvian triumvirate, *commoditie, firmness and delight*. Thus, Mariana Griswold Van Rensselaer defined Architecture as a "mixed art whose ends are use and beauty interwoven."[15] Addressing Ruskin's prioritization of ornament, she asserted, "Beauty is not … an extrinsic, superficial thing, depending altogether on ornamental features, but is inevitably bound up with the very attainment of 'firmness' and commoditie." Thus, "decoration cannot even be considered apart from constructive forms. It must grow from them, depend upon them, follow their lead and enforce their speech."[16]

Van Rensselaer's argument is that Architecture embodies the balanced, integrated coordination of the Vitruvian components. While *commoditie* and *firmness* are relatively uncontroversial, it is *delight* and the proper role of ornament that require clarification. The controversial nature of ornament, and the role that it plays in elevating mere Building to Architecture, informs our understanding of the train station and garage.

In the theory of A.D.F. Hamlin, ornament communicates symbolically *and* delineates structure.[17] The potential for an architectural vocabulary of historically derived elements to represent civic ideals *and* building structure affords the train station architect a measure of flexibility in reconciling perceived conflicts between head building and shed. As Parissien notes, "Even the most oversized and pompous Beaux-Arts temple, such as Daniel Burnham's

Washington Union of 1903–7 ... mirrored the functional spanning arches of their train shed in the façades of their head buildings, in a manner which instantly communicated the building's nature to the travelling public."[18]

While the grand urban train station was a dichotomous statement, the academic architect possessed the tools necessary to mediate the relationship of head building and shed from one of incongruity and conflict to contrast and compatibility. (This assumes that the architect's scope of design responsibility encompassed the entire ensemble.) At the gargantuan scale of the train station, the entry portal may represent a shed structure hundreds of feet behind. In this case, the stylistic element does not so much delineate structure as represent it metaphorically. When translated to the diminutive scale of the garage, the representation of structure becomes more direct and literal. In the previous chapter, we analyzed façade composition as a representation of structure as well as the mixed civic and promotional symbolism of the garage.

The garage architect extracts from the train station the simple lesson that the dichotomy is an effective means of satisfying the programmatic mandate to address the public while accommodating the new industrial machines within. Not burdened with the large-scale, technical demands or symbolic weight of the train station program, the garage is easily designed by a single designer, whether architect, engineer or builder. It would be incorrect, however, to assume that the effortless appropriation of the dichotomous formula by the garage designer reflects the resolution of the various controversies that challenged academic theory—the role of ornament and style, the legitimacy of engineered solutions, and the aesthetic status of utilitarian buildings. These little buildings provide evidence of the schism between academic theory and practice.

The charm of the garages results in part from the unlikely application of the architect's elite academic training to the problem of the parking garage. The contrast between the scope of work that the architect is trained to tackle and that which is required by the garage lends a poignant quality to the results. Nevertheless, the architect's skills are evidenced in the compositions, historicism and ornamentation. We recognize the academic eclectic architect's hand in several respects: the reference to train stations and other prototypes, the selection of a dominant style complemented by secondary sources, symmetrical compositions, and a restrained use of ornament to delineate structure and composition. Perhaps most ironic is that we can also sense the spent and unsustainable quality of the eclectic movement in the architects' treatment of the dichotomy itself as precedential and prototypical. For if the combination of head building and shed was regarded as a compromise in the first place, its ascension to the status of precedent amounts to an acknowledgment of the limitations of academic process and theory.

Historical Context in San Francisco

The rise of the automobile in San Francisco parallels the invention's ascendance in large cities across America. San Francisco experienced all of the major societal impacts wrought by the automobile, including increased traffic congestion, suburbanization, automotive tourism and the development of a consumer-driven economy. However, while San Francisco's experience conforms to national trends, its particular narrative is unique, as it unfolds within the context of local geography, politics, economics, and culture.

In San Francisco — and across America — the automobile was initially a plaything for

the rich. Recalling the early days of the automobile, Leon J. Pinkson, longtime automobile editor of the *Chronicle*, wrote, "The exploits of the young bloods and the mechanical-minded gentry in taming their snorting horseless wagons were favorite subjects of conversation for conservative citizens."[19]

Indeed, as early as 1901, *Town Talk*, a San Francisco weekly catering to the upper crust, included in every issue a column devoted to the automobile. The columns merged society gossip related to motoring with boosterism for the fledgling industry. Consistent with its characterization of driving as a "sport," the column chronicled leisurely jaunts, races, endurance tests (including hill-climbing marathons), and tales of ambitious outings hazarded over poor roads or in bad weather. The following item is typical: "Misses Grace and Lily Spreckels were enjoying a spin in their Autocar runabout last Sunday and both can now handle the chug-wagon with proficiency."[20] Observations regarding women's driving prowess and preferences in automobile design appear frequently.

A 1903 column notes the local embrace of the automobile: "The great advancement made in automobiling in California, and especially in San Francisco, is more noticeable every day, and the number of machines now being used and being sold is something phenomenal. During the past week three automobile men from the East were here and each one expressed surprise at the great enthusiasm being shown on this coast over the horseless carriages."[21] Although the announcement parallels similar reports nationally, the implicit reference to the west coast as an outpost of civilization is common.[22]

To put the "great advancement" in perspective, it is important to note that in 1906 — three years *later*— the rate of ownership in California was just 3 automobiles per 1000 people.[23] The automobile's appearance on city streets was still something of a novelty, and its phenomenal growth was attributable to purchases made by members of the city's elite. However, in the subsequent 25 years, even as the price of cars decreased, sales increased, and ownership infiltrated the middle class, that tone of urbane elitism — so pungent in *Town Talk*— continued to characterize press coverage of automobiles.

This tone reflects both the growing power of the titans of the automobile industry, and a marketing strategy that framed the automobile as a status symbol. Eventually — but not in 1903 — this same tone is assumed by the architecture, including the garages and showroom buildings, that represented and served the automobile in San Francisco.

San Francisco, like all big American cities, experienced initial (and ongoing) resistance to the "juggernaut."[24] As Peter D. Norton writes, "When automobiles were new, many city people regarded them as a misuse of streets. By obstructing and endangering other street users of unquestioned legitimacy, cars violated prevailing notions of what a street is for."[25] In 1901, for example, the newly formed Automobile Club of California had to negotiate with local commissioners for access to Golden Gate Park, because the cars frightened horses.[26] The early appearance of the automobile also exacerbated class tensions, as only the wealthy owned the aggressive new machines. San Francisco automobile journalist R.R. l'Hommedieu recalled, "While welcomed with open arms by the rich man as something that had come to put renewed life in his jaded existence, yet to the ordinary citizen this 'devil on wheels' was met with much opposition."[27]

Other factors were perhaps unique to San Francisco's environment. Driving on the city's steep hills was treacherous, while the fog rendered the experience cold and unpleasant, especially in open cars. These factors figured into Kevin Nelson's conclusion, "One would have been hard pressed to find a city more hostile to the automobile than San Francisco."[28]

The reputation of the automobile improved in 1906. In the aftermath of the earthquake and fire, cars and trucks were famously deployed to facilitate the distribution of food and relief services to local residents.[29] The stellar performance of the automobile was widely publicized and demonstrated to San Franciscans "that the motor car had come to stay as a means of quick, efficient and reliable transportation."[30] Within months, the story was referenced as a positive factor in sales: "The demand for motor cars the past summer has been unparalleled here. Their wonderfully effective service at the time of the great fire is known everywhere, and this may have had something to do with the past summer's business."[31] Plus — as Nelson notes — the gratitude of San Franciscans extended beyond the automobile to the automobile agents and dealers, who "showed true pioneer grit, and contributed to the rebirth of hope."[32]

While the catastrophe may have been indirectly responsible for expediting acceptance of the automobile in San Francisco (and beyond), it decimated the city's auto-use architecture. Only three of the city's largest garages were spared, all located on Golden Gate Avenue.[33] New garages of wood construction quickly sprouted up on Golden Gate to accommodate the displaced businesses, but these did not last long. As described by historian William Kostura, the replacements were "brick buildings of one to three stories in height, usually with classically-derived ornament."[34] Although the replacement architecture did not approach the quality of the mature lowbrow historicist garage, the new buildings did conform to Liebs' notion of the Main St. model of "cornice, wall and storefront." Significantly, Kostura finds a "correspondence between the architecture of these first auto showrooms and the autos that were sold in them," both exhibiting a somewhat unsophisticated appearance.[35] In chapter 8, the garage and the automobile will be examined as cross-referencing symbols sharing a dichotomous organization composed of a public face and industrial viscera. From these early utilitarian models, cars and garages evolve into more urbane, sophisticated and comfortable status symbols in the course of the 1910s and '20s, as signaled by the introduction of interior design in both.

Even as San Francisco mirrored national trends in its automotive history (which includes auto-use architecture), the Great Earthquake set in motion the city's unique experience of that history. The disaster leveled the eastern half of the city at the dawn of the motor age, with the consequence that the period of reconstruction coincided with the initial rise of the automobile. By 1910, as the rebuilt city took shape, car ownership increased to 15 cars for every 1000 Californians — a fivefold increase in just four years. It was at this time that the automobile "challenged the passenger train's dominance."[36] The local history provided ideal circumstances leading to the emergence of the lowbrow historicist garage.

San Franciscans approached the rebuilding of their city with determination and a sense of high-minded purpose; they self-consciously took on the resurrection of a fallen metropolis. This idealism was tempered by doubts about the sheer scale of the task that lay before them.[37] City business leaders set aside deep-seated differences and joined forces to coordinate the effort. Their ability to work in concert proved consequential beyond the immediate building campaign. As William Issel and Robert W. Cherny have noted, "This spirit of business brotherhood found expression in the merger of the four largest business organizations into the Chamber of Commerce in 1911 and in both the Portola Festival of 1909 and the Panama-Pacific International Exposition of 1915."[38] Thus, the earthquake and the Exposition bracket a period of intense architectural production propelled by a collective sense of urgency and civic pride.

There was a widely held — if somewhat shrill — conviction that the city was undergoing a transformation more profound than a simple reconstruction — it was being reborn:

> This apparent catastrophe has been an impetus rather than hindrance to San Francisco's growth and prosperity, and out of her ruins has been built a much grander and more magnificent city. Many of her antiquated and wooden structures have been replaced by marble and granite, and the enterprise of western brain and brawn have culminated in the architectural triumphs which make up the New San Francisco.[39]

The *Chronicle* also discovered a silver lining in the catastrophe, inspiring the city to reconnect with its illustrious roots: "The devastation of the fire was not altogether an evil, for it set San Francisco a task whose physical proportions were greater than the builders of any other city have been called to face. It was a work that called out once more the old spirit of the pioneers."[40]

The "pioneer spirit" trope injected elements of chauvinism and civic pride into the formidable task ahead. As described above by Nelson, this same trope was used to characterize the agents and dealers who drove around the fallen city ("true pioneer grit"). Those who worked to resurrect the city were rewarded with a personal resurrection, and their instruments hallowed. When the heroism of the "automobile men" was invested with the aura of the pioneers, the automobile superseded the horse as the trusted companion facilitating a second Manifest Destiny.

Similarly, any architect, engineer or builder involved in the rebuilding of the city assumed a solemn responsibility as society's agent in executing not just a building, but a contributory piece of this renaissance. This sense of noble purpose extended beyond 1910, only to be rekindled by the Exposition in 1915. The mandate to participate in the creation of a "magnificent city" took precedence over internal building use, and helps to explain why the garages of San Francisco — and other lowbrow building types — look better than their use would suggest.

During the first quarter of the twentieth century, other big American cities experienced upgrades in the public aspect of their buildings, albeit more gradually and less dramatically. One factor underscoring these efforts in San Francisco and across the nation was the conviction of reform-minded design professionals and their clients that urban beautification was necessary to relieve the problems of city life. Implicit in the myth of a silver lining concealed within San Francisco's disaster was the opportunity to achieve in a consolidated building campaign the ubiquitous dream of a beautiful, modern and efficient city.

Reconstruction progressed quickly, with 6000 buildings completed by August 2007.[41] While much was accomplished by 1910, San Francisco was by no means whole. Initial reconstruction had focused on the downtown business district, and around 1910, attention shifted to the adjacent residential neighborhoods.[42] Still, the downtown and the surrounding areas were a work in progress. In 1912, guidebook author Helen Throop Purdy described the downtown as a "congeries of magnificent buildings and stores; but the sky line is ragged, and the presence of large, unbuilt spaces can be explained only by the fire, recent from a standpoint of city building."[43]

Building continued for years to come. The upcoming Exposition proved to be a major impetus to move forward on certain key projects, including City Hall, the Exposition Civic Auditorium, and several pier buildings on the waterfront. These large public buildings — and the architecture of the Exposition itself — established precedents for the smaller buildings — including garages — that slowly filled in the empty spaces of the city.

The Conservatism of Those Designing the City

In describing the architects who worked to rebuild the city — and their designs — Longstreth writes,

> After the 1906 fire, the downtown area was rebuilt as a classical urban center — elegant, dignified, and more cohesive than most American metropolises. The new complex of civic buildings near the commercial core became one of the consummate manifestations of the City Beautiful Movement; for the first time San Francisco actually looked like a great city — a polished combination of New York and Paris, rendered by architects who considered those centers to be the epitome of urban achievement. The results of this renaissance were magnificent and at the same time conservative.... The fresh crop of architects was adroit in purveying fashionable modes but had little interest in innovative departures. What they transplanted from the East and abroad was more method than imagination.[44]

The buildings in the Civic Center were designed by architects of national renown, including Bakewell & Brown, John Galen Howard, George Kelham and G. Albert Lansburgh.[45] These San Francisco architects were members of an elite group of designers who studied at the École, and whose work was regularly featured in *Architect and Engineer*. Three of these architects — John Bakewell, Arthur Brown, Jr., and Lansburgh — studied with Bernard Maybeck before going to Paris.[46]

Many of this core group of elite architects contributed to the auto-use architecture of San Francisco. Lansburgh achieved fame as a designer of theaters and movie palaces across America, including the Martin Beck Theater in New York. His monumental Motor Transportation Building for the Panama-Pacific International Exposition was never built. John Galen Howard — the first Director of the School of Architecture at UC Berkeley — designed the austere Pierce-Arrow showroom building on Polk Street.

Frederick H. Meyer, a prolific architect who did not attend the École, was also involved in the planning of the Civic Center. While Meyer was atypical in holding the Chicago School in high regard, he was nevertheless "typical in his wholehearted embracing of the City Beautiful Movement."[47] Meyer designed the Spanish Colonial Revival garage at 530–544 Taylor, as well as the 1908–1909 showroom building still standing at 550–590 Van Ness.[48] Like Willis Polk, Meyer designed several of the neo-classical power station buildings for Pacific Gas and Electric.

The Civic Center — an exemplar of City Beautiful planning in America — actually postdates some initial reconstruction. As Kostura points out, several early showrooms and auto-use buildings were demolished in 1912 to make way for the new City Hall.[49] Surrounding the Civic Center to the east, north and south are streets rebuilt after the earthquake, and these streets include the largest concentration of lowbrow historicist garages. The architects involved in the reconstruction of these areas, like their colleagues who worked on the Civic Center, subscribed to the City Beautiful movement and a Beaux-Arts process of design. These influences were brought to bear on a number of building types, including automobile showrooms, office buildings, apartment blocks, fire houses, police stations, retail structures, power stations, theaters, private clubs, hotels, film exchanges and of course garages.

August Headman is an important figure in the history of San Francisco architecture, and the evolution of the San Francisco garage. In 1901 he led the founding of the San Francisco Architectural Club. As chronicled by historian Therese Poletti, the club provided education to "talented draftsmen, many from the working classes, to join the ranks of privileged

men and become architects."[50] Typical of similar organizations founded in cities across America, the club established a culture of mentorship among prominent architects and young aspirants. Many of San Francisco's elite architects and École alumni participated, either as instructors, speakers or "patrons" of a design *atelier*. For example, both Meyer and Clarence Ward (who with J. Harry Blohme designed Machinery Hall at the Exposition and several of the city's fire houses) hired club members as draftsmen.[51] In this manner, the Beaux-Arts design process was handed down to a younger generation.

Several members of the club who went on to become successful architects designed garages, either singly or with partners: Earl B. Scott (64 Golden Gate Avenue, 624 Stanyan), Arthur S. Bugbee (1725 Sacramento Street), H.C. Baumann (650 Divisadero) and John H. Ahnden (Drumm Street Garage, North Central Garage). Ahnden and Powers are written into architectural history as the firm working with Maybeck on the Earle C. Anthony Packard building on Van Ness. Headman, who graduated from the University of Pennsylvania in 1907 and went on to study at the École, designed the stately arcade garage at 1745 Hyde Street. In addition to its aesthetic merits, 1745 is noteworthy because it brought together Headman and Joseph A. Pasqualetti, who functioned as the building contractor.

The list of San Francisco architects who designed garages in the 1910s and 1920s is long and impressive: Frederick Meyer, H.C. Baumann, Ward & Blohme, William H. Crim, Earl B. Scott (Crim & Scott), Sylvain Schnaittacher, Mel I. Schwartz, Grace Jewett, Henry C. Smith, Norman Mohr, J.R. Miller, August Headman, T. Paterson Ross, Joseph L. Stewart, (John H.) Powers and (John H.) Ahnden, Conrad Muesdorffer and the O'Brien Brothers. Many of the younger architects apprenticed with masters of the previous generation. William Crim, for example, worked in Willis Polk's office, and John Ahnden was the head draftsman for Bakewell and Brown. J.R. Miller was employed at the office of A. Page Brown, the architect of the Ferry Building.[52]

Many excellent garages were designed without the benefit of an architect. Engineers, builders or real estate owners often assumed responsibility for design. Among these, the most prolific and accomplished garage designer was Joseph A. Pasqualetti. Born in 1879 in a small town in the Italian Alps, Pasqualetti immigrated to America, arriving on Ellis Island in 1903. As a laborer, he helped to fight the great fire of 1906. He pursued a career in construction and studied structural engineering at Stanford. As the founder of the American Concrete Company, Pasqualetti built warehouses, apartment buildings, and garages in San Francisco.[53]

While Pasqualetti may not have studied architecture, he was a talented and thoughtful designer. His interest and specialization in garage design and construction may have been sparked by his work as builder of 1945 Hyde, designed by August Headman. Given his skills in engineering and concrete construction, Pasqualetti was ideally suited to take on the garage. In most instances, Pasqualetti functioned as owner, builder and designer of his own garage projects. In addition to Headman, Pasqualetti worked with architect Henry C. Smith on the skyscraper garage at 265 Eddy, and Frederick Meyer (Meyer and Johnson) on the auto-use building at 1575–95 Bush/1450 Franklin. Although Smith is the architect of record, the continuity between Eddy and Pasqualetti's other garages suggests that Pasqualetti was indeed the designer. Pasqualetti's experience interacting with architects within the small world of San Francisco's design and construction community demonstrates yet another means by which the formal and stylistic preferences of the architectural elite were diffused.

When considering the design of a garage front, all of these designers gave precedence to the overall image of the reborn city. They preferred to integrate the garage stylistically

into the prevailing historicist mode, rather than focus attention on the mechanical aspects of the car or the industrial nature of the interior. The design strategy, while controversial, was acknowledged and indirectly sanctioned by the professional elite. In 1912, for example, *Architect and Engineer* reprinted a *Scientific American* editorial entitled, "The City Beautiful," with the following:

> Such important structures as railroad terminals, steamship and ferry docks and landings and bridges for spanning our great rivers, to say nothing of imposing municipal buildings, should always be planned with reference, not merely to their utilitarian purposes, but to their architectural fitness as related to the site on which they are built, and the character of the architecture by which they are, or in the future are likely to be, surrounded.[54]

In the case of the parking garage, the treatment of the building front as a historicist façade — separate and distinct from the raw interior — provided the means by which "architectural fitness" was accomplished. It was a formula not invented for the garage, having been utilized successfully for livery stables, firehouses, car barns and power substations. This architectural organization appears in the early historicist garages built for automobiles from 1910, at 64 Golden Gate and 624 Stanyan. These buildings, both designed by Crim & Scott, exhibit an architectural presence and standard of care exceeding that of the formulaic "cornice, wall and storefront" retail structure.

The rebuilding of San Francisco occurred in a relatively compressed time period and was undertaken by a closed circle of like-minded, local professionals. These circumstances factor into the integration of the garage — and other utilitarian types — into a predominant architectural mode. The 1983 Nomination Form calling for the establishment of an Apartment Hotel Historic District (including parts of the Tenderloin and Nob Hill) states, "Because virtually the entire District was constructed in the quarter-century between the Great Fire of 1906 and the Great Depression of the 1930s, a limited number of architects, builders and clients produced a harmonious group of structures that share a single, classically oriented visual imagery using similar materials and details."[55] Several architects of apartment buildings — including H. C. Baumann, Mel I. Schwartz, and C. O. Clausen — also designed auto repair or garage buildings in the same neighborhoods. It is not surprising that a garage type would emerge reflective of their generalized commitment to a "classically oriented visual imagery." When working beyond the area consumed by the fire — including the Victorian districts of Western Addition and Pacific Heights — garage designers followed these same predilections.

The elite architects who redesigned the city were members of the last generation to apply the teachings of the École and practice in the academic mode. By the mid–1920s, academic eclecticism was increasingly perceived as exhausted, i.e., lacking the requisite flexibility to respond to contemporary architectural challenges.[56] Around 1928, modernism came to America and its proponents successfully framed the École philosophy as corrupt and archaic. The lowbrow historicist garages built in the 1920s are therefore very late examples of Beaux-Arts influence in America.

Through a combination of circumstances and training, San Francisco architects found themselves in the curious position of applying the academic eclectic process to the parking garage. While the results are easily characterized as "conservative" in hindsight, the term may incorrectly assume an accusatory connotation, as if the architects exercised poor judgment in failing to anticipate the modern movement. It is probably more accurate to observe that without access to historical style and precedent, all but the most imaginative of these architects would be at a loss as to how to proceed.[57]

Plus, as the essays accompanying the typology (chapter 3) demonstrate, the architects rose to the occasion, developing imaginative designs within the historicist genre. Eclecticism offered architects a method to meet the challenges presented by new "demomorphic" building types of a scale large enough to meet the needs of large cities. The architects of the San Francisco garage had the opposite challenge—to compress demomorphic prototypes to the absurd scale of the two-dimensional façade. With a combination of humor and idealism, they created innovative design solutions to this new problem.

Conflict Within the Academic Firmament

The lowbrow historicist garage provides local evidence of a schism between theory and practice within the movement of academic eclecticism. Throughout the 1910s and '20s, West Coast architects participated in a national dialogue regarding the major issues that were cause for concern in the academic firmament, and that were exposed generally by dichotomous buildings. These issues included (1) the separate roles and skills of the engineer and the architect; (2) the function of ornament, style and historical precedent in a "modern" era; and (3) how to account for the integrity of utilitarian structures that do not rely upon ornament and style (or "educated" architects) for their design.

This discussion unfolds in the pages of *Architect and Engineer*, the foremost architectural journal for West Coast design professionals. In 1911, for example, an engineer writes,

> Today, while the architect may consider the engineer somewhat inartistic, he does not hesitate to consult him on all matters where engineering judgment is desired. On the other hand, the engineer may consider the architect at times extravagant.... It is obvious that some types of engineering structures are hardly suited to much adornment. Adorning construction should at all times be fostered, but constructing ornamentation can scarcely be advocated.[58]

The December 1912 issue publishes an address with the following:

> If we look for a distinctive type, a style of building which may without question be recognized as American, we are likely to find it in structures with which the educated architect has had little or nothing to do, crude structures void of any idea of, or attempt at, scholarly design.[59]

Not surprisingly, the address proved controversial to the professional elite, and provoked readership response, either pro or con. One architect wrote, "Should we not aim, therefore, as far as it is within our power, to eliminate the baggage of precedent and analyze each problem in its lowest terms?"[60] However, another writer, in a not-so-veiled attack on developments in Europe, objected to the abandonment of history:

> I do not have much sympathy with the conscious attempts that have been made of recent years to evolve a new architecture which discounts precedents, the heritage of the ages. Architecture must be evolutionary, not revolutionary.[61]

This dialogue continued as the Exposition was designed. As will be discussed in chapter 6, the Exposition architects set aside any doubts, forging ahead with an eclectic dichotomous architecture influenced by the Chicago Exposition of 1893. The architects appeared to revel in "constructing ornamentation," creating a pastiche of historical styles plastered over engineered wood-frame scaffolds. While architects delighted in the success of the Exposition, the soul searching in the architectural press continued.

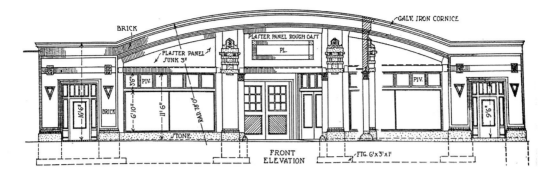

Figure 95. Elevation, South Bend Garage, from *Motor Age*, 1919 (San Francisco Public Library).

Much of this consternation affirms Walter Kidney's observation that "the profession was always at pains to assert the relevance, the appropriateness, of its work to the United States of 1915 or 1925, to prove that, even though the styles might be historical, the works themselves were vital and in the spirit of a living tradition."[62] Clearly, eclectic architects were aware of the inconsistencies in their positions and the possibility of other modes of expression besides historical styles. Historicist garages and other dichotomous building types exposed the stylistic overlay as a thin membrane that barely concealed a raw interior of undeniable architectural strength.

The historicist treatment of the garage façades was common in big cities across America (Fig. 95).[63] As the goal was stylistic integration, these façades mirrored a surrounding architecture that — depending on locale — was sometimes elegant and urbane. However, an overtly ornamental historicism was not the only approach. In the industrial districts of large cities and smaller American cities and towns, the garage façade more typically dispensed with upscale pretensions. While these façades may also have featured symmetrical and hierarchical compositions, they were often more massive, "honest" in the expression of material and structure, and less refined than the garages in this study (and many other early big city garages). They appeared closer in character to factories or other utilitarian types.

While San Francisco architects brought to bear an arsenal of training to the task, and while their compositions were often quite sophisticated, they shared with most American garage designers an underlying commitment to an ordered planar façade with an articulated base, middle and top. In this limited sense, both the overtly ornamented historicist façade of San Francisco and its plainer siblings can be said to exemplify Liebs' notion of the "Main Street model of wall, storefront and cornice." However, the shared adherence to this generalized characterization should not be cited as evidence that the differences in design are trivial. The more rhetorical commercial and civic aspirations expressed on the façades of San Francisco garages reflect the significance and role of the automobile in a class conscious urban context — a new status symbol integrated into an affluent, urbane lifestyle. This lifestyle is illustrated on the many covers of *California Motorist* and *Motor Land* that depict smartly dressed couples going to the theater, attending the auto show (in the Exposition Auditorium), or touring the missions. The garage has a role to play in support of this narrative, and in order to fulfill this role it must present an architectural frame that is more cultivated than a plain retail storefront.

The difference between the lowbrow historicist garage and its more utilitarian siblings is also illuminated by urban design and typological considerations. As an expression of the

decentralization of transportation, for example, the widely dispersed city garage maintains a significantly different relationship to the single urban train station than a single Main Street garage holds with the local depot. The façades communicate the conceptualization of the garage as a miniaturized train station, and the sum total of diminutive train fronts work collectively to signify the citywide scope of decentralization.

Awareness of an alternative sensibility for garage design appears parallel to the expressions of anxiety emanating from the architectural elite regarding the continued viability of academicism. Consideration of the garage specifically is found more often in automobile trade journals than in the architectural press. In a 1915 article dedicated to the appearance of the garage façade, the writer poses a choice between a design employing ornamentation and one based "strictly on utilitarian principles."[64] The choice hinges upon the class of the clientele. Thus, an ornamented façade yields an "attractive appearance," and is appropriate for a "high-class residential district." Conversely, "if there is comparatively little wealth in the district, then it would be unwise to spend much money on mere ornamentation." The historicism of the façade panders to a wealthy audience and augments the status associated with car ownership, insights well known to San Francisco garage operators and their architects.

A less mercenary approach to garage design appears in a 1920 *Motor Age* article, "The Place of the Garage in Architecture." The author, Tom Wilder writes, "an industry so modern as ours should be housed in buildings of modern design, construction and character." He laments the fact that "...there is in reality no such thing as Garage Architecture. Architectural styles grow slowly and the whole motor car industry is of such mushroom growth that styles have not developed during its brief existence. About all we have is a cross between the modern store front and its contemporary, the factory."[65] The text is accompanied by renderings that purport to show "the trend of modern architecture and its possible application to the garage." As shown in Figure 96, the examples include an historicist skyscraper garage, a Wrightian garage (*Motor Age* was published in Chicago), and two factory adaptations, one displaying Moderne influence and the other, Art Deco.

Wilder rejects façade solutions that are either overtly historicist or utilitarian in favor of various strains of a modern style. The article exemplifies Kidney's observation that new industrial building types, lacking "old and strong traditions to dictate composition or ornament,"[66] were well suited for experimentation that dispensed with historicism. "That a commercial building should cast off tradition and look venturesome was of course reasonable.... It was no less reasonable that a powerhouse, a waterworks, a warehouse, or any other conspicuous but culturally extraneous building in the community should do the same."[67]

The notion of the "culturally extraneous" building is key to understanding the significance of the lowbrow historicist garage, and its contemporary siblings — the utilitarian garage and the proposed modern garage. In San Francisco, the garage is not considered culturally extraneous, and is seen — like the automobile — as a symbol of material prosperity and cultural refinement. Those responsible for its imagery reflexively adapt the type to engage the grand tradition of historicist architecture.

Wilder also believes the garage possesses cultural significance, but his convictions do not exactly coincide with those held by San Francisco architects and designers. While both parties may agree that the garage is a symbol of a young, progressive and transformative industry, Wilder does not share the "evolutionary" filter applied by the academic eclectics. They see the automobile and the garage as an outgrowth of the railroad, and quickly attach its imagery to that of a glorious past. The underlying supposition — that progressive tech-

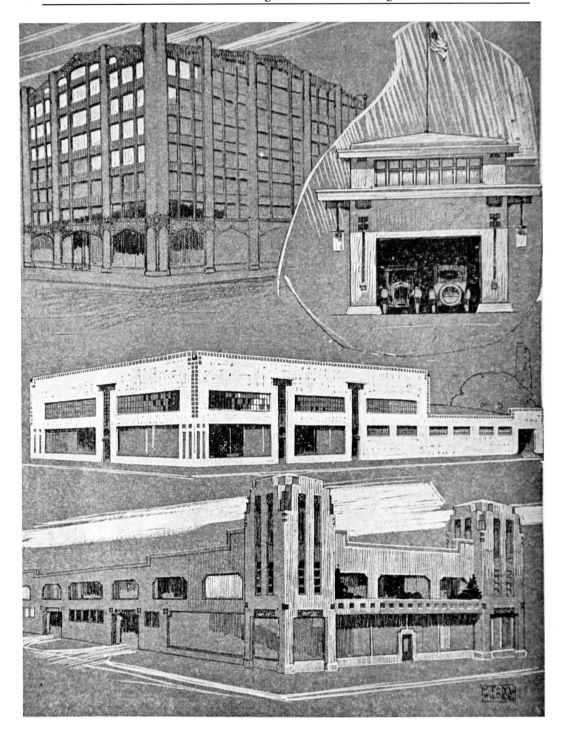

Figure 96. Proposed examples of "modern garage design," from *Motor Age*, 1920 (San Francisco Public Library).

nology is best appreciated as the latest step in an unfolding determinism — comes to the fore and blossoms at the San Francisco Exposition. Wilder, unburdened by the implicit elitism and chauvinism of the eclectics, proposes a simple correspondence of architecture and technology: "the modern is for the modern." It is noteworthy that while the illustrated proposals are not overtly historicist, they are also not a roadside architecture designed to lure the speeding motorist.

For the typical *Motor Age* reader, a consideration of the pure aesthetics of the garage — apart from the attendant promotional benefits — amounted to an exercise in the arcane. The subsequent issue published the Century Garage, at 675 Post in San Francisco (figs. 86–87 in chapter 3). Struggling to rationalize the building, the journalist described "a new idea in the garage service, a structure of beauty with many original features."[68] However, the "beauty" is subsequently ignored, or rather it is implicitly understood to reside in luxurious appointments: "The owners of this garage ... instructed their architect, August Nordin, to design a garage which would be a radical improvement on the old type. The result was not only the installation of a wonderful battery of pumps, oil and gas buggies and safety devices, but the arrangement of elaborate rest rooms for women, smoking rooms for men, lockers for owners, and the maintenance of personal service of high degree for all patrons." While the Century exemplifies the convergence of architectural and class pretensions for promotional purposes, its awkward representation in the pages of *Motor Age* provides insight into the status of the automobile and the garage in San Francisco.

Chapter 5

Dichotomous Architecture and the City Beautiful

Car and Garage as Facilitator of City Beautiful Goals

San Francisco architects looked up to Daniel Burnham, McKim, Meade & White and other architects of national renown who championed City Beautiful ideas in the first decade of the century.[1] Burnham's plan for San Francisco, famously released just before the earthquake, adapted City Beautiful ideas — including a civic center — to the city's hilly terrain. As we have seen, San Francisco architects believed in the City Beautiful movement, heeding the call to superimpose coherence and formal order onto existing cities as they redesigned San Francisco.[2] In the early 1910s, the architects planning the Exposition still regarded the Chicago fair as a towering precedent. More than influences, the City Beautiful movement and academic eclecticism formed the substance of the professional mindset of the architects working in San Francisco during and after the earthquake.

The City Beautiful embraced an aesthetic program for architecture, although it did not develop a specific design process for architects to follow. The movement regarded architecture as a means to achieve its goal of an orderly, aesthetic and functional environment that improved the quality of life for all of the city's inhabitants. Attention naturally focused on the exterior aspect of architecture as a source of urban beautification. For an infill building on the street, the scope of concern narrowed to the façade. The dichotomous organization of historicist façade and industrial interior enabled the building to contribute to the beauty of the city while accommodating the utilitarian program.

City Beautiful convictions motivated architects to grace the fronts of garages with aesthetic façades, a feat that — for these architects — required the application of the eclectic design process. However, there is little or no direct connection between the lofty urban goals of the City Beautiful and the lowbrow garage, a circumstance that contributes to the dismissal of the garage today as inherently insignificant. In order to appreciate how the lowly garage inspired such noble convictions, it is helpful to view the garage as a representation of the automobile, or more precisely, the positive view of the automobile that was promulgated by those — like garage owners — seeking to profit from its success. Of specific interest is the promotion of the automobile as *the* catalyst for an urban decentralization that functioned as a relief valve for problems of concern to City Beautiful advocates and progressives.

Core tenets of the City Beautiful can be construed to provide a theoretical framework for either the warm welcome or hostile rejection of the automobile.[3] For example, the automobile provided city dwellers easy access to nature — although not so much in urban parks.

Weekend drives and vacations on the road delivered city dwellers to the countryside and to scenic wonders like the California missions and Yosemite. These benefits—to the individual and society—were a function of increased mobility resulting from private ownership of automobiles (albeit, often purchased on credit). In other words, the automobile appeared to deliver modified versions of many of the goals of the City Beautiful, and it did so in a manner consistent with the movement's respect for private property and privilege. On the other hand, those urban progressives who regarded the automobile as a dirty, noisy, and dangerous intrusion on city streets rejected it as an agent of beautification and a catalyst for urban relief. They viewed the automobile as a source of congestion and a usurpation of the public domain.[4]

Explaining the point of view held by many progressives at the end of the nineteenth century, Mark Foster has written: "Thoughtful urban decision makers supported any changes which permitted urban dwellers to escape the slums. Although some city engineers and planners adopted the strategy of reviving existing slum areas through better tenement design, improved urban services, lower utility rates, and more park space, growing numbers of planners frankly encouraged flight to outlying areas."[5]

While convictions regarding decentralization precede the automobile, they continue to be held by many social reformers and city planners throughout the 1920s. Initially, and before the impact of the automobile on the city was understood,[6] the goal of suburbanization was to be realized through the construction of new transit systems.[7]

In late nineteenth-century San Francisco, residential expansion beyond the city core was made possible by the streetcar. The cable car—invented and first introduced in San Francisco in 1878—was instrumental in the development of areas immediately outside the core, including Western Addition, Noe Valley, Hayes Valley and the Mission District.[8] Relative to horse-drawn cars, the cable car was fast, clean and sufficiently powerful to scale the city's famous hills.[9] Cable car lines fanned out from the two major transportation hubs: the Ferry Building (and adjacent piers) and the Southern Pacific Street Station at 3rd and Townsend in the district south of Market. San Francisco scholars have concluded that these early cable cars "encouraged" and "stimulated" suburbanization.[10]

Railway companies were private, for-profit companies granted franchises by the city. In 1902, the United Railroads was formed, consolidating into a single entity the large majority of lines serving the city.[11] Following a nationwide trend, San Franciscans grew to resent private ownership of the streetcar systems and other utilities, as the companies were regarded as corrupt and unresponsive to the public's needs. Indeed, bribes by United Railroads to boss Abe Ruef and city supervisors underpinned much of the scandal that engulfed the Schmitz administration, resulting in the graft trials of 1906–08.[12]

The calls for reform that were fueled in part by this corruption are typical of the Progressive Era. In San Francisco, reform politics reached a milestone in 1898 when voters approved a new charter, described as a "model for progressive municipal government."[13] Among other measures, the charter mandated public ownership of utilities, including transportation systems. After numerous failed attempts, San Franciscans voted for bond issues authorizing the city to purchase, modernize and expand an existing streetcar line serving Geary Street. The Municipal Railway opened on December 28, 1912, becoming the first city-owned and -operated streetcar system in the nation. A crowd of approximately 50,000 gathered at the opening ceremonies, presided over by Mayor Rolph. Adapting the City Beautiful cliché of the "people's palace," Rolph celebrated the line as the "people's road."[14]

While the Municipal Railway competed with the much larger United Railroads, it

slowly expanded, facilitating the development of new residential areas in the west and south-west parts of San Francisco. Real estate, merchant and banking interests supported this geographic expansion and the improvements in transportation and infrastructure to support it. More than an exercise in good government, expansion and investment in public projects were deemed necessary to maintain San Francisco's stature as the premiere metropolis on the west coast. As historians Brandi and LaBounty have noted, the earthquake exacerbated concerns regarding the city's preeminent status, creating among business leaders a "climate of desperation to rebuild and create housing for workers...."[15] These leaders feared that a failure to open up new suburbs within the city would encourage displaced people and aspiring suburbanites to migrate beyond San Francisco — to the emerging cities of Berkeley and Oakland and the towns of San Mateo County.

The breadth of the Municipal Railway expanded with the completion of the Stockton Street Tunnel in late 1914 and the Twin Peaks tunnel in 1918. Construction of the Stockton Street Tunnel was not motivated by decentralization but by downtown merchants' wish to ease transportation from North Beach to their stores.[16] Completion of the project was scheduled to coincide with the opening of the Exposition, and to facilitate streetcar travel to the fairgrounds. By 1915, the Municipal Railway extended from the Ferry Building to the Pacific Ocean, and from the fairgrounds in the north (the present Marina) to Potrero Hill in the south.

When the plans for the Twin Peaks tunnel were unveiled in 1912, the *Chronicle* noted, "A population of 200,000 can easily be accommodated with ample room in the area between Twin Peaks and the ocean."[17] (The population of San Francisco in 1910 was 416,912.) Indeed, the project proved to be an effective catalyst for westward expansion and development, bringing "a rich financial return to property owners, business men and real estate promoters." Parkside — the name given to the southern half of the Sunset District — was served by the Tunnel, as were upscale enclaves like Forest Hill and St. Francis Wood. The agents and developers of these prospective neighborhoods anxiously awaited completion of the tunnel and provision of streetcar service. As Sally Woodbridge has written, "Although designed to appeal to those who wanted to escape urban life in the dense inner city neighborhoods, the lots did not sell well before the tunnel's opening."[18] Sales picked up almost immediately upon completion.[19]

The example of St. Francis Wood suggests that in the 1910s, the suburban dream existed — as an idea — independently of the mode of transportation upon which its realization depended. Woodbridge's statement dovetails with historian Scott Bottles' observation that "transportation innovations [like the electric trolley] by themselves did not inevitably lead to the suburbanization of America. Rather, people invented these new modes of transportation in response to the desire of many city dwellers to live on the periphery of the city."[20]

Automobile ownership almost quadrupled in San Francisco between 1914 and 1920,[21] and automobile use quickly became integrated into a suburban lifestyle enjoyed by the relatively well to do. From 1915 to 1920, city engineer Michael O'Shaughnessy — the driving force behind the Municipal Railway's expansion — facilitated automobile use through development of a "boulevard system" that is still in use today.[22] In the 1920s, automobile ownership extended down to the middle classes, as illustrated by the thousands of Sunset District freestanding houses built over a garage. However, the soaring rate of automobile ownership and the popular association of the automobile with a suburban lifestyle do not support the conclusion that the automobile initially propelled the outward flight.

San Francisco exemplified Martin Wachs' observation, "As auto ownership grew by

leaps and bounds, inner-city population densities declined, and suburbs grew in every metropolitan area."[23] However, the potential to commute by car may not have been the prospective suburbanite's foremost consideration when calculating the positive impact of the automobile in accommodating the new lifestyle. As Wachs notes, "In response [to increased automobile ownership and decentralization], transit use increased for work trips but declined dramatically for recreational and social trips, which were increasingly the domain of the automobile."[24] As late as 1927—and deep into the period of the automobile's acceptance—those who entered downtown San Francisco by streetcar outnumbered those commuting in passenger cars by a factor of 2.7.[25] While the automobile did emerge as a preferred mode of transportation on a regional basis, and while the increase in downtown congestion contributed to what Miller McClintock called "premature decentralization," it was the streetcar that primarily facilitated San Francisco's initial phases of commuting and outward expansion. As J. B. Jackson has written, "It was only in 1916 that city planners began to take the automobile into account even in the discussion of urban transportation."[26]

Regardless of the degree to which the automobile was in fact compatible or incompatible with the goals of the City Beautiful, the automobile industry appropriated ideas rooted in the movement and integrated them into its rhetoric. Motordom framed the automobile as the antidote to many of the stresses and strains of urban life. The following excerpt from a *San Francisco Examiner* editorial entitled, "What the Automobile Men Have Done for the World," is typical:

> You have spread out the cities to where gardens grow and surrounded tens of thousands of previously huddled homes with sunshine and fresh air. You have done this not only for the rich, but for the comparatively poor. Because you have provided power so cheap that even the workman has been able to move from the old welter of tenement life close to his job to suburban cottages miles away.[27]

This flowery homage adapts certain City Beautiful ideas and terminology to promote the automobile as an agent of deliverance from epochal and seemingly intractable problems that beset the city. The notion that fresh air, light and natural beauty are restorative is derivative of City Beautiful ideas, irrespective of whether or not the movement's leaders ever endorsed a mass exodus from the inner city.[28] Similarly, the assertion that "Automobile Men" improved the plight of the poor has roots in City Beautiful anxieties regarding class, as does the axiom that capitalists and city leaders have a responsibility to improve the circumstances of the urban poor.[29]

The beneficiaries of the suburban transformation proved not to be the urban poor, but members of the middle and upper classes—those capable of purchasing the suburban house and the car.[30] The editorial exemplifies James Flink's observation that "the facile answer to the slum was that tenement dwellers should buy motorcars and commute to suburbia."[31] Cities across America—San Francisco included—were modified to accommodate the car and the people who owned them. The parking garage—a private building for public use—was a necessary part of this accommodation. Like the automobile and the suburban house, the public garage did not serve the lower classes (except by way of employment).

Just as the automobile industry appropriated City Beautiful ideas to promote the automobile as a relief valve for societal ills and a force for positive change, it also adopted the architectural imagery associated with that movement. In this context, the historicist façade represents not parking or repair, but the significance of the automobile in effecting this social and spatial transformation. The historicist façades impart an air of respectability to these auto-use buildings.

While the urban poor may have been overlooked in the decentralization of the city, the notion of the automobile as catalyst of reduced class tensions endures. The garage contributed to the perpetuation of this myth, but only indirectly. Everyone knew that the grand portals of garage fronts framing the comings and goings of automobiles were not celebrating the formerly impoverished slum dweller rehabilitated through the deliverance of car ownership. Rather, the garage proscenium offered the middle- or upper-class automobile owner a special status that connoted material wealth as tinged with the civic-minded profile of the City Beautiful advocate. The conservative, historicist architecture formed a bond with the technologically progressive automobile to complete the representation of the driver as someone privileged, receptive to innovation, and actively involved in enacting responsible and uplifting change. This bond is also highlighted at the Exposition, where enormous "palaces" evoking ancient empire served as backdrops to the latest cars.

The historicist garage has a role to play in the "facile answer" constructed by motordom, acted upon by city planners, and idealized by journalists. Everything touched by the answer — including the garage façade — reflects the beneficence, wisdom and insightful leadership magnanimously bestowed upon the people of the city by the Automobile Men. Whether residential or commercial, private or public, suburban or urban, the garage is ennobled as the domicile of the automobile, the terminal that facilitates the commute and enables the erstwhile tenement dweller to reap the rewards of "autotopia."

On the residential front, the importance of the garage is reflected in its gradual relocation from the backyard to the front of the house. Drummond Buckley observed that "the utilitarian garage seemed increasingly out of place" in the backyard, increasingly the site of private beautification efforts. "In the 1920s, the alley entrance gave way to the personal driveway. Now the garage could be seen clearly from the street, increasing its value as a status symbol."[32] In dense San Francisco, the emergent house type integrated the garage into the building front, as a base for the residential flat above. The entry stair and front door were situated along the sidewall, as in the narrow city Victorians. (Indeed, countless Victorians were modified to accommodate the car through the addition of a garage beneath the cantilevered bay windows, achieving much the same organization.)

Consideration of the suburban commute throws into high relief the separate spatial spheres of home and work, and the gender stereotypes associated with these realms. Urban geographer Bonnie Lloyd describes a "sexual division of space" wherein "a woman is a housewife, a woman of the house, or perhaps a homemaker or housekeeper. The male belongs to the world outside. He aspires to be 'a man of the world,' and his work takes him outside into 'the real world.'"[33] One legacy of the Progressive Era is the reinforcement of these separate realms, especially a woman's responsibility for keeping a healthy and uncontaminated home — and purchasing new industrial products to assist. Speaking of this responsibility, Gwendolyn Wright has written, "The housewife cleaned harder, remodeled her house, and purchased new 'labor-saving' devices in an effort to approach the new 'therapeutic environment.'"[34]

In the early 1920s, motordom integrated this social narrative into an ad campaign selling the notion that the woman of the house needed exclusive access to a second family car in order to manage her domestic responsibilities. Thus, a magazine ad from 1923 advised, "Chevrolet enables the city housewife to buy vegetables, eggs, poultry and small fruits, direct from the farmer's wife, fresh and cheap."[35] In like manner, Chevrolet enables the farmer's wife to buy dry goods, groceries and household appliances not available in country stores.[36] In the division of labor appropriated and facilitated by motordom, the husband

drove to fulfill his role as breadwinner, while the wife drove to buy the bread. The residential garage grew in size, utility and stature, serving two automobiles, both genders and the image of a productive and successful family.

However, it is in the public and commercial domain that architects and designers expressed the garage's social and cultural significance. Interpreted as the servant and architectural embodiment of the invention that contributed to the realization of many core objectives of the City Beautiful, the garage formed a visual bond with the monumental civic architecture that was a hallmark of the movement. As discussed below, it was especially relevant for the garage to attach to the building type that it symbolically superseded — the train station. In this context, the garage's ubiquity and diminutive size — relative to the centralized people's palace — was itself a metaphor for the disintegration of the city into displaced spheres for work and home.

In addition to promoting the automobile as an instrument of urban decentralization, the automobile industry also celebrated the car as the means by which other progressive goals were realized. The list includes the intertwined objectives of health, exercise, access to nature, self-improvement and maintenance of the political status quo. Locally, these benefits are extolled on the pages of local newspapers and automobile magazines like *California Motorist* and *Motor Land*. Many of the claims made on behalf of the automobile are tenuous, at best. In one article, an academic writes, "The automobile has done more to eliminate tuberculosis than any other single factor known to medical science."[37] Another article offers the "startling hypothesis" that "motoring is probably the finest form of exercise for the average man and woman of today."[38] A third, "Roadism Instead of Bolshevism" (written as American soldiers returned from World War I), advised, "Build good roads and there will be neither social unrest nor problem of unemployment."[39]

Typically, these magazines promoted California tourism, offered technical advice, celebrated the latest models, and editorialized in favor of transforming the American landscape to accommodate the automobile. While this content held no overt connection to Progressive Era goals, the City Beautiful movement or to the architectural design of garages, it did glamorize and popularize an automobile culture, as prescribed by automotive interests. Every issue included dozens of advertisements from manufacturers, dealerships, car part suppliers, oil companies and local garages. Throughout the late 1910s and '20s, issues of these magazines included a list of "Official Hotels and Garages." These were establishments that extended discounts to California State Automobile Association (CSAA) members, in exchange for an annual fee and disclosure to the CSAA of the identities of the members who patronized those establishments. Many of the cooperating businesses, like the Century Garage at 675 Post (Fig. 97), reinforced the marketing potential of the listing by placing ads in the same issues.

The relationship between San Francisco garages and the CSAA demonstrates that garages were stakeholders in the local implementation of motordom's promotional strategy. That strategy — as disseminated in CSAA publications — emphasized the car as essential and affordable, but also a sign of social and economic status. It promulgated a suburban narrative featuring a housewife who drove to accomplish domestic tasks (and shop), and a husband who drove to conduct business downtown. It ennobled the car as the invention that decentralized the city and loosened class tensions. The historicist garage contributed to this campaign by surrounding the automobile with an architecture suggestive of civic purpose and personal privilege.

An Attractive and Comfortable Ladies' Room

Short of Gas
Long on Courtesy and Efficient Service
OILS, ACCESSORIES
SUPPLIES

Century Garage
"The Garage of Distinction for Classy Cars"

Franklin 108 **675 Post Street**

Figure 97. Ad for the Century Garage featuring the women's lounge from *Motor Land*, 1920. Views of finished architectural interiors are rare in garage ads (San Francisco History Center, San Francisco Public Library).

The Garage as Miniaturized Train Station

In approaching the garage — a new building type — San Francisco architects applied the principles of academic eclecticism, which instructed them to generate a design by adapting an existing type to the current problem. They based their adaptations, in part, on the train station — an obvious choice as *the* architectural embodiment of the dominant mode of transportation to that point. Other smaller-scale transportation buildings — the livery stable, bike shop and firehouse — were also relevant models.

The garage, a necessary adjunct of the automobile, contributes to a system of signs and symbols that promotes the car as an object of desire and a source of mobility. Insofar as the mobility afforded by the car is unprecedented, the utilization and transformation of *design* precedents — train and station — constitute an effective basis for signification, as these antecedents function as datum lines against which the relative enhancements in mobility can be expressed.

Americans' gradual preference for transportation by automobile over the passenger train is well documented elsewhere. However, a few facts are helpful in providing a chronological perspective. The automobile first presented a serious challenge to the passenger train around 1910.[40] Throughout the 1910s, an increasing number of Americans found that touring in automobiles and camping along the road was cheaper and more adventurous and offered more autonomy than traveling by train to hotels built by the railroads.[41] Instructively, in 1916, "more visitors came to Yosemite by car than train."[42] On a national scale, the dramatic shift between railroad and automobile travel unfolded in the early 1920s, following the economic recession of 1921. According to Flink, "passenger miles traveled by automobiles were only 25 percent of rail passenger miles in 1922, but were twice as great as rail passenger miles by 1925 and four times as great by 1929."[43] In the 1920s, San Francisco experienced "a definite shift from the dominance of public transportation to the widespread popularity of the private automobile."[44]

The evolution of the lowbrow historicist garage parallels this period of transition. In San Francisco, early historicist garages — as opposed to plainer storefront-type garages — appeared around 1910, the point at which the automobile ceased to be just a toy for the rich and received more general acceptance. The garages at 64 Golden Gate (Fig. 60 in chapter 3) and 624 Stanyan (Fig. 14 in chapter 2), both designed by Crim & Scott, exemplify this emergence. Of the two, 64 Golden Gate is the more forward-looking and locally influential, particularly in the use of a sophisticated façade composition to promote the automobile and the garage. By contrast, 624 Stanyan — with its massive front of exposed brick and small openings — maintains greater continuity with the utilitarian buildings of the past, as exemplified by Polk's PG & E substation of 1907 and the brick car barns of the late nineteenth century. Indeed, among San Francisco garages, the Stanyan garage is most like the typical mid-scale brick garages appearing in *Horseless Carriage* and *Motor Age*. Like Stanyan, these buildings also derive strength and presence from tectonic expression — seemingly more forthcoming in announcing their utilitarian use to the street.

Around 1915, the historicist garage matures into an overtly monumental form, a development that reflects the architecture and significance of the Exposition. 1641 Jackson and 2405 Bush are noteworthy examples. The prolific era of garage construction coincided with the explosion of automobile use in the early 1920s (and heightened congestion in the city). During the Depression, garage construction hit a lull. (When it resumed later in the 1930s, the façades were designed in an Art Deco or Moderne style.) Importantly, the historicist

garage did not appear as a full-blown building type that served a singularly triumphant new technology. Rather, it developed as the automobile and rail-based transportation systems (passenger trains, trolleys and cable cars) vied for dominance.

If the architects' reliance upon the train station was obvious, it was also inspired and inspirational. The building type was highly esteemed by City Beautiful leaders and advocates. Charles Mulford Robinson devoted a chapter of his landmark book of 1909, *Modern Civic Art*, to the train station (and its fronting plaza).[45] Picking up on Philip Hardwick's conceptualization dating back to the 1830s, Robinson described the station as the "portal of a city" and urged architects to appropriate the "portal idea."[46] Daniel Burnham designed and built monumental Beaux-Arts–influenced train stations throughout America, creating a national brand known as "Burnham Baroque."[47] His use of the portal motif extended the influence of the Chicago Exposition generally, and Charles B. Atwood's Exposition station in particular. The train station received monumental architectural expression in major American cities, including New York, Washington and Boston. In San Francisco — the city on the bay — the Ferry Building served as the city's transportation hub and symbolic gate. While the Ferry Building is designed in a Beaux-Arts style and the Southern Pacific train station is Mission, both present imposing triple portals to the city.

However, the significance of the train station as a precedent for the historicist garage extends beyond the simple borrowing of an architectural motif— a motif that concurrently graced the fronts of other highbrow types like libraries and museums. Also relevant to the garage was the station's functional role in the life of the city, its schematic architectural organization, and its hybrid status as both civic and commercial monument. To the garage architects, these properties informed the symbolic relevance of the portal motif and of the train station as the architectural embodiment of a government sanctioned, institutionalized mobility. All of these aspects of the station were discussed by Robinson, and would have been familiar to architects who followed City Beautiful theory.[48]

True to the conviction that the purpose of city beautification is to enhance the lives of the city's inhabitants, Robinson roots the design mandate in its social utility:

> For as far as the citizens are concerned the station is a focal centre, and as far as the rest of the world is involved it is the point from which the first serious impression of the town is gained. It should be, then, one of the first and most important points to be considered in making a general plan for the development of the city on thoroughly modern and rational lines, and for its beautifying.[49]

The advice is urban in scope yet reductive in its consideration of a few simple terms: the train station is a singular centralized hub (albeit located on the geographic periphery) that serves the entire population and represents the city to itself and to the world. This role demands that the station be beautiful in a manner expressive of its civic breadth. In order to accommodate so many people and establish its hierarchical dominance, the building must preside over a large public space, correspondingly urban in character and scale.

While the industrial train shed often presents a colossal arched cross section that signifies and indeed accommodates entrance, the lightweight enclosure lacks the gravitas to serve as a city gate. The station building represents this cross sectional profile to the public, utilizing a classical architectural vocabulary that bestows honor on the city's portal. Significantly, the architectural monument houses those functions — waiting room, restrooms and ticket counter — that are weighted towards people and not trains. A permeable membrane or casing, the architectural head building separates the public from the trains, providing a transitional and spatial resting place between "inside" and "outside" as experienced on an

urban level. Its arched portal is a funnel that receives, embraces, frames and celebrates what Meeks described as "the daily flow of multitudes."[50] The station assumes a dichotomous profile in which an architectural head building serving and symbolizing the public realm is adjacent to an engineered shed that serves and symbolizes the industrial realm.

The monumental train station also reflects the conviction that "beauty pays off," an intellectual bequest from Olmsted to City Beautiful theory.[51] Robinson wrote, "If by a pleasing station and an attractive setting for it travel is apparently shorn of some of its repellent discomforts, the railroad company gains as much by the greater willingness of the townspeople to travel as the town gains by the more urgent invitation thus extended to travelers to stop there."[52] Indeed, the railroad companies commissioned opulent urban stations to contribute to society and to reap the economic rewards attendant upon impressing the public and outdoing the competition. Railroad companies appreciated and exploited the fact that a commercial structure dressed in the garb of civic architecture signified the company's prestige, beneficence, high regard for the customer/citizen, and authority in the customer/citizen's life.

City Beautiful ideas, generally and in regard to the train station, continued to influence American architects' theoretical convictions through the early 1920s.[53] As discussed in the previous section, these concepts occupied the minds of the elite cadre of architects working in San Francisco. The City Beautiful interpretation of the train and the train station provided the garage architect with the ideological tools to interpret the automobile and the garage as the respective successors to these antecedents.

During the period of transition, the transformative impact of the automobile on society was a matter of discussion and controversy. Advocates often attributed to the automobile transcendent powers to overcome the physical laws of nature in service to humanity. In one of dozens of rhapsodic odes published in the Sunday auto sections of San Francisco newspapers, one journalist wrote, "For the power you [automotive industrialists] have played with has had influence upon the elements of infinity itself—which are time and space."[54]

Similar declarations originated from less obsequious sources within the design profession. For example, the city planning editor of *Architect and Engineer* wrote, "The automobile, the aeroplane, the zeppelin have lifted the civilized peoples out of the mire, and have suddenly changed our whole concept of space and time."[55] In a statement reflecting a City Beautiful–inspired appreciation of the organic relationship between transportation and the city, she wrote, "The city of the future will resemble as much the city of the past, as the modern automobile resembles a Roman chariot."[56]

Hyperbolic expressions of mastery over time and space are understandable when the autonomy, convenience and efficiency of automobile travel are grasped in relative terms — as a change from norms established by the railroad. Catherine Gudis offers this perspective on the contemporaneous mindset: "Independence through automobility sometimes came in rather abstract forms, as the car altered the geographical imagination of travelers formerly accustomed to measuring physical distances according to train schedules and routes."[57]

Descriptions of automobility emphasizing the car's capacity to dramatically collapse distances and travel times most aptly describe the automobile on the open road. The unhindered linear movement of the car gives rise to new spatial contexts — the freeway and the strip — that become commercialized and then institutionalized as a distinctly American form of promotional architecture and signage. However, because the historicist garage is an urban type, the experience of personal mobility in the city is especially relevant.

Norton notes that automotive interests, responding to widespread discontent with

traffic accidents and congestion, enveloped automobile use in a "rhetoric of freedom."[58] Exploiting a traditional American predisposition to defend the rights of the individual against regulation, these interests framed driving as an expression of personal liberty. This argument was originally formulated to counter objections raised to motorists' appropriation of city streets. The argument was also deployed when lobbying on behalf of freeway construction within and without the boundaries of the city.

The ethos of personal freedom effortlessly translates from driving in the city to the open road, where the sensibility finds much greater legitimacy (and encounters less resistance). While *privatized mobility* is indeed a transformative concept that gets to the heart of the relative superiority of the automobile over the train in an urban (or any) context, the concept of *privatized mobility* is closely related to, but not synonymous with, an ethos of individual freedom.

On a relative scale, the driver in the city did not generally enjoy the unfettered, limitless, linear movement that has been romanticized as a peculiarly American form of individual expression. (However, this same city driver was no doubt susceptible to the notion of driving as an exercise in personal freedom, and surely experienced it while touring or vacationing — but not commuting.) As a result, the benefits of automobile ownership and use are slightly different in the urban context.

In order to understand the symbolism of the historicist garage, we need to analyze the difference in the character and extent of the mobility afforded the individual by the train and the automobile, as circumscribed by the spatial configuration of the city. It's helpful to first acknowledge the correlation between the automobile and its antecedents. The automobile wed the autonomy of the horse-drawn vehicle with the power of the train. After an early period in which the automobile often resembled a "motorized horse buggy,"[59] the car assumed the physical characteristics of a compressed train. The Ford Model T, introduced in 1908, presented an engine (locomotive) in front and an open cab (passenger car) behind. These adjacent elements, while fused into a single unit sitting on a chassis, maintained their distinct profiles. With the introduction of the closed cab — which became a common feature in the early 1920s — the automobile provided the enclosure of the railroad passenger car.

We can appreciate the automobile metaphorically as a unit of a decoupled train, the individual cars of which have been outfitted with small locomotive engines. Alternatively, we can regard the automobile as a locomotive that has been transformed such that the relative length of the engine and the engineer's cab is reversed and reapportioned. Both interpretations frame the car as a progressive, miniaturized, unitized and autonomous version of a massive precedent.

Advertisers commonly exploited the visual and metaphorical link between automobile and train to sell gasoline, oil, engines and entire automobiles. A typical motif depicts automobile and train speeding in parallel motion, the automobile always in the foreground and the train in the background — diminished in stature through foreshortening. A Union Oil ad from the early 1920s (Fig. 98) depicts freight train and automobile running neck and neck in an unacknowledged contest of related transportation machines. As the machines rush by, an ambulatory sailor — something of an ancient mariner — is consigned to admire this demonstration of power and speed from the sidelines. The tag line, "Union gasoline and Aristo motor oil are to your motor what steam is to the locomotive," renders the analogy explicit.

While this ad represents the idea that the unique significance of the automobile can be apprehended as a function of the train, the ad does not illustrate the urban implications

Figure 98. Union Oil ad from *Motor Land*, 1920. Shows train and automobile as analogous vehicles engaged in an unacknowledged race (San Francisco History Center, San Francisco Public Library).

of this significance. The spatial context for this ad is an open landscape in which both automobile and train achieve maximum speed on the analogously unidirectional and obstacle-free mediums of freeway and rail, respectively.

Still, the implication is that the automobile is a kind of train. It holds its own with the train but offers the intertwined advantages of personal ownership and portability, resulting in an immediate responsiveness. The automobile bestows upon the individual the prerogatives of owning a small train, one with the unusual capacity to transport over any land that is reasonably flat and clear.

In the city, the automobile transports over streets. We can imagine a physical parable of progress that begins with a passenger train pulling into a monumental station — a terminal — situated on the edge of the city. The individual cars detach from one another, transforming into automobiles that literally jump the tracks — on their own steam, so to speak. Like the litter of a large mechanical animal, the automobiles leave the station, scatter, and infiltrate the grid of the city. Not constrained by rail, movement about the grid appears arbitrary, as when automobiles cross paths having followed different routes to the point of intersection.

Eventually, it becomes clear that the automobiles are headed away from the station, in a loose radial pattern. One by one, they reach their respective destinations — buildings dis-

persed unevenly throughout the city grid. Each automobile passes through the façade of what appears to be a train station, appropriately scaled down to accommodate the small offspring. The automobile pulls into the garage.

Within the city, the garage is to the station what the automobile is to the train. The garage is the architectural embodiment of the early automobile, as the train station is the embodiment of the train. Like the automobile, the garage is a miniaturized version of a massive, monumental, and singular parent. Adapting to reflect and accommodate the automobile as an instrument of private mobility, the garage also multiplies and infiltrates the city grid. It is the train station decentralized (Fig. 99).

In his 1927 Traffic Survey for San Francisco, Miller McClintock wrote, "Motor vehicles have no utility to their owners unless it is possible to stand these units of transportation, once the driver has reached his destination."[60] In a dense city with limited street parking capacity and thousands of residential units without private garages, the public garage is essential to the individual's enjoyment of the convenience and flexibility of the automobile. In other words, the garage must follow the automobile, "going" where it goes.

The automobile, along with the wristwatch and radio, exemplified technological advances that increased the autonomy of the individual. Through consumption of these contemporary devices, Americans participated in a mass cultural phenomenon that para-

Figure 99. 10th Avenue Garage, San Diego. Illustrates influence of the train and the station on garage design (courtesy the Buss family).

doxically enhanced privacy, for the individual, for the family, and for the individuals within a family. Gudis alludes to this paradox when she states, "The car had come to symbolize an autonomy otherwise lacking in people's daily lives…. Automobility allowed one to imagine being part of a collective, yet still offered social atomism."[61] One's enjoyment of this paradoxical state encompassed simultaneous public and private dimensions, perhaps best achieved by exposing one's private experience to public view (and envy). Thus, the automobile became a status symbol as well as a symbol of mobility — transporting the owner, as it were, to a state of class fulfillment. Michael Berger observed, "Distance and mobility created a social situation in which people increasingly came to be judged by superficial appearances, and the automobile became a significant contributor to one's image in the outside world."[62]

The garage does not represent an advance in technology, but it is an accessory to the automobile and its symbolism. As such, the building has a supporting role to play in the drama staged to publicize the automobile owner's exercise of privacy and mobility merged. The façade of the garage celebrates the passage of the status symbol, and the building rises to the occasion by accessing its own architectural traditions and symbols of empowerment.

Garage designers found a suitable precedent in the railway station — the architectural correlative and home of the train. In the adaptation, the basic components of the station can still be identified, despite the extreme compression to which these components are subjected. Indeed, a degree of distortion can be expected when a centralized monument is miniaturized into a tiny infill building. Thus, the architectural head building of the train station is flattened into the garage façade, and the engineered train shed is reduced to a common utilitarian shoebox. Although the adaptation suggests a progression from the sublime to the ridiculous, the basic elements function similarly in both urban types.

Significantly, however, the centerpiece of the adaptation — the portal motif— undergoes a profound change of use: instead of framing the passage of people, it marks the comings and goings of the machines. The change cannot be dismissed as value neutral, as the innocuous consequence of infill site conditions. (The typical infill site, with entry limited to a single street frontage, cannot function as an urban gatehouse, which receives machines on one side and people on the other.) Rather, the limited access of the infill site is a condition that dovetails perfectly with the architectural mandate to lionize the automobile (and its owner), but not the citizen or pedestrian.

In this interpretation, the historicist garage reflects a cynicism on the part of designers and their clients, who appropriate the civic symbolism of the train station in order to promote the new status symbol. However, the train station is itself a civic and commercial hybrid — both people's palace and temple of capitalism. When garage designers welcome the passage of machines through composed façades, they seem to be acting upon (or initiating) a reordering of the various mandates emanating out of City Beautiful thinking. Here, the idea that beautification edifies the citizenry and inspires a sense of civic pride takes a back seat to the notion that "beauty pays off." Personal envy replaces collective pride.

As a practical necessity, the designer of an infill garage has no choice but to admit automobiles in through the street front — a concession to reality that also applies to the livery stable, the bike shop and the firehouse. However, the designer — as the agent of the owner and interpreter of the owner's intentions — does exercise choice when deciding upon the architectural treatment of that front. The decision to grace the fronts of parking sheds with well-composed and ornamented façades suggests the execution of a deliberate strategy to exploit the opportunity presented by the infill condition.

As we have seen, architects did not always "play it straight" when acting upon the

mandate to utilize a historically derived architectural language — with anthropomorphic characteristics — to celebrate the machine. The façades at 111 Stevenson (Fig. 67 in chapter 3) and 550 O'Farrell (Fig. 63 in chapter 3), for example, reflect the architect's determination to comment upon the perverse nature of the requirement. In these and other cases, the façades satisfy the mandate, only to subvert it on a deeper and more arcane level. The conflict resolves in the automobile showroom building, a garage that restores the hegemony of the human being over the machine.

Implicit in the idea that the garage is a little station that infiltrates the city grid and receives cars through a portaled front is the further notion that the city street is a forum for automobiles. As Norton makes clear, the auto industry implemented a campaign to promote the idea that cars have a legitimate place on city streets: "...before the city could be physically reconstructed for the sake of motorists, its streets had to be socially reconstructed as places where motorists unquestionably belonged."[63] While the development of the historicist garage façade may not have been explicitly mandated by motordom (unlike the showroom building), the end result is consistent with its aims.

The garage proscenium facilitated and symbolized the displacement of people by automobiles as the characters active on the public stage. Having jumped the tracks, the automobile empowered the driver with the forcefulness of the train and the agility of the pedestrian. What better way to flaunt this achievement than by staging the relevant urban narrative — the procession into (or out of) the train station — but with the automobile replacing the railway passenger as the dramatic star?

While the potency of this development is impossible to experience today, it remains discernible in contemporaneous ads that exaggerate and romanticize that development. A Standard Oil ad from 1927 (Fig. 100) features a diamond-shaped road sign that frames the tag line: "Money Can't Buy a Better Oil Than the New Zerolene." In the background, an automobile approaches the central portal of the Reliable Garage, repository of the New Zerolene. The building is monumental, stable and proud, and — were it not for the sign and the automobile — could be construed as a Mission-style train station. While the Reliable Garage may not elicit feelings of civic pride, it does establish the credibility of the commercial enterprise, the good judgment of the car owner, and the superiority of the product.

The ad's concurrent references to money and reliability also suggest that the building is a bank — another lowbrow type that exploits historically derived styles to connote stability, wealth and prestige. Either way, the ad — targeted to car owners — positions the viewer as a voyeur who desires to become the driver and enact the public spectacle of commandeering a machine through the portal front of a temple.

When interpreted as a contributing member of a building typology, the garage mirrors the sensibility of the automobile owner who — as described by Gudis — regards him- or herself as both an autonomous individual *and* a member of a collective. Within San Francisco the buildings assert a collective identity, yet each one is distinct. In architectural terms, the garages reflect general properties held in common — site conditions, composition, scale and use — while assuming individual characteristics borne of the specifics of site and program. In the city, the automobile owner is dependent upon both the automobile and the garage to facilitate this hybrid sensibility. While the owner may never consider the garage in these terms, its efficacy as a symbol of automobility is increased by the typological condition — the state of being one of many possible related destinations situated within a distinct forum. Similarly, the selection of a particular automobile is a function of personal choice, but once made, the owner participates in a group endeavor.

MONEY CAN'T BUY A BETTER OIL *than* **THE NEW ZEROLENE**

REDWOOD GARAGE

Reason why (OF MANY)
AVAILABILITY A correct grade for your car at Standard Oil Service Stations and 15,000 dealers. The modern oil for modern motor cars.

THE NEW ZEROLENE

25¢ a quart

at Standard Oil Service Stations,
Correct Lubrication Specialists,
Garages and other Dealers

STANDARD OIL COMPANY OF CALIFORNIA

Figure 100. The Mission-style garage illustrated in this Standard Oil ad from 1927 possesses the monumentality of a train station (San Francisco Public Library).

Significantly, the garages are not all situated on Main Street — the thoroughfare at the pinnacle of an urban hierarchy. Scattered unevenly throughout the urban grid, the buildings appear on Market Street (San Francisco's main street), on many downtown streets of comparable size and importance, on arteries leading to the outskirts of the city, and on quiet residential streets. Their dispersal is central to the interpretation of the collection as the

decentralized offspring of a parent building type. The garage's appearance in a variety of neighborhoods and contexts — a simple response to need — signifies the flexibility and convenience of the automobile. Through the common reference to the station type, the distribution also signifies — with a touch of irony — the rigidity of the train. This irony is readily apparent in the garage at 1355 Fulton (Fig. 78 in chapter 3), a building that caricatures a specific Beaux-Arts–inspired train station model.

Today, the historicist garage no longer signifies the flexibility and convenience of the automobile. (In some San Francisco neighborhoods infamous for a lack of street parking, the garage signifies the *inconvenience* of car ownership, standing as a temple of privilege benefiting those few who can afford private spaces.) The ubiquitous private residential garage has rendered this signification obsolete. As a result, the collection has lost a vitality that was a function of use and relevance. Now, few residents of the Western Addition are cognizant of the erstwhile symbolism of the Fulton Street façade.

The loss of this signification is a large contributing factor to the overall disintegration of the architectural collective. No longer linked to one another as accessory symbols of car ownership, the garages become isolated. Each garage — to the extent that it is perceived at all — is experienced as architectural *ground*, one of countless generic vestiges of the past. The gathering together of the garages into a building typology attempts to re-establish the link by emphasizing the architecture as an end in its own right — however dislocated that architecture is from its original significance.

The Garage and Other Dichotomous Building Types

The discussion has thus far focused on the urban train station as a precedent for the historicist garage. However, other building types that closely resemble the garage in scale, infill site conditions, and use also inform our appreciation of the garage. The set encompasses those types that deploy a grand public façade to simultaneously ennoble and conceal the gritty industrial machinery within. Related building types include the electrical substation, firehouse, and car barn. While this book creates an internalized structure around just the garages, that structure is just one part of a broader urban typology that wraps around all of these types.

All of these buildings are products of academic eclecticism. Architects developed their designs as adaptations of common architectural ancestors. Beyond the superficial affinities of style, they reflect the eclectic architect's decision to fuse together *architecture* and *building*. Encountered on the street, the façades communicate the owner's pride in the industrial enterprise, while screening the public from undue exposure to the instruments of that enterprise. This approach identifies these buildings and binds them together.

Despite the basic function common to all — the storage of industrial machines (either automotive or electrical) — each type has a distinct character that represents not storage, but the larger corporate or public enterprise. Between the poles of the highbrow and the lowbrow, the façades exhibit the relative formality deemed appropriate. As a consequence of placing the garage in the context of these related building types, we arrive at a better understanding of dichotomous industrial buildings.

The San Francisco Car Barn

According to electric railway historian Charles Smallwood, the Market Street Railway operated fourteen car barns, half of which were constructed of brick and half of wood.[64] Most were freestanding sheds, larger in scale than the garages. Relevant here are only the smaller-scale brick buildings utilizing classicizing portals to welcome and send off motorized vehicles.[65] These examples include not only car barns, but similarly designed railway electrical substations.

The street railway system brings to the city grid the rigid linear movement and mass transit capability of the railroads long before the infiltration of the automobile and the garage. As a small train shed transplanted from the railway yard to the city street, the car barn anticipates the infiltration of the garage. As storage facilities serving a semi-centralized system, car barns were never as ubiquitous as garages and were often situated at the outskirts of the city. Nevertheless, car barns and garages both allow moving industrial vehicles to pass through their façades. While the streetcar—like the automobile—approaches parallel to the façade and executes a ninety-degree turn to effect a perpendicular entrance (a narrative foretold by the tracks), it lacks the mobility and autonomy of the automobile performing the same maneuver.

Although displaced to the street and exposed to public view, the brick car barn maintains its rugged, heavy presence and utilitarian character (Fig. 101). Brick detailing expressive of construction technology was the norm, including gauged brick arch surrounds, stringcourses and corbelled courses outlining gable or stepped profiles. Many occupied corner sites, revealing simple shed volumes and the fact that front and side walls received equal treatment in terms of architectural vocabulary and brick type. In other words, the concept

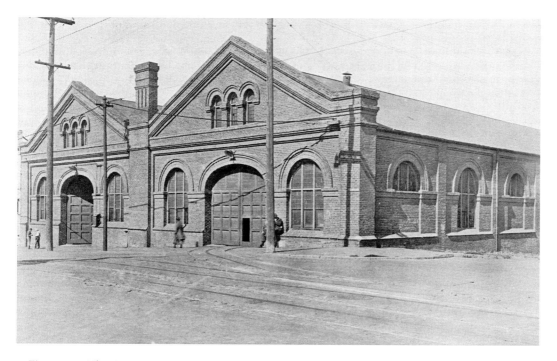

Figure 101. **The Castro Street Barn, built in the 1880s, is designed in the style of Richardsonian Romanesque (San Francisco History Center, San Francisco Public Library).**

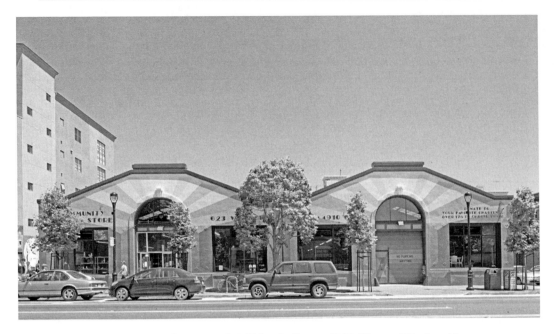

Figure 102. Garage at 623 Valencia Street, 1915 (Sharon Risedorph).

of façade was less accentuated. The Castro Street car barn — a cable car house — reflects the influence of Richardsonian Romanesque, exuding a similar power rooted in the massiveness of masonry construction. A comparison of Castro Street and 623 Valencia (Fig. 102) — both examples are double sheds — reveals the relative sense of weight and mass of the car barn over the garage.

The car barn has its own distinct precedents in the roundhouse and the engine house — the utilitarian sheds of the train yard. The type stays true to its blue-collar roots, seemingly disinterested in the architectural trappings of the station head building or the garage façade. Unlike the garage, the car barn is oblivious to promotional concerns, is not imbued with the spirit of personalized mobility, and has no connection to the emerging car culture. Built over the end of the line, it serves no clientele apart from a crew either coming to port or embarking on a new trip. Unassuming to the core, the car barn even understates its public service role as an essential cog in the machinery of mass transit. The car barn's stolid role is reflected in its matte dusty finish, silent solid presence, and introspective isolation from life on the street.

The Electrical Substation

Substations, disbursed throughout the city, are architectural boxes containing large industrial electrical equipment. Fronting the street, many occupy corner sites or sit adjacent to private alleys — a condition that exposes side elevations and architectural volume. The Jessie Street substation (now the Contemporary Jewish Museum) is the most famous of the city's excellent electrical substations (Fig. 103). As noted in *Splendid Survivors*, "Following the example of Willis Polk's Substation C at 222–226 Jessie Street, the Pacific Gas and Electric Co. became a national leader in that aspect of the City Beautiful Movement which 'beautified' common industrial structures in its treatment of power substations in San Fran-

Figure 103. PG & E Electrical Substation C at 736 Mission Street (originally 222–226 Jessie Street). Willis Polk & Co., Architects, 1907–1909. Currently the Contemporary Jewish Museum (photograph by Haley Hubbard).

cisco."[66] Like McKim, Meade & White on the east coast, master architects in San Francisco — including Polk and Frederick Meyer — took on these industrial commissions.

While related to the garage, the substation is the evolutionary product of a separate architectural lineage within the City Beautiful domain. Functionally unrelated to passage and the triumphal arch, the substation is an adaptation of a Roman temple or — given the monolithic quality — a mausoleum.

In a more contemporary vein, the substation is related to the exposition building, in a manner similar to the link between the garage and the train station. Like the exposition palace devoted to machinery or transportation, the substation is a shell with a monumental exterior and unfinished interior, providing generalized enclosed space for heavy industrial equipment. While the centralized "parent" — train station or exposition palace — welcomes the public, the decentralized garage or substation does not. Polk's landmark on Jessie Street is unusual in its large size and exposed brick.[67] Most are smaller structures of reinforced concrete faced in stucco, and appear as miniaturizations of larger prototypes.

As subtypes within a typology of urban utilitarian/historicist buildings, the garage and the substation — along with the other subtypes — engage in a dialogue regarding the extent and character of the architectural dichotomy separating inside and outside. The substation must isolate the electrical equipment as a matter of public safety. Polk, Meyer and Frickstad (an in-house architect for Pacific Gas and Electric) respond to this requirement by elevating the dichotomy to the status of architectural antinomy. Sober, monumental exteriors and Piranesi-like interiors co-exist in a state of dialectical opposition, the exterior focused exclusively on the representation of the client to the public, the interior determined solely by the dictates of efficiency and utility (Fig. 104).

PG & E pursued this version of the dichotomy consciously. Referring to the building exteriors, Frickstad wrote, "The appearance of all that was to be in evidence to the eyes of the public should be pleasing and capable of inspiring confidence in the company's strength and ability to deliver perfect service."[68] This design intention is generally consistent with the utility's efforts to restore its tainted reputation following the revelation that it had offered political bribes during the reign of Abe Ruef. With respect to the relationship of exterior to interior:

> The "City" type [of substation] has developed as a windowless building, as it has been found that a windowless building gives the maximum economy in arrangement, that it provides unbroken wall surfaces which are needed for attaching various parts of the installation, and makes possible the insulation against the noise of the station operation disturbing the neighborhood in which it may be located.... This has given the designer an opportunity to treat wall surfaces with but one opening to consider. This is the main entrance and is treated as such by the concentration of ornament at this point.[69]

The eclectic architect's skill in designing the windowless building manifests itself in the artful manipulation of the remaining historically derived (and opaque) elements at his or her disposal. A typical solution is a symmetrical composition centering on an oversized door (Fig. 105). The door is set in a monumental frame, composed of paired pilasters supporting an entablature, often with a sculpture group above. This frame is superimposed on

Opposite, top: Figure 104. Interior, PG & E Electrical Substation C at 736 Mission Street. Willis Polk & Co., Architects, 1907–1909 from *Architect and Engineer,* 1915 (San Francisco History Center, San Francisco Public Library). *Bottom:* Figure 105. PG & E Electrical Substation D at 1345 Bush. Willis Polk & Co., Architects, 1912 (photograph by Sarah Chan).

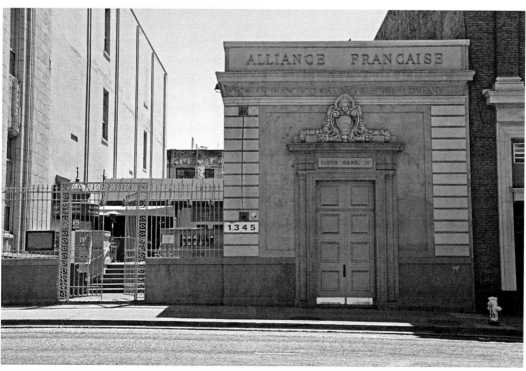

a larger frontispiece with "corner rustications" flanking a blind recessed panel. The doorway interrupts the base upon which the rusticated columns rest. While these façades establish elaborate symmetries around a door, that door intimidates and repels, offering the reception of a hostile fortress or house of the dead.

Polk received national acclaim for his substation designs in *Architecture Record*. Referring to Polk's substation in Sacramento (also for PG & E), the critic wrote, "That there should be any architecture at all in such a building, however, is vastly commendable.... It is doubtful if any other architect has come so near vanquishing the unesthetic in this purely utilitarian type of building."[70] Both the San Francisco substation and the central compound of the Exposition exemplify Polk's willingness to create starkly different domains between interior and exterior. These utilitarian building types offer rare opportunities to demonstrate City Beautiful ideas, and Polk did not hesitate to design civic monuments around power generators.

As in the relationship of the garage and the train station, the electrical substation first establishes continuity with the exposition building, and then subversively exploits the connection to assert its own unique significance. (This process exemplifies the eclectic architect's creation of an "evolutionary architecture.") While the exposition building operates in a festive atmosphere and invites the masses to enter and marvel at the achievements of industry, the substation spurns the masses and jealously conceals those same achievements. As a holistic architectural statement, the building advertises the authority of the monopolistic utility company, both in the civic grandeur of the building exterior and its presence as a locked vault on the street. Even the neo-classical bank — another architectural vault — welcomes its customers inside.

Representing an extreme and pure form of dichotomous architecture, the substation rigidly separates a building's public symbolic program from its actual use. The difficulty and absurdity of this condition crystallizes in the oxymoronic door — a symbol of passage that admits no one. While the composition amplifies the significance of the door, the super-human scale of the element and its wall surround are daunting.

It is this aspect of the substation that enables us to arrive at a deeper appreciation of the garage. Both building types resort to a dichotomous strategy in order to enable rhetorical and idealizing signs and symbols to be communicated to people on the street, unsullied by the artless spectacle of structure and mechanical function. In both building types, the distorting influence of machine-oriented building programs on a humanistic architectural language is revealed. While the garage substitutes the machine for the human being as the moving object that is framed by its portals, the substation dispenses with passage altogether, its machinery already ensconced within. In this regard, the overscaled garage door void is the opposite of the substation oversized door: the former is always open and the latter is always closed.

The contrast demonstrates that the garage is essentially interactive despite its dichotomous nature. Its historicism is actively engaged in beckoning and celebrating the motorist, in addition to aggrandizing the enterprise and the culture to which the garage belongs. While *architecture* yields to *building* just inside the entrance, the two collaborate on the intended seductions. The façade and interior of the substation do not interact in a comparable manner. Rather, they inertly dictate a separation that leaves the character, layout and functioning of the interior a matter of speculation and mystery.

The San Francisco Firehouse

San Francisco's splendid firehouses—those built after the fire and through the U.S. entry into World War I—reflect both the success of the city's rebuilding effort and the quick transition from a horse-drawn to an automotive technology. The firehouses built in the aftermath of the catastrophe, designed by city architect Newton J. Tharp, feature two- or three-story façades on narrow, 30-foot-wide lots. The façades express the functional arrangement of dormitory above and "apparatus" storage below. Thus, the composition presents stacked sections, with lighter upper floors supported on a base. All sections are tripartite, and ultimately center upon a prominent—usually arched—portal that is carved out of the base. These buildings first accommodated horse-drawn vehicles and were converted to accommodate motorized technology a few years later.

A second wave of firehouse construction occurs between 1914 and 1917, the buildings designed by Ward & Blohme or John Reid, Jr. These buildings are designed for automotive engines and trucks and usually for larger companies. Typically, Tharp's compositional template is adapted to wider lots by incorporating additional arched portals downstairs and dormitory windows upstairs. Efficiency demands that lot width be exploited to provide as many vehicular bays as possible, each portal providing independent street access for an engine or truck. As a result, the ground floors of these firehouses may include one, two or three portals.

The fire department's need to rebuild and modernize itself in the years following the earthquake (twenty firehouses were destroyed) coincides with the widespread acceptance of the automobile, nationally and locally.[71] While the firehouses discussed above precede the explosion in garage construction that began in the early 1920s, automotive garages did appear concurrently. A lowbrow historicist firehouse graced the Exposition grounds, the façade serving as a stage set for some dramatic photographs of glistening fire engines (Fig. 112 in chapter 6). By 1917, just two years after the Exposition, there were several monumental garages and automotive-based firehouses in San Francisco.

The two building types share the portal as the focal point of an elevation that is composed, compact, symmetrical and ornamented. These proscenia highlight the comings and goings of automotive vehicles, both passenger cars and fire engines. While garage fronts devote vehicular openings to either ground floor access or ramps, firehouse openings unilaterally access ground-floor bays. Despite the considerable overlap, contemporaneous garage and firehouse façades diverge most often in overall proportions and parapet profiles. Although there are wide firehouses with three portals across the ground floor, the typical firehouse is slender and presents a more upright appearance than the typical 1910s garage. While the parapet of a brick box garage usually crests (to conceal the shed), the firehouse parapet is typically flat. However, the two building types are fundamentally dissimilar in a subtler vein that reflects the stature, reputation and mythology surrounding their respective uses.

Tharp's firehouses are adaptations of earlier Victorian firehouses that also occupied narrow lots and featured residential quarters above the animals and the equipment. Compositionally, the façades are quite similar. However, these antecedents are rendered in wood and appear more residential in character (even though they present a pointedly non–Victorian symmetry). Tharp reinterpreted the composition in a Beaux-Art mode, replacing Victoriana with the formal vocabulary of a French hotel. He transformed the neighborhood firehouse into a miniaturized civic monument, and dressed it up for downtown.

This representation was appropriate for a department that performed heroically in the fire, and that relished the opportunity to re-establish its authority in the rebuilt city. Clarence R. Ward, who designed several of the new firehouses (as well as the Machinery Building at the Exposition with partner J. Harry Blohme) made an explicit connection between the heroic figure of the firefighter and the distinguished bearing of the façade:

> As it is with the soldier, so it is with the fireman, the more comfortable and cheerful his environment the more keen and capable he is for his dangerous work.... It has been found that if an effort is made to give the exterior of these houses some semblance of architectural dignity or beauty, the dwellers (the fireman practically lives in the firehouse) become imbued with a certain pride in their particular house, as one might have in his home.[72]

On a superficial level, the firehouse and the garage are both transportation storage buildings. For the academic eclectic architect, this circumstance provides a sufficient basis upon which to access the triumphal arch motif, and exploit its symbolism to announce the transition from inside to outside. However, of the two building types, the firehouse has an elevated civic status, as it shelters the "fireman" who risks life and limb to rescue citizens in distress. Surely, the department was held in especially high esteem in the aftermath of the fire. Although Ward likens the firehouse to the home, he emphasizes "dignity" rather than domestic comfort.

When garage and firehouse are compared as architectural symbols of either the vehicles or the people served, the garage is revealed to be a commercial structure, with no equivalent combination of moral underpinning and civic purpose. Relative to the firehouse, the garage is a less heroic structure, even when regarded in its most favorable light as a symbol of automobility and urban decentralization. While the garage façades may symbolize the city's gratitude for the automobile's exceptional performance in 1906, the garage owner has an economic incentive to inspire this reflection. Despite the commonalities in architectural language, material palette and basic purpose, the firehouse is a temple of public service and personal sacrifice, while the garage is a temple of private prerogative and personal freedom.

The contrast between the meaning of the garage and firehouse is evident upon a comparison of façades, as exemplified by the garage at 242 Sutter Street (Fig. 106), and Engine House #17 at Mint Avenue—both demolished (Fig. 107). These buildings are exemplars of their respective types, built within a year of one another (1916 and 1917) and designed by elite architectural firms (Heiman and Schwartz, and Ward and Blohme, respectively).

Both façades are typical in overall proportions and composition. Solidity, balance and tectonic integrity are shared characteristics. However, the engine house is the more elegant structure, a function of superior materials and detailing (but not design skill).

The garage façade is rough and grainy, courtesy of the relatively clunky brick employed. In contrast, the engine house imparts the dense and refined character of its smaller and more precise pressed brick. While the garage façade includes some contrast in the form of marble lintels and terra cotta inserts, the major historicist details are reliant upon—and expressive of—brick craftsmanship. At the engine house, all of the major stylistic devices are rendered in finely ornamented terra cotta, marble (second floor columns), and glazed tile. Lastly, the garage façade is flat—it awkwardly fails to project the gabled frontispiece in front of its flanking wings. By contrast, the central block of the firehouse gets a solid backdrop against which moldings and cornices return and resolve.

While the firehouse symbolizes the ability of the city to protect itself in its rebirth, the garage represents the status and aspirations of the individual who can afford a car. The car

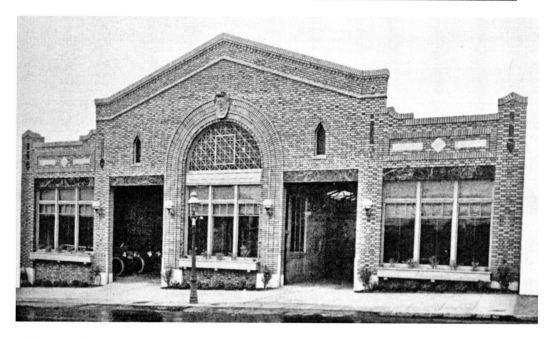

Figure 106. Garage at 242 Sutter Street (demolished). Heiman & Schwartz, Architects, 1916 from *Architect and Engineer*, 1916 (San Francisco History Center, San Francisco Public Library).

promises independence, mobility, travel, and relative mastery over space and time; the fire engine displays a similar mobility, but one reserved for desperate races against time and nature. Expressed on the firehouse façade is the firefighter's mission — sober, heroic and tinged by the recent memory of the inferno. By contrast, the symbolic mandate of the garage façade is frivolous — to express the elitism and choices of the upscale, urban car owner.

The number of automobile garages in San Francisco exceeds the total of electrical substations, car barns and firehouses combined. The tally reflects both the popularity of the automobile (and the scarcity of parking) and the qualitative difference between commercial and public or quasi-public enterprises. With the exception of the garage, the dichotomous building types discussed here are undertaken without entrepreneurial motivation: they are necessary expenditures required to maintain a system that delivers citywide services. Generally, they are built to serve a contributory area, and not to compete for business. The industrial products housed within these structures may be stationary or automotive, but they are the property of the city, utility or public franchise — not the individual. While the public benefits from the services provided, and even — in the case of the streetcar — directly interacts with the machinery, citizens have no reason to enter the buildings.

These other building types are experienced uniquely as working satellites — physical manifestations — of civic institutions that may or may not have a centralized architectural presence. They are functional City Beautiful monuments that attest to the diligence, competency and power of the sponsoring agency. Within this broad symbolism, each type conveys a more specific message emanating from its use, and the particular dynamic between building, machinery and street.

Thus, the car barn is the least allusive and engaged with the public, a consequence of its rail yard provenance. One step beyond the "last stop," the barn receives a conveyance devoid of passengers. The electrical substation is the most monumental and funereal, its

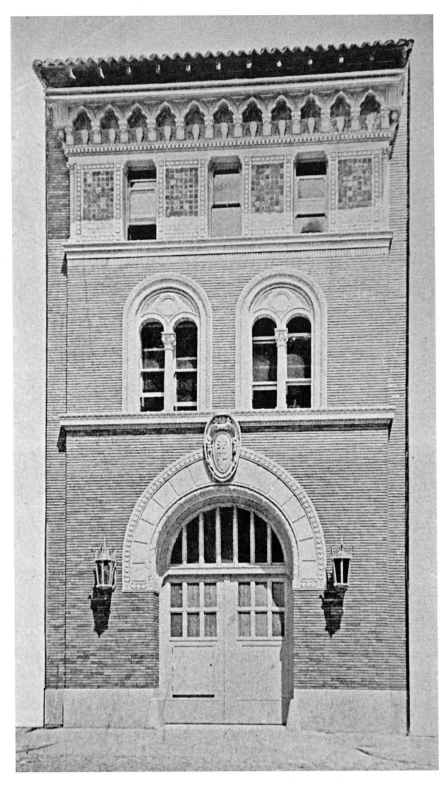

Figure 107. Engine House #17 at Mint Avenue. Ward & Blohme, Architects, c. 1917 (San Francisco Department of Public Works Albums, San Francisco History Center, San Francisco Public Library).

allusive classicism seems to compensate for its utter inaccessibility. Most akin to the garage is the firehouse: its doors are open, its dynamic vehicles are admired from outside, and its façade exerts a dignified presence on the street. However, the exuberant, idealistic and heroic stature of the firehouse — a potential source of affinity with the garage — is tempered by the fact that these characteristics symbolize the dangerous mission of the firefighter and not the optimism of a newly empowered consumer.

Chapter 6

The Panama-Pacific
International Exposition

Thus far, the historicist garage has been analyzed as a building type, and as a subset of a larger urban typology composed of historicist dichotomous buildings fronting on San Francisco streets. In addition, the garage has been described as an adaptation of the great urban train station — the net result of an "evolutionary" design process initiated to accommodate the automobile. Attention now turns to the architecture of the Panama-Pacific International Exposition, and the influence of this apparition on the San Francisco garage.

The Exposition stood in San Francisco for nine months in 1915, on the site of what is now the Marina District. Known as the "Walled City," it presented a compact imperial fantasy of towers, domes, portals and cloistered courts. Built to stand temporarily, the architecture featured plaster-on-wood simulations of an imagined and romanticized antiquity. Maybeck's Palace of Fine Arts, a beloved landmark and the one major structure to survive, decayed severely and was rebuilt in concrete in 1965.

Polk and other architects involved in the planning saw in the Exposition an opportunity to realize the City Beautiful on a small scale. The plaster exterior — the site of this realization — was pointedly dislocated from structure, enclosure and interior development. While this dislocation was in part a byproduct of the temporary construction technology, the architects welcomed it as a means of separating the City Beautiful demonstration from the interior exhibits. Motivated to insulate their model city from the impurities of crass commercialism and industrial production, they devised a site plan that reinforced this separation.

If the architects of the main group of buildings (the "compound") ever subscribed to the academic cliché, "you may decorate your construction, never construct your decoration," they abandoned it with stunning aplomb. The disintegration of architecture into distinct tectonic and non-tectonic realms undermined the integrity of the ostensibly monumental exterior. Whatever its merits as an example of the City Beautiful, the Exposition was brilliant and innovative as an expression of dichotomous architecture.

In San Francisco's development of a dichotomous architecture, big business was the bridge that spanned civic pride and industrial production, Architecture and mere Building. Historians Issel and Cherny describe a political culture in San Francisco dominated by an elite core of businessmen who exercised considerable influence over local government, assuming a highly visible presence as decision-makers in public affairs. This group, centered on James Duval Phelan and William Henry Crocker, "shared the conviction that profitable business and urban progress went hand in hand."[1]

This business elite had its counterpart in the group of San Francisco architects who redesigned the downtown in the years after the fire, and designed the Exposition.[2] The

shared sense of *noblesse oblige* that binds the businessmen and the architects is captured in the following address delivered by Phelan to the Architectural League of the Pacific Coast in 1909:

> The future of the beauty of San Francisco is yours. You are the high priests of architecture, and it devolves upon you to direct the public in the work which would result in their mutual benefit. You are the priests at the altar of beauty. If you can elevate the minds of the people to mutual benefit in that sentiment which is true, then everything will be easy. The city as a community will progress in lines of business and beauty....[3]

In 1904, Phelan and other members of this business elite commissioned Daniel Burnham, the man responsible for the White City in Chicago and the McMillan Plan for Washington, DC, to prepare a city plan for San Francisco.[4] Highly anticipated in the days before the quake, the Plan applied City Beautiful design concepts to San Francisco's geography and layout. It called for a formal civic center and the superimposition — onto the existing city grid — of new parks and diagonal boulevards linking key city sites.

When the earthquake struck, lofty notions of "urban progress" took a back seat to the urgent need to quickly and efficiently rebuild the city. To the disappointment of many, the Plan was set aside. Polk was particularly disappointed, having personally "volunteered many hours to assist in [the Plan's] preparation."[5] Just months after the disaster, Polk spoke of a future world's fair as a means to rejuvenate the scrapped Burnham Plan.

Polk published his thoughts in an essay entitled "The City Beautiful."[6] Indeed, support for the movement's goals and admiration for Burnham framed Polk's view of the Exposition as first and foremost an exercise in city planning. Plus, as the movement generally embraced Expositions as a means of demonstrating its aims,[7] there was precedent for envisioning the Exposition as a stand-in for the Burnham Plan.

The same businessmen who led the rebuilding effort also organized and promoted the Exposition. (This included members of the local automobile industry, like a Studebaker executive who displayed blowups of the Exposition button in his showroom windows.)[8] In this regard, earthquake and Exposition served as bookends of a protracted building campaign, the one initiating the campaign in motion, the other a self-congratulatory pat on the back for a job well done. As a miniaturized city that demonstrated the formal design principles promised by the Burnham Plan, the Exposition was reified as a counterweight and antidote to the catastrophe that derailed the Plan. The Exposition therefore carried considerable symbolic weight, a load that stood in inverse proportion to its light physical weight, low budget, speedy construction and short duration.

The Site Plan

City leaders viewed a world's fair as a vehicle for broadcasting San Francisco's re-emergence as a world-class city. They led a successful campaign before Congress to have San Francisco selected as the host of an exposition commemorating the completion of the Panama Canal. With this theme in tow, the exhibits and architecture were ostensibly united in representing the march of human achievement culminating in the Canal. In fact, the architects entrusted with designing the fair approached the exhibits and the architecture as distinct, if not incompatible entities. They generated a site plan that bifurcated the experience of the Exposition into two separate and unequal domains — an ornate architectural exterior and a rough utilitarian interior (for the exhibits). In Vitruvian terms, they disintegrated

beauty from structure and function, assigning beauty an exclusively exterior role. The effectiveness of this strategy is implicit in the following assessment offered by artist and teacher Eugen Neuhaus:

> It is generally conceded that the essential lesson of the Exposition is the lesson of art. However strongly the industrial element may have asserted itself in the many interesting exhibits, no matter how extensive the appeal of the applied sciences may be, the final and lasting effect will be found in the great and enduring lesson of beauty which the Exposition so unforgetably [sic] teaches.[9]

The design of the compound has long been hailed as a success (Fig. 108). For example, Jordy wrote:

> The Panama-Pacific Exposition was overall among the best designed of American Expositions. Its quality owed much to the decision to design the major part of the Exposition as, in effect, a single building with three large interior courts. Hence the individual architects were given "courts" rather than "buildings" to design.[10]

While architectural luminaries like McKim, Meade & White, Louis Christian Mullgardt, Henry Bacon and George Kelham designed the courts, "The construction of the buildings, behind the architectural decoration of the walls, was left to the engineers of the Division of Works."[11] The courts were composed of exterior planes fronting portions of the four surrounding palaces. Exhibits were confined to the palace interiors, the designs of which were delegated by the architects to the in-house engineers.

Historical geographer Gray Brechin commented on the figure/ground reversal of the

Figure 108. Plan, Panama-Pacific International Exposition, showing major group of palace buildings (San Francisco Ephemera Collection, San Francisco Public Library).

plan, "...in which space becomes the positive element and buildings simply a neutral infill."[12] The pure shapes of the courts were superimposed onto the otherwise regular plan configurations of the palaces, establishing the courts as "figures" and the palaces as "ground." All exterior architecture was generalized and reclassified as "wall," "court," or "tower"—but not the autonomous "building." These exterior elements were exclusively rendered in the ornate, monumental forms of Beaux-Arts–inspired, Mission, or Neo-Gothic styles. Figural, iconic, colorful and decorative, the exterior assumed the perceptual priority described by Neuhaus as the "final and lasting effect" of the Exposition.

Conversely, all interior architecture was generalized into eight basilicas devoted to Food, Education, Agriculture, Liberal Arts, Transportation, Manufactures, Mines and Metallurgy, and Varied Industries. Subsumed within the integrated whole of the compound, and reduced to infill, the plan cleverly obscured the perception of freestanding buildings devoted to a single theme. From the ground, the basilicas were somewhat concealed, reduced to portals that either interrupted the surrounding wall of the compound, or were integrated into the architectural screens that surrounded the courts.

As a formal sequence of contained, adorned and symmetrical spaces nested deep within the compound, the courts possessed the quality of "interior" rooms *en suite*. Architect and critic B.J.S. Cahill referred to this inversion when he wrote: "The whole scheme is the reverse and opposite of the usual one, bearing in a curious way something the relation that a negative photograph does to a positive print."[13] The actual interior space—the enclosed space within the palaces—became relegated to a third tier, preceded by the primary experience of the compound and the secondary experience of the courts. Conceptually, the palace-bound visitor to the Exposition was forced to push beyond the "normal" architectural sequence of exterior and interior in order to access the exhibits.

In this interpretation, entering the palaces is like breaking into architectural *poche*—the inked portions of architectural plans and sections that represent inaccessible, solid construction. In wood-frame construction, this procession is akin to entering a giant interior wall cavity. Indeed, the detailing of the interior is consistent with this interpretation (Fig. 109). Like the interior of a stud wall, the palaces present structure as subservient to exterior profile. The rough lumber appears makeshift and temporary, qualities that expose the sham of the simulated permanence that holds sway on that *other* inside, the courts. To the architects, the interior enclosure was not intended to possess architectural merit—it was valuable only as a warehouse for pavilions, exhibits and industrial products. This reasoning explains the architects' decision to hand off design responsibility for the interior architecture to the engineers.

The products of technology and industry were housed in these rough, cavernous interiors. While the details were clumsy, the building shells possessed an integrity rooted in the exposed wood structures. The appearance of regular structural bays composed of built-up columns, bowed trusses, cross-bracing and rafters imparted a clunky rationalism similar to other common engineered transportation structures, like bridges and train sheds.

In essence, the courtyard architecture reproduced a condition typically encountered on city streets: façades with doors in them define public exterior space while concealing the architectural volumes behind. This condition facilitated the architects' central goal: the liberation of Architecture from material and mercantile interests, and its ascent into the realm of "sublimity." For Polk, the potential for greatness was not a function of program, structure, interior development or the exhibits; it resided in the relationship of the exterior to the natural setting:

Figure 109. Palace of Agriculture, 1915 (courtesy Bancroft Library, University of California, Berkeley).

> The brilliant sunlight permits of the widespread use of color on the structures; the sea, the hills, and the endless vistas call for majesty of outline, and inspire the architect to meet nature, which has challenged him by reason of the sublimity of her settings; here he must fashion his designs to scale with and fit into the majestic surroundings that nature has provided.[14]

This vow to produce architecture that rises to the challenge of majestic surroundings reflects the architect's noble mission and unique burden — to create art as sublime as nature. The statement reads like a direct response to Phelan's call to arms: "The future of the beauty of San Francisco is yours."[15]

The site plan permitted Polk and his group to pursue this lofty goal by disentangling the architecture from the commercial and educational aspects of the program. The goal and the strategy for achieving it is summed up in Polk's August 1915 address to the Commonwealth Club: "It was this motive, the city planning motive, that inspired my interest in the Exposition. I did not care anything about the buildings, but the city planning business is really a serious thing."[16]

Indeed, city planning was a "serious thing" in San Francisco, a city forced to postpone the fulfillment of its design destiny courtesy of a calamitous earthquake and fire. The statement reflects Polk's loyalty to the Burnham Plan and his gratification in helping to bring

to fruition an Exposition that incorporates some of the Plan's major compositional principles.

Allegory

Another principle of the City Beautiful movement to which the Exposition architects subscribed was collaborative work with sculptors and painters, under architectural leadership.[17] The architects and artists coordinated and produced a pedantic collection of allegorical art, with themes supposedly derived from the crowning achievement of the Panama Canal. Programmatic content included the meeting of East and West, evolution, and technological progress. There was also a ubiquitous undercurrent of sexism, racism, Social Darwinism and a glorification of aggression.[18] The work—especially the sculpture—figured prominently, positioned atop or within portals, triumphal arches, monumental columns and pools. Major pieces served as focal points of formal axes, or formed symmetrical frames about those axes.

The allegorical art bolstered the legitimacy of the architecture by providing literary content to stage sets that were architecturally weak, unmoored from structural considerations. To the architects and artists, the allegorical program enabled the exteriors to vie with the palaces as destinations worthy of "contemplation." The decision to isolate the fruits of artistic collaboration from the exhibits was made self-consciously and even with a hint of contempt. Exposition historian Frank Morton Todd reports that Karl Bitter, the original Chief of Sculpture, expressed the following opinion to his colleagues:

> [The sculpture] should not be massed all in one place, nor put where people would not see it until after they had wearied themselves with overmuch contemplation of sewing machines and cream-separators, but should be well distributed, in attendance, artistically, on the architecture.[19]

Bitter's statement reveals one primary motivation for devising a scheme assigning formal and sequential priority to the exterior and the courts. Anxious at the prospect of competing with the industrial exhibits for attention, he looked to the design to ensure that visitors encountered the sculpture first.

The creative team's perception that the exhibits and the art and architecture would compete for attention reflected a divergence in the reasons for holding the Exposition. While the Panama Canal gave a unifying theme to the enterprise, powerful sub-texts lay just beneath the surface. The Exposition provided a forum for business and industry to promote its ascendancy and its wares—which follows from the notion that a world's fair is primarily "a phenomenon of industrial capitalism."[20] At the same time, the Exposition represented San Francisco's physical reconstruction and re-emergence onto the world stage, accomplishments generating a surge of local civic pride.

For city leaders performing double duty in business and politics, the commercial and civic goals of the Exposition were inextricable. However, the architects regarded themselves as members of a professional elite charged with the City Beautiful mandate to edify the masses through art. They gravitated to the civic realm and tolerated the commercial, a concession to the movement's conviction that "beauty pays off." The site plan reflected the architects' convictions, and the evidence suggests that the architects were successful in prioritizing the exterior. Todd wrote:

The whole picture was a composition of courts, towers, gardens, and fountains, which, properly worked out, would make a place where people that loved beauty could delight themselves indefinitely without setting foot in a building.[21]

More pointed were the introductory comments of Commonwealth Club President Beverly L. Hodghead, delivered at the meeting on August 11, 1915 (and reproduced as they appear in the published minutes):

Now these international Expositions or world's fairs, have, by very high authority, been described as the time keepers of the world's progress. In past Expositions, the central attractiveness has quite generally been in their art, and that rule has not been changed here except that the motive has, in a measure, been shifted from the inside to the outside. This Exposition would be a success if it did not have any exhibits at all. (Applause.) It is probably the first where persons have formed a habit of attending frequently without visiting the interior.[22]

Hodghead invoked "progress" when praising the exterior architecture, although progress resided more convincingly in the technological and industrial spheres of the interior exhibits. While the architects and their supporters sought to focus attention on the architecture as the central accomplishment of the Exposition, the public was indeed responsive to exhibits and activities devoted to industry — especially in transportation. In hindsight, the public's interest was neither frivolous nor temporary (like the architecture), but rooted in the advance and impact of the automobile and the airplane.

Even before the Exposition opened, the automobile industry promoted the connection between the fair and the automobile. On July 15, 1914, the California State Automobile Association (CSAA) sponsored a parade of cars (a common occurrence in San Francisco) to celebrate the completion of the Palace of Transportation.[23] The parade route tied together the city's primary transportation architecture, including its major hub (the Ferry Building), Auto Row (Van Ness Avenue) and finally, the Palace of Transportation.

Ford operated an assembly line within the Palace of Transportation (Fig. 110), which Todd deemed "one of the main show places of the Exposition. Every afternoon hundreds of visitors lined up along the guard rail and watched the process as though life depended on it."[24] On "Auto Day," another event organized by the CSAA, 5000 cars paraded down Van Ness Avenue to the Exposition.[25] There was a racetrack on the fair grounds, and on February 27 more than 65,000 fans endured the rain to watch the first International Grand Prix.[26] A week later 100,000 people attended the Vanderbilt Cup race.[27] (The day before the race, the *Chronicle* led with the headline, "Speed Demons Are Keen For Vanderbilt Cup."[28]) Famed aviator Lincoln Beachy flew acrobatic flights over the fairgrounds. When he crashed his plane into the bay and died, the acrobatic program did not cease, but was taken up by Art Smith.

The site designers achieved success in the emphatic separation of interior from exterior architecture, commerce from art. However, automobiles routinely violated this separation, as if emissaries from Ford's assembly line were dispatched to the exterior upon completion. While the fairgrounds included a track that formed an autonomous closed loop, the course for the Grand Prix and Vanderbilt Cup races extended beyond this loop, exploding onto the pedestrian thoroughfares surrounding the central compound. Most of this course was laid in asphalt — a "new road condition" that promised to be "fast and easy on tires."[29] Only ropes separated spectators from the speeding automobiles. Viewed in the context of the Exposition as a microcosm and symbol of a reconstructed San Francisco, this scenario romanticizes and celebrates the evolving impact of the automobile on the city.

Figure 110. Palace of Transportation, showing automobiles rolling off the on-site Ford assembly line (San Francisco History Center, San Francisco Public Library).

The photographic record of the Exposition includes many shots juxtaposing automobiles and buildings. In one, famed racecar driver (and future aviator) Eddie Rickenbacker sits at the wheel of his Maxwell racecar, smartly posed in front of the Tower of Jewels (Fig. 111). The two objects are dynamically linked in a representation of passage that approaches the surreal: An awkward caricature of a Roman triumphal arch proudly rests after accommodating the penetration of the Maxwell. Instructively, the automobile is some distance from the tower, and is not positioned on axis with the archway. The arrangement emphasizes the autonomy and agility of the car, which negotiates and impels its own movement through the arch to arrive at this particular position. Metaphorically, the photo captures the interpretation of the automobile as a small train or locomotive that has liberated itself (and its driver) by jumping the tracks and exiting the station through the front portal.

Another image depicts the façade of the Exposition firehouse, with fire engines rakishly positioned beneath each of the three arches, as if executing a coordinated exit (Fig. 112). One of several photographs of the Exposition fire company, the scene is similar to countless portraits of American fire companies posing — with their equipment — in front of firehouses. Usually these photographs are taken frontally, resulting in static and stable compositions. Here, the angle emphasizes the repetition of a motif — the one-to-one correspondence of

Figure 111. Eddie Rickenbacker (in white) in a Maxwell racing car, in front of the Tower of Jewels, 1915 (San Francisco History Center, San Francisco Public Library).

arch and vehicle. Although the trucks are stationary, the implication of passage, and the power of the arch to celebrate that passage, is clear.

These photographs suggest an intimate bond between cars and archways, as objects enjoying a mutually beneficial relationship. The bringing together of the seemingly very old and very new in an updated reenactment of the ancient ritual of passage is both compelling and satisfying. In the staged isolation of drivers, automobiles and portals from all else, the images engage in a verisimilitude that seeks to persuade of the inevitability and correctness

Figure 112. Firehouse in the South Gardens of the Exposition, 1915 (San Francisco History Center, San Francisco Public Library).

of this bond, as if timeless. They also confer upon the automobile a special status as an approved representative of the industrial products normally confined to the palace interiors; the car is a fit denizen of the classical fantasy.

In order for these images to persuade, the viewer must hold certain realities in suspension. The fantasy requires the viewer to momentarily agree that the architecture is older and more permanent than it really is — a precondition to the thrilling possibility that ancient culture and modern technology have collaborated for his or her amusement and advancement. The invitation to participate in the staged drama by contributing one's suspension of belief is enticing, and therefore a valuable part of the promotional strategy. At the Exposition, the architecture promotes a classical brand that stands for a continuity of progress extending from imperial Rome to present-day San Francisco. In the specific case of the automobile — that emissary of industry welcomed into the light of day — the arched portals bestow their authority and stature upon the updated chariot, signifying the endorsement of Western culture.

The influence of the Exposition on the garage was symptomatic of its influence on the architecture and infrastructure of the entire city. To accommodate thousands of anticipated visitors, government and private entities commissioned a host of architectural, civic and infrastructure improvements. The list included new housing in the Tenderloin, the Exposition Auditorium (and planning of the Civic Center), the Southern Pacific train terminal,

pier buildings on the Embarcadero, and the Stockton Street tunnel (which then served streetcars). The major buildings and improvements functioned as satellites of the Exposition itself, extending its reach into the city grid, in terms of use, imagery and symbolism. Stylistically, these facilities employed the same eclectic mix of Beaux-Arts classicism and Mission-style monumentality. Thus, while the Exposition Auditorium and the Stockton Tunnel perform widely different functions, they both support the Exposition and refer to it visually through the utilization of a portal motif on their respective façades.

Together with the Ferry Building and the evolving Auto Row on Van Ness Avenue, the Exposition and its related satellites define a web of architectural landmarks superimposed onto the layout of the city. The automobile parades advancing from the Ferry Building to the Exposition bring strands of this web to life, animating a linear path through the city, from hub to hub. Double-decker buses carrying fifty passengers also serve this route.[30] The showrooms on Van Ness Avenue, and the model cars facing the street from within, bear witness to the automotive procession outside — effecting a solipsistic spectacle that infuse the architecture and the automobile with the anthropomorphic ability to observe. While the streetcar system constitutes the majority of mobile lines to the transportation network, it is automobility that eventually captures the public's imagination. Symbolically and spatially, the historicist architecture of this era frames and supports the public's engagement, even as this same constellation of buildings and cars contributes to horrific congestion.

Individual garages are too minor in scope and capacity to qualify as "hubs" in the transportation system that quickly coalesces around the Exposition. However, in the metaphor of the garages as the decentralized litter of a great urban station, the buildings assume a collective identity as a specialized piece of the transportation network. Today, San Franciscans' recognition of the buildings as an urban typology — and not as discrete structures — is a precondition to appreciating their significance in the life of the city.

The Walled City and the historicist garage are both examples of a dichotomous architecture that expresses its civic and commercial aspirations through the draping of a classically inspired mask over a utilitarian container. The shared architectural organization (historicist façade over utilitarian interior), urban setting and historical context provide the basis for the lowly garage to piggyback onto the significance of the Exposition, as a symbol of the city's renaissance, cultural sophistication and embrace of technological progress. These meanings are overlaid onto the established meaning of the garage as an accessory status symbol of the automobile.

At the Exposition, the contrasting natures of interior and exterior worked in tandem to support the fair's brief lifespan and simulation of timelessness. On the one hand, the exterior was a masterful demonstration of City Beautiful formal order and planning — monumental, imposing, and all encompassing. On the other, it was architecturally insubstantial and frivolous — seeming to flaunt its independence from the structural system implied by its classical forms. While the compound achieved the absurdity of a stage set through the revelation of interior scaffolding, the garage managed comparable effects through the flattening of the same historical forms into two-dimensional caricatures.

The Exposition architecture offered an immediate precedent, an invitation to designers of lowbrow dichotomous building types to mirror its monumentality, presence and confidence. While the symbolic program of all these building types naturally gravitated to the exterior, the Exposition presented a more complete separation of symbolic and tectonic elements. In taking the dichotomy to extremes, the Exposition architects reinforced the propo-

sition that soaring architectural creations enjoyed autonomy as civic monuments — unaffected by interior considerations.

The Exposition institutionalized the importance of the automobile, providing a model for auto-use architecture in an urban context. More specifically, the Exposition integrated the automobile into the City Beautiful dream, allowing thousands of people from San Francisco and across the country to witness and appreciate the dynamic interaction of cars and historically inspired architecture, formally planned. As the automobile propelled itself through or alongside the simulated portals of antiquity, it became celebrated as a tangible symbol of progress and a counterweight to the accomplishments of the past.

Garages built around this time aspired towards an unprecedented monumentality. The building type was implicated both as a satellite of the Exposition's extended transportation network and as an accessory and symbol of the automobile. In this regard, the San Francisco garage was not only the spawn of the great urban station, it also served as the miniaturized agent of the Exposition. This agency relationship is illustrated by the Station garages, which rest on San Francisco streets as small-scale Exposition palaces.

Garages exhibiting the influence of the Exposition include 1641 Jackson (Fig. 73 in chapter 3), 2405 Bush (Fig. 75 in chapter 3), 242 Sutter (Fig. 106 in chapter 5) and 1240 Post (Fig. 79 in chapter 3). All feature grand single- or triple-arched openings that rise up from the ground to either push up against the limits of a bounding gable, or break through a flat entablature. In the first three examples, the glazed arch is not filled with industrial sash, but subdivided with the radial, concentric or diagonal muntins of Beaux-Arts–inspired portals. Amplifying the stature of these arches is a variety of gauged brick bands, turned moldings, terra cotta keystones and decorative medallions. The façade of 1240 Post Street presents a diminutive version of Atwood's train station at the Chicago World's Fair — the building that lies at the convergence of train station and exposition architecture. In modified form this same design graces the front of Ward & Blohme's Machinery Building, a borrowing that links the Post garage directly to the Exposition. All of these designs present the wondrous spectacle of highbrow pretensions superimposed onto a lowbrow template.

In addition to the surge in monumentality, the influence of the Exposition is evident in the independence of the façade from the shed. The compositions and silhouettes of the façades at Jackson, Bush and Sutter are especially responsive to the public, as the presentation of the frontispiece appears to be the architects' overarching concern. At Jackson and Bush, the monumental features appear to ignore the roof profile behind, while vehicular circulation is incorporated into the composition via flanking bays. These aspects of the façades are discussed in chapter 3.

With the demise of the Exposition, the San Francisco garage loses a unifying reference point. Unknown to most observers, the garage keeps alive — in limited fashion — the Exposition's commitment to city beautification, urbanity, corporate capitalism, and boosterism. The garage façades continue the historicist brand, reflecting the conviction of those who commissioned these buildings that art and commerce go hand in hand.

The legacy of the Exposition is more explicitly kept alive through the continued presence of the Civic Center, which was designed by the same group of architects. This group viewed the undertakings as complementary opportunities to re-establish San Francisco's place among the world's great cities.[31] Cahill, for example, wrote: "Whether in the transient and fleeting forms embodying the Exposition, or in the more permanent enterprises of the Civic Center, both of these really magnificent events will live always as expressions of our opulent life, as examples of our technical skill, and as standards of civic magnificence to

which our imperial democracy may fittingly aspire."[32] This remark reflects the supreme self-confidence that percolated within the architectural intelligentsia as it rose to the occasion of representing an American empire in architectural form. Still, the Civic Center remains an exemplar of the City Beautiful in America, and City Hall, by Bakewell and Brown, is indeed magnificent.

This same elite group of architects also designed many of the showroom buildings along Van Ness Avenue. As photographed in 1913, the auto-use buildings on Van Ness were generally rugged and unassuming retail structures, two to three stories in height, and adorned with a few promotional flourishes. By early 1918 — two years after the demolition of the Exposition — Auto Row experienced a transformation, with bigger, fancier, and more pretentious buildings. Boxy palazzos clad in multi-story pilasters and topped with heavy cornices, the buildings spoke more of corporate power than entrepreneurial aspirations. While less ornamented and detached from structure than the Exposition courtyards, the showroom buildings did employ a similarly shrill monumentality to aggrandize big business and automobiles. Describing the relative merits of San Francisco's Van Ness, Kevin Nelson wrote, "During the boom years of the Roaring Twenties auto rows popped up all around California and America, but few of them anywhere could match Van Ness Avenue for its mishmash of elements, both grand and grandly tacky."[33]

Auto Row includes two of the greatest American showrooms buildings, the Don Lee Cadillac Showroom by Weeks and Day (1921), and the Earle C. Anthony Packard Showroom by Maybeck, with Powers and Ahnden (1927). Built by rival innovators and master salesmen, the buildings — and especially the showrooms — are conspicuous for opulence in materials and a theatrical approach to historically derived detail. The quality of gleeful excess apparent in these buildings was indeed reminiscent of the Exposition. Reviewing the Packard Showroom, for example, Morrow wrote, "For those gifted with a memory as long as twelve years its whimsical pseudo-classicism, its black Belgian and red Numidian marble and green tile polychrome, its horticultural accessories, will seem like a flowering in worthy form of the generous promises of San Francisco's Panama-Pacific Exposition."[34]

The original photographs of the Packard Showroom are conspicuous for the fact that no automobiles are shown. Instead, models clad in Elizabethan costumes appear as in a play. Women cast longing glances from a balcony; a man descends a staircase, on a rendezvous with his paramour. Maybeck regarded his showroom as a stage set for drama, not for car sales. The master architect's insistence that his work serves art and not commerce extends to Auto Row the same architectural prejudices that were brought to bear on the Exposition. In describing the grandiose details of the showroom interior, architectural historian Esther McCoy concluded, "These symbols of power were woven into a single theme — commerce — by one who was innocent of the subject."[35] As a selective and idealistic proponent of City Beautiful theory, Maybeck subscribed to the notion that beauty inspires and educates, not the idea that "beauty pays off." The showroom, designed as a palace for gamboling nobility, establishes an extreme contrast with the auto-centric and industrial interior of the lowbrow historicist garage.

While Civic Center and Auto Row remained contiguous architectural reminders of the Exposition in the heart of the city, the annual car shows brought civic and automotive interests together under one roof, that of the Exposition Auditorium. Again, car shows were not unique to San Francisco and they predated the Exposition. Nevertheless, the local galas constituted something of a reenactment of the Exposition itself. The same business leaders that brought the Exposition to fruition spearheaded the car shows, and they commissioned

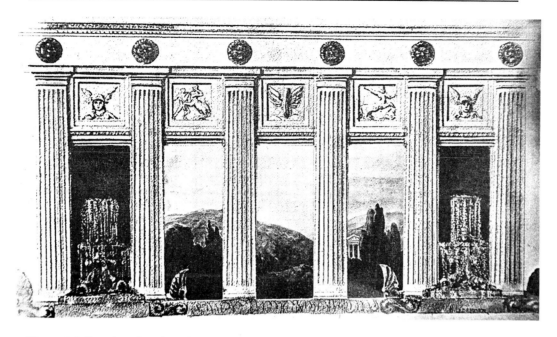

Figure 113. Interior elevation, from *Motor Land*, of the design for the 1920 Pacific Automobile Show, Civic Auditorium, Ward & Blohme, Architects. The design draws from the imagery and spirit of the Exposition (courtesy AAA NCNU Archives).

Exposition architects to design lavish stage sets reincarnating the classical splendor of the Walled City.

Ward & Blohme, the firm responsible for the Machinery Building, designed the 1920 car show (Fig. 113). *Motor Land* wrote, "Art critics who have inspected the work declare it the crowning achievement in San Francisco's decorative creations since the days of the Exposition."[36] According to the *Chronicle*, "Scenic grandeur and mechanical perfection will meet.... Visitors will behold a huge circular peristyle of white-fluted columns and entablature ... under the dome of the Auditorium. Grouped within and around its edges will be hundreds of passenger cars."[37] Here, the *interior* of the auditorium was dressed up in the upscale *exterior* garb of the Exposition, an arrangement that promoted the car as a consumable status symbol.

As a landmark that symbolically balanced the earthquake and concluded a phase of reconstruction, the Exposition held a local significance that permeated the entire city and extended beyond the physical limits of the fairgrounds. The architects and builders involved in both the rebuilding effort and the Exposition were in a unique position to express this significance. Perceiving that buildings devoted to transportation were related to the Exposition in its various roles as model city, urban destination, and symbol of technological progress, they seized the opportunity to extend the imagery of the Exposition to these related satellites, both those built in preparation and those built afterward. The garages are the beneficiaries of this continuity. In the years following the Exposition, lowbrow historicist garages continue to be built, a process that accelerates with the explosion in car ownership that occurs in the early 1920s. While very few garages built after 1917 refer to the Exposition, monumental historicist garages continue to appear, generally extending the legacy established by the Station garages built around this time.

Chapter 7

Parking, Congestion
and the Garage

The significance of the historicist garage is also informed by the struggle for control over city streets precipitated by the automobile. This struggle pitted automotive interests against various segments of society who regarded the street as a publicly owned resource to be shared and enjoyed by all. The conflicts experienced in San Francisco were typical of those occurring in cities throughout America, as brilliantly chronicled by Norton in his book, *Fighting Traffic: The Dawn of the Motor Age in the American City.*

Norton writes, "In the city street of 1920 the automobile was a nuisance, even an intruder. Automobiles were extravagant in their use of scarce space, they were dangerous (especially to non-motorists), they had to be parked, and they served only a small minority of city people."[1] This synopsis sets the stage for an appreciation of the garage as a factor in the public debate regarding the viability of the automobile in the city.

Even as it enjoyed increasing popularity and acceptance, the automobile presented unprecedented challenges to the physical infrastructure of the city. Conflicts developed around two major and intertwined problems: public safety and congestion. As a direct factor in either the heightening or easing of these tensions, the garage was primarily relevant to congestion, not to public safety. As a symbol of the automobile, however, the garage was relevant to both. Also, the public's perception of changes introduced into city life by the automobile was understandably inclusive of both traffic safety and congestion, as both were directly attributable to the car, one issue exacerbated the other, and both grew in urgency as the decade progressed.

Public Safety

The task of relieving congestion and protecting the public from traffic accidents fell to government, which held the power of regulation and law enforcement. On December 1, 1915 (three days prior to the closing of the Exposition), the San Francisco Board of Supervisors published "Transportation Ordinances," which established basic rules of the road for turning, passing, keeping to the right, etc. The ordinances sought to minimize conflicts between streetcars and other vehicles, and to protect boarding or alighting streetcar passengers from automobiles. One ordinance mandated a forty-minute limit on parking during business hours in San Francisco's central business district, an early indicator of insufficient parking spaces and congestion.

The police department attracted criticism for its lax enforcement of traffic laws, despite concurrent acknowledgment that the department lacked adequate resources to do the job.

A *Town Talk* editorial from 1920 complained, "San Francisco is probably the only important city in the Union where motorists persistently refuse to obey the regulations in respect to motor traffic, and where the police apparently have no intention of enforcing them or else have not taken the trouble to inform themselves as to what they are." Later, the editor conceded, "There are not enough policemen to enforce such regulations as may exist."[2] Five years later, Pinkson praised the "the handling of vehicular traffic in the downtown section of the city where police control is in effect."[3] However, in the uncontrolled residential districts, one encountered "hundreds of flagrant violations of the traffic laws and a general display of carelessness that would make any sane automobile operator shudder and fear the result."[4]

San Francisco newspapers offered daily accounts of car accidents leading to death, injury and destruction of property. At the same time, conflicts between motorists and pedestrians were parodied in countless comics. The coverage became more sensational and pointed in the mid– to late–1920s, as the number of cars and accidents increased. In a typical and tawdry example from 1927, the *Chronicle* ran a front-page story under the headline, "Hit, Run Autoist Knocks 2 Women Down, Drives Over Bodies Second Time."[5]

That same month, the newspaper published a more sober but partisan piece entitled, "Autos Kill 114,879 in Five Years."[6] The article, written by the Director of the American Road Builders Association, characterized most accidents as "avoidable," and identified "carelessness" as the primary cause. It cited the deaths of "over 7000 children of school age, the majority of whom were killed while playing in or crossing the thoroughfare."

While the opinion expressed in the article appeared sympathetic to victims of automobile accidents, it did not challenge the right of motorists to use the street. Norton identifies this construction as "the motor age model of traffic safety," which "rejected notions of the inherent danger of automobiles, and sought to rid streets of reckless motorists so that the allegedly harmless majority could prove the truth of this claim."[7] The article cited above is one of hundreds appearing on the pages of the automobile sections of local newspapers that presented the rhetoric of motordom in the guise of news or editorials.

San Francisco participated in national campaigns that sought to reduce traffic accidents through increased government regulation of motorists and pedestrians, and the education of children and pedestrians in the safe use of the street. Locally, the California State Automobile Association (CSAA) supported and led these campaigns, which enabled its members to posture as concerned citizens while advancing the notion that automobiles were safe when driven responsibly.

Promoting the slogan, "Drive Carefully as a Motorist — Watch Your Step as a Pedestrian," a California women's group conducted a three-month safety campaign in 1925. Groups supporting the campaign included the CSAA, the State Division of Motor Vehicles and the California Peace Officers' Association.[8] As part of the campaign, women were dispatched to busy San Francisco intersections to briefly direct traffic — and pose for newspaper coverage. One woman, described in the *Chronicle* as "a smiling Titian-haired miss," was photographed wearing an officer's cap and badge and waving campaign flags.

Another manifestation of the traffic safety model was the formation of a "school traffic reserve," a corps of student crossing guards who directed fellow students at street intersections. The CSAA organized the effort, with the support of the San Francisco Police Department and Board of Education. One newspaper account credits the student guards with "doing valiant work in the name of humanity by saving the life and limb of their fellow schoolmates by alert and careful work."[9] In a related campaign, the CSAA distributed

posters on the safe crossing of streets to 10,000 classrooms in public schools, accompanied by a stock lecture to be recited in class by the teacher.[10]

These examples do not constitute a comprehensive history of the impact of the automobile on public safety in San Francisco during the 1920s. The intention here is rather to familiarize the reader with the general level of concern surrounding public safety — as reflected in contemporaneous newspaper accounts — and to identify the major groups that engaged the issue. Of particular relevance is the CSAA's deployment of a strategy following the contours of the traffic safety model. As implemented, the CSAA arrays all stakeholders — civic groups, regulatory agencies and law enforcement — into a united front against reckless drivers and in support of safety education. The various activities of this front, along with the daily accounting of the victims of traffic accidents, make up the majority of press coverage devoted to this issue during the golden age of garage construction.

The Garage on the Public Street

As a building type that facilitated automobile use in the city, and utilized architectural symbolism to celebrate that use, the historicist garage played a small part in a broader industry-sponsored promotional and political campaign. That campaign sought to persuade the public that the street functioned primarily to accommodate automobiles. The traffic safety model is one expression of that campaign. As Norton makes clear, the goal was to reframe the public's conceptualization of the street, such that the pedestrian was literally relegated to the sidelines — the sidewalk and the crosswalk.

The garage engaged in a verisimilitude that supported this campaign and reproduced its reversal of priorities, creating an architecture that likewise served automobiles, and not pedestrians. This achievement is revealed not in the simple fact that automobiles crossed the garages' thresholds, but in the appropriation of a traditionally anthropomorphic architectural vocabulary to aggrandize the passage of the automotive machine — and not the pedestrian or citizen.

The dichotomous design organization of the historicist garage is consistent with motordom's quest to wrest control of the street from the public and deliver it to the automobile. The garage presents its portals to the street — the contested resource and battleground — and completes an alternative urban narrative in which the entire city is re-conceptualized around the automobile. In order for automobiles to metaphorically replace pedestrians, cars too must have architectural destinations — homes — that face the street and receive self-propelled (mechanical) beings. The garage interior is largely irrelevant to this presentation of the auto-centric city, and the hyperactive signification so conspicuous on the façade is abruptly abandoned in favor of a kind of non-aesthetic just inside.

Relevant too is the concept of the garage as a decentralized train station that multiplies and infiltrates the street grid to better serve the automobile. The adaptation substitutes the automobile for the train traveler as the "being" that passes through the monumental portal facing the town square or — as transformed — city street. As a small locomotive that propels itself purposefully without reliance upon rails, the automobile demonstrates an autonomy of motion that parallels the pedestrian's.

On a secondary level, the disposition of garage ramps and the absence of dedicated circulation facilities for customers also suggest the primacy of the automobile. The positioning of ramps on the front property line — an efficient placement that increases parking

capacity—appears aggressive to the pedestrian, who must exercise extreme caution when walking on the sidewalk alongside the garage. Similarly, the appropriation of the driveway and street into the vertical circulation system of the garage (see chapter 2) extends the vehicular realm beyond the front of the building and impinges upon the pedestrian domain. Profit propels this infringement, as rentable parking spaces generate money.

I am not suggesting that San Francisco architects built these aggressive features into their designs as part of a deliberate strategy to intimidate pedestrians and advance the primacy of the automobile. The intention is rather to point out the consistency of garage design with the organized campaign to install the automobile as a permanent fixture of city life. In this example, both the pedestrian's need to exercise caution when walking by a garage and the exiting motorist's need to come to a full stop before crossing the sidewalk are consistent with a traffic safety model predicated on a new reality—the arrival of the automobile.

Congestion on Market Street and the Ferry Building

The lowbrow historicist garage played a more direct role in facilitating the car culture as a partial solution to congestion—a national urban phenomenon. Of course, congestion jammed city streets long before the dawn of the automobile age. Flink, describing turn-of-the-century conditions in New York, wrote: "traffic was often clogged by the carcasses of overworked dray horses that dropped in their tracks during summer heat waves or had to be destroyed after stumbling on slippery pavements and breaking their legs."[11] At the time of the earthquake, horses contributed more to San Francisco congestion than cars.[12]

As the population of San Francisco and the Bay Area grew in the first three decades of the twentieth century, so did congestion. Within the city, the problem intensified on Market Street and climaxed at the Ferry Building, the region's major transportation hub. Surrounded by water on all sides but the south, the San Francisco peninsula relied on ferry service for connections to East Bay cities (Oakland, Berkeley and Alameda), Vallejo to the north, and Marin County. While boats converged on the bay side of the Ferry Building, streetcars approached the front side via Market Street. A track loop in Ferry Plaza facilitated U-turns. At the same time, state-owned Belt Line freight trains ran along the waterfront, serving the working port of San Francisco. From 1912 on, these trains ran parallel to the Ferry Building façade.[13] During rush hours, commuters flooded the plaza, adding to the bustle and inhibiting traffic flow.

The traffic situation grew more complex with the growth of the Municipal Railway and the increasing presence of automobiles. In 1913, Mayor Rolph negotiated a deal with United Railways—subsequently approved by the voters—allowing the new Municipal Railway to use Market Street and reach the Ferry Building. Horse-drawn cars were immediately and permanently prohibited. In 1918, lower Market Street—120 feet wide—hosted four parallel streetcar lines, the inside pair operated by the private railway, the outside pair by the city-owned railway. Congestion worsened at the Ferry Building. According to Perles et al., cars from both companies "were lined up as much as five to eight blocks, waiting to traverse the terminal loop, although passengers had abandoned the cars to try a run for their boats."[14]

The Panama-Pacific International Exposition increased the load on the Ferry Building

and the city's transportation networks. San Franciscans flocked to the Exposition, as did tourists from around the nation. Out-of-towners approached in the tens of thousands by train and passenger car. Historian Nancy Olmsted noted that the Municipal Railway accommodated over one million visitors during the first two weeks of the Exposition.[15] Indeed, new lines serving the Exposition were built in anticipation of the crowds, and the Municipal Railway received official recognition for its performance.[16]

Despite the growth of the Municipal Railway, the PPIE "was the first fair in which the automobile replaced the horse and buggy," a circumstance resulting in congestion and competition between different modes of transportation.[17] Just before the Exposition opened, *Horseless Age* reported, "automobiles competing with the street cars have become a 'menace' that is engaging the serious attention of street railroad officials in Pacific Coast cities." Estimating that automobiles for hire—"jitneys"—were costing the city one dollar per minute in lost railway revenue, the Board of Supervisors passed an ordinance regulating the jitneys and reserving "the right to keep jitneys off the Municipal Railway routes or other streets."[18]

The Ferry Building served an ever-increasing load of passengers after the Exposition closed, and throughout the late 1910s and '20s.[19] A pedestrian bridge spanning the Plaza was added in 1917 for convenience and safety, and to reduce congestion down below. In 1924, the State Harbor Commission began construction of the Embarcadero Subway, an underground tunnel allowing cars to bypass (and reduce) the congestion on the Plaza. The Chief Engineer, explaining the project's urgency, wrote that 8000 vehicles ventured across Ferry Plaza every business day, creating "an entire cessation of street railway car movement [and a] corresponding tie-up of vehicular traffic."[20] The subway opened the following year and by 1926 it handled 11,000 vehicles a day.[21]

Despite these improvements, traffic jams on Market Street did not dissipate. In his 1927 San Francisco Traffic Survey, traffic engineer Miller McClintock concluded, "Instead of being a traffic artery Market Street is practically a traffic barrier, and the solution of the multitude of problems created by that barrier and by the tremendous congestion of street railway movement on Market Street is one of the most important and difficult matters facing the city."[22]

Looking retrospectively at the scenario greeting the tourist, an author wrote:

> To millions of visitors who have ventured through the portal of the Ferry Building at its southern end to set foot for the first time in the city of St. Francis, Market Street must have seemed a little frightening. After a calm leisurely ferryboat voyage from the main railroad terminals across the Bay, the visitor plunged into what was obviously a traffic engineer's nightmare.[23]

The scope and complexity of regional transportation increased even further with the introduction of auto ferry service. First introduced to the line between Richmond and Marin in 1915, the service spurred construction of a parking garage in Richmond to accommodate the vehicles coming off the boats.[24] By the early 1920s, bigger, stronger boats carried hundreds of vehicles and thousands of passengers every day to and from the Ferry Building. The trend continued and in 1927, traffic engineer Miller McClintock counted almost 115,000 people coming through the Ferry Building every business day—108,000 on passenger ferries and the remaining 7,000 on automotive ferries, accompanied by 4800 automobiles.[25]

Thus, thousands of automobiles, either waiting to embark or driving off the boats, joined the chaotic mix of streetcars, freight trains, taxis and pedestrians crossing paths before the transportation hub. In the relay race of cross–Bay travel, boats handed off commuters to streetcars (on the city side), taxis or the commuters' own private automobiles. While the

ferries disgorged their loads directly onto the Embarcadero—and not through the portals of the Ferry Building—the disembarkation of automobiles recalls the parable of automobiles as the empowered cars of a decoupled train that advance onto the city grid (see chapter 5). All of these automobiles, in addition to a percentage of those coming from the south and from within the city, converged on downtown San Francisco. The downtown garages, including skyscraper garages dressed up as office buildings and smaller garages that looked like little depots, existed to profit from this convergence.

Auto ferry service nested one form of transportation within another, enabling automobile owners to take their vehicles with them across the bay. The service held out the tantalizing promise that Bay Area automobile owners could—with the brief interruption of the ferry ride—realize the dream of automobilia. Speed, linear movement, and personal autonomy awaited the automobile owner who accepted this compromise with nature by ferrying the car to the open road.

Unfortunately, the promise remained largely unfulfilled, as auto ferry service exacerbated congestion. The increased traffic mess displeased everyone, but it particularly frustrated car owners, who were denied the full enjoyment of their vehicles. A *Town Talk* editorial opined, "The man in the automobile should be able to scoot hither and thither without waiting an hour or two for a ferryboat."[26] The dissatisfaction encompassed commuters and those engaging in weekend auto tourism—a fairly new form of entertainment. Whether traveling via the auto ferries or the oversubscribed highway to the south, the automobile owner often experienced traffic jams.

The situation crystallized, in terms specific to San Francisco's geography and physical limits, the conflict between congestion in the city and the open road. While the auto ferry facilitated many aspects of automobilia by conquering the Bay, it left in place the hated reliance upon a rigid schedule of arrivals and departures, exactly like the railroads (which owned the auto ferries). Worse, that reliance encumbered not just an individual, but a car owner actively seeking to enjoy his or her liberation from train schedules, a reliance that underpinned the decision to purchase the new status symbol in the first place. The frustration of automobile owners was illustrated and exploited in a series of political cartoons placed as newspaper ads by the San Francisco Car Dealers Association in 1921. These ads sought to garner public support for the construction of a bridge to span the bay, and of additional highways connecting to the South Bay. The Bay Bridge opened in 1936, and three years later—with the inauguration of electric train service across the bridge—congestion finally migrated away from the Ferry Building.[27]

The Ferry Building was not a train station, but it nevertheless functioned as the centerpiece of a vast regional transportation system. Historian Tom Cole wrote, "By the late 1920s, fifty million people a year were using the ferries, and the Ferry Building was the busiest transit station in the United States."[28] It is remarkable how many different modes of transportation converged on this one building. While the Mission-style Southern Pacific train station served San Francisco on its southern flank, that building was never the city's primary gate, either functionally or symbolically.

As a network of miniaturized stations, the garages of San Francisco disbursed in the shadow of the Ferry Building. While the back of the station never accommodated trains, the building offered the monumental presence, evocation of civic pride, and grand portal of the great urban train station. These are characteristics mimicked by the garages. Once the piers flanking the Ferry Building provided transportation to automobiles, the aesthetic link between station and garage was complemented and animated by a new geographic and

spatial connection — the movement of a certain number of cars from the large terminal to the small ones (and visa versa). Conceptually, the garages and the Ferry Building existed in equilibrium, the garages approximating — as a collective — the disbursed gravitas of a landmark giant that was overworked to the brink of a congestion-induced paralysis.

Congestion, Parking and the Garage

As increasing numbers of automobiles converged on the central business district, existing curbside parking proved insufficient. For example, McClintock's 1927 Traffic Survey for San Francisco reported that curbs available for parking in the central business district were capable of accommodating 2010 vehicles at one time, a fraction of the 81,000 vehicles entering the district on a daily basis.[29] Cars spent increasing time on the street in search of parking. In combination with inadequate traffic regulations and enforcement of existing regulations, gridlock ensued and travel time increased. Automobiles, streetcars and pedestrians jockeyed for position and competed for the right of way.

Traffic congestion caused extreme frustration and endangered public safety. Perhaps more importantly, it slowed down economic activity in cities across America. The situation was ironic, as the automobile — a machine that conquered space and time — promised unparalleled efficiency. Sachs described the economic ramifications of this efficiency: "While the automobile gave producers and dealers the chance to eat up minutes and kilometers through accelerated circulation, it provided consumers the chance to connect with the circulation and gain access to more goods and services."[30] Congestion caused goods, services and consumers to eat up time in vehicles. The drag on downtown economic activity spurred retail decentralization. Gudis wrote, "Real-estate developers and merchants ... went to the fringes of the central city, where land was less expensive, parking ample, and congestion not yet an issue."[31]

The automobile industry endorsed any solution resulting in the sale of new cars. As Norton points out, industry feared that "the real bridle on the demand for automobiles was not the consumer's wallet, but street capacity."[32] Congestion was seized upon by motordom as an opportunity to (once again) represent its corporate goals as a relief valve for problems facing the city. It favored both expansion of residential and retail districts to outlying areas *and* the retrofitting of the city to accommodate more cars. While decentralization relieved congestion, the retrofitting of the city maximized efficiency and economic growth. This position was summarized in a 1922 article from *Motor Land*, in which the author expounds on why per capita ownership of cars is lower in cities than in rural America:

> The reason ... is that in the cities we find congestion of traffic and poverty. But on the other hand, the motor car is the solution to the very thing that holds it back, strange as it may seem. Motor car facilities if properly extended will release the population of the cities and develop the outlying districts.[33]

And the solution:

> More parking spaces, garage skyscrapers, more highways, a bridge over the bay, these are some of the things that are needed to enable the city [San Francisco] to come into its own in the matter of the ownership and increased efficiency through the use of the motor car.[34]

The argument was that congestion is not caused by automobiles, but by government's sluggishness in undertaking the infrastructure projects to accommodate the automobile. How-

ever, on a national basis, this opinion was not shared by all. For example, in 1920, the mayor of Cincinnati asked the local car dealers to "work out plans for the erection of a large public garage in this city, the cost to be defrayed by themselves."[35] Part of a plan "to relieve traffic congestion on the streets," the request reflected a determination "to put the garage problem squarely up to the dealers on the ground that they have made their money here and should spend some of it in this way."

Motordom eventually prevailed upon municipal governments across America to physically modify cities to accommodate the automobile. Flink wrote, "City planners and politicians largely ignored the needs of the autoless [sic] for better public transportation, while undertaking a massive restructuring of American cities at public expense to accommodate middle-class motorists."[36]

The experience of San Francisco more or less conformed to the national pattern. While the 1915 ordinance limiting downtown parking was an early indication of congestion, the issue took on more prominence around 1920. Newspaper articles, editorials and architectural journals frequently reported on issues related to San Francisco's congestion.

A *Town Talk* editorial endorsed the designation of Post and Bush streets as one-way thoroughfares.[37] A supervisor proposed that all streetcar lines terminate at Market Street, with passengers transferring to a dedicated Market Street line extending to the Ferry Building.[38] A Civic Improvement League offered a parking plan in 1922 to ban all "rent cars, taxicabs, sightseeing cars, baggage cars and the like" from certain downtown streets.[39] A syndicated comic strip satirized the conflict between pedestrians and traffic with an illustration of shoppers getting hoisted in cranes over a congested street.

Attempts to deal with San Francisco's congestion assumed a less piecemeal and more organized profile starting around 1924. The change reflected the intractable nature of the problem, the institutionalization of the traffic safety model, and the maturation of a city planning discipline that acknowledged jurisdiction over traffic regulation. As a design profession, city planning is related to architecture, and it is at this time that the relationship of building size to congestion piqued the interest of architects. Part of this interest was channeled into a consideration of the garage building as an architectural challenge.

Architects began to regard the garage not dispassionately as a simple storage building, but as a potential solution to downtown congestion. For example, *Architect and Engineer* published an editorial praising the inclusion of a parking garage in the basement of the Matson Building, a new office building on Market Street. The article introduced the problem this way:

> Traffic congestion has become so acute that every day, it would seem, the parking sections are placed further and further away from the business centers. Business men [sic] must walk blocks from their parked machines to their offices and shoppers have the same difficulty reaching the department stores. There is already talk of several large public garages in the down-town [sic] sections of San Francisco and Los Angeles to take care of business men's machines, but to place these buildings where they will be a real accommodation means the utilization of valuable land that is now occupied by office buildings bringing in good income.[40]

Another *Architect and Engineer* article, devoted to the proper ventilation of city garages, acknowledged the inevitability of downtown garages as a byproduct of congestion:

> The increasing demand for parking space in mid-city sections, together with the blockading of streets, has made it imperative for police departments to regulate parking time of standing automobiles. The considerable inconvenience these regulations are causing the owners of both

pleasure and commercial cars has in turn given rise to an insistent demand for mid-city parking garages.[41]

In December 1924, *Architect and Engineer* published an article by M. McCants entitled "Tall Buildings and Traffic Congestion." Typical of the approach of a city planner, McCants assumed a broad and academic perspective, discussing traffic congestion as the byproduct of several intersecting factors, including building height, productivity, real estate values, population growth, and modes of transportation. He conducted a "very careful check ... of the street cars and autos leaving the business district"[42] during the evening rush hour, and reported that automobiles constituted 92 percent of the vehicles leaving the city, yet carried only 18 percent of the people. Also, each "auto passenger occupied fourteen times as much linear street space as did each street car passenger."[43]

Conforming to what Norton called "the public utility model," McCants advocated for "a system of regulations which shall obtain the most advantageous use of streets — advantageous in the sense of the larger social benefit to be derived.... Without any radical changes in our transportation facilities, but with proper control we should be able adequately to take care of our transportation needs."[44] While infrastructure projects like the Dumbarton Bridge and the Bayshore Highway improved regional transportation by automobile to and from the city, the approach outlined by McCants was adhered to within the more entrenched central city during the second half of the decade.

Described as "A New Motor Bible,"[45] San Francisco unveiled its revised traffic ordinance in July 1924. Enjoying the support of the CSAA (which produced its trademark yellow diamond-shaped signs to guide motorists), the new traffic laws exemplified the traffic safety model. The laws required motorists to "learn a new code of driving ethics in the mastery of 'one-way streets,' 'boulevard stop' [yielding to cross traffic on a major thoroughfare] and 'no left-hand turn' restrictions."

However, the revision that spurred garage construction was the enlargement of restricted parking areas downtown, and the introduction of new parking restrictions on shopping streets and major thoroughfares throughout the city. During business hours, parking was either prohibited, or limited to 20, 40 or 60 minutes. While time restrictions increased the total number of cars having access to curbside parking spaces, these limits precluded the possibility of leaving one's car in one space for extended periods while in the office, the store, or even at home. The garage provided the necessary accommodation. The relationship between time-delimited parking and garage construction was well established. For example, in 1919 the city of St. Louis lifted a ban on the operation of downtown garages when it decreased the parking limit from two hours to one.[46]

The Garage as Status Symbol

In San Francisco, the new parking restrictions provoke immediate objections from car owners, who "feel that they will have to forego the use of their cars during the business hours because it will be too costly to drive them in and out of 'parking lots' [sic] or house them in garages during the day."[47] These objections may be dismissible as the prospective grumblings of car owners for whom any mandated expense is undesirable. However, the parking restrictions do have the effect of dampening the appeal of the automotive commute and encouraging the use of mass transit.

In 1924, the urban poor did not generally own cars, while the middle and upper classes

acquired the new status symbol. The proposition that not all car owners could afford an off-street parking space reframed the garage as an even more exclusive indicator of status and wealth — a building type that filtered out the poseurs. This possibility dovetails with Wachs' observation that suburbanization and car ownership was accompanied by an increase in the use of mass transit for the daily commute, and automobile use for touring.

The historicism of the building façades in this study supports the interpretation of these garages as status symbols. This dimension of the garage's significance is perhaps best exemplified by 675 Post — the Century Garage — that reinforces the upscale pretensions of its façade with opulent lounge facilities (Fig. 97 in chapter 5). In its monthly ads published in *Motor Land*, the Century management rotated three photographs: an image of the façade, another of the circular staircase in the interior, and a third of the "Attractive and Comfortable Ladies' Room." The Century was dubbed (somewhat oxymoronically) "The Garage of Distinction for Classy Cars."

As exclusive gateways positioned on the street, the façades — albeit lowbrow — employ an architectural vocabulary typically reserved for more upscale uses in order to reinforce the class affiliations (or aspirations) of those who purchase this rite of passage. The communication of exclusivity is directed at everyone — pedestrians, transit users without cars, transit users with cars (who leave their vehicles at home as a matter of expense, thrift or convenience), and the privileged few who patronize the facility. (It is important to note that many wealthy commuters simply elect to use public transportation, and they may or may not be influenced by the symbolism of the historicist façade.) Again, the symbolism has little to do with the storage or repair of vehicles. If it did, a strictly utilitarian shed would suffice — as occurs on the rear façades of these same buildings (including those that daylight on a public alley).

Earlier in the book, the garage façade is discussed as a fitting architectural symbol for a middle- or upper-class owner, a marker that connotes wealth and urbanity. As an application of City Beautiful ideas, the façade may even suggest that the client is a member of the city's business and civic elite. Here, however, the description of the beneficiaries of this symbolism is qualified to acknowledge that not all car owners can afford the privilege of passage through these portals. In the new consumer economy ushered in by motordom, the arousal of envy in those unable to afford the downtown garage — or a more expensive car to navigate through its portals — is good for business.

The McClintock Report

The landmark event in San Francisco's effort to contain congestion was the release of Miller McClintock's San Francisco Traffic Survey in 1927. McClintock, the leading traffic engineer in America, had already completed his celebrated code for Los Angeles. His San Francisco Survey took a year to prepare, and the recommendations contained therein were adopted as the new traffic code in late September. The new ordinance enjoyed the backing of the CSAA, and conformed "in all essential respects with the uniform traffic ordinance for California cities drafted by the legal departments of the California State Automobile Association and the Automobile Club of Southern California."[48] As deaths resulting from automobile accidents continued to rise, the code was deemed urgently necessary.[49]

In the introduction McClintock wrote, "The Survey believes that concurrent with planning activities all possible steps should be taken to put the present street area to the

most effective use. Therefore, this study has been undertaken with the object of securing maximum fluidity of traffic by means of regulatory and minor physical improvements, and hence at minimum cost."[50] The emphasis on the efficient use of existing street facilities is typical of McClintock's earlier work, before his conversion to advocating on behalf of increasing facilities for automobiles.[51] As a result, the survey reproduced many recommendations from the Los Angeles work, as modified to reflect local conditions.

McClintock prioritized traffic flow over street parking and anticipates the eventual elimination of all curbside parking. Therefore,

> It is essential in all central districts in American cities that provision should be made for off-street storage of motor cars. This is merely one of the many adjustments that is being necessitated by the intense motorization of traffic. The period of transition may be difficult and may involve some inconveniences, but ultimately the establishment of in-town terminal facilities for motor cars will tend to standardize individual automobile transportation as can never be the case under present and haphazard parking conditions.[52]

The survey generally endorsed many traffic control strategies already in effect under the 1924 code, including one-way streets and time-based parking limits. By 1927, almost all of the downtown garages in this study were in operation, in part a consequence of these restrictions. It is therefore not surprising that McClintock found "the development of garage facilities in San Francisco is already very encouraging." However, he concluded, "It is to be hoped that the mercantile and financial interests of the city will encourage, within reason, the construction of storage garages, either as independent structures or as parts of hotels, office buildings and other establishments. San Francisco already possesses excellent examples of hotel and office building garages."[53]

Architectural aesthetics and the utility of the city garage finally merged in McClintock's address to the American Institute of Architects in April 1929. Typical of his thinking at this time, McClintock defined congestion as "a situation of unbalanced supply and demand; the demand for traffic facilities — the demand for transportation facilities — placed by the concentration of structures in limited areas exceeds the efficient supply of space in the streets and in the transportation agencies."[54] He then offered his views on the two possible solutions: reducing demand or increasing supply. The garage was offered as an example of the latter:

> The central district garage offers a solution. There appears to be a definite antipathy on the part of zoning officials, on the part of many builders, and on the part of many merchants who own properties in central districts, against the garage. In other words, many of them think of the garage as the converted livery stable, which was, of course, an undesirable neighbor. You know, naturally, that a modern garage can be constructed in such a way that it is not only a very presentable neighbor from the standpoint of artistic appearance, but likewise a very desirable neighbor from the standpoint of the operations which are carried on within it.[55]

To support his opinion, McClintock referred to a large skyscraper garage in Boston, located in Park Square adjacent to an exclusive hotel. He told the architects, "Assuredly no one conducting business or anyone interested in the preservation of the beauty of the city could object to such a structure."[56]

In distinguishing between the "artistic appearance" and the "operations" of the garage, McClintock engaged the historicist garage's dichotomous organization. Implicitly, the garage was acknowledged to be a service structure that could not assume the utilitarian appearance typical of such structures. In this interpretation, the façade was camouflage that enabled the garage to blend in with its context and not detract from its surroundings. It provided

cover for the performance of an essential but unsightly urban function — the storage of automobiles — that was accommodated within.

McClintock addressed the architects just six months before the Crash, an event that severely inhibited the construction of both office buildings and garages. In 1929, central business districts across America were taller and denser than at the middle of the decade, when most of the San Francisco historicist garages were built. In order to exert a positive impact of any significance on the parking and congestion problem, and in order to blend in with a downtown composed of tall buildings, the "central district garage" to which McClintock referred must be a skyscraper garage.

In late 1925, two skyscraper garages opened in San Francisco — the Bell Garage at 175 Turk (still standing) and the North Central Garage at 355 Bush (demolished). Advertisements placed in the *Chronicle* announcing the opening of the new facilities feature rendered perspective views of the buildings, as opposed to photographs. The illustration of the North Central emphasized the heroic stature of the building while it downplayed the vehicular interface at the ground level (Fig. 114). This garage could pass as an office building. By contrast, the rendering of the Bell Garage seems less invested in effecting this particular deception (Fig. 115). The dedication of the basket handle archways to vehicular access was more apparent, as was the industrial nature of the multi-paned windows. While they differed from one another in emphasis, these idealized views represented the buildings in a manner consistent with McClintock's interpretation of the garage as a "presentable neighbor from the standpoint of artistic appearance."

In San Francisco, the difference between a one- or two-story garage and a skyscraper garage is a matter of size and scale, not architectural organization, exterior historicism or even architectural pedigree. As we have seen, the skyscraper garage usually employs the ground floor of the shorter garage as a base, and the industrial sash window as the basic module of the building shaft. Parapets are identical, creating the impression that the skyscraper is nothing more than a short garage with a shaft inserted between the ground floor portals and a raised parapet. The relationship between the two is not coincidental, but the result of an eclectic approach that governs the compositions and ornamentation of both. For Pasqualetti and the O'Brien Bros., the visual similarity between the tall and short garage may also have been a labor-saving strategy and a means of architectural branding.

McClintock's argument — that the historicist garage can be contextually sensitive and appropriate to its surroundings — applies to both the tall and short versions discussed here. The dichotomous approach is predicated on the notion that the façade must be an artistic addition to the street, and that a transparent presentation of stored vehicles is antithetical to that mandate. The taller garage can be represented as an office building, or — to continue the earlier train station metaphor — as a station with a hotel above. One- and two-story garages are less effective, as they do not enjoy access to these particular representations, and they hold fewer cars. However, the shorter garage is often in scale with lower existing neighbors on the street and a source of relief from cavernous streets. Tall or short, McClintock's argument in favor of the garage links the dichotomous approach to garage design with congestion.

As Norton tells us, efforts to confront urban traffic congestion progressed from a model based on maximizing the efficiency of existing capacities to a more aggressive model based on the creation of increased capacities. The latter approach — championed by motordom — entailed massive construction projects, paid for by government, to widen streets and create grade separations for crossing traffic.[57]

The New
NORTH CENTRAL
de Humy Ramp Plan
GARAGE
355 BUSH STREET · · · *Between Kearny & Montgomery Sts.*
Seven Floors Capacity 350 Cars

Figure 114. Ad for the North Central Garage at 355 Bush Street (demolished). Powers and Ahnden, Architects, 1925 (*The Chronicle*, San Francisco Public Library).

Day or Theater
Parking . . 35¢
Transient . 50¢
Storage $6.50
a month up

Repairing
Crankcase and
Battery Service
Washing
Lubricating

DESIGNED BY
E. H. DENKE

CAHILL BROS.
General Contractors

BELL GARAGE
175 TURK STREET NEAR TAYLOR
RAMP PLAN 1000 CARS CAPACITY
OPENS TODAY

BELL Garage is structurally the most efficient building ever erected for scientific automobile maintenance. Its equipment includes every ultra-modern appliance for the care and repair of automobiles. Its service and supplies provide everything for the motorist.

Figure 115. Ad for the Bell Garage at 175 Turk Street. E.H. Denke, Designer, 1925 (*The Chronicle*, San Francisco Public Library).

The significance of the garage lies in part in its special status as an acceptable instrument of reducing congestion under both models. When city planners and traffic engineers characterize garages as a constructive means of relieving congestion, they advance motordom's interests. Garages are predicated on an acceptance of the automobile — otherwise the building type would be unnecessary. It is an accessory of the automobile and it facilitates its use. While it reduces congestion by supplementing a finite amount of restricted curbside parking,

the garage attracts cars to the city by providing an off-street capacity that would not otherwise exist. If allowable curbside parking is completely utilized, congestion — in terms of traffic flow — is not relieved by the garage but exacerbated by the additional load of cars attributable to garage use.

Any parking garage is a product of automotive interests. The *historicist* garage is also a status symbol, enabling an upper crust of car owners to flaunt their prerogatives by calling attention to the act of passage. In this interpretation, the contextualism of the downtown historicist façade cannot be understood exclusively in neutral aesthetic or architectural terms, as suggested by McClintock. While the garage may have been a "presentable neighbor from the standpoint of artistic appearance," the neighborhood was the heart of the corporate capitalist economy on the west coast. The presentable new neighbor was appropriately tinged with privilege.

Chapter 8

Consumerism and the Limits
of a Dichotomous Architecture

San Francisco garages are cultural and historical artifacts of the early twentieth century. As architecture, these small buildings exemplify academic eclectic design and a process that relies upon the transformation of precedents. The fact that the architectural treatment is limited to the façade ties this building type to several others, all of them responsive to the City Beautiful mandate to enhance through grand and noble gestures. Building use and construction cost demand expediency, however, and upon fulfilling the mixed goals of public promotion and civic duty, beauty yields to structure and functional accommodation.

The disintegration of the Vitruvian triad into mutually exclusive spheres of exterior (delight) and interior (commoditie and firmness) constitutes a forced resolution, however. While perhaps unavoidable in the larger train station and understandable in the temporary Exposition building, the separation assumes — over time — a tired and derivative quality in the garage. Something has to give — either beauty must migrate to the interior, or tectonic expression must take over the entire structure and found to be beautiful (a solution more amenable to modernist preferences).

The lowbrow historicist garage reflects the strains of this dilemma, particularly in the 1920s. Pasqualetti's movement towards a factory aesthetic (see the Narrow ABCBA Façades, chapter 3) provides evidence of this tension, as do the even-bay symmetries of the Twin Arch category. However, these tentative experiments with a less rigid façade are overshadowed by the more dramatic efforts to bring beauty inside. The campaign is driven by the marketing strategies of the automobile manufacturers, and it attaches to those aspects of both car and garage design thought to enhance sales, especially to women. In the case of the automobile, the closed car facilitates the addition of interior design to the passenger cab. In the garage, the showroom building facilitates the addition of interior design into one room — the showroom itself.

This chapter examines the limitations of the dichotomous garage as a symbol of the object it serves and celebrates — the automobile. In particular, the discussion focuses on the introduction of interior design as a means of rendering the garage (with showroom) and the automobile habitable, comfortable and *trichotomous*.

Despite obvious differences, the design objects are initially structured in a dichotomous fashion, and share the following properties:

- A finished exterior casing or façade that defines the public identity of the object, like a face or the human form.
- A rough, engineered, and industrial interior that supports the exterior, is concealed from view by that exterior, and is essential to the functioning of the object. This interior is analogous to a person's viscera.

211

The idea that the dichotomy is an underlying structure common to the garage and the automobile is useful as a balanced and stable starting point — a datum line — against which changes to both artifacts can be measured. Over the first three decades of the twentieth century, the car and the garage evolved in loosely parallel fashion, gaining in sophistication and elegance as the car culture transformed Americans into consumers.

The design link between car and garage provides a basis upon which to consider the automobile in architectural terms, or more directly, as an architectural object. Once established, the architectural metaphor serves as a criterion for comparisons with other building types. Of particular interest are comparisons with types that are "normal" in the sense that they are built for human (and not automotive) occupancy.

Chief among these are home and office, representing the spheres of family and work. Circumscribed within the new metropolitan area, home and office are the architectural poles served by the automobile, which sustains the suburban lifestyle (at least as viewed from motordom's vantage point). Significantly, both of these poles include a garage as an adjunct — a separate home dedicated to the automobile. Thus, the automobile engages in a commute that parallels that of its driver. As a mobile architectural object, the automobile solipsistically shuttles between static versions of itself.

The key difference between home and office on the one hand and the historicist garage on the other is the provision of a third realm — a finished architectural interior. Home and office would be unfit for human habitation without it, as the interior accommodates life's activities. However, the automobile, particularly in its early dichotomous form, is perfectly at home in the analogously dichotomous garage.

Measured against this definition of architectural normalcy, both the early car and the lowbrow historicist garage are deficient. The separated realms of finished exterior and industrial interior create abrupt contrast, and the objects lack an appropriate middle ground — an interior environment to inhabit. In both the early car and the garage, human comfort and repose are not foremost considerations.

Of course, the early car and the garage provide minimal physical accommodation. The car includes an open cab with seats while the garage provides a weatherproof enclosure. Oddly, they disappoint in related but opposite fashion: while the car subjects its occupants to overexposure, the garage is inadequate as a source of light and air. In both cases, the objects are too expressive of their specialized functions and industrial essence. The exteriors, while highly charged as signs, are relatively thin and flimsy.

Marketing and sales are the driving forces behind the transformation of the dichotomous car and garage into trichotomous objects that assume a more human-centric purpose through the introduction of interior development. This chapter provides a synopsis of that evolution, emphasizing major design changes in automobiles and historicist garages that occurred loosely in tandem. The intention is to show how the dichotomous parking garage lost vitality as a symbol of the evolving automobile, while the trichotomous auto showroom building picked up the symbolic slack.

Design Analysis: Automobiles, Locomotives, and Garages

At the beginning of the twentieth century, the automobile business was speculative, and the competitive edge of the car over existing modes of transportation was uncertain.

Thus, a San Francisco ad from 1905 claimed, "BUSINESS MEN ARE TAKING TO IT. Cheaper Than a Horse. Faster and Surer than a Horse. More Work Done and TIME FOR PLEASURE."[1]

Not surprisingly, both automobiles and garages appeared as transitional design objects — devices of the horse-drawn or bicycle age modified to accommodate the new technology. For example, the curved-dash Olds, "the best-selling car in the world from its intro in 1901 until 1904,"[2] was "merely a motorized horse buggy."[3] Its cab was open to the elements — as was typical of the early car — and its seat was positioned awkwardly atop the body proper — like a loveseat stacked over a trunk. The Olds is comparable to the early garage — often a converted bike shop or livery stable. According to Pinkson, "the establishments of the industry's pioneers were, in most cases, simple stores with doors wide enough to permit a motor car to be driven through."[4]

The early car and garage imparted a makeshift quality, as if the design process involved tinkering and improvisation. These visual attributes were reinforced by the fact that the automobile required constant maintenance and repair, the necessary services often administered within the garage. Even the basic technology was in flux, as gasoline, electric and steam-powered models vied for dominance. As works in progress, the identities of the design objects were not firmly fixed, and it was premature for the exteriors to engage in extensive rhetorical messaging. Building fronts and automobile exteriors appeared unpretentious and utilitarian.

By 1910, the automobile culture was more established nationwide. In San Francisco, the lowbrow historicist garage appeared as a building type precisely when the automobile challenged the railroad for dominance.[5] In light of motordom's campaign to wrest control of city streets for automobiles, the garage architect's fashioning of the façade as a miniaturized and decentralized terminal signified the ascendance of the automobile as *the* successor to the rails. This signification necessitated the independence of the front wall from the interior, and the wall's assumption of an additional role beyond enclosure, access and the provision of a generic storefront. That new role was to engage the public in a dialogue, using architectural devices — composition, ornament and signage — to promote the automobile and the garage facility.

The garage at 64 Golden Gate Avenue exemplifies the early dichotomous garage (Fig. 60 in chapter 3). An industrial brick box, the building nevertheless required the services of an elite San Francisco architectural firm, Crim & Scott. The firm's participation was necessary to ensure that the building fulfilled its new rhetorical role — to celebrate the automobile, confer status upon the clientele, and identify the garage as a good neighbor in the rebuilt city. These goals were cleverly achieved by adapting the imagery and architectural vocabulary of the train station to the façade. While stately, refined and allusive — relative to its use — the façade did not aspire to achieve the monumentality of its precedent.

The evolution from a utilitarian or generic storefront building to a lowbrow historicist garage reflected the increasing confidence and stature of the automobile industry. Upscale stables, power stations and firehouses anticipated the dichotomous solution, and their façades all expressed a pride of mission. The garage adapted this formula when the automobile industry achieved a comparable maturity.

That maturity is reflected in the Model T, "the car that put America on wheels."[6] Ford introduced the car in 1908, opened the Highland Park factory (designed by Albert Kahn) in 1910, and produced the car on the assembly line starting in 1913. He intended to keep the design of the Model T constant and to offer it at lower and lower prices. It remained in production until 1927.

Figure 116. Ford Model T Touring Car, 1908 (author's photograph, automobile from the California Automobile Museum, Sacramento, CA).

The Model T is perhaps *the* iconic image of the early American automobile (Fig. 116). Automobile historian Frank Donovan affectionately described it as "probably the homeliest vehicle in America — unless one could see beauty in pure functionalism. Stubby and boxlike, it was far too high for its length by any aesthetic standards."[7] As a design, it was a great leap forward over the curved-dash Olds, and consigned the motorized buggy to history. The seat was lowered into the body of the vehicle, no longer awkwardly stacked on top of it, as in the Olds. While the side elevation still showed the articulation of the seat, the cutout in the metal formed a continuous and graceful line towards the floorboard and back up towards the front of the cab. More importantly, the engine and radiator were positioned in the front (as in the 1901 Mercedes), which afforded the vehicle more aesthetic balance. The car had a clearly stated front, middle and rear.

While the criticism of the Model T as homely and boxlike was well deserved, its beauty might not be attributable to "pure functionalism." Ford engineers famously scrutinized and refined each part of the automobile, and I am not suggesting that the finished product did not achieve an elegance of utility. However, it was still *designed* as an aesthetic object; its form cannot be explained as the inexorable result of technological determinism.

If the curved-dash Olds was a transitional object that referenced the buggy, the Model T was a fully formed object that referenced the locomotive and, more abstractly, the train. Of course, in scale and technology, the steam locomotive was fundamentally different than the Model T — and countless other models conforming to the same schematic template. The proportion of engine to cab was also much larger in the locomotive than the car. Still, this template established an iconic identity for the automobile by situating the engine in

front of the conductor's cab, articulating both as adjacent stages, and setting them on a chassis supported on wheels.

In both locomotives and automobiles, an engine is encased in a metal enclosure, the cross section of which is simple, compact, symmetrical and constant over its entire length. This enclosure is headed off by the front of the cab — the second stage — that presents a vertical wall to the engine enclosure. That wall is taller and wider than the engine enclosure. The cab itself is more overtly architectural, an open or closed box of thin walls containing seats. Springs and suspension devices associated with the transfer of load to the chassis and wheels are exposed to view. Locomotive and automobile look like what they are — self-propelled machines for moving people.

The front elevations of the automobile and locomotive reveal aesthetic intentions with architectural overtones. In both machines, the front of the extruded engine casing is the prominent element in a simple symmetrical elevation. In the classic steam locomotive façade, the round cap of the cylindrical smokebox sits above the cowcatcher; headlight, coupler and smokestack emphasize the central axis.

In the Model T, the prominent element is the radiator grill, expressed as a rectangle supporting an isosceles trapezoid of matching width. The interior of the rectangle — outlined in metal — is filled with metal mesh, while the trapezoid is solid metal (brass, originally). The grill is cradled within a larger base that includes the front fenders, axle and wheels, and suspension apparatus. When framed with headlights (originally not included),[8] the symmetrical elevation assumes a pointedly anthropomorphic quality. Windshield and top, also "extras," shift the center of gravity upwards. The radiator cap, a crowning flourish at the crest of the grill, is analogous to the locomotive smokestack.

In its composition and aesthetics, the automobile's front elevation is similar to the façade of city infill buildings of the same era, and the lowbrow historical garage, in particular. The radiator grill of the Model T is a frontispiece, not unlike the portals that grace the historicist façades of garages. Like them, the grill is the hierarchical center that stabilizes and unifies a larger composition. While not historicist in style or covered in ornament, the grill is traditional in its shape, balance and symmetry. The crowning gesture — the solid isosceles trapezoid — is not unlike the parapet of the lowbrow historicist garage, which also emphasizes the center. As a result of these properties, the front of the automobile assumes an architectural character. While evidence suggesting contemporaneous awareness of the connection is indeed scant, a writer for *Horseless Age* noted, "One Western dealer some years ago built a garage with a front representing the radiator outline of the car he handled."[9]

The engine enclosure is a skin that conceals and protects the car's industrial viscera. The engine, an asymmetrical and complex assemblage of industrial parts, is represented to the public as a smooth, symmetrical box with a façade on it. This is a dichotomous solution, one predicated on different requirements for exterior and interior; the former prioritizes identity and symbolism for public consumption, while the latter is home to raw industrial components. Automobile and garage therefore both present façades that idealize the design object through traditional compositional devices — symmetry, balance and hierarchy.

This notion is antithetical to modernist interpretations of the automobile as an exemplar of a machine aesthetic and functional design. Explaining this aesthetic, Sachs wrote, "Up until now one criterion of beauty had been 'uselessness.' From now on a lamp or a locomotive could be perceived as beautiful, as long as its form expressed unadorned function: the more strictly functional the machine, the more beautiful its formal aesthetic."[10] While the engine enclosure of the automobile represents the engine, it does so schematically, as one volume

relative to another (the cab). Like all schematic designs, the solution is generalized, filtered through a process of abstraction that is difficult to reconcile with an expression of pure functionalism.

Why design the automobile to assume architectural characteristics? To borrow Louis Kahn's term, the automobile "wants" to become architectural in order to signify that arrival as a substantial, stable and durable object — no longer the unreliable gizmo of lightweight parts and pieces.

While the garage façade is an architectural object that incorporates industrial elements to appear more machine-like, the automobile is a machine that incorporates architectural elements to appear more building-like. In the garage front, the multi-pane factory windows represent the industrial realm inside, and they compromise the purity of a potentially high-brow historicist façade. The architectural radiator grill — symmetrical, tapering and stable — compromises the purity of a strictly functional machine. These fronts meet each other halfway, and they present a wonderful and unexpected mix of the classical and the industrial. They are both lowbrow façades.

The correspondence helps to explain the unlikely affinity between classical architectural portals and transportation machines, a kinship that is strikingly apparent in the photos from the Exposition. The garage façade, its arched portal, and the front of the car (or locomotive) form concentric frames within frames, each one exhibiting the same compositional qualities, but at incrementally smaller scales.

Earlier I described a parable in which the cars of a train are decoupled, each one outfitted with a small engine in the front, and collectively set free to roam the streets of the city. As a conceptual or schematic design, the early automobile — as exemplified by the Model T — fits this description. Concurrently, the garage undergoes a comparable transformation, becoming a lowbrow historicist structure. It references the train station in diminutive fashion, multiplies and finds infill sites on city streets. The relationship between train and terminal is reproduced, with the profound difference that the automobile passes through the front, not the back, of the garage.

It is worth recalling that the garage of pre-earthquake San Francisco and the garage of 1910 accommodated overlapping but not congruent uses. The older building type was more generalized — an all-purpose facility for sales, repair and storage. It likely provided simultaneous accommodation for bicycles or horses. The generalized-use profile, facilitated within a relatively small space, reflects the unsure status of the young entrepreneurial industry as well as the small, though well heeled, customer base.

By 1910, a garage — like the example on Golden Gate — accommodated only cars, and was devoted to parking, repair, or some combination of the two. Thus, the Golden Gate Garage responded to the day-and-night demand for parking in the business and entertainment districts. The sales function consolidated in showroom buildings on Auto Row, eventually Van Ness Avenue. This specialization of use reflects the growth in the number of cars on city streets and the emerging economic might of the automobile industry. Describing the Auto Row phenomenon, Liebs said, "Automobile-dealership buildings were no longer considered merely places where a fad was merchandised; now they were the point of contact between the public and a rapidly expanding industry, consisting of scores of manufacturers."[11]

As discussed earlier, the specialization of use gave rise to a specialization of design, introducing divergent strains of urban auto-use architecture. The critical difference between the lowbrow historicist garage and the showroom building was the ground floor showroom

(set within an exterior that looked like a commercial office building). Albert Kahn designed the first showroom building in 1907, on Broadway and 61st Street in New York City. Called the "Packard Garage" (an apt appellation, overall), the showroom alone presented a well-appointed architectural interior in which to display and sell cars. Visible from the street, it resembled the lobby of a hotel or office building. As Liebs has written, automobile manufacturers specifically developed the idea of an "impressive and attractive"[12] sales environment as part of a larger campaign to "inspire public confidence" in an industry that had matured. Kahn's showroom template was reproduced hundreds of times across America. San Francisco architects, including Bernard Maybeck, built some of the most luxurious showrooms in the country in the 1920s.

While the lowbrow historicist garage is dichotomous, the showroom building encompasses a trichotomous organization within the isolated realm of the showroom. In this single room, the raw structure that is exposed in the dichotomous garage interior is dressed up in architectural finishes. The shift in design is linked not only to a specialization of use that distinguishes the showroom building from the parking garage, but also the showroom from the rest of its host building. In the showroom, auto-use architecture is transformed, becoming "fit for human habitation," and thereby aligned with the architecture of home and office. Ironically, both home and office — those poles of an auto-centric suburban life — include a *dichotomous* garage as standard equipment.

In 1910, the lowbrow historicist garage and the Model T were expressions of the industry's initial arrival, and not of imperial power. Nationally, the expression of empire developed in the monumental showroom buildings of America's Auto Rows. In San Francisco, however, the Exposition added its stylistic influence to this trend towards monumentality, affecting garages as well as showroom buildings. The change was realized in the Station garages at 1641 Jackson (1914) and 2405 Bush (1916), which presented Beaux-Arts–inspired façades with giant portals mimicking a conspicuous Exposition and train station motif (Figs. 73, 75 in chapter 3). On the showroom building side, John Galen Howard's Pierce-Arrow Building (1912–1913) was an austere palazzo (finished before the Exposition) that pushed local automotive architecture into the realm of the highbrow, despite its incorporation of industrial sash windows (Fig. 117). These buildings survive the Exposition and keep alive its memory and influence. That influence is experienced as a call to contemporary notions of excellence and as a reminder of the City Beautiful mandate to enhance the city through aesthetic architecture.

While the Model T remained relatively constant in design over the years, both car and assembly line were featured and celebrated within the Exposition's Palace of Transportation (Fig. 110, chapter 6). Every twenty minutes the line brought forth a new car, a ritual of efficient quasi-architectural production that mirrored the quick construction of the Exposition and the rebuilding of San Francisco. Pinkson noted, "Henry Ford, Thomas A. Edison and Harvey Firestone dropped in one day to watch the work. On another occasion Ford himself donned a jacket and 'personally' built a Ford car as a gift for Rear Admiral Fullam, his guest."[13] These personal appearances by three giants of American resourcefulness and industry confirmed the importance of the Exposition and the automobile — and the convergence of the two — in the eyes of San Franciscans.

In 1915, the automobile industry began preparations for World War I.[14] The factories shifted production, complementing automobiles with trucks, airplanes and other war supplies. Passenger cars became expensive, as demand exceeded supply. Used cars were rebuilt and kept in use.[15] In San Francisco, construction of new garages fell off from 1916 to 1918.

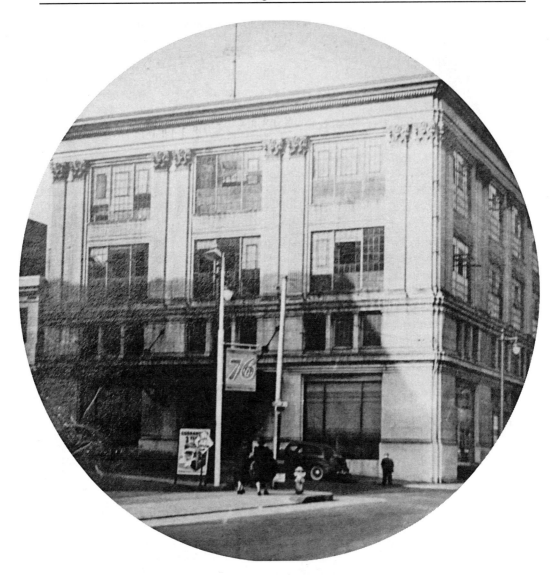

Figure 117. Pierce-Arrow Building at 1001 Polk Street. John Galen Howard, Architect, 1912–1913 (San Francisco History Center, San Francisco Public Library).

Motordom patted itself on the back for a job well done and assumed a patriotic and somber tone. An editorial in *California Motorist* stated, "And after only twenty-two years of existence, regarded first as a crazy idea, then as a luxury only for the rich, it [the motor vehicle] now assumes in 1918 the aspect of a grim necessity upon which perhaps the safety of the world may hinge."[16] An *Examiner* "editorial" directed San Franciscans to purchase a car as an act of decency and patriotism: "It is the duty of Government to uphold and encourage the automobile industry. It is the duty of the individual that can afford it to encourage that industry as an individual, buying the machine that he can afford —AND EVERY MAN CAN AFFORD SOME MACHINE NOW."[17]

This editorial is framed by small photographs of nineteen Auto Row showroom buildings arranged in a border around the page. While each image is a monument to the individual

enterprise that built it, the page design reassembles these enterprises into a corporate congress that supports the war effort and asks you to do your part. Like the banking industry, motordom chose to represent its power and promotional message through architecture.

Despite the wartime footing, annual car shows continued in the Civic Auditorium. Many of the cars displayed a sophistication of design that exposed the dated look of the Model T. Some manufacturers, including Buick, Cadillac, Pierce-Arrow and Kissel, featured "enclosed models" — cars in which a complete cab was integrated into the design (Fig. 118). The side elevation of these models showed off the consolidation of the automobile into two distinct and boxlike forms: engine enclosure and cab. While these forms were joined by finish, material and placement on a single chassis, they maintained separate identities and profiles. Relative to the Model T, these models appeared more unified, heavy and urbane. Significantly, they were at once more train-like and architectural, especially as regards the room-like quality of the cab.

Marketing Cars to Women

No discussion of the automobile industry's promotional strategies during this time would be complete without a consideration of the marketing of automobiles to women. Popular and trade literature devoted to the automobile is replete with patronizing generalizations, speculations and declarations regarding the relationship of women to cars. These musings emanated from industry pundits seemingly fixated on defining a narrow and exclusive basis for women's automotive preferences. Explanations of "what women want" typically isolated one of three realms as the primary source of interest: the technology (including ease of use considerations), the exterior, or the cab interior. (Sometimes, a woman's alleged preference for "style" is inclusive of interior and exterior.) These realms correlated to those of our architectural trichotomy.

The popular literature is uneven and inconsistent, as these conflicting stereotypes run parallel to one another. However, they all influenced motordom's development of a coherent marketing strategy in the 1920s. The strategy involved — among other things — the highlighting of the interior design of automobiles and showrooms. Thus, the design realm believed to interest women in particular — interior design — was that which transformed car and garage from dichotomous to trichotomous objects.

At the dawn of the motor age, motoring was a rich person's pastime, and the exploits of the well to do filled the gossip and automobile sections of local newspapers. Columns reported on men more than women, an imbalance exacerbated by the focus on automobile executives, who were overwhelmingly male. Still, society women appeared regularly, and their enjoyment of driving deemed worthy of comment. Nationally, fashion for drivers was an early topic of interest, one that continued throughout the 1920s. Smart outfits were featured for both men and women, the balance in coverage due in part to the specialized dress required for anyone — man or woman — who toured in open vehicles. Leather was ubiquitous in motoring attire, as it was in automobile tops and upholstery.

Women appeared routinely behind the wheel of automobiles in early promotional photographs and illustrations published in popular magazines and newspapers, on an international basis. A San Francisco example — the cover of a 1905 issue of *Speed*—features a smiling woman driver, her bonnet securely knotted beneath the chin (Fig. 119). The caption, "'A Good Pair' — California Beauty and Model K Winton," ties a related knot that bound

THESE FINE 1918 MODELS WILL BE SHOWN

Keeping pace with the times the new Buick model will be eclipsed by few cars for comfort, appearance and mechanical efficiency.

One of the new models of the Nash Motors Company of Kenosha, Wis. Pacific Nash Motor Company, local agents.

Cadillac Eight Imperial Limousine. Most finished and luxurious type of enclosed model.

Beauty of line and sturdy construction are featured in the new Paige models.

The Pierce-Arrow maintains year after year a certain high standard of comfort, dependability and safety with a reasonable outlay for gasoline and tires.

Above is a reproduction of one of the models of the sturdy Stutz cars for 1918.

Figure 118. This page from *California Motorist* shows that a mix of open and closed models was displayed at the 1918 car show (courtesy AAA NCNU Archives).

Figure 119. The inaugural issue of *Speed* (1905) features a woman driver above the caption, "'A Good Pair'— California Beauty and Model K Winton" (San Francisco Ephemera Collection, San Francisco Public Library).

women to cars in advertising. This type of ad, and thousands like it in the years to come, offered the presumed advantage of promoting the automobile to both men and women.

As the automobile, the garage, and the showroom evolved around 1910, women were regarded as a distinct class of buyers: "The fact that women have always wielded an important influence in the purchase of automobiles, is admitted by all manufacturers and representatives of motor cars. In no place has this been demonstrated more than in San Francisco."[18]

Marketing on the basis of gender stereotypes was well under way. Virginia Scharff wrote:

> With some hesitancy, manufacturers of gas-powered vehicles began to include electrical systems and, more broadly, features associated with safety, comfort, and convenience, attributes deemed appropriate to women drivers. Innovations such as the self-starter doubtless served the interest of male drivers as well, helping to change driving from elite sport to popular transportation mode to everyday necessity for a broad middle-class constituency.[19]

The profile of the electric car corresponds to a portrait of a woman driver as one who stays at home, shops and run errands close to home. She prioritizes ease of use. One article sums it up this way: "Of all the types of self propelled vehicles, the electric is now, and seems likely to remain, the simplest to handle on the road and to care for at home, whereby it still is, and seems likely to continue to be, the ladies [sic] favorite."[20]

Also emergent around this time was the proposition that women were primarily interested in the superficial aspects of the car, like finish and upholstery, and disinclined to learn about its mechanical features. A 1909 issue of *Town Talk* quoted Studebaker manager Chester N. Weaver: "The feminine side of the house ... is seriously interested in design, coloring and upholstering of the car with which she does her shopping, makes her calls, and utilizes probably five evenings out of the week."[21] Another article, however, reports on the unreliability of this stereotype:

> As a rule, women are not very greatly interested in the mechanical parts of an automobile, preferring rather to admire the luster of the finish and the luxurious upholstery. E. C. Collins, manager of the Cartercar Company, differs with this opinion, however. He states that many women stopped and watched the operation of the friction transmission and chain-in-oil drive as demonstrated by the stripped chassis of the Cartercar at the Grand Central Palace automobile show.[22]

Following the introduction of the electric starter in 1912, the gas-powered car became ascendant. However, this triumph was not accompanied by a cessation in marketing to women on the basis of stereotypes, nor did it end speculation on "what women want" in a car.

During World War I, with thousands of men abroad, the economy at home relied upon working women. The narrative emanating from motordom temporarily shifted gear, accordingly. In a brief respite from convention, women were not framed as housebound wives fearful of speed and power, but as active, working participants in the societal shift caused by the war. For example, an article, "Women's Work in War Time," stated categorically, "Every woman in the United States should learn to drive a motor car." Based on observations in Europe, the author wrote:

> The women of France, the women of Belgium, the women of England and the women of Roumania have laid aside their feminine prerogative of staying home and minding babies to relieve men who are able to shoulder a gun and fight for liberty. To my mind one of the chief occupations of women today is the handling of the ambulances, as well as the nursing of the sick.[23]

Another wartime article, "Women Become Auto Mechanics," notes, "It is remarkable how quickly the women are able to grasp the multitudinous duties of the various parts of the motor, rear axle, and other units that go to make up an automobile."[24] A *Chronicle* piece, "Women Aid in Auto Industry," includes the tag line, "They Work in Overalls."[25] Despite the revelation that women worked in mechanics' clothing, high fashion did not disappear — it merely adapted to wartime conditions: "The latest fad in motor coats for women this season are the trench coat, very mannish, following the military idea in every respect."[26]

At war's end, the soldiers returned and motordom reverted back to older gender stereotypes. However, thousands of women had experienced a new independence and autonomy — in part, facilitated by the automobile. Reactionary forces found this social shift worrisome and expended considerable effort in keeping women confined to traditional roles.

Saturation

In the early 1920s, automobile manufacturers developed various marketing strategies to ensure continued sales and to insulate themselves from the post–World War I depression and market saturation (the notion that all households capable of purchasing a car had already done so). These plans sought to expand the car market by persuading the buying public of the automobile's central role in facilitating an efficient, contemporary, and pleasurable lifestyle. The strategy to address saturation incorporated improvements in product design — the closed cab, in particular — into a broad promotional campaign targeting women. Interior design emerged as a significant theme, as the easy provision of an architecturally detailed passenger cab was assumed to appeal to women. The strategy had implications for auto-use architecture, especially the places in which cars were sold. A well-appointed showroom heightened awareness of a well-appointed cab. The commonality of interior design to the showroom and the automobile had implications for the dichotomous garage as well, accelerating the pace at which it lost relevance as a symbol of the automobile. While all three components under discussion — closed cabs, showroom buildings and ad campaigns targeting women — already existed in some fashion before the 1920s, it was only in the context of this coordinated strategy that they became mutually enhancing.

One campaign that was autonomous but nevertheless relevant to the notion that women needed their own cars was the reframing of the automobile as an essential tool of life. According to Norton, "Early perceptions of the passenger automobile are reflected in a popular name for it: 'pleasure car.' When auto interests perceived the modifier 'pleasure' as a limitation, they worked to remove it."[27] In part, the automotive industry was fighting to preserve easy credit from banks, which were tightening credit for purchases of luxury items. The industry fiercely maintained that the automobile was no luxury.

As a point of reference, a 1910 *Chronicle* editorial maintained, "So far, the automobile as a luxury, has had a more complete demonstration than the automobile as a utility."[28] Ten years later, *Motor Land* advanced the new strategy in an editorial entitled, "The Motor Car — A Daily Necessity": "It [the motor car] has demonstrated its practical utility and its invaluable daily service in saving time and labor for both the farmer and the city business or professional man." Industry's position is summed up this way: "If automobiles and trucks are luxuries, so are shoes."[29]

Indeed, as manufacturers produced cheaper cars, more Americans owned, enjoyed and

relied on them. Liebs has written, "By the 1920s ... driving had become a potent form of mass entertainment, and the automobile elevated to a much sought-after cultural icon. Next to a home, a car was a family's most expensive purchase.... Assaulted by advertising, goaded by peer pressure, and lured by the installment plan, many people of limited means made the leap."[30]

Due in no small measure to motordom's promotional strategies, the automobile was transformed into an object of desire, not just for the wealthy, but also for a growing middle class. At the heart of this transformation, according to Wolfgang Sachs, was an advertising motif extending back to the early promotion of the car: the bringing together of women and cars.

> The association between ladies and the automobile first cleared the way for the establishment of driving as a model of consumption. At no other time does one find so many placards and commercials that present women (better, ladies) together with cars. The automobile was slowly invested with the emotional aura of consumption, for it was the figure of the lady that embodied the domain of private gratification.[31]

The promotional strategy encompassed two seemingly contradictory themes: the car as necessity and the car as entertainment. As a necessity, the car was integrated into the struggle of everyday life, a vital tool that increased efficiency by squeezing valuable time and space out of the workday. As a source of entertainment, the automobile was fun and driving a pleasurable means of spending free time. Ultimately, these visions of the automobile were complementary, as the time saved as a result of increased productivity translated into free time during evenings and weekends. A new way of life emerged that hinged on the purchase of this expensive item. At once, the automobile reduced the time it took to conduct business, facilitated the purchase of additional labor-saving goods and services, and enabled auto tourism — the reward for becoming a consumer. Sachs has written, "Not only the entrepreneurial spirit and factory discipline but also extravagance and a joy in buying had to triumph if true consumers were to be made of self-sufficient citizens."[32]

Many factors contributed to the emergence of a mature automobile culture in the 1920s: easy credit, cheaper more dependable cars, better roads, tourism, and seemingly cheerful economic prospects. With success, however, came fears of market saturation, which the automobile industry addressed by resolving to sell cars to women. The campaign exploited the suburban lifestyle, selling the notion that if men claimed the family car for business, women were stuck at home, ill equipped to attend to responsibilities and recreational activities requiring mobility. A second family car — placed at the disposal of the woman of the house — was the solution. Indeed, the notion that management of domestic affairs required mobility reflected a shift, well under way, towards the industrialization and externalized availability of goods and services formerly produced at home.[33]

The strategy was predicated on the assumption that men and women inhabited separate spheres, in terms of urban geography and daily activities; as a result, the spheres themselves assumed gendered profiles. Lloyd's notion of the "sexual division of space" describes a traditional breakdown in which "interior spaces are for women; exterior spaces for men."[34] The male sphere was downtown, the center of commerce, business dealings and the making of money. Physically, the environment was dense, crowded and intimidating. The female sphere was the suburban home, the site of child rearing, interior design and housekeeping. Densities of buildings, people and traffic dropped precipitously.

As architectural historian Gwendolyn Wright has written, the Progressive Era introduced women to a new role: guardian of a "pure home environment."[35] Women were com-

missioned to wage an ongoing campaign against dust, dirt and germs, armed with an array of consumer goods, said to "insure purity and preserve domestic happiness."[36] Interior design was implicated as a means of achieving a reduction in exposed surfaces and an increase in cleanable ones. Referring to the expanding availability of fashionable built-ins, Wright noted, "The new furniture was most significant, because it protected household items from dust, thereby reducing the need for the housewife's constant attention."[37]

In the early twentieth century, women joined the work force in unprecedented numbers. During World War I, women gained access to types of work previously reserved for men. They commuted to worksites outside the home, thereby transgressing the "sexual division of space." Historian Ruth Schwartz Cowan describes the profile "of what was then called the 'new girl'— more athletic, better educated, [and] less circumscribed by traditional behavior patterns...."[38] Threatened by the prospect of women shedding traditional roles and exercising self-determination, conservative elements of society sought to reaffirm a woman's place in the home. They embraced the idea of women as protectors of domestic purity. Wachs refers to "opinion leaders ... who spoke out against the declining importance of family and home, and transformed the very meaning of the liberation of women from a change in their roles to a release from drudgery by applying technology to the reinforcement of women's traditional roles."[39]

At the same time, advertisers promoted their wares — to both sexes — as an antidote to the doldrums of work and a routinized existence. Historian T. J. Jackson Lears wrote, "They [advertisers] held out the hope that life could be perpetually fulfilling; and they implied that one ought to strive for that fulfillment through consumption."[40] The automobile, unlike consumer goods expressly produced for cleaning and cooking, offered the possibility of fulfillment through mobility and independence. Nelson observed, "...the automobile had nothing to do with a woman's traditional role as homemaker. In fact, it took her away from the house and into society at large."[41] As part of the effort to counter this possibility, conservative advertisers emphasized the automobile's usefulness in performing domestic chores — shopping, picking up schoolchildren and running chores.

Articles appear in the popular and trade press of the early to mid–1920s, acknowledging the increase in the number of women drivers, and framing the automobile as an extension of a woman's domestic sphere. A 1926 article in *Motor Land* is typical: "Good housekeeping, recognized as an inherent quality in the American woman of all classes, is being broadened in this period to include good car keeping. Making the home run smoothly is finding a parallel in making the automobile run the same way."[42] The accompanying illustration depicts a woman applying a duster to her automobile, above the caption, "With good housekeeping being broadened into good car keeping, the American woman may be found chasing dirt just as religiously from the car as from the living room." Metaphorically, the automobile becomes an extension of the house — another room to keep clean.

This conceptualization of the second family car adapted the "car as necessity" theme to the female sphere. It complemented an older version of the theme specific to the male sphere — the car as conqueror of time and space, and instrument of increased efficiency for the businessman. Now the car was a necessity to both men and women, enabling them to perform the responsibilities specific to their geographic realms and gendered roles.

A concurrent theme in the marketing of automobiles to women was the representation of the car as a gender-specific status symbol. As discussed earlier, the automobile helped establish a status-conscious society characterized by a heightened interest in outward appearances. The power of the automobile as a status symbol resided in part on its special condition

as a mobile architecture — an object that ostensibly provided privacy while framing a voyeuristic view from without. Passengers came to view the car as a sign of personal status and wealth.

While passengers of both genders were susceptible to this form of vanity, motordom promoted the idea that the automobile complemented and enhanced a woman's appearance, and functions like fashion. In this latter regard, the colors and finishes of the automobile were a matter of personal aesthetic choice, one that reflected upon a woman's refinement and taste. Of particular interest was the closed car's interior design, interpreted as an extension of the residential interior — a significant area of focus within the woman's domain. In this instance, the mobility of the architectural object heightened the accessibility of a woman's design choices to public scrutiny.

By contrast, an open car heightened the accessibility of the woman herself as an object. In a wartime article by actress Lillian Russell, women drivers were cautioned to apply "cream and soothing lotions ... to keep the skin in the peak of perfection," and to don gloves to "keep their hands soft." Russell concludes, "Don't abandon your claim to poise and graceful bearing for the privilege and pleasure of driving a car. You can drive well and look well at the same time."[43]

This theme draws upon and restates the longstanding stereotype asserting that a woman's interest in automobiles was limited to appearance, comfort and ease of use, and did not extend to mechanical features or repairs.[44] During World War I this stereotype was seemingly set aside, as women entered the workforce in various capacities, becoming — among other things — mechanics, factory workers, and drivers. However, the magazine and newspaper writers who commented upon these developments rarely dispensed with the patronizing and disingenuous tone typical of articles about women and cars. Often, as in the example provided above, authors expressed surprise at the improbable capacities demonstrated by women. The reinvigoration of the older stereotype was symptomatic of the larger effort to stifle the movement for personal autonomy and to consign women to traditional roles.

The closed car facilitated the resurgence of the stereotype. Scharff notes that electrics "often were designed as enclosed vehicles," a packaging of technology and design that supposedly enhanced these cars' appeal to women.[45] A woman's alleged preference for the closed design is expressed in this 1910 *Chronicle* article: "The man may have his touring car, but the lady, too, must have her closed car. It is no longer the fashion for women to travel about a city in the open touring car that served two years ago."[46] In 1921, this history was appreciated retrospectively: "Manufacturers long ago recognized that design and refinement of the car made must appeal to women. This influence can be traced through the growing popularity of the enclosed car — the coupe and sedan."[47] A dramatic increase in ownership of closed cars occurred as the marketing effort unfolded. According to Flink, "Hudson introduced the "first inexpensive closed car in 1921.... Only 10.3% of US cars were closed in 1919; 82.2% were closed in 1927."[48]

The closed car offered the benefits of any architectural enclosure: privacy, intimacy (relative to the outdoors), and protection from the elements. The watertight enclosure afforded flexibility in dress and interior design. Leather was supplanted as the material of choice for a passenger's clothing and the cabin's finishes.

The architectural quality of the closed car was emphasized in the marketing of cars to women. A *Motor Land* article from December 1920 entitled "The Reign of Feminism" exemplifies the centrality of interior design to the promotion (Fig. 120). The article winks at its

Figure 120. The "Reign of Feminism," from *Motor Land*, refers to the notion that a woman chooses the family car. Doors ajar, these closed car models emphasize the interior design of the passenger cab (*Motor Land*, courtesy AAA NCNU Archives).

male audience with the opening, "Whoever else may sign the check it is the woman who picks the car ten times out of eleven."[49] Featured are the interiors of closed cars (Daniels, Cunningham, Marmon, Buick and Packard), photographed through open doors. The seat upholstery, floor carpets, and interior side door fabrics are highlighted. Framed windows form a continuous band — like a folded ribbon window — around the cabin. One model, the more expensive Marmon, is outfitted with coordinated Victorian fabric coverings on inside door faces and cushions.

Captions are rendered in an italicized script, and set in panels adorned with a festoon, floral motif or cameo. The architectural metaphor is explicitly stated: "Designers first argued that miladi's [sic] car should have the same attention as her boudoir, and must be decorative and gorgeous to the last degree."[50] Interior design, fashion and accessories for the woman converge in a discussion of the cab:

> Tans and grays are the tones in general favor. They are not only practical, but they harmonize with any gown the fair occupant may choose to wear.... No end of thought and labor is spent on these decorations and fittings designed to catch the feminine fancy. There are the cases containing bottles for scent and smelling salts, mirror, notebook and tiny toilet set; soft pillows and foot rests and a hundred and one other very desirable feminine requisites.[51]

The article concluded by acknowledging the campaign and restating its initial premise: "At the automobile shows both exhibitors and salesmen are stressing the feminine note. Verily

man pays and woman chooses."[52] There was a decidedly upper-crust tone to the article, which might have reflected the fact that these particular cars were expensive, and/or the writer's understanding that marketing to "feminine fancy" necessarily involved the exploitation of gender-based representations of status. Either way, the article provides an example of marketing to both sexes based on the proposition that the inside of the cab was an interior design consideration. As such, it fell within a woman's sphere of expertise, and effectively extended her domain from the house to the car. The strategy focused on the architectural quality of the interior to inspire desire for the product and provide a criterion for selection.

Women, Garages and Interior Design

In the 1920s, women drove in increasing numbers. When driving, they were often viewed as emissaries from the domestic sphere and the battle waged on behalf of purity. It was assumed that they brought the campaign with them, maintaining a vigilant eye out for unhealthy or immoral conditions wherever they traveled. This possibility became a source of concern for garage owners, who risked unfavorable judgments of the facilities rendered by the champions of purity. The self-consciousness of mechanics regarding the interior conditions of the garage — as seen through a woman's eyes — reflected a break in the symbolic link between the dichotomous car and garage.

The expectations of female patrons became the subject of considerable discussion in trade and tourism magazines. One writer noted, "Women, in ever-increasing numbers are driving cars, and they will not submit to doing business with a garage the slovenly appearance of which is not only abhorrent, but emphasizes the inefficiency that must result."[53] Another article warned, "In addition to having service work well done, there is another element creeping in, in these days, when milady drives the car into the service station, namely, CLEANLINESS! ... The men on the job must be attired in clean garb and their utterances must be tolerable."[54]

A regular feature of *Motor Age* was entitled, "Garage Planning: Service Station Arrangements." In response to inquiries from prospective garage operators, the editors developed a plan layout accompanied by a written explanation. In 1919, one garage operator proposed an "electric garage" for women, a project that provoked a discussion of interior design improvements deemed appropriate for the clientele. The garage operator envisioned an "arch ceiling of white tile [which] would not only be clean but, inasmuch as this is to be a ladies' garage, it would be very attractive." The editors concurred: "You will have a beautiful place and one that will be irresistible to women, which is your desire." Later, the editors cautioned the operator,

> Women as a rule are adverse to machinery and do not appreciate the hum of a dynamo any more than that of a bumblebee. Inasmuch as you are catering to women, you can't make it any too agreeable for them. You should have an especially attractive waiting or restroom.... Put in a small piano, some comfortable chairs, a couch, some plants and ferns, a bookcase with a few late magazines and good fiction, and after it is complete take care of it, keep it clean and neat.[55]

A later editorial acknowledged a "problem" for the dealer or garage operator, who was called upon to "devise ways and means for properly taking care of the women drivers." To assist, the editor published a letter from a woman driver (a presumed spokeswoman for the gender), who offered the following advice:

Although attractive waiting rooms are very desirable, we do not expect, or even desire to be ushered into one of these rooms with the invitation to spend the time reading current magazines or otherwise wasting time which could be made very valuable if the service stations would only adopt the right attitude toward us. Why not, rather, invite us to watch the mechanic do the work on our car? Perhaps had we understood the trouble, we could easily have made the adjustment ourselves.[56]

All of these articles from 1919 to 1921 express anxieties regarding interactions with women, both personally and in relation to the garage interior. Clearly, the interior is the realm of the male mechanic, who — in consideration of his isolation — has established certain norms of décor and decorum. Both can be described as raw and rough. Women were demanding outsiders, to be tolerated and accommodated through modifications in behavior, attire and the upkeep of the facility. The adoption of civility and cleanliness represented the superimposition of a woman's preferences onto the facility and the deconstruction of the monolithic male domain. Our letter writer proposed an intrusive foray deep into the lair, where she could observe the mechanic and his surroundings.

In a variation of this trope — one that bridges the gender gap — the (female) maid and (male) mechanic were likened as servants hired to maintain the house and its mobile satellite, the automobile: "The best mechanics, like the best house servants, are the ones who work most and talk least."[57] This scenario positioned the housewife as a somewhat burdened consumer of services, a position requiring managerial skills. The comment affirmed the apprehensions of the mechanics.

Much of the discussion focused on the interior design of the garage. In order to offer women a comfortable environment, the garage must discard its rigid dichotomous nature through the incorporation of a finished architectural interior. The entire facility did not warrant transformation, just a single waiting room or lounge. This accommodation, accompanied by others like cleanliness and "tolerable utterances," did, however, cause a shift in the social culture of the facility. By contrast, the provision of lounge space and sleeping quarters for chauffeurs — a common amenity in garages of the 1910s — did not cause comparable concerns.

The large majority of lowbrow historicist garages in San Francisco contain no finished architectural rooms for customers.[58] Most garages in downtown San Francisco occupy narrow sites, and limited frontages are devoted to vehicular access, offices and some retail display.

A few garages mentioned special accommodations for women in their ads. The North Central at 355 Bush and the Bell at 175 Turk — both skyscrapers from 1925 — included a "ladies rest room," as did the Century at 675 Post. All three were close to shopping districts, a circumstance that factored into the promotion of these amenities. Shannon Sanders McDonald writes, "Once women began to drive downtown to shop, parking was needed not only for the cars of businessmen, but for their wives as well, as they went about their errands for the family. Thus, early garages often included lounges where owners would wait for the retrieval of their cars, and to which packages could be delivered after shopping."[59]

The Century was home to a women's restroom with a fully developed lounge. As discussed earlier, this room was featured in the Century's ads. Although the garage also provided a smoking room for men, photographs of this room were never published. Like the closed-car interiors shown in the example above, the women's lounge was a status symbol representing the convergence of gender and class. In this building, the lounge constituted one part of a larger effort to pander to both sexes on the basis of class.

Nevertheless, the Century was significant as evidence that a finished architectural inte-

rior was viewed as an enticement to wealthy (or would-be wealthy) women, furnishing a familiar amenity within an unfamiliar realm. Indeed, the lounge was analogous to the auto showroom as the one finished room, created for comfort, within a much larger dichotomous garage building. It is not surprising that the *Motor Age* article devoted to the Century included the following caption beneath the photograph of the women's restroom: "This is not a view of the mezzanine floor in a fashionable hotel, but a corner of the women's rest room in the Century Garage."[60] The caption was similar to many descriptions of the auto showroom — a new room type that was also likened to a hotel lobby. These comparisons were usually offered by way of clarification, anticipating the observer's bemusement.

The Architectural Nature of the Neo-Classical Automobile

In the 1920s, the architectural nature of the automobile grew, not only visually, but also as a source of shelter, security and privacy. In order for the second family automobile to fulfill its role as a necessary and fashionable appliance, dependability was essential. The prospect of constant equipment failure — so common in the early days of automobility — was simply incompatible with the representation of the car as an extension of home or office — an elegant room on wheels. Indeed, manufacturers produced more advanced and reliable automobiles. Flink notes, "With the exception of the automatic transmission, the major mechanical innovations that distinguish cars of the post–World War II period from the 1908 Model T had been incorporated into production cars by the late 1920s."[61] While self-congratulatory, the following observation offered by one California car executive in 1925 was not unreasonable: "It is not many years since roadside breakdowns were accepted as an inevitable feature of every motor trip.... Those days are gone forever."[62]

The Chrysler Six, released in 1924 during the heyday of historicist garage construction, was fashionable, technically advanced yet moderately priced (Fig. 121). Earlier, it was noted that the cars exhibited in the 1918 car show appeared more consolidated and cohesive than the clunky Model T; the gap widened with the Chrysler Six and cars of this generation. While the design continued to represent the automobile as the fusion of engine and cab, the two elements were better integrated than the 1918 sampling. For example, the engine enclosure of the Chrysler Six widened and rose as it approached the cab, effecting a smoother transition. The horizontal seam between hood and engine enclosure was extended as a belt line across the side elevation of the cab. There were two windows on the side elevations instead of three or more. The cabin was lower and less boxy.

Still, the reference to the train locomotive remained. While the Chrysler Six and the Model T appeared vastly different, the contrasts were most evident in the side elevations; the front façades remained alike. Both compositions focused on the radiator grill as an architectural frontispiece and hierarchical center. Functional elements continued to extend out symmetrically from the center: front wheels, axle, suspension system and headlights. Proportionately, the Chrysler Six was superior to the Model T, however. The radiator grill was taller and more imposing, its metal trim formed a continuous arched frame around the mesh. Viewed head on, the car appeared more monumental and substantial. On a more luxurious plane, the Packard Eight also exemplified the architectural quality of the early 1920s car front, anchored by its "famous Gothic radiator shape."[63]

The form of the automobile became increasingly body like. The silhouette was more

Figure 121. The Chrysler Six, 1924 (courtesy Chrysler Group LLC).

constant and less episodic, exposed industrial parts were minimized, and the two volumes (cab and engine) brought together by a constant beltline. Asymmetries, complexities and irregularities were subsumed within the metal enclosure that functioned as a skin. The object appeared complete, visually assuming the autonomous presence worthy of its creature-like mobility.

The Chrysler and the Packard reflected the increasing importance of style. While the exterior form became more responsive to aesthetic concerns, a more complicated engineering apparatus was better concealed. As an architectural metaphor, this weighty, stable and symmetrical object was more aligned with historicist garages, power stations and firehouses than it was with the floating asymmetrical buildings of the modern movement. The perceived aesthetic affinity of these objects was evident in an *Examiner* cartoon (celebrating the 1923 car show and its unfortunate racist theme).[64] Historicist building and automobile merged into a single object, with the Civic Auditorium transformed into cab and an adjoining urban building serving as radiator grill (Fig. 122).

Throughout the 1920s, car interests exploited the aesthetic affinity between historicist buildings and automobiles in their newspaper and magazine ads. A typical image features an automobile in the foreground and a historicist landmark or upscale residence in the background (Fig. 123). In San Francisco, favored backdrops include the Palace of Fine Arts (the lone survivor of the Exposition) and the band shell in Golden Gate Park — familiar settings that are local, yet pastoral.

The ad copy makes explicit the basis of comparison. Thus, a 1925 ad for Lincoln juxtaposes photos of the car and the *Arc de Triomphe* beneath the heading "Masterpieces."[65] In the Peerless ad shown, car and band shell are equivalent expressions of "master" building; the objects are oriented parallel to one another, emphasizing the monumentality of their analogous façades.

Figure 122. An *Examiner* cartoon, "Now For a Record Run!" promotes the 1923 car show — and its racist theme — with an image of car and building merged. The Civic Auditorium is the passenger cab (courtesy San Francisco Examiner).

San Francisco landmarks typically serve more expensive automobile models. Ads drawing a parallel between expensive cars and cultural landmarks sell the urbane lifestyle and cultural sophistication associated with the building. While nationally, upscale architectural backdrops promote cars across the entire price range, the local patina of elitism limits the universality of the design parallel. In 1925, a Model T — or even a more stylish Chevy — photographed before the Palace of Fine Arts might have struck the contemporary San Fran-

Figure 123. This ad juxtaposes two examples of "master building": the Peerless Eight automobile and the Temple of Music (the "bandshell") at Golden Gate Park (*Motor Land*, courtesy AAA NCNU Archives).

ciscan as a tenuous juxtaposition (even though the cars produced in the Palace of Transportation ten years earlier were Fords).

Nevertheless, these ads impart an equivalent status to buildings and cars as objects, and some — like the Peerless ad — exploit a similarity in the appearance of the façades to reinforce this equivalence. The San Francisco images recall those of the Exposition, and continue the celebratory pairing of automobiles and historicist architecture. Not surprisingly, the ad campaigns unfolded alongside of the annual car shows in the Civic Auditorium and the increasingly monumental architectural development of Auto Row — other expressions of empire that drew from the spirit and imagery of the Exposition. The façades of the lowbrow historicist garage also drew from the Exposition, while the interiors — like those of the Exposition palaces — abruptly dispensed with the fanfare.

The architectural metaphor extended to the residence as well, as illustrated on the cover of the December 1920 issue of *Motor Land* (Fig. 124). In a vision of American wellbeing and affluence, a husband escorts wife and child outside to admire her Christmas present, a new car. The family marvels from the oversized and elegant entrance. A neo-classical frontispiece frames a doorway with an arched transom window.

These examples represent buildings and cars in a park or suburban landscape, views that emphasize the autonomous nature of the objects. The autonomy creates the illusion of equivalence and comparability, important preconditions to the further representation of the objects as mutually reinforcing status symbols. As a parallel development, the inside of the automobile and the residence are represented as comparable spatial entities, especially as finished interior rooms. The analogy also extends to architectural construction technology and process: cars and buildings as rough structures or armatures subsequently overlaid with surface design and finish. For marketing purposes, the analogy attaches to the residence. One local car executive wrote:

> Building a closed-car body is like building a house. More than a solid foundation is required. There must be substantial side walls, the proper kind of roof and high-class interior fittings. It is impossible to skimp on materials and workmanship and build a closed car body that will endure.[66]

The author did not introduce gender into the discussion. However, his concern regarding the use of superficial design features as the basis for the selection of an automobile recalled the earlier stereotypical description of women's preferences:

> The casual observer may be won by closed cars because of their grace of line, beauty of finish and upholstery and features of equipment; and naturally so, for these are surface qualities, and important ones in judging closed car quality. But with the body, as with the chassis, most of the features of quality are hidden, and these have a vital bearing upon the service, comfort and all-around satisfaction which the owner enjoys.[67]

The writer grappled with the ramifications of the closed car, especially the transformation from a dichotomous machine to a trichotomous architecture. He posited what amounted to an opposition between the two distinct realms of the object's interior — the concealed industrial apparatus and the finished cab. The viscera and skeleton were the true sources of quality while the aesthetic features were misleading and superficial. If we allow ourselves a bit of critical license and superimpose the gender identities implied in the discussion, the author cautioned men not to be seduced by the "Reign of Feminism."

This cautionary tale is an automotive complement to earlier examples recounting garage operators' anxiety at the prospect of hosting women clients. The garage interior was like

Figure 124. In this *Motor Land* cover, a wife and mother gets a new car for Christmas. The illustration advances the strategy of marketing cars to women and represents the car as a status symbol equivalent to the classically inspired house (San Francisco History Center, San Francisco Public Library).

the frame of a house or the engine under the hood — the rough, raw and industrial material that was trustworthy and sure. This was the domain of the male mechanic or house builder. The raw garage interior was uniquely open to view, a circumstance that exposed both the architecture and the mechanic to a woman's critical appraisal. With the application of interior finishes to the closed cabs of cars and the showrooms of garages (showroom buildings), women's alleged preferences were accommodated while the true source of integrity became concealed.

More garages were built in San Francisco between the end of World War I and 1925 than in any previous period. During these years, architectural design in San Francisco remained historicist, eclectic, and influenced by the architecture of the Exposition. While automotive design — a national phenomenon — evolved, the later models (those that rendered the Model T visually obsolete) were easily integrated into that intimate bond linking local historicist architecture and cars. This continuity in relationship is revealed in a comparison of photos from the Exposition and ads from the 1920s.

Like the automobile and the showroom, the garage emerged as a more mature form during the 1920s, establishing its own conventions and identity. This maturity manifested itself in the building structure, a two-story concrete frame with ramps. This structure stabilized the garage form and established an underlying template. It represented an advance over earlier garages that maintained links to an earlier building technology (masonry construction) and previous modes of transportation (horse-drawn vehicles).

What results was a remarkable continuity among dozens of buildings. Projected to the façade, this structure was amenable to a gridded composition based on the articulation of horizontal stories and vertical bays. Indeed, the first three façade categories discussed in chapter 3, the Twin Arch, the Narrow ABCBA and the Wide ABCBA, are all elaborations upon this template. The four Pasqualetti garages that fill the narrow ABCBA type are compelling as variations on a narrowly defined theme. This template also supports a dialogue among buildings of different styles and designers, like 66 Page, 1550 Union and 530–544 Taylor.

This template also underlies the majority of examples that offer an alternative to the façade composition centered on a void or glazed portal. In the Twin Arch and the Wide ABCBA types (530–544 Taylor excepted), the skyscraper at 111 Stevenson (Fig. 67 in chapter 3) and the Gothic 550–560 O'Farrell (Fig. 63 in chapter 3), all from the 1920s, the architects experimented with alternate paradigms relating symmetrical composition to the car. More modern conceptions were introduced that expressed the dynamic movement of the automobile in the city. Chief among these are compositions emphasizing rotation about a fixed center, the opposing in-and-out motion of the automobile, and the incline of the street. Rather than amplify the symmetry of the automobile front, as in the triumphal arch type of composition, these façades represented the structured conflict of automobile traffic in the city — two-way streets, intersections and the rules of the road.

However, as if reluctant to assert this affinity with the modern city too stridently, the 1920s garage kept one foot in both worlds, the more progressive represented by the even-bay Twin Arch, the more traditional by the odd-bay Narrow ABCBA category (and the stunning garage at 770 North Point). The latest garage in the study, the Twin Arch at 2120 Polk (Fig. 31 in chapter 3), struggled to reconcile the opposing tendencies between a composition inwardly focused on the automobile, and one expansively open to the city.

As the automobile solidified behind its symmetrical face, the garage façade slowly dispensed with the triumphal arch. As the automobile became more creature-like and architec-

tural, the garage becomes more machine-like and efficient. While both objects relied on technological advances to become safer and more reliable, they retained aesthetic ties to the past.

Automobility, Trichotomy and the Don Lee Showroom

With the perfection of the closed car, the introduction of interior design, increased dependability and a form more expressive of the autonomy of the object, the automobile transformed from a dichotomous moving contraption into a mobile piece of architecture. The transformation greatly enhanced the popular appeal of the automobile, due in no small measure to the ability of a self-propelled architecture to deliver on the world-altering promise associated with the term "automobility."

Automobility afforded Americans a wondrous freedom of movement, an immediacy of experience, and opportunities for exploration. In its recreational application, the new-found mastery over time and space exploded the limitations of a provincial existence, promising adventure and a steady stream of new sensations. A conceptual diagram of this expansiveness is like a child's drawing of the sun, with rays shooting out in all directions from a central sphere. Home was a starting point, a source and a center; the automobile was a satellite of the home — an agent specially outfitted for mobility and travel. The car provided the comfort and privacy of home, as mediated by compaction in a small space and exposure within an infinite space. It brought together and sharpened feelings of safety and risk, intimacy and overexposure, boredom and excitement. Driving opened up the possibility of living in the moment while daydreaming, of exercising intense focus while relaxing. While auto tourism was the activity that brought to mind these sensations, all auto excursions involved some measure of this new mix of feelings.

The architectural implications of automobility were known well before the implementation of the various design and engineering changes that would result in a more architectural car. In 1909, Chester Weaver said, "The house and its equipment furnish the interior comfort and luxury of the family, while the automobile furnishes the outdoor enjoyment which is so beneficial to health and strength."[68] Properties of the automobile and automobility were often described by reference to comparable properties of home and domestic life. As Weaver suggests, home and automobile offered individuals and families a new balance in life, a previously unknown choice of privately owned and habitable enclosures — one large and static, the other small and mobile. The two objects were inextricably linked.

Indeed, as a satellite of the home, the automobile accommodated many social activities of residential life. Berger wrote, "The automobile was a parlor, and sometimes a bedroom, on wheels."[69] Buckley Drummond observed, "Motoring was in some ways analogous to sitting on the porch."[70] While early car enthusiasts found adventure in "taming their snorting horseless wagons,"[71] automobilists of the 1920s found it invigorating to experience typical social interactions within the confined space of the automobile. In order to successfully translate these activities from house to car, key attributes of the home had to be translated as well, including privacy, enclosure and comfort. The coordinated architectural elements of the cabin interior — roof, lighting fixtures, glazing, seats, fabric, hardware, ashtrays, glove compartments, mirrors, trim — formed a specialized but serviceable analogue. Built-ins, these appointments paralleled the cabinets, shelving units and appliances of the smaller, more efficient kitchen, then becoming fashionable.

The lowbrow historicist garage was initially the architectural embodiment of the automobile, but as the automobile became more architectural, the garage lost potency and relevance as a symbol. When the automobile realized its own autonomous nature and liberated itself from references to carriages and train cars, the garage that referenced stables and train stations became anachronistic. The divide grew slowly over the course of the decade, as automobiles transitioned from open to closed models, as dependability increased (reducing the centrality of the repair garage), and as car styling accelerated the pace of modernization.

The need to sell cars was the driving force behind motordom's development of all of these changes, and the introduction of the affordable closed cab with developed interior was a prime example. The marketing of the closed car to women was essential to motordom's answer to saturation: sell families a second car for use by the wife. To borrow Scharff's observation (concerning the electric starter), the closed cab was better for everyone, regardless of its promotional target.

The strategy was supported by motordom's awareness of the dramatic increase in the number of women drivers since World War I, and its conviction that women exerted considerable (if not disproportionate) influence in the family's selection of a car.[72] Drawing upon the widely held assumption that women were drawn to the aesthetics of the automobile, and especially to its interior design, the closed car — which included a developed interior — was marketed to women.

The new automobile required fewer trips beneath the hood while it included a substantial interior space. These shifts had the effect of altering the balance of the three basic elements — technical apparatus, exterior casing and interior cab — in a manner that mimicked habitable buildings. Increasingly, the industrial viscera functioned in the car like the building systems and structure of a work of architecture — essential, concealed, rarely accessed and out of mind. Meanwhile, exterior and interior formulated a new dichotomy that centered on aesthetics and design. Thus, the transition in car design that unfolded in the 1920s concluded with the transformation of the individual into a mature consumer — one who purchased, used and discarded.

The historicist public garage remained dichotomous and did not undergo a shift comparable to that of the automobile. This is another way of describing the dislocation of the symbolic link between the two objects. While the car was endlessly manipulated to enhance sales, the garage — like the Model T — remained constant. Organizationally, the garage maintained its relationship to the Exposition building, or more abstractly, to a flattened train station. To motordom, the insertion of a finished interior into an industrial object was an essential sales tool, applicable both to buildings and cars. The strategy had already been used since 1907 in the auto showroom building, a facility devoted first and foremost to sales.

As Liebs points out, the construction of luxurious showroom buildings was a national phenomenon, and inspired "a game of visual one-upmanship" among the dealers working within a particular city.[73] Even so, San Francisco boasted particularly sumptuous examples. As discussed earlier, San Francisco's history was one factor that motivated the striving for monumentality along Auto Row. The elite group of architects who rebuilt the city brought to bear their City Beautiful convictions and Beaux-Arts training on the Exposition, Civic Center, and Auto Row. The showrooms within these buildings were interior complements to those advertising images depicting automobiles alongside cultural landmarks like the Palace of Fine Arts.

The coordination of monumental architecture, opulent interior design, car design and fashion design — all in the service of marketing to women (and men) — reached a pinnacle in "Closed Car Week," an exposition-like festival staged along Auto Row showrooms in cities across America during 1921. These events, spearheaded by Studebaker, employed live music, special lighting, red carpets, liveried doormen and free gifts to lure people into the showrooms. Featured were the latest models of closed cars. Perhaps the most novel aspect of these events, however, was the appearance — in Studebaker showrooms — of live models wearing the latest fashions. Thus, the coverage of the Chicago event in *Motor Age* led with the headline, "Milady Now Reviews the Latest in Enclosed Cars and Clothes at the Same Time."[74]

San Francisco's Closed Car Week was a huge success. Covering the event for the *Chronicle*, Pinkson reported, "All afternoon long and through the evening hours crowds of interested spectators thronged the showrooms inspecting the varied exhibits."[75] At the Studebaker showroom, evening presentations were organized, "in the nature of tableaux, showing in succession the different types of Studebaker cars which, when they were presented to the large gathering on hand, were peopled with living models wearing the gowns appropriate to the style of car."[76] Women wearing "costly evening gowns"[77] accompanied the Big Six sedan, while "two pretty girls attired in golf costumes"[78] alighted from the Light Six Coupe.

The spectacle lit up Van Ness Avenue with the tasteless pomp of the annual car show. Special lighting effects, including "spotlights, systems of indirect lighting and multi-colored globes, some hidden in festoons of flowers," recalled the colored lighting shows that illuminated the nighttime sky above the Exposition. The show incorporated the ambience of the city and the imposing presence of a wall of showroom buildings into its promotional seductions. However, the real extravaganza was inside, where the showrooms and the automobiles tantalized their guests with the promise of urbane luxury. Studebaker's juxtaposition of fashion and cars delivered the message that its guests were in fact consumers, consigned to endlessly desire the latest models. In this regard the event anticipated the more formal institution of car styling as a means of creating consumer demand, a marketing strategy that occurred a few years later.

The Don Lee Building, a Cadillac dealership and showroom, opened on Auto Row in the same year as the staging of Closed Car Week (Fig. 125). The building epitomized the use of architectural design to sell cars. Designed by Weeks and Day, the exterior was particularly imposing and its showroom sumptuous. (The building façade is now a frontispiece for an AMC multiplex theater; the showroom is the lobby.) Here, the showroom proper fronts Van Ness Avenue, at the base of an eight-story building. The room provided an opulent setting for customers to consider the purchase of a luxury vehicle. Cars were rakishly positioned amidst a lush double-height interior that included a patterned brick floor, coffered ceiling, and carved wooden staircase and mezzanine balustrade. The modern frame structure was expressed, but the reinforced concrete was concealed within clustered Gothic column and painted wooden beam enclosures.

Entrance to the showroom was provided by an enormous portal consisting of an arched doorway framed by pairs of columns, the shafts of which were elaborately adorned in Renaissance motifs. The columns were crowned by a heavy entablature supporting a fantastic sculptural group, one that could well be dubbed *Ode to Cadillac*. It consisted of the corporate logo ensconced within a heraldic shield, against which flanking male nudes lie in repose, each one keeping a steadying hand atop an upright spoked wheel.[79]

However, this portal — like all showroom entrances on Van Ness — celebrated people

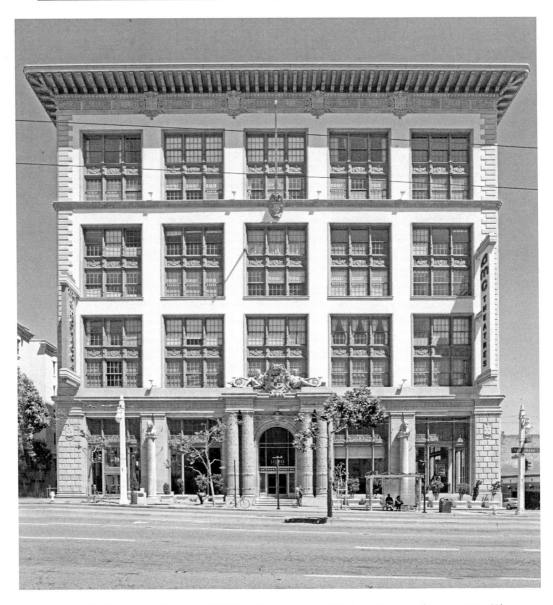

Figure 125. Don Lee Building at 1000 Van Ness Avenue. Weeks & Day, Architects, 1921 (Sharon Risedorph).

in the act of entering and exiting *on their own steam*. The cars — as inanimate as everything else in the interior — awaited the arrival of their potential masters. Advancing generally the cause of consumerism, the manufacturers' immediate goal was to redefine the car and the basis for wanting one: status trumped utility. This shift involved re-contextualizing the car — literally repositioning it as a high-end interior furnishing. At the same time, however, its large and static appearance within the showroom provoked an inevitable consideration of how it got there — if not through the front door. This consideration imbued the automotive denizen with an exotic and oxymoronic presence, akin to a pet lion: it's beautiful in its setting, potentially overpowering, and strange to encounter indoors.

The intention was to inspire desire for the automobile on the basis of its symbolism more than its functionalism, its luxury more than its mobility. The goal necessitated the emphatic rejection of the garage — not only as an industrialized interior environment, but also as a working architectural machine. This machine is engaged — turned on — by the movement of the automotive machine, an engagement that forever links the car to its greasy innards, utilitarian purpose, and tendency to experience *mechanical* breakdown. Such associations are hardly the stuff of luxury or even trouble-free touring.

Unlike the garage, the auto showroom purported to present an integrated architectural statement that encompassed exterior and interior. The large storefront windows on Van Ness extending from floor to ceiling encouraged viewers to appreciate the specific continuity linking the façade and the showroom. The substance of this ostensible continuity did not lie in the choice of materials or style; it resided in the singular representation of the upscale. A unified signification delivered the message that the auto showroom building was urbane, dignified and plush — analogous to a downtown office building or hotel. These are building types that unequivocally revolve around people (the garage revolves around the car). The showroom transforms the garage into a "normal" building in the sense of being habitable — analogous to home and office.

Just as the garage interior represents those aspects of the car that are likewise rough and industrial, the auto showroom brings out those aspects of the car that are correspondingly suave, well-appointed and accommodating to people. While the garage interior mirrors that which is under the hood, the auto showroom mirrors everything that is not. In the context of the showroom, the essence of the car is its wholeness as an integrated, trouble-free unit designed to house and transport the human body. Its exterior has front and side elevations — like a building. Its interior is plush, mimicking the comforts of the living room. Like buildings, it has concealed systems that are serviced by blue-collar specialists who are comfortable amidst the viscera. And like people (and pet lions), it has mysterious internal organs that are likewise, thankfully, hidden from view. And, in the unlikely event that you get sick, you go to the hospital; if your car breaks down, you take it to the garage. While we are all grateful such facilities exist, they are not places we look forward to visiting.

On the sales room floor, the car is to be admired and desired; a deep knowledge of how it works is not required, nor is it a pre-condition of the status that simply accrues with ownership. The car becomes the showroom's emissary, in terms of beauty, opulence, and most importantly, the freedom from encumbrance that these qualities confer. Simply put, it is the architecture that frames the car as an object of consumption. And while architecture has been used for thousands of years to sell and promote objects and ideas, this is very specifically the architecture of corporate American consumerism, of fashion, and of built-in obsolescence.

In order for the architecture to successfully transform car buyers into consumers, it must first undergo an internal shift from a car-centric building (garage) to one centered on people (auto showroom). Instead of driving (or walking) through a garage-door portal into an industrial interior, the replacement scenario has clients walk through an office building portal into an upscale interior. The shift entails a basic restructuring of the relationships between people, cars and buildings, such that the customer — and not the product — is the honored guest that is celebrated by the enclosure.

At Don Lee, the architects and designers were actively engaged in facilitating this change, employing formal devices and interior design to promote and reinforce the new priority (Fig. 126). This is most evident in the relationship established between the portal

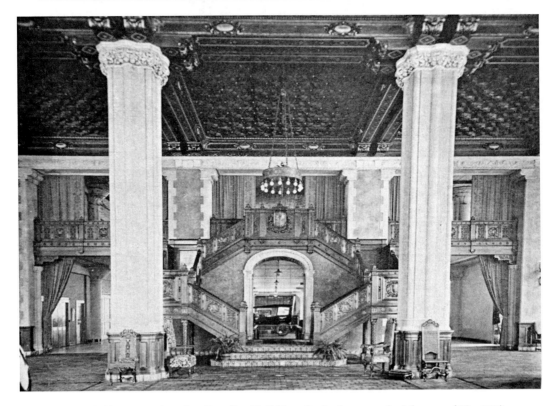

Figure 126. Showroom interior, Don Lee Building. Both photographs (above and Fig. 127) were shot along the major axis linking the entrance to the staircase. The photograph above was shot in 1921, with no cars in view (although shots from other angles do show cars). The figure on page 243 was shot in 1929 (San Francisco History Center, San Francisco Public Library).

and the interior layout. Centered on both the Van Ness façade and the showroom within, the portal enlists the entire structure in establishing its authority to direct movement along the shared centerline. Upon entry, it is revealed that the portal is not merely the entrance to a generalized interior, and its highest calling is not the delivery of prospective Cadillac owners to their objects of desire. Rather, the portal is — first and foremost — the gateway of a formal axis that traverses the depth of the room and terminates in the entry portal's thematic twin — the grand stair on the opposite wall.

The effect of these formal and visual manipulations is to transfix the attention of the entering visitor and focus attention on the stair. A pair of enormous columns that reinforce the monumentality of the vista frames this altar-like terminus. The stair projects into the room in a gesture that beckons towards the visitor. No cars impede this foreshortened parade: the pedestrian has the right-of-way.

It's no accident that the focus of all this effort is a staircase: a composite architectural element the basic unit of which is the step — a shelf whose dimensions are exclusively responsive to the physical capabilities of the human body. This element epitomizes, functionally and symbolically, that which cannot be negotiated by cars — only by people. Its placement and priority in the room foretells a regal procession and ritualistic ascent that is only to be experienced by those who have embraced the lifestyle implied by the showroom — and have elected to purchase a Cadillac.

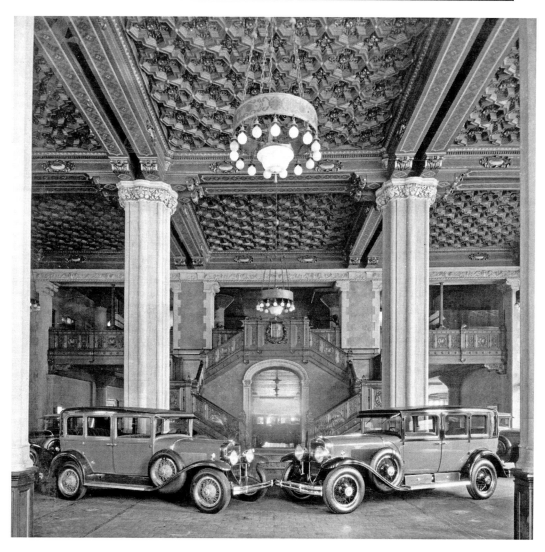

Figure 127. See the caption on page 242 (Holliday Development, DDR/ Van Ness Operating Company, L.P., and San Francisco History Center, San Francisco Public Library).

The staircase arrives at a mezzanine that gives access to three niches, the interiors of which are obscured by partially drawn drapes. Presumably, it is in within these sacred retreats that contracts are executed, monies and keys exchanged. Thereafter in the idealized narrative suggested by the architecture, the car owner takes possession, drives home, and considers whether to store the vehicle on the street (for maximum exposure), in the living room (the residential showroom), or — least desirable of all — in the garage.

In his architectural review of the Don Lee, Morrow focused on the deployment of "decorative unessentials"[80] within a building that was, beyond the showroom itself, a utilitarian garage. With tongue in cheek, he raised the possibility that the frivolous was the exclusive domain of the wealthy, and that the lush showroom was therefore appropriate for "cars of the highest class."[81] This suggests the complementary possibility that cheaper cars merit a less opulent architectural setting. However, this was not the case. In his discussion

on the industry-wide endorsement of the showroom, Liebs writes, "This philosophy of exhibition held true, not just for expensive cars, but for Detroit's more utilitarian offerings as well. In New York City, for example, even Model T Fords were exhibited in a salesroom, built in 1917, that boasted high-coffered ceilings, plush armchairs, oriental rugs, chandeliers, potted palms, walnut paneling, and a grand staircase."[82] Nevertheless, the Don Lee is a particularly well-heeled showroom that was regarded — at least by local pundits — as "the finest automobile service building in the United States."[83]

It is noteworthy that Morrow's musings on the appropriateness of high-end interior design for an essentially industrial use was still relevant a full fourteen years after Albert Kahn built the prototype — the Packard showroom located on Broadway in New York (1907).[84] The issue may have been kept alive by the continued appearance of the lowbrow historicist garage, a building type without a showroom and therefore more forthcoming about its industrial roots.

Critical consideration of the showroom may also be fueled by the ongoing campaign to transform the repair garage from a dark, dirty, intimidating place into a clean, welcoming retail environment. The campaign assumed a shrill tone in late 1921, when the Don Lee opened. A new point of attack focused on the extreme disparity in the quality and character of the interior architecture that occurred within the showroom building. One trade journalist wrote,

> Those very essentials of our living, light and cleanliness, have been totally ignored in the case of the service station, and in their stead we find darkness and filth. There is too much Circassian walnut in the salesrooms and too little paint or calcimine in the service department.[85]

Underlying this complaint was concern for the comfort and wellbeing of the woman client, who recoiled when forced to endure the sullied environment of the garage: "She draws her garments a little closer to her for fear of brushing up against a smeary post. Her white shoes make a wonderful contrast, too, with the slimy floor, black with the accumulations of dirt and oil. She is not at home here."[86]

She was, however, at home in the Don Lee showroom. Like the Cadillacs, the showroom was clean, comfortable and dependable. The sales staff was well attired, solicitous and courteous. Unlike the garage, within which the customer was of secondary importance to the automobile, the showroom lavished attention on the client.

A photo of the Don Lee taken eight years after the opening, on May 29, 1929, shows a dramatic turnaround in marketing. The strategy of selling cars by assigning the highest priority to the unencumbered ceremonial procession of the customer was abandoned. Instead, the consumer was greeted rather abruptly by a pair of Cadillacs (Fig. 127). The cars formed a closed gate that prohibited axial movement to the grand stair and substituted itself as the terminus. While it is tempting to ascribe this reversal in visual merchandising to business anxieties about market saturation[87] and dealers' struggles to turn a profit, such an assertion would be inaccurate. According to Flink, "luxury car sales peaked ... in 1928 and 1929,"[88] and did not decline until after the Crash. Regardless, with respect to photographic views of the showroom taken from the entry, both the absence of cars in 1921 and the presence of cars in 1929 were equally conspicuous, and revealed an ongoing preoccupation with the power of architectural procession to celebrate and promote.

In the early garage, ceremonial passage welcomed cars into their natural habitat, an industrial, utilitarian shed. In showroom buildings, the same portals were employed to

restore the hegemony of people over machines. However, that restoration was incomplete without the introduction of interior design to comfort, pander and seduce. The showroom building contributed to the obsolescence of the historicist garage by offering the illusion of unity between inside and outside, between the sales floor and the façade. By contrast, the lowbrow historicist garage maintained a firm separation between the public and private spheres, between the architectural façade and the industrial interior. Despite the profound differences, however, both building types are ultimately garages, as architectural boxes that facilitate the storage of vehicles.

Chapter 9

What Is to Be Done?

Note: Separate passages in this chapter first appeared in two articles written by the author: "Educate, Preserve, Reuse: The Good (Not Great) Garage Buildings of San Francisco," *AIA Report on University Research, Volume 4* (Washington DC: AIA, 2008); and "Sowing Seeds of Diversity: The Influence of Sustainability on Adaptive Reuse," *The Value of Design: Design is at the Core of What we Teach and Practice*, Proceedings of the 97th Annual Meeting of the Association of Collegiate Schools of Architecture, edited by Phoebe Crisman and Mark Gillem (Washington DC: ACSA Press, 2009). These passages are reproduced courtesy of the AIA and the ACSA, respectively.

The lowbrow historicist garage was the architectural embodiment of the early automobile. However, the symbolic link between the two artifacts lost potency as motordom transformed the automobile from a mechanical device into a consumer object. In the previous chapter, I discussed the deployment of interior design as a contributing factor in the framing of the automobile as a fashionable object. This effort encompassed passenger cab interiors and increasingly opulent showrooms. In the late 1920s, the process of transformation accelerated through the introduction of built-in obsolescence, annual changes in styling and "buying up." Industry promoted the purchase of new cars over the repair of old ones. Since its industrial interior represented tinkering, repair, the mechanic (and the parking attendant), the garage — while still necessary — became symbolically inconvenient. Plus, as the nation grew to prefer the automobile over the train, the garage façade — which touted the benefits of automobilia by reference to the train station — emphasized a moot point. The significance of the lowbrow historicist garage drifted into obscurity.

Today, that obscurity benefits a developer — private or public — who seeks to justify a project requiring demolition, a deleterious modification, and/or an insensitive change of use. These projects occur routinely, despite the fact that the lowbrow historicist garage is rich in historical and architectural meaning. Familiarity with the processes by which garages are marginalized and compromised helps us to understand the urgency of the situation, while provoking a reconsideration of the substance of architectural significance.

Roughly half of the 300 garages listed in the 1928 city directory still stand.[1] Most are still used for parking or repair, contributing to the economic and street life of San Francisco. Convenient to locals and flexible in layout, these buildings continue to facilitate small auto repair and parking businesses, eighty to one hundred years after construction. This is remarkable, considering the technological advancement in automobile design over this span, and the change in the garage business from one based on repair to one of maintenance and upkeep.[2]

The garages first appeared as a consequence of the city's growth, modernization, and congestion. Now, these same developments factor into their gradual disappearance. Just as there are observable patterns in their siting throughout the city — in the central business

district, along major thoroughfares and on the side streets off Auto Row—there are comparable patterns in their demolition. The following synopsis suggests that the urban geography and history of San Francisco in the twentieth century can be summarized through the decline of the garage—interpreted as a form of collateral damage that accompanies the city's larger building campaigns.

Garages, smaller office buildings and retail facilities located in the present downtown financial district—and its extension south of Market Street—have been sacrificed for new skyscrapers. For example, seven garages once stood in the former produce district just west of the Ferry Building, on land presently occupied by the Embarcadero Center and the open space before One Maritime Plaza. In addition to smaller-scale structures, skyscraper parking garages have also been demolished—the Bohemian at 375 O'Farrell and the North Central at 355 Bush. Some skyscraper garages have survived, two of which are included in this study. The loss of lowbrow historicist structures occurred as well in the residential development north of the Embarcadero Center.

In the 1950s and '60s, garages in the Western Addition were replaced by public housing projects. At least six auto-related buildings were torn down in the late 1950s for the Phillip Burton Federal Building on Golden Gate Avenue. In 1998, another three were demolished across the street to facilitate the construction of the Hiram W. Johnson State Office Building.[3] Some of these buildings were contributors to the city's initial Auto Row, and housed the first auto-related businesses to reopen after the quake.[4] Similarly, some garages made way for the commercial center of Japantown.

In the 1970s and '80s, garages and other lowbrow infill buildings were displaced by the new cultural and convention facilities (and related redevelopment) along Third and Fourth Streets—Yerba Buena and the Moscone Center. The Bridgeway Garage, designed in 1921 by Joseph L. Stewart—one of the best garage architects in San Francisco—once stood at 145 Fourth Street (Fig. 17 in chapter 2).[5] More recently, throughout the district south of Market and the Auto Row district along and surrounding Van Ness, garage and warehouse buildings have fallen to residential towers and live/work lofts.

A few garages have been razed in the Tenderloin in favor of tall affordable housing projects. However, more often than not, non-profit developers active in the Tenderloin renovate existing single-room occupancy buildings. Fortunately, this district is home to many excellent examples of the building type, as well as scores of other lowbrow structures. Fourteen of the thirty-six garages discussed in the typology chapter are located in the Tenderloin, and dozens of other garages and auto-use buildings remain.

Underutilization

A garage building's vulnerability results first and foremost from the fact that it underutilizes the land on which it stands. A landlord who owns real estate with unrealized potential has an array of choices—from maintaining the status quo to pursuing various development options. The decision is informed by many factors, including the physical condition of the structure, the cost of an upgrade, the building's capacity to accommodate a garage business or a variety of other uses, the economic pressures to change use and increase size, and the code restrictions on use and development.

Building owners have an understandable interest in maximizing the potential of their properties. One landlord and mechanic told me that if he did not own his own buildings,

his auto-repair business would not survive. "The rents are very high and the profit margins are very low." While he freely acknowledges the "distinctive look" of these buildings and takes pride in ownership, he believes they will not endure, and that he should not be asked to make a personal financial sacrifice by preserving the examples that he owns. Another mechanic owns a garage in a very desirable neighborhood and plans to develop three houses on the property "if the city lets me." He is correct in his assumption that development will be conditional upon city approval and that the preservation parameters of the project — including the scope of any proposed demolition — will be negotiated.

Today, lowbrow historicist garages are especially threatened in the northeastern quadrant of San Francisco. Most garages are lost due to a single property owner's decision to develop a particular piece of real estate, or to sell the property to a developer. Typically, a small infill building is replaced with a larger one. The most common scenario is the development of properties for residential use. This use is profitable in San Francisco, where demand for housing exceeds supply. If the site is zoned for bigger bulk, full development of the property could reap substantial rewards, especially in upscale neighborhoods like Russian Hill and Nob Hill and along the Union Street corridor. In the past few years, three garages located just blocks from one another in the desirable Russian Hill district have been demolished in favor of infill residential buildings.[6]

Judging from the consistently good-to-excellent quality of the demolished garages for which there are photographs, many fine examples have been lost (figs. 88 in chapter 3, 128). It's important to consider the impact of their absence when assessing the need to protect those that remain. The impact includes not only the effect on the street and the sibling garages throughout the city, but the relative merits of the succeeding structure (assuming there is one), measured in terms of *its* contributions to the public good. In some instances, as in the construction of affordable housing in the Tenderloin, we may decide that the loss of a garage is in our best interest. In weighing the pros and cons of any proposal, we must take into account that the violent removal of a building knit into the fabric of the city leaves a void; while the hole can be patched by new construction, the replacement does not easily integrate into the warp and woof of the urban texture.

While underutilization of real estate is the driving force behind the disappearance of garages, other factors increase the buildings' vulnerability. A poor visual appearance can support the assumption that the garage is a dirty and therefore unhygienic place. In some part, this assumption is a lingering holdover from the Progressive Era fixation on cleanliness and "pure" environments. Today, such concerns are subsumed within the term "blight." Unfortunately, it is all too easy to mischaracterize the visual aspect of an old working garage with the more profound moral deficiencies conjured up by the term. If this assumption is not balanced by an appreciation of the historical and architectural meaning of the building type, it is more likely that the garage will be razed or sanitized.

Most garages have undergone modifications that have altered their outward appearance for the worse, including the removal of parapets, stripping of ornament, widening of garage door openings, elimination of garage doors, insertion of standard doors in wide openings, and removal of steel or wood sash windows. Modern fabric awnings that obscure composition and ornamentation are ubiquitous in the Tenderloin (Fig. 15 in chapter 2). Often, a façade is little more than an armature supporting a chaotic collage of signs that identify and distinguish the various automotive repair businesses housed within a single sub-divided building (Fig. 38 in chapter 3).

Paradoxically, all of these compromises are improvements, in the sense that the owner

Figure 128. Garage at 1737 Jackson Street (demolished), built as the Cunningham Auto Show-room, 1920. Photograph from the 1960s (San Francisco Assessor's Office Negative Collection, San Francisco History Center, San Francisco Public Library).

or tenant invests time and money enacting alterations resulting in safer and more functional buildings. These alterations often constitute the minimum expenditure that will solve the problem, an approach that can be ascribed to the owner/mechanic's sense of the industrial nature of the business (and the building) and the low margins of profit.

However, these solutions are pursued with insufficient regard for the integrity of the building and its details. For example, at 1776 Green, the widening of a garage door — a functional upgrade — compromises the façade through the displacement of the piers that visually and formally support the arched portal (Fig. 7 in chapter 1). The alteration honestly represents the fact that the building facilitates a working business and cannot be regarded as a static masterpiece of architecture. Nevertheless, the change increases the possibility that the building will be framed as hopelessly compromised, strictly utilitarian and therefore beyond preservation.

Another visual attribute with negative symbolic potential is disrepair — a broken pane of glass, peeling paint or a corroded pressed-metal cornice. Often, disrepair and insensitive modifications act in concert to significantly compromise a building's *apparent* integrity. Who would guess, for example, that the shabby garage at 740 O'Farrell once looked as stately as it did (Figs. 129–130)? A building's neglect hastens its demise, since its present condition, and not its original design, is the basis for assessment by government agencies.

Those who fight to save the garages are on the defensive: the buildings are not land-marks, their historical significance is generally unknown, and the developer promises that

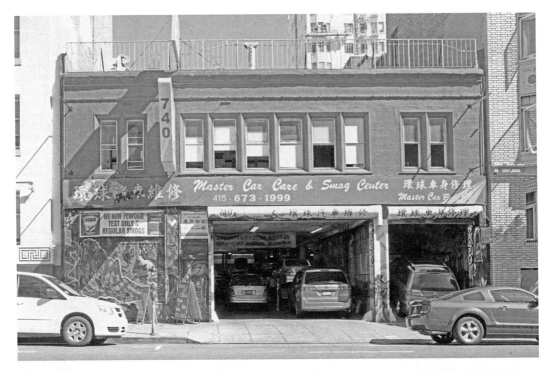

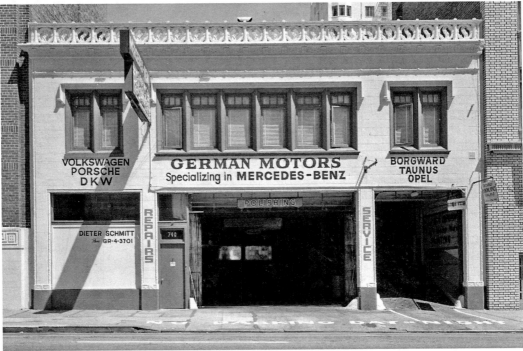

Top: Figure 129. Garage at 740 O'Farrell Street, as it looks today. James H. Hjul, Engineer, 1922 (Sharon Risedorph). *Bottom:* Figure 130. Garage at 740 O'Farrell Street, photographed in the 1960s (San Francisco Assessor's Office Negative Collection, San Francisco History Center, San Francisco Public Library).

the new project will enhance the neighborhood. However, as buildings that are part of the industrial, transportation and cultural history of the city, they should not be taken for granted.

While it is not a solution, a typological approach can be a particularly effective means of instilling a sense of architectural value. This approach conceptually isolates the symbolic dimension of cheap upgrades and disrepair, and precludes this dimension from exerting too great an influence on our perceptions. The basis upon which architectural merit is established does not hinge upon historical significance or even the function of the building. It is simply the visual continuity established among buildings and the sense of gratification that comes with the ability to identify related threads of the urban fabric.

A typological appreciation of garages will be anathema to developers of land on which garages presently stand. For them, a garage's worth is limited by its financial return, and no further critical appraisal is warranted. The suggestion that a garage merits protection by virtue of its status as one of a collection of related buildings enlarges the scope of potential environmental impact from the street or historic district to the entire city. While the isolation of the garage encourages an appraisal based upon the building's individual assets and liabilities, the typological approach encourages an appreciation of the building's broader urban contributions.

The recently demolished garage at 1355 Pacific illustrates this point. A victim of horrific remodels and changes over the years, the building was not terribly impressive before its demise (Fig. 131). The composition and symmetry of the façade — which was still recognizable on the second floor — was thoroughly compromised by ground-floor upgrades, including the walling up of the wide center bay, the addition of a high ribbon window, and the lopsided juxtaposition of roll-up doors on the extreme end of the building. Original steel sash windows were replaced by aluminum substitutes, and the decorative acanthus-leaf molding was removed from the strip of wall just beneath the projecting portion of the cornice.

However, this garage once looked very similar to its typological siblings (Figs. 43–44 in chapter 3, 132). Through comparison with those siblings that have fared better over the years, we can reconstruct the original design of 1355 Pacific, realize its potential (conceptually, at this point) and appreciate its value. Conversely, absent this comparison, 1355 Pacific is dismissible as just another mangled old building of no particular note.

This example illustrates the potential of a typological analysis to counter anonymity through the establishment of relationship. Placing garages in the context of their relatives also enables us to understand the disproportionate symbolic influence of cheap alterations and disrepair on an isolated example. The developer's interest is served precisely through the isolation of a compromised building.

One central goal of this study is to provoke a reconsideration of an architecture that we are encouraged to take for granted, or worse, to view as a *symbol* of urban blight. This book asks us to reevaluate the architectural qualities of age, decay, grime and disrepair as necessary signifiers of economic failure and an unsafe, unhealthful environment.

Government Oversight

The protection of garages is consistent with the findings of Article 10 of the San Francisco Planning Code, which states,

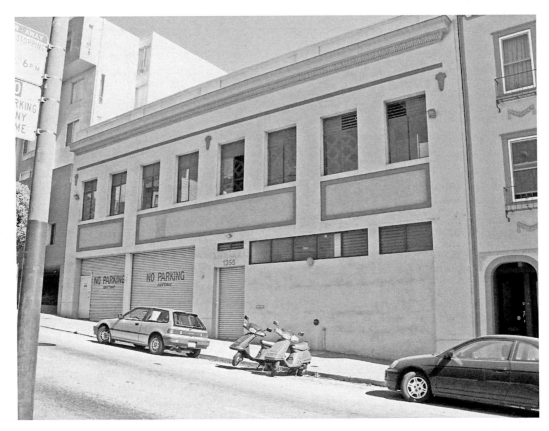

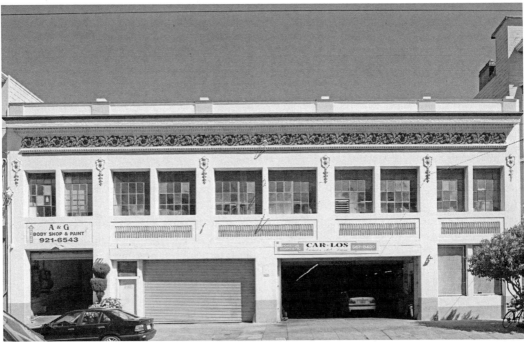

Top: Figure 131. Garage at 1355 Pacific Avenue (demolished). Joseph A. Pasqualetti, Builder, 1925 (author's photograph). *Bottom:* Figure 132. Garage at 1970 McAllister Street. Joseph A. Pasqualetti, Builder, 1925 (Sharon Risedorph).

It is hereby found that structures, sites and areas of special character or special historical architectural or aesthetic interest or value have been and continue to be unnecessarily destroyed or impaired, despite the feasibility of preserving them. It is further found that the prevention of such needless destruction and impairment is essential to the health, safety and general welfare of the public.[7]

In proposals to modify or demolish an existing historicist garage, conflicts may arise between the financial interest of a building owner and the community interest in preservation. Such conflicts are typically mediated by the San Francisco Planning Department (SFPD), which reviews all proposals to demolish, modify and/or change the use of older garage buildings. The review is triggered by the status of old garages as either known or potential "historic resources." Once alerted, SFPD must determine (1) whether the existing building is historically significant, (2) wherein lies that significance, and (3) whether the proposed scope of work compromises that significance.

Since individual property rights are such an entrenched American value, the criteria used to establish significance, and limit those rights, are rooted in an unassailable shared value — the preservation of our historical and cultural heritage.[8] Under the California Environmental Quality Act (CEQA), if a building is deemed to be an historical resource, the governmental agency reviews the proposed scope of work to guard against "substantial adverse change," the threshold of which is "demolition, destruction, relocation, or alteration of the resource ... such that *the significance* of the historic resource would be materially impaired [emphasis added]."[9]

In an attempt to satisfy the conflicting interests of individual property owners and the community, the law doesn't exactly protect the resource, it protects its *significance*. This distinction sanctions the division of a structure into significant and insignificant parts, with protection efforts focused on the former. In privately owned infill buildings like garages, if significance exists, it is deemed to reside in the façades. This approach preserves that part of the building that is public and that contributes to the character of the street or the historical district. It also affords the building owner the right to pursue changes of use or building additions — behind and above the façade — that otherwise conform with the code.

The conversion of 520 Chestnut Street illustrates the architectural outcome resulting from the application of the law's mandate (Fig. 133). Previously, the lot supported a second-rate Gothic-inspired garage building from 1927 (Fig. 134), and now it hosts a 20-unit condominium. Easily discernible from the street are the specific design features that enabled the developer to secure the approval of the SFPD. The community interest is served in the preservation of the garage and the setback of the taller new volume — in deference to the façade and the scale of the street. The owner's interest is realized in the change to a more profitable use, and the increase of the building in height and bulk.

In its final assessment of the design, the SFPD determined that "the project would retain the historic character of the existing building and would preserve elements of the area's historic land use character."[10] However, the finished building suggests otherwise. While the garage physically remains, it has lost its identity as a historic resource. As built, the façade maintains its original proportions, Main Street–style parapet, and decorative recessed lancets beneath the parapet. However, these gestures are overwhelmed by those resulting from the conversion to residential use: the introduction of modern doors, windows and shades, the expression of a full second story behind the façade, and the new role of the façade as a frontispiece for the residential setback. The preserved building merely assumes

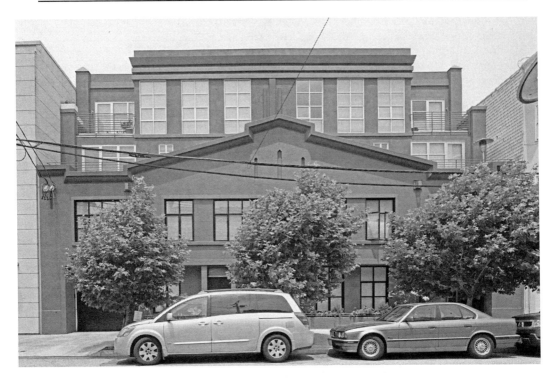

Top: Figure 133. Residential building at 520 Chestnut Street (Sharon Risedorph). *Bottom:* Figure 134. Garage at 520 Chestnut St. before conversion (author's photograph).

the character of the new use. Effectively, we can no longer relate this building to its siblings in the garage typology (Fig. 39 in chapter 3).

This would seem to defeat the point of declaring the façade a historical resource in the first place. Indeed, California law requires that a historical resource be protected from impairment that "demolishes or materially alters in an adverse manner those physical characteristics of a historical resource that convey its historical significance."[11]

The net effect of this obliteration of character goes beyond *façadism*, which implies an insubstantial stage set representing the original architecture.[12] Here, the observer of the building would be hard pressed to identify the façade as ever having belonged to a garage. No stage set exists. The loss of character precludes any meaningful interaction of new and old, residential and industrial.

This analysis in no way constitutes an architectural critique of what appears to be a very attractive design—one that reflects the considerable amount of skill brought to bear on the challenge of integrating the old building and façade. The intention is to illustrate the self-contradictory aspects of a mandate to preserve that is predicated on a flawed understanding of the source of architectural significance.

On Chestnut Street, with residential uses on either side of the converted garage, a bland continuity of residential use supersedes the exuberant former diversity. This characterization runs counter to the goals of classic city planning, which establishes order through the separation of incompatible uses. Indeed, when zoning ordinances were first developed in San Francisco, the separation of garages from predominantly residential streets was viewed as a positive development. Residents regarded garages as inappropriate neighbors. The following letter—sent by a Cole Valley landlord in response to a 1917 questionnaire regarding the need for zoning regulations—captures the antipathy:

> I am the owner of two small flats on Broderick street [sic], near Cole, which have greatly depreciated in value owing to an automobile repair shop which has come next door. The rentals from said flats are very low, but are my only source of income. One of my tenants has given notice that she cannot continue to occupy the premises owing to the dirty condition of the place adjoining, and the procession of automobiles constantly before her door. She finds it impossible for her to keep her home in a state fit for her friends to visit her.[13]

Today, such protestations sound quaint. In the present real estate environment, the party who wants to remove the garage from the residential street is not the neighbor, but the owner of the underutilized real estate. While the zoning ordinances initially brought order to a potentially chaotic mix of uses, that same regulation today fails to protect the rare and very intermittent industrial survivor. A small-scale garage building on a residential street is no longer incompatible or undesirable—it is a valuable source of urban character that sustains real estate values by maintaining diversity and vibrancy.

If all the garages in San Francisco were to be demolished or altered beyond recognition, we would forever lose this link to our past. Implicit in a consideration of the building type on a citywide basis is the contributory value of even a *second-rate* garage. While surely not a superior example of the building type (at least as it appeared prior to its demolition), the Chestnut Street garage was nevertheless a thread of the urban fabric—the richness of which is a function of the patterns and relationships amongst its constituent elements. A garage on this residential street exemplifies a diversity of use that contributes to this richness. The architectural references that this garage makes to similar structures throughout the city are another expression of this richness. In effect, this garage has been silenced—removed from engaging in a dialogue with its neighbors and its typological siblings.

Garages and lowbrow historicist buildings remain vulnerable to large-scale redevelopment and small-scale conversion. This is so despite the commitment to preserve and to respect existing urban character, a mandate that is written into the Planning Code and listed as a goal of all redevelopment projects. Clearly, the scope of protection suggested by the term *preservation* is in need of revision — both in terms of its popular usage and legal applications.

What Is to Be Done?

Robert Ivey, FAIA and editor-in-chief of *Architectural Record*, recently asked, "What can be greener than reuse?"[14] The rhetorical question implicitly acknowledges that the preservation of good buildings is not the first thing that pops into people's minds if and when they think about sustainable design. Many regard the preservation movement as a worthy but wormy cause taken up by an elite cadre of concerned design professionals and civic-minded celebrities. While sustainability — which includes sustainable design — has galvanized the nation, the notion that the preservation of buildings constitutes an integral part of the sustainable solution remains understated. Through a forceful explanation of the link between preservation, livable cities and a sustainable environment, the preservation mandate can be dramatically strengthened.

A livable city is a *commons* that nourishes and sustains. Its physical aspect includes streets and built form specific to its culture and history (Fig. 135). Its building stock is a man-made version of a natural resource, offering a rich diversity of types, scales, materials and eras. This diversity is irreplaceable, because the buildings were built over time, and the conditions that gave rise to them will not repeat.

Lowbrow historicist structures and light industrial buildings are part of this diversity, yet they are often identified as underperforming resources and deemed expendable. Under-utilization refers to unrealized economic return for the landlord and does not acknowledge a community interest. The potential contribution that the development of real estate makes to economic growth and/or profit holds more sway than the contribution made by a good older building to the diversity and character of the city.

Addressing underutilization through development can result in urban monocultures — of architectural design and/or use. In the latter case, a developer or building owner seeking to maximize economic performance will pursue the most profitable use for the property. In San Francisco, that use is residential. At 520 Chestnut Street, for example, the conversion of a single property eliminates diversity and establishes a continuity of use. The repetition of this scenario many times over introduces an imbalance that influences the city's capacity to sustain economic growth.[15]

A developer responding to underutilized real estate will complement the change of use with a maximization of size, constructing the largest structure or addition that the city will allow. This results in an architecture that is bulkier and taller than the existing condition. In addition, low-end materials and labor-saving construction techniques are typically employed to contain construction costs and maximize profit. The contemporary detailing of relatively inexpensive materials can produce an architecture that is both busy and bland.

Architecture is an art, and this is not a diatribe against contemporary work. All too often, the shallow clichés of contemporary design are employed as wrapping paper for an unwanted gift that takes more than it gives. We can all recognize that combined state of

Figure 135. View of Golden Gate Avenue looking east, 1926. Note Mission-style parapet on Golden Gate Avenue Garage, left (San Francisco History Center, San Francisco Public Library).

newness and sameness that abruptly interrupts the character and scale of the street. The salient characteristic of architectural monoculture is impersonality and the dislodging of the streetscape from its host city. The monoculture makes us feel like we can be anywhere, and as a result we are nowhere.

In San Francisco, some locales change gradually — on a parcel-by-parcel basis — while others sustain dramatic change. The Russian Hill neighborhood exemplifies a slow process. While several garages have been demolished (and more are threatened), the sheer number of older buildings makes it highly unlikely that a monoculture of mediocre contemporary design will occur anytime soon. Here, the issue is one of use. Every time a garage is replaced by a condo or converted to one, the neighborhood is less rich and diverse — architecturally and otherwise. Jane Jacobs was right when she said, "Cities need old buildings so badly that it is probably impossible for vigorous streets and districts to grow without them."[16]

Lowbrow historicist structures that have been literally or figuratively condemned as dilapidated or blighted nevertheless maintain the potential to reclaim a vibrancy that may or may not have ever existed. The factors that cause blight are complex and may not be addressed through the removal of one of its symptoms. That's why cynicism is a reasonable response to developers (public and private) who cite blight as a justification for the demolition or insensitive development of good, adaptable buildings. The older architecture may be sacrificed while the new architecture may just substitute new stagnation for old.[17]

However, at least the old and perhaps dilapidated buildings can respond to improving

Figure 136. Gym (Alhambra Theater), Miller & Pflueger, Architect, 1925 (author's photograph).

conditions and enhance the prospects of new businesses and uses through the provision of enclosures of true character. This is on display throughout San Francisco, in innovative adaptations like the assault on the neo-classical Bank of San Francisco by a martial arts studio, the makeover of the Bank of America on Castro and Market into a Diesel clothing store, and the recasting of the great Alhambra movie palace as a Crunch gym (Fig. 136). In these instances, the engagement between old shell and new use adds a value that benefits the enterprise and the public, and that is worth more than either constituent piece considered by itself.

As a commons, the city is the repository of architectural diversity. The community, through the regulatory authority of local government, must exercise increased vigilance to effect real protection. We don't have to settle for a process by which good buildings (or parts of buildings) create opportunities for development that contribute to an architectural mono-culture and benefit the developer more than the community. The notion that a good existing building is expendable because it falls short of architectural excellence or historical signifi-cance does not insure that its replacement will constitute an improvement; it does, however, insure that opportunities for rejuvenation via appropriate adaptive reuse disappear with the building. Alternative criteria for government listing and protection can emerge from the incorporation of sustainability, interpreted as a community interest. This criteria would be specifically formulated around (1) protection of existing architectural diversity; (2) protection

against the wasteful and unnecessary demolition of existing structures; and (3) protection against partial demolitions, building additions or changes of use *that compromise the integrity* of useful existing structures.

It is worth noting that *historical significance* is not a primary factor in the proposed reformulation. As the recycling of buildings is understood as a form of sustainable design, it grows in stature as a responsible alternative to a profit-driven cycle of demolition and replacement (or the combination of conversion and building addition). Adaptive reuse becomes a more prevalent means by which most — but not all — new needs are met. Via the process of adaptive reuse — fueled by the mandate of sustainability — the goal of an alternative vision of renewal is achieved. A notion of progress based on the replacement of the old with the new gives way to a new conception predicated on the fluid intermingling of existing and new material.

Garages and Adaptive Reuse

Adaptive reuse is a time-honored means of extending the life of valued existing buildings. Many garages have already been converted in San Francisco. A list of new uses includes a clothing store, pharmacy, art gallery, music agency, architectural office, organic grocery, high school, condominium, church, strip club, gym, sporting goods store, high-end residence, restaurant and an artist's studio.

Garage buildings, like many lowbrow historicist types, are well suited for adaptive reuse. The façades exert great presence on the street, and their car-sized portals monumentalize pedestrian entry for any new use. The interiors are flexible shoeboxes of space with a minimum of interior columns. Upper floors are lofty, with tall ceilings that assume the bowed, shed or flat profile of the roof. While the buildings underutilize their lots vertically — the code permits greater height and more stories — the floor plates inhabit the entire lot and unify the available square footage in a single volume.

More importantly, the interiors are beautiful examples of industrial architecture. It is a travesty that these interiors are not recognized and protected. Until such time as these interiors are protected, adaptive reuse keeps them standing.

While adaptive reuse is crucial, it is a mixed bag as presently conceived and executed. Some uses are simply incompatible with the public nature of the building. When a garage hosts a residential use, the interior becomes inaccessible as a matter of security. At 520 Chestnut, the residential use overwhelms the garage use, as communicated on the façade. Projects must be undertaken with consciousness about the sustainable dimension of the reuse, respect for existing material, and a desire to strike a balance between old and new. Architects must learn to function not strictly as facilitators of growth, but as agents of continuity, actively involved in the slow evolution of the city. The motive to minimize construction costs must be tempered by a building code or restoration program that protects the architectural integrity of buildings.

The goals of giving the building new life and respecting its aesthetic identity are not mutually exclusive. In the specific case of the historicist garage, these goals are complicated by the hybrid nature of the building (façade and interior). A designer insensitive to the duality of the garage risks one or both of the following pitfalls: (1) the insertion of an autonomous interior design that obscures the industrial shell, and (2) a modernization of the façade that removes historical detail and style.

The first problem is evident in the adaptive reuse of the building at 2120 Polk Street from a garage to a pharmacy (Fig. 31 in chapter 3). Here, the building remains largely intact (with the notable exception of the removal of the ramp). The new use is compatible with Polk Street, the main shopping corridor in Russian Hill. Accessible and useful to the public, the store contributes to street life.

The new use does not permanently compromise the most noteworthy aspects of the façade. In fact, the ornament has been nicely restored. While modern glass and aluminum windows and storefront are bulky and insufficiently recessed into their openings, these "improvements" are easily removed.

However, giving priority to brand image and economic expedience, the pharmacy inserted its standard store design of finishes, fixturing and casework. The interior is indistinguishable from that of any other pharmacy chain store. As the square footage available on the ground floor is sufficient, the second floor is inaccessible and used for storage. There is no relationship between old and new. It's a banal interior and a lost opportunity. However, the ceiling is intact and store fixtures can easily be removed.

The transformation of the old Jerome Garage (1920) into a retail store provides another object lesson in missed opportunities for architectural expression (Figs. 8 in chapter 1, 137). The modernization of the exterior includes the removal of the overhanging cornice and the two arched entrances on Jackson Street; the flattening of the gridded treatment of the side elevation; the relocation of the building entrance to the corner; and the substitution of modern windows for the older industrial sash. Most dramatically, the expression of the building as a solid block is obscured by the super-scale graphics that adorn the exterior surfaces. In this adaptive reuse, the history of the building and its industrial roots are difficult to discern.

A gentler interior conversion occurs at 636 Shrader, which is now an agency that represents musicians (Figs. 138–139). Not a big-budget renovation, the design exploits the

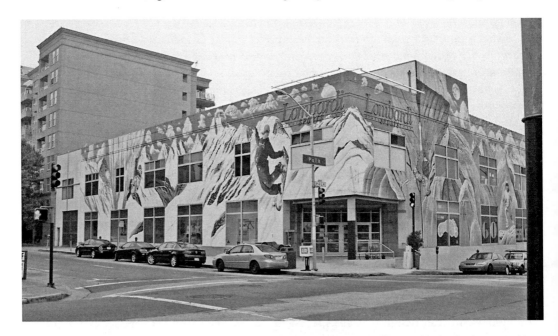

Figure 137. Garage building at Jackson and Polk streets, now a retail store (author's photograph).

222



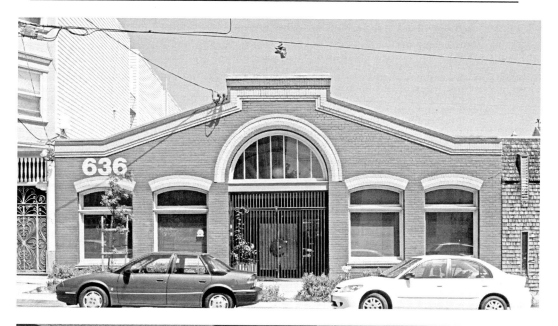

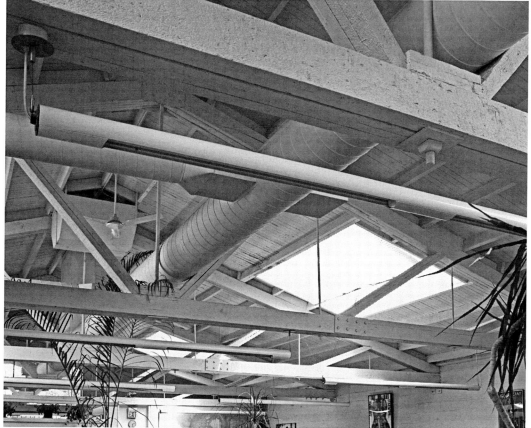

Top: Figure 138. Garage building at 636 Shrader Street, now a music agency. *Bottom:* Figure 139. Interior, 636 Shrader Street (both photographs, Sharon Risedorph).

amenities of the building shell, most notably the trusses, skylights and wood framing of the roof structure. New spiral ducts and lighting fixtures engage the trusses and form geometric patterns in the ceiling plan. Everything is painted white. These new elements reinforce the rhythms and industrial roots of the existing structure. While the workstations below are low end, the net effect is casual, light and airy.

A subtler disguising of original character occurs in the conversion of the Post Street Garage into an art gallery (Figs. 54–55 in chapter 3). The building retains its two important elements — the arcade and the ornate, overhanging eaves. Symmetry has been restored (or introduced) to the arcade, represented as an ABAABA composition. Here, dual recessed entrances (B) are each flanked by storefront bays (A). However, high-end touches — half-dome awnings, ornamental metalwork, lanterns and keystone ornaments — shift the imagery away from the lowbrow historicism of the garage. The new use is accommodated in a building that now appears to be an upscale palazzo.

Adaptive reuse is the means by which buildings are recycled to accommodate change, and this can be a rich source of design expression. It has the potential to promote diversity both within and without the building envelope, from small-scale juxtapositions of interior details to exterior contrasts with adjacent buildings. Conceptually, it's inherently postmodern, not in the stylistic sense of historical caricature, but in the simultaneity of meanings generated by the adaptation. Signs and symbols associated with original use, and the tectonic presence of that which is adapted, mingle with corresponding expressions of the new use. The contrast can be projected onto the façade, as a wall containing a delicate balance of new and old elements. Ironies are inevitable, as the unsuspecting host accommodates a new and foreign use that it was not designed to handle.

This potential is realized in the conversion of the garage at 770 North Point to a Patagonia clothing store (Fig. 140). The façade is restored in a manner that celebrates the original use and character while gently asserting and inserting the new identity. Crisp and freshly painted, the banded ornament articulates the building silhouette. The composition climaxes in the *bas relief* sculpture and the "1924" sign, details that call attention to the building and not to the store (Fig. 141).

A common challenge in garage conversions to retail is the insertion of a modern storefront — with conventional entry doors — into the wider garage-door openings. Here, the storefront breaks away from the façade and moves into the space, establishing a parallel, recessed plane for entry in the center. The solution maintains the large rectangular voids that set the wall in relief, and mimics the appearance of the garage with the doors open. Similarly, the fenestration reproduces the small panes and thin mullions of the original industrial windows. The Patagonia store is announced by three elements: a flag, a hanging sign recessed into the entry, and the merchandising of the storefront. The store relies upon the engagement of the viewer with the building to draw attention to the clothes and the brand. It's an understated approach for retail — in which sensory overload is the norm. This façade signifies adaptive reuse through the balanced interaction of recycled and new elements.

The interior is open to the industrial ceiling, lofty and filled with natural light that enters from skylights (Fig. 142). The trusses and ceiling are painted white, and the eye is lifted up upon entry. Here, too, the store defers to the building — store fixtures are low and sparse. Mounted on a wall adjacent to the entry is a frame containing four vintage photographs of the building — the Barsotti garage (Fig. 143). The photos affirm the faithfulness of the rehabilitation, while the presentation reflects Patagonia's pride in the building and consciousness of the meaning of adaptive reuse.

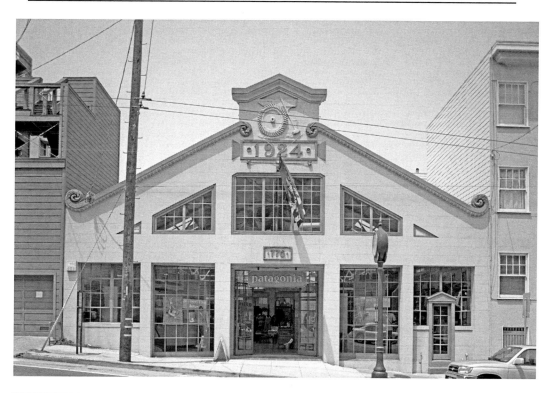

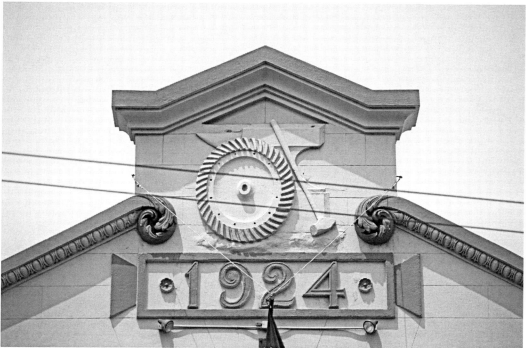

Top: Figure 140. Garage building at 770 North Point. Charles Fantoni, Architect, 1924. Renovation to Patagonia store by Richard Altuna and Steve Nelson, 1986. *Bottom:* Figure 141. Detail, 770 North Point (both photographs, Sharon Risedorph).

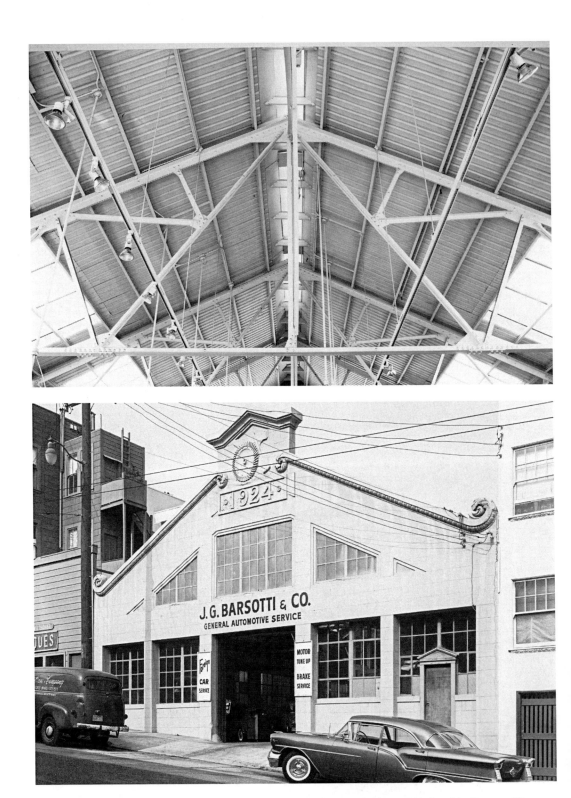

Top: Figure 142. Interior, Patagonia store, 770 North Point (Sharon Risedorph). *Bottom:* Figure 143. Archival photograph of Barsotti Garage, similar to those on view inside the Patagonia store (San Francisco Assessor's Office Negative Collection, San Francisco History Center, San Francisco Public Library).

When I inquired about the photos, the store clerks explained to me that the opening of stores in recycled buildings is a company policy. Visiting its website, I found the company mission statement: "Build the best product, cause no unnecessary harm, use business to inspire and implement solutions to the environmental crisis."[18]

This garage renovation demonstrates the potential for adaptive reuse to express and signify the idea that architectural recycling is a form of sustainability. In the service of a business enterprise, it also promotes the company's commitment to this form of sustainability. The goal is achieved primarily through restraint, deference and respect, such that the character of the original building is not overwhelmed by its new use.

Ideally, San Francisco garages would continue in a transportation use, while adapting to changing priorities. While automobile use in the city is discouraged, it will not disappear overnight. The garage can be useful as a transportation facility during a period of transition. This potential lies at the heart of an innovative proposal developed by Kathleen Courtney and Scott Edmondson, members of the Russian Hill Community Association. They propose to convert the San Francisco garage into a Neighborhood Transportation Center (NTC). The program for the NTC is intentionally flexible and diverse, including charging stations for electric vehicles, bike rentals, mass transit information, and yes — parking. As the profile of transportation use in the neighborhood changes, the NTC responds with a revised allocation of space. The NTC concept deserves further study and consideration, as it offers substantial benefits: it preserves the lowbrow historicist garage, maintains its transportation use, opens up the industrial interior to the public, and adapts to progressive developments in technology and city life.

Conclusion

In order to stave off architectural monoculture, it is necessary to elevate the status of the good-but-not-great older buildings that possess architectural character. The historicist garage epitomizes the type of building that needs reconsideration. In the absence of a thorough understanding of the significance of the building type, we assess garages not as cohesive architectural statements, but as public façades and private interiors. By treating the components as separate entities, we conclude that garages are distinctive yet anonymous, historically significant yet disposable, valuable as architecture but underperforming as real estate.

The key to improving the buildings' prospects is to lift them out of anonymity through education and consciousness-raising. This occurs within and without, so to speak: internally through a process of architectural and historical analysis, and externally through an appreciation of the buildings' contribution to the city. A typological approach unites the two efforts by revealing the diversity that exists within the collection of garages, and the citywide diversity of which the garage is just one type. A process of classification based upon a sorting out of differences and similarities is the means by which the essence of the type is approached.

The argument that historic preservation protects architectural diversity has not been a transformative premise, capable of countering real estate development. Societal benefits said to trickle down from development — housing, jobs, urban amenities — are vital and compelling; people can't be expected to disregard these benefits in order to preserve buildings held in high esteem by design professionals. However, the notions that (1) architectural diversity is inextricable from other forms of diversity that we hold dear and (2) all of these

diversities are building blocks of a *sustainable* environment do indeed possess the potential to be transformative.

Implicit in society's absorption of the notion that historic preservation, diversity and sustainability are aligned — if not synonymous — is an increased mandate for government regulatory agencies to protect irreplaceable buildings.

Adaptive reuse is an alternative to the new replacing the old. The narrative told by a reused building is a chapter in the history of the city. A building's preservation and reuse is itself symbolic of tolerance, co-existence, and a celebration of diversity. In the current environmental crisis, the exposure of repair, decay, stabilization, and damage communicates the commitment to work with what we already have, and to let the old *be* old. At the same time, the new material reinvigorates the old — gives it a new reason to be. The rich interplay of architecture and use — the adaptation — nourishes the building, the city and the people who use it.

Chapter Notes

Preface

1. *New Oxford American Dictionary* 2.0.3 (Cupertino, CA: Apple Inc., 2009).

Introduction

1. A team of undergraduate design students from UC Davis arrived at this estimate by accessing each address listed in the 1928 telephone directory on Google Street View. Since performing this task in 2008, several additional garages have been demolished.

2. William Kostura, *Van Ness Auto Row Support Structures* (Palo Alto, CA: W. Kostura, 2010), 36. http://www.parks.ca.gov/pages/1054/files/van%20ness%20auto%20row.pdf (accessed June 29, 2012).

3. Tom Wilder, "Selecting the Site," *Motor Age* 37, no. 15 (April 8, 1920): 8.

4. San Francisco Planning Department, *Nomination of Uptown Tenderloin Historic District to the National Register of Historic Places*, OMB No. 1024-0018 (May 2008): Section 7, p3.

5. Kostura, *Van Ness Auto Row*, 16.

6. San Francisco Planning Department, *Nomination of Uptown Tenderloin*, Sec. 8, pp. 14–15; San Francisco Planning Department, *Nomination of Lower Nob Hill Apartment Hotel District to the National Register of Historic Places*, OMB No. 1024-0018 (September 1988): Sec. 8, p. 8.3.

7. Concerning an architecture of Main Street, see: Chester H. Liebs, *Main Street to Miracle Mile: American Roadside Architecture* (1985; repr. Baltimore: John Hopkins University Press, 1995), 3–10; and Richard Longstreth, *The Buildings of Main Street: A Guide to American Commercial Architecture* (1987; repr. Walnut Creek, CA: AltaMira Press, 2000), 12–13.

8. For a general discussion of the relationship of "taxpayers" to urban development, see Liebs, *Main Street*, 10–15. For a description of the taxpayer that notes the low architectural expectations associated with the building type, see "Tax Payers," *Architectural Forum* 59, no. 1 (July 1933): 86.

9. California Natural Resources Agency, *California Environmental Quality Act (CEQA) Statute and Guidelines* Section 5020.1(h) (2011), http://ceres.ca.gov/ceqa/ (accessed July 21, 2011).

10. An image of this painting is available on *Wikipedia*, http://en.wikipedia.org/wiki/Broadway_Boogie-Woogie (accessed June 28, 2012).

11. J. B. Jackson, "The Domestication of the Garage," *Landscape* 20, no. 2 (Winter 1976): 19.

Chapter 1

1. Robert Venturi, Denise Scott Brown, and Steven Izenour, *Learning from Las Vegas: The Forgotten Symbolism of Architectural Form,* rev. ed. (Cambridge: MIT Press, 1977), 90.

2. J. B. Jackson, "The Domestication of the Garage," *Landscape* 20, no. 2 (Winter 1976): 11.

3. San Francisco Board of Supervisors, *San Francisco Building Laws* (San Francisco: Daily Pacific Builder, 1910), 236.

4. Chester H. Liebs, *Main Street to Miracle Mile: American Roadside Architecture* (1985. Baltimore: John Hopkins University Press, 1995), 9.

5. "Hitching Post is Fast Fading Away," *San Francisco Call*, July 6, 1913 http://cdnc.ucr.edu/cdnc (accessed June 25, 2012).

6. This assertion is based upon interviews with tenants and building owners, the historical files maintained at the San Francisco Planning Department, and physical evidence on the premises. Notices of permit applications and the awarding of construction contracts for projects to convert stables to garages were published in *The Building and Engineering News*.

7. Knapp Architects, "Historic Evaluation Report: 1336 Grove Street," July 20, 2008, 1–2.

8. R. R. l'Hommedieu, "The Evolution of Auto Row," *San Francisco Newsletter* (Christmas Number, 1913): 64.

9. B. M. Ikert, "Service Station or Garage?" *Motor Age* 40, no. 20 (Nov. 17, 1921): 8.

10. Ibid., 9.

11. Tom Wilder, "Selecting the Site," *Motor Age* 37, no. 15 (April 1920): 8.

12. *San Francisco Chronicle*, May 28, 1910.

13. Jackson, "Domestication of the Garage," 11.

14. Shannon Sanders McDonald, *The Parking Garage: Design and Evolution of a Modern Urban Form* (Washington DC: Urban Land Institute, 2007) 25.

15. "The Jerome Garage, San Francisco, Cal.," *Horseless Age* 34, no. 6 (Aug. 5, 1914): 202.

16. "Accomplishments in Garage Architecture," *Motor Age* 37, no. 20 (May 13, 1920): 12.

17. Ibid.

18. Parcels in San Francisco vary significantly in size and proportion, and garages reflect this broad range. Some commercial garages are just 25' wide and one story in height, circumstances that restrict façade development to a single vehicular bay and an adjacent small office. With limited capacity for storage, these buildings are generally used for repair. These garages are excluded from this study, as the narrow width generally limits the opportunities for façade composition. Also left out are certain garages on the other end of the size spectrum — larger buildings with superstructures greater than two stories, usually on corner lots. The distinguishing feature of these buildings — the basis for exclusion — is the absence of a façade in which historical allusion and ornament predominate.

19. "Garage Planning: Service Station Arrangements," *Motor Age* 36, no. 23 (Dec 4, 1919): 34.

20. "Standard Layout for 60 Ft. Garage," *Motor Age* 36, no. 3 (July 17, 1919): 27.

21. For a complete description of the d'Humy Motoramp System, see "Inclined Driveways for Garage and Factory Buildings," *Architect and Engineer* 66 (Sep 1921): 100–101.

Chapter 2

1. For readers unfamiliar with this nomenclature and its relationship to graphic analysis, reference is made to Fig. 40. The strings of "dimensions" above and below the elevation illustrate the subdivision of the façade into sections or bays, with each bay assigned a letter designation. Like bays receive the same letter. The difference between the dimension strings above and below the elevation demonstrates the flexibility of this graphic device in documenting simultaneous and contrasting interpretations of compositional makeup. As abstracted from the drawing and compressed into a sequence of letters, the composition of a particular building can be referenced in the text.

2. "Garage Ventilation An Important Factor to the Architect and Builder," *Architect and Engineer* 86, no. 1 (July 1926): 101.

3. Julia Scalzo, "All a Matter of Taste: The Problem of Victorian and Edwardian Shop Fronts," *Journal of the Society of Architectural Historians* 68, no. 1 (March 2009): 52.

4. Irving F. Morrow, "Recent Work by Charles W. McCall, Architect," *Architect and Engineer* 64, no. 1 (Jan 1921): 48–49.

5. "Restrictions on Motorists Made in Interest of Public Safety," *San Francisco Chronicle*, October 22, 1927.

6. The Villa Savoye (1928–1931), designed by LeCorbusier, offers a compelling comparison. The path of an automobile in relation to the symmetrical rear elevation reveals a similar dynamic to that illustrated in the model of 66 Page Street. For images and drawings of the Villa Savoye, see University of Virginia, "Arch101_Images," http://cti.itc.virginia.edu/~arch200/Images/VillaSavoye/01.htm.

7. A. D. F. Hamlin, "Gothic Architecture and Its Critics," *Architectural Record* 39 (May 1916): 422.

Chapter 3

1. James S. Ackerman, *Palladio's Villas* (Locust Valley, NY: J. J. Augustin, 1967), 10.

2. Richard Longstreth, *The Buildings of Main Street: A Guide to American Commercial Architecture*, rev. ed. (Walnut Creek, CA: AltaMira Press, 2000), 16.

3. Walter Gropius summed up this point of view: "We have had enough and to spare of the arbitrary reproduction of historic styles. In the progress of our advance from the vagaries of mere architectural caprice to the dictates of structural logic, we have learned to seek concrete expression of the life our epoch in clear and crisply simplified forms." Walter Gropius, *The New Architecture and the Bauhaus* (1938), trans. P. Morton Shand (Cambridge, MIT Press, 1971), 44.

4. "Some Pacific Coast Ideas That Have Helped the Automobile Business," *Motor Age* 40, no. 11 (September 15, 1921): 11.

5. For 550 Turk, see William Kostura, *Van Ness Auto Row Support Structures* (Palo Alto, CA: W. Kostura, 2010), 39, http://www.parks.ca.gov/pages/1054/files/van%20ness%20auto%20row.pdf (accessed June 29, 2012). For 265

Eddy, see San Francisco Planning Department, *Nomination of Uptown Tenderloin*, Sec. 7, p18.

6. The Post-Taylor Garage, at 530–544 Taylor, is included in this category despite the fact that it is only 60 feet wide. Designed by Frederick Meyer, the façade composition is more wall-like and less gridded than comparable Pasqualetti façades, a circumstance that is especially noticeable around the implied "B" bays. The Meyer garage possesses thematic similarities to 818 Leavenworth, most notably in the Churrigueresque treatment of the middle bay — a compositional fulcrum that centers the façade.

7. The present façade, the basis for this analysis, is not in original condition. The windows occupying the ground-floor middle bays are smaller modern equivalents; the outlines of the original openings are still evident on the exterior. Other elements of the façade may also have been altered.

8. A more specific example of a garage as a miniaturized and compressed Mission train station is 825 Sansome Street (Fig. 16), which resembles the Santa Fe depot in San Diego, designed by Bakewell and Brown (1915).

9. San Francisco Planning Department, *Nomination of Uptown Tenderloin*, Sec. 7, p77.

10. Frederick Jennings, "Some California Railroad Stations," *Architect and Engineer* 48, no. 2 (Feb 1917): 43.

11. *California Motorist*, Aug 1917, cover.

12. San Francisco Planning Department, "Historic Resources Inventory," *North Beach Historical Project*, June 1982. Folder, "721 Filbert," History Files, San Francisco Planning Department.

13. Kostura, *Van Ness Auto Row*, 40.

14. Ibid., 18.

15. San Francisco Planning Department, *Certificate of Determination of Exemption/Exclusion from Environmental Review*, Case no. 2004.0380E (December 7, 2004): 4.

Chapter 4

1. Chester H. Liebs, *Main Street to Miracle Mile: American Roadside Architecture* (1985, Baltimore: John Hopkins University Press, 1995), 9.

2. Ibid., 29.

3. Ibid., 40.

4. Ibid., 41.

5. Nicholas Pevsner, *An Outline of European Architecture*, rev. ed. (1943, Layton, UT: Gibbs Smith, 2009), 10.

6. Julia Scalzo, "All a Matter of Taste: The Problem of Victorian and Edwardian Shop Fronts," *Journal of the Society of Architectural Historians* 68, no. 1 (March 2009): 57.

7. Carroll L. V. Meeks, *The Railroad Station: An Architectural History* (New Haven: Yale University Press, 1956), 92.

8. François Loyer, *Architecture of the Industrial Age*, trans. R.F.M. Dexter (Geneva: Skira, 1983): 58.

9. Kenneth Frampton and Yukio Futagawa, *Modern Architecture 1851–1919* (New York: Rizzoli, 1983), 3–4.

10. Meeks, *The Railroad Station*, 92.

11. Ibid., 39.

12. Sir Reginald Blomfield, "Architecture and the Craftsman," *The Mistress Art* (London: Edward Arnold, 1908), 104.

13. William H. Jordy, *American Buildings and Their Architects: Progressive and Academic Ideals at the Turn of the Twentieth Century* (Garden City, NY: Doubleday, 1972), 347.

14. Steven Parissien, *Station to Station* (1997, repr. New York: Phaidon, 2001), 29.

15. Mariana Griswold Van Rensselaer, "Recent Architecture in America: Public Buildings," *Century* 28, no. 1

(May 1884): 48, http://digital.library.cornell.edu/cgi/t/te xt/text-idx?c=cent;idno=cent0028-1 (accessed July 26, 2011).

16. Ibid., 51.

17. A.D.F. Hamlin, "Gothic Architecture and Its Critics: The Definition of Architecture, Part 2: The Definition of Gothic." *Architectural Record* 39, no. 5 (May, 1916): 422.

18. Parissien, *Station to Station*, 29.

19. Leon J. Pinkson, "A History of Motoring Progress in San Francisco," *San Francisco Chronicle*, January 28, 1940, A1, http://www.sfgenealogy.com/sf/history/hgaut. htm (accessed July 25, 2011).

20. "Automobile Topics," *Town Talk*, January 7, 1905, p. 28.

21. "Automobile Topics," *Town Talk*, September 5, 1903, p. 27.

22. James Flink, *The Automobile Age* (Cambridge, MA: MIT Press, 1988), 29.

23. Gregory Lee Thompson, *The Passenger Train in the Motor Age: California's Rail and Bus Industries, 1910–1941* (Columbus: Ohio State University Press, 1993), appendix 3.

24. Frank Donovan, *Wheels for a Nation* (New York: Crowell, 1965), 4.

25. Peter D. Norton, *Fighting Traffic: The Dawn of the Motor Age in the American City* (Cambridge, MA: MIT Press, 2008), 7.

26. "The Automobile," *Town Talk*, March 16, 1901, p. 20; and Pinkson, "A History of Motoring Progress."

27. R. R. l'Hommedieu, "The Evolution of Auto Row," *San Francisco Newsletter* (Christmas 1913): 26.

28. Kevin Nelson, *Wheels of Change from Zero to 600 M.P.H.: The Amazing Story of California and the Automobile* (Berkeley: Heyday Books, 2009), 4.

29. Ibid., 43–45.

30. Pinkson, "A History of Motoring."

31. "Rebuilding San Francisco's Garage District," *Horseless Age* 18, no. 10 (September 5, 1906): 308.

32. Nelson, *Wheels of Change*, 150.

33. "Rebuilding San Francisco's Garage District," 308.

34. William Kostura, *Van Ness Auto Row Support Structures* (Palo Alto, CA: W. Kostura, 2010), http://www.parks. ca.gov/pages/1054/files/van%20ness%20auto%20row.pdf (accessed June 29, 2012), 16.

35. Ibid.

36. Thompson, *Passenger Train in the Motor Age*, 31.

37. A. C. David, "The New San Francisco," *Architectural Record* 31, no. 1 (January 1912): 2.

38. William Issel and Robert W. Cherny, *San Francisco, 1865–1932: Politics, Power and Urban Development* (Berkeley, CA: University of CA Press, 1986), 39.

39. Ellis E. A. Davis, *Davis' Commercial Encyclopedia* (Berkeley, CA: E.A. Davis, 1910), 56.

40. "San Francisco Rebuilt by Inspiration of the Past and Call of the Future," *San Francisco Chronicle*, January 30, 1910.

41. Michael R. Corbett, *Splendid Survivors*, prepared by Charles Hall Page & Associates (San Francisco: California Living Books, 1979), 32.

42. "Some of the Work of Wm. H. Crim, Jr. and Earl B. Scott, Architects," *Architect and Engineer of California* 21, no. 1 (May 1910): 44.

43. Helen Throop Purdy, *San Francisco: As It Was, As It Is and How To See It* (San Francisco: Paul Elder & Company, 1912), x.

44. Richard Longstreth, *On the Edge of the World: Four Architects in San Francisco at the Turn of the Century* (Berkeley: University of California Press, 1983), 298.

45. Ibid., 297.

46. Corbett, *Splendid Survivors*, 50.

47. Ibid., 52.

48. Kostura, *Van Ness Auto Row*, 17.

49. Ibid., 20.

50. Therese Poletti, "Comrades in the Atelier: The Early Years of the San Francisco Architectural Club," *Argonaut* 20, no. 1 (Spring 2009): 48.

51. Ibid., 50.

52. William Kostura, "Primary Record, Department of Parks and Recreation Form DPR 523A, 1745 Clay Street," December 2009, http://sf-planning.org/ftp/files/ DPRforms/Clay%201745.pdf (accessed June 24, 2012).

53. Kaaren Tank, personal interview, November 12, 2009.

54. "The City Beautiful," *Architect and Engineer* 30, no. 3 (October 1912): 94.

55. San Francisco Planning Department, *Nomination of Uptown Tenderloin,* Sec. 7, p. 3.

56. Walter H. Kidney, *The Architecture of Choice: Eclecticism in America, 1880–1930* (New York: George Braziller, 1974), 3.

57. Ibid., 52. Kidney cites Cass Gilbert and Albert Kahn as architects capable of stepping out of the eclectic mode when designing a factory or a warehouse.

58. Luzerne S. Cowles, "The Architect and the Engineer," *Architect and Engineer* 26, no. 1 (August 1911): 53.

59. W. R. B. Willcox, "Architecture and the Architect: The Fancy of Clients and the Attitude of Architects," *Architect and Engineer* 31, no. 2 (December 1912): 67.

60. Carl F. Gould, "Architecture as a Fine Art," *Architect and Engineer* 31, no. 3 (January 1913): 53.

61. David J. Myers, "Architecture Defined," *Architect and Engineer* 31, no. 3 (January 1913): 54.

62. Kidney, *Architecture of Choice*, 4.

63. Shannon Sanders McDonald, *The Parking Garage: Design and Evolution of a Modern Urban Form* (Washington, DC: Urban Land Institute, 2007), 7–23.

64. P. M. Heldt, "The Garage Business — Buildings, Equipment, Methods," *Horseless Age* 36, no. 13 (December 1, 1915): 493.

65. Tom Wilder, "The Place of the Garage in Architecture," *Motor Age* 37 (May 6, 1920): 7–8.

66. Kidney, *Architecture of Choice*, 53.

67. Ibid., 55.

68. "Accomplishments in Garage Architecture." *Motor Age* 37, no. 20 (May 13, 1920): 12.

Chapter 5

1. Richard Longstreth, *On the Edge of the World: Four Architects in San Francisco at the Turn of the Century* (1983, Berkeley: University of California Press, 1998), 296–298.

2. Michael Corbett, *Splendid Survivors: San Francisco's Downtown Architectural Heritage*. Prepared by Charles Hall Page and Associates (San Francisco: California Living Books, 1979), 52. Corbett points out that although the influence of the City Beautiful movement on San Francisco architects was closely related to the influence of the École, some prominent San Francisco architects, including Frederick Meyer and Bernard J. S. Cahill, endorsed the City Beautiful movement while emerging out of different educational backgrounds than the École.

3. For a comprehensive exposition of City Beautiful ideas and goals, see William H. Wilson, *The City Beautiful Movement* (Baltimore: John Hopkins University Press, 1989), 75–86.

4. Peter D. Norton, *Fighting Traffic: The Dawn of the Motor Age in the American City* (Cambridge, MA: MIT Press, 2008), 7.

5. Mark S. Foster, "The Automobile and the City," in *The Automobile and American Culture*, eds. David L. Lewis and Laurence Goldstein (Ann Arbor: University of Michigan Press, 1983), 26.

6. Catherine Gudis, *Buyways: Billboards, Automobiles, and the American Landscape* (New York and London: Routledge, 2004), 40.

7. Foster, "The Automobile and the City," 26; and Martin Wachs, "Men, Women and Urban Travel," in *The Car and the City*, eds. Martin Wachs and Margaret Crawford, with the assistance of Susan Marie Wirka and Taina Marjatta Rikala (Ann Arbor: University of Michigan Press, 1998), 90.

8. Richard Brandi and Woody LaBounty, *San Francisco's Parkside District: 1905–1957* (San Francisco: Mayor's Office of Economic and Workforce Development, 2008), 3, http://www.outsidelands.org/parkside-statement.pdf (accessed June 21, 2012).

9. Kenneth T. Jackson, *Crabgrass Frontier: The Suburbanization of the United States* (New York: Oxford University Press, 1985), 104.

10. See Brandi and LaBounty, *San Francisco's Parkside District*, 3; Sally Woodbridge, *San Francisco in Maps & Views* (New York: Rizzoli, 2006), 105.

11. William Issel and Robert W. Cherny, *San Francisco, 1865–1932: Politics, Power and Urban Development* (Berkeley: University of California Press, 1986), 172–173.

12. Ibid., 158.

13. Workers of the Writers' Program of the Work Projects Administration in Northern California, *San Francisco: The Bay and Its Cities* (New York: Hastings House, 1947), 106.

14. Anthony Perles with John McKane, Tom Matoff, and Peter Straus, *The People's Railway: The History of the Municipal Railway of San Francisco* (Glendale, CA: Interurban Press, 1981), 27.

15. Brandi and LaBounty, *San Francisco's Parkside District*, 22.

16. Kevin Wallace, "The City's Tunnels: When San Francisco Can't Go Over, It Goes Under Its Hills," *San Francisco Chronicle*, March 27, 1949, http://www.sfgenealogy.com/sf/history/hgtun.htm, accessed June 21, 2012.

17. "The Twin Peaks Tunnel," *San Francisco Chronicle*, October 10, 1912.

18. Woodbridge, *San Francisco in Maps*, 126.

19. Wallace, "The City's Tunnels."

20. Scott L. Bottles, *Los Angeles and the Automobile: The Making of a Modern City* (Berkeley: University of California Press, 1987), 10.

21. Miller McClintock, *Report on San Francisco City-wide Traffic Survey* (San Francisco: Pisani Printing & Publishing, 1927), 29.

22. Brandi and LaBounty, *San Francisco's Parkside District*, 32–33.

23. Wachs, "Men, Women, and Urban Travel," 92. For decentralization in San Francisco, see McClintock, *Report on San Francisco*, 84.

24. Wachs, "Men, Women and Urban Travel," 92.

25. McClintock, *Report on San Francisco*, 13.

26. J. B. Jackson, "The Domestication of the Garage," 15.

27. "What the Automobile Men Have Done for the World," *San Francisco Examiner*, February 3, 1918.

28. Wilson characterizes the environmentalism of City Beautiful advocates as follows: "When they trumpeted the meliorative power of beauty, they were stating their belief in its capacity to shape human thought and behavior." Wilson, *The City Beautiful*, 79.

29. Ibid., 84.

30. James Flink, *The Automobile Age* (Cambridge, MA: MIT Press, 1988), 135.

31. Ibid., 139.

32. Drummond Buckley, "A Car in the House," in Wachs and Crawford, *The Car and the City*, 129.

33. Bonnie Lloyd, "Woman's Place, Man's Place," *Landscape* 20, no. 1 (October 1975): 9.

34. Gwendolyn Wright, "Sweet and Clean: The Domestic Landscape in the Progressive Era," *Landscape* 20, no. 1 (October 1975): 43.

35. "Where Town and Country Meet," Chevrolet advertisement, *Literary Digest* 79, October 6, 1923, p. 41.

36. Ibid.

37. Phillipp Rahtjen, "Automobile vs. Tuberculosis," *California Motorist*, February 1918, p. 10.

38. "Driving Auto is Health-Giving," *Oakland Tribune*, sec. D-11, July 13, 1919, http://newspaperarchive.com/oakland-tribune/1919-07-13/page-39/ (accessed June 25, 2012).

39. "Roadism instead of Bolshevism," *Motor Land*, June 1919, p. 33.

40. Gregory Lee Thompson, *The Passenger Train in the Motor Age: California's Rail and Bus Industries, 1910–1941* (Columbus: Ohio State University Press, 1993), 1.

41. Flink, *Automobile Age*, 183.

42. Ibid., 173.

43. Ibid., 360.

44. C. Harvey & J. Lammers, Page & Turnbull, Inc., "District Record: Civic Center Auto Repair Historic Resources," December 2007, p. 5.

45. Charles Mulford Robinson, *Modern Civic Art or The City Made Beautiful* (New York: Knickerbocker Press, 1909), 59–80.

46. Ibid., 63.

47. Carroll L. V. Meeks, *The Railroad Station: An Architectural History* (New Haven: Yale University Press, 1956), 129.

48. See note 53 below.

49. Robinson, *Modern Civic Art*, 64.

50. Meeks, *Railroad Station*, 133.

51. Wilson, *City Beautiful Movement*, 29.

52. Robinson, *Modern Civic Art*, 64.

53. For one example of the continued influence of City Beautiful ideas on the design of the train station, see "Should Passenger Stations be Architectural Monuments," *Architect and Engineer* 69, no. 1 (April 1922): 102.

54. "What the Automobile Men Have done for the World," *San Francisco Examiner*, Feb 3, 1918.

55. Carol Aronovici, "Social Progress and the Open Road," City Planning and Housing, *Architect and Engineer* 78, no. 2 (August 1924): 101.

56. Ibid.

57. Gudis, *Buyways*, 41.

58. Norton, *Fighting Traffic*, 4.

59. Flink, *Automobile Age*, 33.

60. McClintock, *Report on San Francisco*, 146.

61. Gudis, *Buyways*, 46.

62. Michael Berger, "The Car's Impact on American Family," in Wachs and Crawford, *The Car and the City*, 60.

63. Norton, *Fighting Traffic*, 1.

64. Charles Smallwood, *The White Front Cars of San Francisco* (Glendale, CA: Interurbans, 1978), 435.

65. Examples of these buildings are still scattered around the city. One good building is on 8th Avenue south of Geary, and another on Fillmore off Turk.

66. Corbett, *Splendid Survivors*, 252.

67. While open to Mission Street today, the building was originally situated on a narrow alley. Ivan C. Frickstad lamented the building's obscurity: "Few people realize its

existence or have an opportunity of viewing this very fine piece of work in red brick and cream colored terra cotta." Ivan C. Frickstad, "Some Sub-Stations of the Pacific Gas & Electric Co.," *Architect and Engineer 43*, no. 2 (November 1915): 63.

68. Ibid., 55.

69. Issel and Cherny, *San Francisco*, 158–160.

70. C. Matlack Price, "Notes on the Varied Work of Willis Polk, Architect," *Architectural Record* (Dec 1913): 573.

71. For synopses of the gradual acceptance of the automobile across America, see Wachs, "Men, Women, and Urban Travel," 91; and Chester H. Liebs, *Main Street to Miracle Mile: American Roadside Architecture* (1985, Baltimore: John Hopkins University Press, 1995), 17.

72. Clarence R. Ward, "The Housing of a Fire Department," *Architect and Engineer 50*, no. 1 (July 1917): 51.

Chapter 6

1. William Issel and Robert W. Cherny, *San Francisco, 1865–1932: Politics, Power and Urban Development* (Berkeley: University of California Press, 1986), 35.

2. Michael Corbett, *Splendid Survivors: San Francisco's Downtown Architectural Heritage*, prepared by Charles Hall Page and Associates (San Francisco: California Living Books, 1979), 37.

3. James Duval Phelan, "Architectural League of Pacific Coast," *Architect and Engineer 19*, no. 1 (August 1909): 36.

4. Issel and Cherny, *San Francisco*, 110.

5. Richard Longstreth, *On the Edge of the World: Four Architects in San Francisco at the Turn of the Century* (1983, Berkeley: University of California Press, 1998), 300.

6. Willis Polk, "The City Beautiful," *Town Talk*, December 22, 1906, p. 43–45.

7. William H. Wilson, *The City Beautiful Movement* (Baltimore: John Hopkins University Press, 1989), 45.

8. W. H. B. Fowler, "E-M-F Company Places New Agency," *San Francisco Chronicle*, January 7, 1910.

9. Eugen Neuhaus, *The Art of the Exposition: Personal Impressions of the Architecture, Sculpture, Mural Decorations, Color Scheme and Other Aesthetic Aspects of the Panama-Pacific International Exposition* (San Francisco: Paul Elder & Co., 1915), 3.

10. William H. Jordy, *American Buildings and Their Architects*, vol. 4 (New York: Oxford University Press, 1986), 291.

11. Frank Morton Todd, *The Story of the Exposition: Being the Official History of the International Celebration Held at San Francisco in 1915 to Commemorate the Discovery of the Pacific Ocean and the Construction of the Panama Canal*, vol. 1 (New York: G. P. Putnam's Sons, 1921), 287.

12. Gray Brechin, "Sailing to Byzantium: The Architecture of the Fair," in *The Anthropology of World's Fairs: San Francisco's Panama-Pacific International Exposition of 1915*, ed. Burton Benedict, 97 (Berkeley: Scolar Press, 1983).

13. B. J. S. Cahill, "A Criticism of Some of the Work Shown at the Annual Exhibition of San Francisco Architectural Club," *The Architect and Engineer 32*, no. 3 (April 1913), 47.

14. Willis Polk, "A Brilliant Future for American Art," in *Art in California: A Survey of American Art with Special Reference to Californian Painting Sculpture and Architecture Past and Present Particularly as Those Arts Were Represented at the Panama-Pacific International Exposition: Being Essays and Articles* (Irvine, CA: Westphal Publishing, 1988 [San Francisco: R.L. Benier Publishers, 1916]), 78. Citation refers to the Westphal edition.

15. Polk's essay, written seven years after Phelan's address to the Architectural League, begins as an even more specific response to Phelan: "San Francisco, through the Exposition, has had a taste, a glimpse of art. She has been taught the value of beauty. She will not in the future willingly forego any opportunity to gratify the taste thus acquired." Polk, "A Brilliant Future," 77.

16. Willis Polk, *Transactions of the Commonwealth Club of California*, August 1915, p. 356.

17. Wilson, *The City Beautiful*, 59–60.

18. Elizabeth N. Armstrong, "Hercules and the Muses: Public Art and the Fair," in Benedict, *Anthropology of World's Fairs*, 114–133. Armstrong provides a comprehensive overview of the allegorical art, including its intended meaning, the contemporaneous reaction and a visual cultural analysis.

19. Todd, *The Story of the Exposition*, vol. 1: 305.

20. Burton Benedict, "The Anthropology of World's Fairs," in *Anthropology of World's Fairs*, 2.

21. Todd, *The Story of the Exposition*, vol. 1: 169.

22. Beverly L. Hodghead, *Transactions of the Commonwealth Club*, August 1915, p. 347.

23. "Automobile Show Is Wonder of Thousands," *San Francisco Chronicle*, July 16, 1914; and *Horseless Age 34*, no. 5 (July 1914): 155.

24. Todd, *The Story of the Exposition*, vol. 4: 247.

25. Ibid., 228–229.

26. Ibid., vol. 3: 13–15.

27. Ibid., 16–17.

28. "Speed Demons Are Keen For Vanderbilt Cup," *San Francisco Chronicle*, March 6, 1915.

29. "Thirty-Two Cars Named for Vanderbilt Cup Race," *The Horseless Age 35*, no. 7 (February 1915): 224b.

30. C. L. Edholm, "Motor Car Exhibits at the Panama Exposition," *The Horseless Age 36*, no. 2 (July 14, 1915): 39.

31. Corbett, *Splendid Survivors*, 37.

32. Cahill, "A Criticism of Some of the Work," 47.

33. Kevin Nelson, *Wheels of Change: From Zero to 600 M.P.H., The Amazing Story of California and the Automobile* (Berkeley: Heyday Books, 2009), 157.

34. Irving F. Morrow, "The Earle C. Anthony Inc. Packard Building San Francisco," *The Architect and Engineer 90*, no. 1 (July 1927): 61.

35. Esther McCoy, *Five California Architects*, rev. ed. (1960, repr. Santa Monica, CA: Hennessey + Ingalls, 2004), 53.

36. "The Pacific Automobile Show," *Motor Land* (February 1920): 34.

37. "Auto Show Decorations Will Feature California Scenery," *San Francisco Chronicle*, February 1, 1920.

Chapter 7

1. Peter D. Norton, *Fighting Traffic: The Dawn of the Motor Age in the American City* (Cambridge, MA: MIT Press, 2008), 16.

2. "Why Traffic Regulations?" *Town Talk*, April 17, 1920, p. 3.

3. Leon J. Pinkson, "S. F. Traffic Handling in Residence Section is Hit," *San Francisco Chronicle*, October 11, 1925.

4. Ibid.

5. "Hit, Run Autoist Knocks 2 Women Down Drives Over Bodies Second Time," *San Francisco Chronicle*, October 7, 1927.

6. Chas. M. Upham, "Autos Kill 114,879 in Five Years," *San Francisco Chronicle*, October 2, 1927.

7. Norton, *Fighting Traffic,* 212.

8. Leon J. Pinkson, "Women Big Success in Safety Fight," *San Francisco Chronicle,* October 14, 1925.

9. "School Traffic Reserve Big Success," *San Francisco Chronicle,* October 11, 1925.

10. "Children are Given Lessons on Crossing," *San Francisco Chronicle,* October 9, 1927.

11. James Flink, *The Automobile Age* (Cambridge, MA: MIT Press, 1988), 136.

12. Kevin Nelson, *Wheels of Change: From Zero to 600 M.P.H., The Amazing Story of California and the Automobile* (Berkeley: Heyday Books, 2009), 17.

13. Workers of the Writers' Program of the Work Projects Administration in Northern California, *San Francisco: The Bay and Its Cities* (New York: Hastings House, 1947), 265.

14. Anthony Perles, with John McKane, Tom Matoff, and Peter Straus, *The People's Railway: The History of the Municipal Railway of San Francisco* (Glendale: Interurban Press, 1981), 71.

15. Nancy Olmsted, *The Ferry Building: Witness to a Century for Change 1898–1998* (Berkeley, CA: Heyday Books, 1998), 69.

16. Perles, *The People's Railway,* 46.

17. Olmsted, *Ferry Building,* 73.

18. "Frisco Police to Control 'Jitney' Buses," *The Horseless Age* 35, no. 5 (February 3, 1915): 176.

19. Olmsted, *Ferry Building,* 103.

20. Frank G. White, "The Embarcadero Subway, San Francisco," *The Architect and Engineer* 76, no. 1 (January 1924): 95.

21. Olmsted, *Ferry Building,* 113.

22. Miller McClintock, "Diagnosing the Ills of San Francisco's Traffic," *Motor Land* (August 1927): 20–21.

23. Workers of the Writers' Program, *San Francisco,* 175.

24. "Garage Notes," *The Horseless Age* 35, no. 6 (February 10, 1915): 201.

25. McClintock, "Diagnosing the Ills," 21.

26. "Automobile Ferry — Maybe," *Town Talk,* September 11, 1920, p. 6.

27. Olmsted, *Ferry Building,* 139.

28. Tom Cole, *Short History of San Francisco* (San Francisco, CA: Lexikos, 1981), 125.

29. Miller McClintock, *A Report on the Street Traffic Control Problem of San Francisco* (San Francisco, 1927), 152.

30. Wolfgang Sachs, *For Love of the Automobile: Looking Back into the History of Our Desires,* trans. Don Reneau (Berkeley, CA: University of California Press, 1992), 164–165.

31. Catherine Gudis, *Buyways: Billboards, Automobiles and the American Landscape* (New York: Routledge, 2004), 151.

32. Norton, *Fighting Traffic,* 154.

33. "Vonard Fraser, the Pacific Automobile Show," *Motor Land* (January 1922): 56.

34. Ibid.

35. "Call on Dealers to Build Garage," *Motor Age* (February 19, 1920): 29.

36. Flink, *Automobile Age,* 151.

37. *Town Talk,* March 20, 1920, p. 3.

38. "Supervisor Offers Traffic Solution," *San Francisco Chronicle,* May 6, 1920.

39. "Civic League Presents New Parking Plan," *San Francisco Chronicle,* March 15, 1922.

40. "Garages for Office Buildings," *Architect and Engineer* 77, no. 1 (April 1924): 116.

41. "Garage Ventilation," *Architect and Engineer* 78, no. 2 (August 1924): 109.

42. M. McCants, "Tall Buildings and Traffic Congestion," *Architect and Engineer* 79, no. 3 (December 1924): 103.

43. Ibid., 106–107.

44. Ibid., 108.

45. "A New Motor Bible," *Motor Land* (July 1924): 38.

46. "St. Louis Lifts Garage Ban," *Motor Age* 36, no. 4 (July 31, 1919): 31.

47. Leon J. Pinkson, "Opinion Divided Over New S.F. Traffic Regulations," *San Francisco Chronicle,* July 6, 1924.

48. "Pedestrian Control in San Francisco," *New York Times,* October 30, 1927.

49. "Introducing New Traffic Code Up to Law Enforcement Board," *San Francisco Chronicle,* October 5, 1927.

50. McClintock, *Report on San Francisco,* 1.

51. Norton, *Fighting Traffic,* 168.

52. McClintock, *Report on San Francisco,* 160–161.

53. Ibid., 162.

54. Miller McClintock, "Street Traffic and the Office Building," in *Proceedings of the Sixty-Second Annual Convention of the American Institute of Architects,* ed. Publicist of the Institute, 114 (Washington DC: Bd. of Directors, American Institute of Architects, 1929). For an explanation of congestion as a function of supply and demand, see Norton, *Fighting Traffic,* 166.

55. Ibid., 118.

56. Ibid.

57. Norton, *Fighting Traffic,* 3.

Chapter 8

1. Pioneer Automobile ad, *Town Talk,* January 7, 1905, p. 29.

2. James Flink, *The Automobile Age* (Cambridge, MA: MIT Press, 1988), 33.

3. Ibid., 93.

4. Leon J. Pinkson, "A History of Motoring Progress in San Francisco," *San Francisco Chronicle,* January 28, 1940, http://www.sfgenealogy.com/sf/history/hgaut.html.

5. Gregory Lee Thompson, *The Passenger Train in the Motor Age: California's Rail and Bus Industries, 1910–1941* (Columbus: Ohio State University Press, 1993), 1.

6. Flink, *Automobile Age,* 94.

7. Frank Donovan, *Wheels for a Nation* (New York: Crowell, 1965), 100.

8. Ibid., 103.

9. P. M. Heldt, "The Garage Business — Buildings, Equipment, Methods," *The Horseless Age* 36, no. 13 (December 1, 1915): 492–93.

10. Wolfgang Sachs, *For the Love of the Automobile: Looking Back into the History of Our Desires,* trans. Don Reneau (Berkeley: University of California Press: 1992), 35. Sachs' reference to "uselessness" as a criterion of beauty is consistent with criticism of Ruskin's notion of ornament being the principle part of architecture (see chapter 4).

11. Chester H. Liebs, *Main Street to Miracle Mile: American Roadside Architecture* (1985, Baltimore: John Hopkins University Press, 1995), 78.

12. Ibid., 79.

13. Pinkson, "A History of Motoring."

14. Flink, *Automobile Age,* 77.

15. Pinkson, "A History of Motoring."

16. Editorial, *The California Motorist,* n.d., 21.

17. "The Automobile in 1918," *San Francisco Examiner,* February 17, 1918.

18. "Auto Notes," *Town Talk,* February 6, 1909, p. 31.

While this article runs contrary to popular opinion in the assertion that the gasoline-powered car is easiest, it does conform to the popular notion that women choose on the basis of ease of use.

19. Virginia Scharff, "Gender, Electricity and the Automobile," in Wachs and Crawford, *The Car and the City*, 84.

20. Ryland P. Madison, "The Lady and the Electric," *Country Life in America* 22, July 15, 1912, p. 36.

21. "Auto Notes," *Town Talk*, March 13, 1909, p. 35.

22. "Women Interested in Cartercar System," *San Francisco Chronicle*, January 30, 1910.

23. "Women's Work in War Time," *The California Motorist* (December 1918): 20.

24. Harry R. Lamster, "Women Become Auto Mechanics," *The California Motorist*, n.d., 20.

25. "Women Aid in Auto Industry," *San Francisco Chronicle*, July 7, 1918.

26. Camille Aimee, "Beauty Hints for Fair Drivers," *The California Motorist*, n.d., 14.

27. Peter D. Norton, *Fighting Traffic: The Dawn of the Motor Age in the American City* (Cambridge, MA: MIT Press, 2008), 12.

28. *San Francisco Chronicle*, January 9, 1910.

29. "The Motor Car — A Daily Necessity," *Motor Land* (August 1920): 20.

30. Liebs, *Main Street to Miracle Mile*, 20.

31. Sachs, *Love of the Automobile*, 38.

32. Ibid.

33. Gwendolyn Wright, "Sweet and Clean: The Domestic Landscape in the Progressive Era," *Landscape* 20, no. 1 (October 1975): 38–39.

34. Bonnie Lloyd, "Woman's Place, Man's Place," *Landscape* 20, no. 1 (October 1975): 10.

35. Wright, "Sweet and Clean," 38.

36. Ibid.

37. Ibid., 41.

38. Ruth Schwartz Cowan, *More Work for Mothers: The Ironies of Household Technology from the Open Hearth to the Microwave* (New York: Basic Books, Inc., 1983), 83.

39. Martin Wachs, "Men, Women and Urban Travel," in Wachs and Crawford, *The Car and the City*, 93.

40. T. J. Jackson Lears, "From Salvation to Self-Realization: Advertising and the Therapeutic Roots of the Consumer Culture, 1880–1930," in *The Culture of Consumption: Critical Essays in American History, 1880–1980*, ed. by Richard Wightman Fox and T. J. Jackson Lears (New York: Pantheon Books, 1983), 27.

41. Kevin Nelson, *Wheels of Change: From Zero to 600 M.P.H., The Amazing Story of California and the Automobile* (Berkeley: Heyday Books, 2009), 69.

42. Marie R. Ullman, "We Women," *Motor Land* (May 1926): 18.

43. Lillian Russell, "Don't For the Woman Car Driver," *San Francisco Chronicle*, May 5, 1918.

44. Wachs, "Men, Women, and Urban Travel," 95.

45. Virginia Scharff, *Taking the Wheel: Women and the Coming of the Motor Age* (New Mexico: University of New Mexico Press), 37.

46. "Big Demand Now for Closed Cars," *San Francisco Chronicle*, January 9, 1910.

47. "Plan to Drive to Get the Woman Motorist's Business," *Motor Age* 40, no. 9 (Sep 1, 1921): 14.

48. Flink, *Automobile Age*, 213.

49. "The Reign of Feminism," *Motor Land* (April 1920): 14.

50. Ibid.

51. Ibid., 15.

52. Ibid.

53. "How a State Automobile Trade Association Has Cleaned Up Its Garage and Service Departments," *Motor Age* 40, no. 25 (December 22, 1921): 7.

54. "Editorial: Let's Have Cleanliness in the Service Station," *Motor Age* (February 19, 1920): 24.

55. "No. 97: Is Planning a Woman's Garage," Garage Planning, Service Station Arrangements, *Motor Age* 36, no. 9 (August 28, 1919): 29–30.

56. "Editorial: What of the Women Drivers?" *Motor Land* (April 1920): 22.

57. Ullman, "We Women," 18–19.

58. As discussed in chapter 2, many early brick garages included a mezzanine in the front, the rooms of which were finished in a quasi-residential, quasi-office character. These rooms most probably served chauffeurs and staff.

59. Shannon Sanders McDonald, *The Parking Garage: Design and Evolution of a Modern Urban Form* (Washington, DC: Urban Land Institute, 2007), 18.

60. "Accomplishments in Garage Architecture," *Motor Age*, 12.

61. Flink, *Automobile Age*, 212.

62. "Auto Troubles Thing of Past," *San Francisco Chronicle*, October 4, 1925.

63. Richard Carson Burns, *The Olympian Cars* (New York: Alfred A. Knopf, 1976), 20.

64. Cartoon, "Now for a Record Run," *San Francisco Examiner*, February 17, 1923.

65. "Masterpieces," *Motor Land* (January 1924): 399.

66. "Car Making Like Building A House," *San Francisco Examiner*, February 18, 1923.

67. Ibid.

68. Chester Weaver, *Town Talk*, February 20, 1909.

69. Michael Berger, "The Car's Impact on American Family," in Wachs and Crawford, *The Car and the City*, 73.

70. Buckley, "Garage in the House," in Wachs and Crawford, *The Car and the City*, 129.

71. Pinkson, "A History of Motoring."

72. Donovan, *Wheels for a Nation*, 122–123.

73. Liebs, *Main Street to Miracle*, 81.

74. "Milady Now Reviews the Latest in Enclosed Cars and Clothes at the Same Time," *Motor Age* 40, no. 25 (December 22, 1921): 23.

75. Leon J. Pinkson, "Splendid Showing of Late Models Features Closed Car Week on Auto Row," *San Francisco Chronicle*, November 8, 1921, http://www.proquest.com/ (accessed June 25, 2012).

76. "Live Models Take Part in Weaver Show," *San Francisco Chronicle*, November 8, 1921, http://www.proquest.com/ (accessed June 25, 2012).

77. Ibid.

78. Ibid.

79. The group recalls the statuary at the Exposition and a privatized, miniaturized version of "Transportation" by Jules-Alexis Coutan, a sculpture that presides above the entrance to Grand Central Station.

80. Irving F. Morrow, "The Don Lee Building, San Francisco," *The Architect and Engineer*, 67, no. 1 (October 1921): 408.

81. Ibid.

82. Liebs, *Main Street to Miracle Mile,* 83.

83. "Here and There in Motordom, *Motor Land* (1921): 52.

84. Kahn's design also included a grand stair opposite the entrance. However, as if to deflect customers off the central axis and towards the cars, he designed an awkward double stair, both legs of which begin perpendicular to the path of movement. See "The Packard Garage, New

York," *Architects and Builders' Magazine* 40, no. 3, Old Series (December 1907): 110–112.

85. B. M. Ikert, "Average Service Station Lacks Tone," *Motor Age* 40, no. 12 (Sep. 22, 1921): 7.

86. Ibid., 9.

87. Flink, *The Automobile Age*, 189–193.

88. Ibid., 218.

Chapter 9

1. See Note 1, Introduction.

2. Frances Hong, "Mechanics Become Technicians," *San Francisco Examiner*, February 2, 1998, http://articl es.sfgate.com/1998-02-02/news/28608685_1 (accessed July 29, 2011).

3. Based on an analysis of Sanborn maps that predate the Federal Building and State Building. Also see "Golden Gate Avenue, between Polk and Larkin Sts, proposed site of Federal Building," 1956, *San Francisco Public Library Historical Photograph Collection*, http://sflib1.sfpl.org:82/ record=b1019725~S0 (accessed July 21, 2011).

4. "Rebuilding San Francisco's Garage District," *Horseless Age* 18, no. 10 (Sep 5, 1906): 308.

5. The existence of this garage is based upon corroborating information from the following: Sanborn Map Co., *Sanborn Maps: 1867–1970* (San Francisco, Series 5, 1913–Dec. 1950, vol. 2, Sheet 146); *Architect and Engineer* 66, no. 2 (August 1921): 105.

6. The demolished garages were located at 1355 Pacific, 1536 Pacific, and 1737 Jackson.

7. City and County of San Francisco, *Municipal Planning Code*, Art. 10, Sec. 1001, http://library2.municode. com/4201/home.htm?infobase=14139&doc_action=whats new (accessed October 29, 2009).

8. Four criteria are used to qualify a building for listing in the California Register of Historical Resources: "(1) it [the building] is associated with events that have made a significant contribution to the broad patterns of California's history and cultural heritage; (2) it is associated with the lives of persons important in California's past;

(3) it embodies the distinctive characteristics of a type, period, region, or method of construction, or represents the work of an important creative individual, or possesses high artistic value; or (4) it has yielded or is likely to yield information important in prehistory or history." California Natural Resources Agency, *California Environmental Quality Act Statute and Guidelines (CEQA)* (Palm Desert, CA: Association of Environmental Professionals, 2011): Sec. 15064.5(a)(3), http://ceres.ca.gov/ceqa/ (accessed July 21, 2011).

9. Ibid., Sec 15064.5(b)(1).

10. San Francisco Planning Department, *Final Mitigated Negative Declaration*, Case No. 2003.0053E (August 12, 2004): 5

11. CA Natural Resources Agency, *CEQA*, Sec 15064.5(b)(2).

12. Longstreth associates *facadism* with "attempts to revitalize Main Street [that] transform historic settings into virtual theme parks that mock, rather than respect, the past." Richard Longstreth, *The Buildings of Main Street: A Guide to American Commercial Architecture*, rev. ed. (Walnut Creek, CA: AltaMira Press, 2000), 4.

13. "Zoning Regulations," *Architect and Engineer* 50, no. 1 (July 1917): 68.

14. Robert Ivy, "Interpretive," *Architectural Record* 195, no. 6 (June 2006): 23.

15. In an article about the new Transbay project, journalist Robert Selna wrote, "Condo development was all the rage downtown during the city's most recent building boom because it fetched the highest prices, but city officials say San Francisco rapidly is running out of room to accommodate new jobs." Robert Selna, "Transbay Terminal: Extra Fees for new Transit District," *San Francisco Chronicle*, March 2, 2009.

16. Jane Jacobs, *The Death and Life of Cities of Great American Cities,* 2nd printing (New York: Random House, 1961), 187.

17. Ibid., 198.

18. "Our Reason for Being," *Patagonia,* http://www. votetheenvironment.org/?ln=234 (accessed August 26, 2008).

Bibliography

Published Material

"Accomplishments in Garage Architecture." *Motor Age* 37, no. 20 (May 13, 1920): 12–13.

Ackerman, James S. *Palladio's Villas*. Locust Valley, NY: J. J. Augustin Publisher, 1967.

Allen, Harris. "Recent Theaters Designed by G. Albert Lansburgh, Architect." *Architect and Engineer* 71, no. 2 (November 1922): 47–68.

Amelar, Sarah. "John McAslan + Partners Revives London's Roundhouse, a Free-Spirited Performance Venue with Multiple Past Lives." *Architectural Record* 195, no. 6 (June 2006): 122–127.

Applebaum, Stanley. *The Chicago World's Fair of 1893: A Photographic Record*. New York: Dover Publications, 1980.

Armstrong, Elizabeth. "Hercules to the Muses: Public Art at the Fair." In *The Anthropology of World's Fairs: San Francisco's Panama-Pacific International Exposition of 1915*, edited by Burton Benedict, 114–133. Berkeley: Scolar Press, 1983.

Aronovici, Carol. "Frequency and Geometric Relations of Highways." Street Planning and Research. *Architect and Engineer* 79, no. 2 (November 1924): 104–106.

———. "Social Progress and the Open Road: City Planning and Housing." *Architect and Engineer* 79, no. 2 (August 1924): 100–101.

Art in California: A Survey of American Art with Special Reference to Californian Painting Sculpture and Architecture Past and Present Particularly as Those Arts Were Represented at the Panama-Pacific International Exposition: Being Essays and Articles. Irvine, CA: Westphal Publishing, 1988 [San Francisco: R.L. Benier Publishers, 1916].

Augé, Marc. *Non-Places: Introduction to an Anthropology of Supermodernity*. Trans. by John Howe. New York: Verso, 1995.

Barlow, J. Q. "Southern Pacific Company's Improvement of Coast Line Terminal." *Building and Engineering News* (January 1916): 6–7.

Benedict, Burton, ed. *The Anthropology of World's Fairs: San Francisco's Panama-Pacific International Exposition of 1915*. Berkeley: Scolar Press, 1983.

Benton, Tim, and Charlotte Benton, eds. *Architecture and Design, 1890–1939: An International Anthology of Original Articles*. With Dennis Sharp. New York: Whitney Library of Design, 1975.

Blomfied, Reginald. *The Mistress Art*. London: Edward Arnold, 1908.

Bottles, Scott L. *Los Angeles and the Automobile: The Making of the Modern City*. Berkeley: University of California Press, 1987.

Brandi, Richard, and Woody LaBounty. *San Francisco's Parkside District: 1905–1957*. San Francisco: Mayor's Office of Economic and Workforce Development, 2007. http://www.outsidelands.org/parkside-statement.pdf (accessed June 29, 2012).

Brechin, Gray. "Sailing to Byzantium: The Architecture of the Fair." In *The Anthropology World's Fairs: San Francisco's Panama-Pacific International Exposition of 1915*, edited by Burton Benedict, 94–113. Berkeley: Scolar Press, 1983.

Burnham, Daniel H. *Report on a Plan for San Francisco*. Assisted by Edward H. Bennett. San Francisco: Sunset Press, 1905.

Byers, Charles Alma. "The Popular Bungalow-Court Idea." *Architect and Engineer* 59, no. 1 (October 1919): 80–85.

Cahill, B. J. S. "A Criticism of Some of the Work Shown and the Annual Exhibition of San Francisco Architectural Club." *Architect and Engineer* 32, no. 3 (April 1913): 47–50.

California Natural Resources Agency. 2011 *California Environmental Quality Act (CEQA) Statute and Guidelines*. Palm Desert, CA: Association of Environmental Professionals, 2011. http://ceres.ca.gov/ceqa/ (accessed July 21, 2011).

"Call of Dealers to Build Garage." *Motor Age* (February 19, 1920): 29.

Carson, Richard Burns. *The Olympian Cars*. New York: Alfred A. Knopf, 1976.

Claudy, C. H. "The Woman and Her Car." *Country Life in America* 22, January 1913, 41–42.

Cole, Tom. *A Short History of San Francisco*. San Francisco: Lexikos, 1981.

Corbett, Michael. *Splendid Survivors: San Francisco's Downtown Architectural Heritage*. Prepared by Charles Hall Page and Associates. San Francisco: California Living Books, 1979.

Cowan, Ruth Schwartz. *More Work for Mother: The Ironies of Household Technology from the Open

Hearth to the Microwave. New York: Basic Books, 1983.

Cowles, Luzerne S. "The Architect and the Engineer." *Architect and Engineer* 26, no. 1 (August 1911): 52–55.

Cram, Ralph Adams. "Decadence of French Church Architecture." *Architectural Forum* 50, no. 3 (March 1929): 306–307.

Crocker-Langley San Francisco City Directory. San Francisco: H. S. Crocker Co., 1920–1929.

David, A. C. "The New San Francisco." *Architectural Record* 31, no. 1 (January 1912): 1–26.

Davis, Ellis E. A. *Davis' Commercial Encyclopedia.* Berkeley: Ellis A. Davis, 1910.

DeNevi, Don, and Thomas Moulin. *Motor Touring in Old California: Picturesque Ramblings with Auto Enthusiasts.* Millbrae, CA: Celestial Arts, 1979.

Digital Sanborn Maps 1867–1970. ProQuest database. *San Francisco, 1913–1950, 11 Vols.* http://sanborn,umi.com.ezproxy.sfpl.org/con/813/datedid000030.htm?CCSI=12747n (accessed July 31, 2011).

"Don Lee Building, San Francisco, California." *Western Architect* 32 (November 1923): Pl. 1–3.

Donovan, Frank. *Wheels for a Nation.* New York: Crowell, 1965.

Dunn, J. F. "Islam Temple — An Example of Arabia Architecture." *Architect and Engineer* 50, no. 3 (September 1917): 93–94.

Edholm, C. L. "Motor Car Exhibits at the Panama Exposition," *The Horseless Age* 36, no. 2 (July 14, 1915): 39.

Eisenman, Peter. "The Futility of Objects: Decomposition and the Process of Difference." *Harvard Architecture Review* 3 (Winter 1984): 65–82.

"Exposition Architecture." Minutes from a Commonwealth Club meeting, San Francisco, CA, August 11, 1915. File: "PPIE — Fairs and Expositions, Commonwealth Club." Environmental Design Archives, UC Berkeley.

Fitzgerald, W. J. "Some Engineering Features of the Twin Peaks Tunnel." *Architect and Engineer* 46 (September 1916): 73–78.

Flink, James. *The Automobile Age.* Cambridge, MA: MIT Press, 1988.

Frampton, Kenneth, and Yukio Futagawa. *Modern Architecture: A Critical History.* London: Thames and Hudson, 1985.

Frickstad, Ivan C. "Some Sub-Stations of the Pacific Gas & Electric Co." *Architect and Engineer* 43 (November 1915): 54–68.

"Frisco Police to Control 'Jitney' Buses." *The Horseless Age* 35, no. 5 (February 3, 1915): 176.

"Garaging the Car a Problem." *Motor Age* 16, no. 11 (March 17, 1910): 1–3.

Gates, Eleanor. "Motoring Among the Missions." *Sunset* 28, no. 4 (April 1912): 438–441.

Gebhard, David. "Architectural Imagery, The Mission and California." *Harvard Architecture Review* 1 (Spring 1980): 137–146.

Giedion, Sigfried. *Space Time and Architecture*, 5th ed. Cambridge: Harvard University Press, 1976.

Gould, Carl F. "Architecture as a Fine Art." *Architect and Engineer* 31, no. 3 (January 1913): 51–53.

"Garage Planning: Service Station Arrangements." *Motor Age* (July 31, 1919): 31.

"Garage Ventilation." *Architect and Engineer* 78, no. 2 (August 1924): 109.

"Garages for Office Buildings." *Architect and Engineer* 77, no. 1 (April 1924): 116.

Gropius, Walter. *The New Architecture and the Bauhaus.* Trans. P. Morton Shand. 1938. Cambridge: MIT Press, 1971.

Groth, Paul. "San Francisco. Third and Howard: Skid Row and the Limits of Architecture." In *Streets: Critical Perspectives on Public Space*, edited by Zeynep Celik, Diane Favro, and Richard Ingersoll, 23–34. Berkeley: University of California Press, 1994.

"Guardians of the City: Fire Department." Edited by San Francisco Fire Department Museum. http://guardiansofthecity.org/sffd/index.html (accessed July 30, 2011).

Gudis, Catherine. *Buyways: Billboards, Automobiles and the American Landscape.* New York: Routledge, 2004.

Hamlin, A.D.F. "Gothic Architecture and Its Critics, Part 1: The Lure of Gothic." *Architectural Record* 39, no. 4 (April 1916): 338–354.

_____. "Gothic Architecture and Its Critics: The Definition of Architecture, Part 2: The Definition of Gothic." *Architectural Record* 39, no. 5 (May, 1916): 419–435.

Hardy Holzman Pfeiffer Associates. *Reusing Railroad Stations.* New York: Educational Facilities Laboratories, 1974.

Harvey, C., and J. Lammers, Page & Turnbull, Inc. *District Record: Civic Auto Repair Historic Resources* (December 2007): 5.

Hastings, Thomas. "Modern Architecture." *Architect and Engineer* 78, no. 3 (September 1924): 94–101.

Heldt, P. M. "The Garage Business — Buildings, Equipment, Methods," *The Horseless Age* 36, no. 13 (December 1, 1915): 493.

"How a State Automobile Trade Association Has Cleaned Up Its Garage and Service Departments." *Motor Age* 40, no. 25 (December 22, 1921): 7.

Ikert, B. M. "Average Service Station Lacks Tone." *Motor Age* 40, no. 12 (September 22, 1921): 7.

_____. "Is Yours 'Just Another Garage'?" *Motor Age* 40, no. 20 (November 17, 1921): 8–9.

_____. "Service Station or Garage?" *Motor Age* 40, no. 20 (November 17, 1921): 8.

Issel, William, and Robert W. Cherny. *San Francisco, 1865–1932: Politics, Power and Urban Development.* Berkeley: University of California Press, 1986.

Ivy, Robert. "Interpretive." *Architectural Record* 195, no. 6 (June 2006): 23.

Jackson, J. B. "The Domestication of the Garage." *Landscape* 20, no. 2 (Winter 1976): 19.

Jackson, Kenneth T. *Crabgrass Frontier.* New York: Oxford University Press, 1985.

Jacobs, Jane. *The Death and Life of Great American Cities.* New York: Random House, 1961.

Jennings, Frederick. "Some California Railroad Stations." *Architect and Engineer* 48, no. 2 (February 1917): 43–47.

Jordy, William H. *American Buildings and Their Architects.* 4 vols. 1972. New York: Oxford University Press, 1986.

Kahn, Albert. "The Packard Garage, New York." *Architects' and Builders' Magazine* 40, no. 3 (December, 1907): 110–112.

Kelley, Tim. *Context Statement: Landmark Nomination, Carnegie Branch Libraries of San Francisco.* San Francisco, 2001. http://sfpl.org/pdf/libraries/main/about/carnegie_branch_libraries.pdf (accessed July 30, 2011).

Kessler, Mark. "Educate, Preserve, Reuse: The Good (Not Great) Garage Buildings of San Francisco." *AIA Report on University Research, Volume 4.* Washington, DC: AIA, 2008.

_____. "Fix the Car, Save the City: An Alternative Approach to Architectural History." In *Seeking the City: Visionaries on the Margins, 96th ACSA Annual Meeting,* edited by Dietmar Froehlich and Michaele Pride, 750–757. Washington, DC: ACSA Press, 2008.

_____. "Sowing Seeds of Diversity: The Influence of Sustainability on Adaptive Reuse." *The Value of Design: Design is at the Core of What We Teach and Practice,* edited by Phoebe Crisman and Mark Gillem. Washington, DC: ACSA Press, 2009.

Kidney, Walter C. *The Architecture of Choice: Eclecticism in America 1880–1930.* New York: George Braziller, 1974.

Kimball, Fiske. "What is Modern Architecture?" *Architect and Engineer* 78, no. 2 (August 1924): 112–115.

Knapp Architects. *Historic Evaluation Report: 1336 Grove Street.* San Francisco, July 20, 2008.

Kohlmaier, Georg, and Barna von Sartory. *Houses of Glass: A Nineteenth-Century Building Type.* Translated by John C. Harvey. Cambridge, MA: MIT Press, 1986.

Kostura, William. "Primary Record, Department of Parks and Recreation Form DPR 523A, 1745 Clay Street." San Francisco, 2009. http://sf-planning.org/ftp/files/DPRforms/Clay%201745.pdf.

_____. *Van Ness Auto Row Support Structures.* Palo Alto, CA: W. Kostura, 2010. http://www.parks.ca.gov/pages/1054/files/van%20ness%20auto%20row.pdf. (accessed June 29, 2012).

Lears, T. J. Jackson. "From Salvation to Self-Realization: Advertising and the Therapeutic Roots of the Consumer Culture, 1880–1930." In *The Culture of Consumption: Critical Essays in American History, 1880–1930,* edited by Richard Wightman Fox and T. J. Jackson Lears,. New York: Pantheon Books, 1983.

Le Corbusier. *Towards a New Architecture.* Trans. Frederick Etchells. 1927. New York: Praeger, 1974.

The Legacy of the Exposition: Interpretation of the Intellectual and Moral Heritage Left to Mankind by the World Celebration at San Francisco in 1915. San Francisco: Panama-Pacific International Exposition Company: 1916.

Lewis, David L., and Laurence Goldstein, eds. *The Automobile and American Culture.* 1980. Ann Arbor: University of Michigan Press, 1986.

"Let's Have Cleanliness in the Service Station." *Motor Age* 37 (February 19, 1920): 24.

l'Hommedieu, R. R. "The Evolution of Auto Row." *San Francisco Newsletter,* Christmas 1913, 64.

Libeskind, Daniel, with Sarah Crichton. *Breaking Ground.* New York: Riverhead Books, 2004.

Liebs, Chester H. *Main Street to Miracle Mile: American Roadside Architecture.* 1985. Baltimore: John Hopkins University Press, 1995.

Lloyd, Bonnie. "Woman's Place, Man's Place," *Landscape* 20, no. 1 (October 1975): 9–10.

Longstreth, Richard. *The Buildings of Main Street: A Guide to American Commercial Architecture.* Rev. ed. Walnut Creek, CA: AltaMira Press, 2000.

_____. *City Center to Regional Mall: Architecture, the Automobile, and Retailing in Los Angeles, 1920–1950.* Cambridge: The MIT Press, 1997.

_____. *On the Edge of the World: Four Architects in San Francisco at the Turn of the Century.* 1983. Berkeley: University of California Press, 1998.

Loos, Adolph. *Ornament and Crime: Selected Essays.* Trans. Michael Mitchell. Riverside, CA: Ariadne Press, 1998.

Loyer, Francois. Trans. R. F. M. Dexter. *Architecture of the Industrial Age, 1789–1914.* Geneva: Skira, 1983.

McCants, M. "Tall Buildings and Traffic Congestion: The Hen or the Egg?" Street Planning and Research. *Architect and Engineer* 79, no. 3 (December 1924): 103–108.

McClintock, Miller. "Diagnosing the Ills of San Francisco's Traffic." *Motor Land* (August 1927): 20–21, 48–50.

_____. *A Report on the Street Traffic Control Problem of San Francisco.* San Francisco, 1927.

_____. "Street Traffic and the Office Building." Paper presented at the Sixty-Second Annual Convention of the American Institute of Architects, Washington, DC, April 23, 1929.

McCoy, Esther. *Five California Architects.* 1960. Santa Monica, CA: Hennessey and Ingalls, 2004.

McDonald, Shannon Sanders. *The Parking Garage: Design and Evolution of a Modern Urban Form.* Washington, DC: Urban Land Institute, 2007.

Macomber, Ben. *The Jewel City.* San Francisco: John H. Williams, 1915.

Madison, Ryland P. "The Lady and the Electric: The Automobile." *Country Life in America* 22 (July 15, 1912): 36, 44, 46, 48.

Maliszewski-Pickart, Margaret. *Architecture and Ornament: An Illustrated Dictionary.* Jefferson, NC: McFarland, 2009.

Maybeck, Bernard. *The Palace of Fine Arts and Lagoon: Panama-Pacific International Exposition, 1915.* San Francisco: Paul Elder, 1915.

Meeks, Carroll L. V. *The Railroad Station: An Architectural History.* New Haven: Yale University Press, 1956.

Mercer, George J. "Trend of Body Design as Indicated at New York Salon." *Motor Age* 40, no. 23 (December 8, 1921): 10–13.

"Milady Now Reviews the Latest in Enclosed Cars and Clothes at the Same Time." *Motor Age* 40, no. 25 (December 22, 1921): 23.

Morgan, William. *American Country Churches.* Photos by Radek Kurzaj. New York: Harry Abrams, 2004.

Morrow, Irving F. "Aspects of Modern Architecture." *Architect and Engineer* 90, no. 1 (July 1927): 55–58.

_____. "The Don Lee Building, San Francisco." *Architect and Engineer* 67, no. 1 (October 1921): 47–59.

_____. "The Earle C. Anthony Inc. Packard Building." *Architect and Engineer* 90, no. 1 (July 1927): 60–66.

_____. "The New Chronicle Building, San Francisco." *Architect and Engineer* 80, no. 3 (March 1925): 83–90.

_____. "Recent Work by Charles W. McCall, Architect." *Architect and Engineer* 64, no. 1 (January 1921): 47–49.

_____. "Work by John Reid, Jr., AIA." *Architect and Engineer* 60, no. 2 (February 1920): 43–45.

Mullgardt, Christian, Maud Worting Raymond, and John Hamlin. *The Architecture and Landscape Gardening of the Exposition: a Pictorial Survey of the Most Beautiful of the Architectural Compositions of the Panama-Pacific International Exposition.* 1915. Books About California: 2010. http://www.books-about-california.com/Pages/Architecture_Landscape_Garden/Architect_Essay.html (accessed June 29, 2012).

Myers, David J. "Architecture Defined." *Architect and Engineer* 31, no. 3 (January 1913): 54–55.

"Need for Garages." *Motor Age* 40, no. 11 (September 15, 1921): 18.

Nelson, Kevin. *Wheels of Change: From Zero to 600 M.P.H., The Amazing Story of California and the Automobile.* Berkeley: Heyday Books, 2009.

Neuhaus, Eugen. *The Art of the Exposition: Personal Impressions of the Architecture, Sculpture, Mural Decorations, Color Scheme and Other Aesthetic Aspects of the Panama-Pacific International Exposition.* San Francisco: Paul Elder, 1915.

"A New Motor Bible." *Motor Land* (July 1924): 38–39, 48.

"No. 97: Is Planning a Woman's Garage? Garage Planning, Service Station Arrangements." *Motor Age* 36, no. 9 (August 28, 1919): 29–30.

Norton, Peter D. *Fighting Traffic: The Dawn of the Motor Age in the American City.* Cambridge, MA: MIT Press, 2008.

Olmsted, Nancy. *The Ferry Building: Witness to a Century of Change, 1898–1998.* Berkeley, CA: Heydey Books, 1998.

"P/A Fifth Annual Design Awards Program, Planning: Award Citation, Ferry Park Project." *Progressive Architecture* 39 (January 1958): 124–125.

Parissien, Steven. *Pennsylvania Station: McKim, Meade and White.* London: Phaidon, 1996.

_____. *Station to Station.* 1997. London: Phaidon, 2001.

Patagonia. "Our Reason for Being." http://www.patagonia.com/us/patagonia.go?assetid=2047 (accessed July 30, 2011).

Perles, Anthony, with John McKane, Tom Matoff, and Peter Straus. *The People's Railway: The History of the Municipal Railway of San Francisco.* Glendale, CA: Interurban Press, 1981.

Pevsner, Nikolaus. *An Outline of European Architecture.* 1943. Layton: UT: Gibbs Smith, 2009.

Phelan, James Duval. "Address to the Architectural League of Pacific Coast." *Architect and Engineer* 19, no. 1 (August 1909): 36.

Phipps, Michael. "Hallidie's Folly: The Story of the Clay Street Hill Railroad Cable Cars." *Argonaut* 20, no. 2 (Winter 2009): 34–67.

Pinkson, Leon J. "A History of Motoring Progress in San Francisco." *San Francisco Chronicle,* January 28, 1940. http://www.sfgenealogy.com/sf/history/hgaut.html.

"Plan a Drive to get the Woman Motorist's Business." *Motor Age* 40, no. 9 (September 1, 1921): 14.

Poletti, Therese. "Comrades in the Atelier: The Early Years of the San Francisco Architectural Club." *Argonaut* 20, no. 1 (Spring 2009): 48–65.

Polk, Willis. "A Brilliant Future for American Art." In *A Survey of American Art with Special Reference to Californian Painting Sculpture and Architecture Past and Present Particularly as Those Arts Were Represented at the Panama-Pacific International Exposition,* 77–78. San Francisco: R.L. Bernier, 1916.

_____. "The City Beautiful." *Town Talk,* December 22, 1906, 43–45.

_____. "The Panama-Pacific Plan." *Sunset,* April 1912, 487–493.

Price, C. Matlack. "Notes on the Varied Work of Willis Polk, Architect." *Architectural Record* 34, December 1913, 566–583.

Purdy, Helen Throop. *San Francisco: As It Was, as It Is, and How to See It.* San Francisco: Paul Elder, 1912.

Rae, John B. *The American Automobile: A Brief*

History. Chicago: University of Chicago Press, 1965.

"The Reign of Feminism." *Motor Land* (April 1920): 14–15.

"Restrictions on Motorists Made in Interest of Public Safety." *San Francisco Chronicle*, October 22, 1927.

Rexford, Newcomb. *The Franciscan Mission Architecture of Alta California*. New York: Architectural Book Publishing, 1916.

Robinson, Charles Mulford. *Modern Civic Art or The City Made Beautiful*. 3rd ed. New York: G. P. Putnam's Sons, 1909.

_____. "Real Estate Men and City Planning." *Architect and Engineer* 53, no. 1 (April 1918): 98–99.

Ruskin, John. *The Seven Lamps of Architecture*. Leipzig: Bernhard Tauchnitz, 1907.

_____. *The True and the Beautiful in Nature, Art, Morals, and Religion: Selected from the Works of John Ruskin, A.M.* 2nd ed. (New York: Merrill and Baker, n.d.) 293. http://books.google.com/books/download/The_True_and_the_Beautiful_in_Nature_Art.pdf?id=jAR3k8sFKiIC&hl=en&capid=AFLRE70DqFKTarD2TSMFmxkVPPVDp3DpnwfeMJfwcoS530g3xCO3BoTDc9k8SO4s4_Gjgil0NR5fyJv-lBE9Ra0mmICRIFZVtg&continue=http://books.google.com/books/download/The_True_and_the_Beautiful_in_Nature_Art.pdf%3Fid%3DjAR3k8sFKiIC%26output%3Dpdf%26hl%3Den (accessed July 30, 2011).

Russell, Lillian. "Don't For the Woman Car Driver." *San Francisco Chronicle*, May 5, 1918.

Sachs, Wolfgang. *For the Love of the Automobile: Looking Back into the History of our Desires*. Trans. Don Reneau. Berkeley: University of California Press: 1992.

San Francisco Board of Supervisors. *Transportation Ordinances Including Ordinances Relating to the Use or Streets for Any Class of Vehicles Such as Street Cars, Steam Cars, Automobiles and Jitneys As Follows: Traffic Ordinance, Rates of Fare Ordinance, Personal Baggage Ordinance, Jitney Ordinance and Street Railway Ordinance*. San Francisco: Phillips and Van Orden, 1915.

San Francisco, City and County. *The Building Law and the Plumbing Law of the City and County of San Francisco: The State Tenement House Act and Ordinance No. 746*. San Francisco: Daily Pacific Builder, 1910.

San Francisco Planning Department. *1976 Department of City Planning Architectural Survey*. San Francisco, 1976.

_____. *Certificate of Determination of Exemption/Exclusion from Environmental Review*, Case no. 2004.0380E (December 7, 2004): 4.

_____. *City within a City: Historic Context Statement for San Francisco's Mission District*. San Francisco, 2007. www.parks.ca.gov/pages/.../Mission_District_context_111607%20(2).pdf (accessed July 30, 2011).

_____. *Final Mitigated Negative Declaration*, Case No. 2003.0053E (August 12, 2004): 5.

_____. *Nomination of Lower Nob Hill Apartment Historic District to the National Register of Historic Places*. San Francisco, n.d., ca. 1988.

_____. *Nomination of San Francisco Apartment Hotel Historic District to the National Register of Historic Places*. San Francisco, n.d., ca. 2001.

_____. *Nomination of Uptown Tenderloin Historic District to the National Register of Historic Places*. San Francisco, 2008.

_____. *San Francisco Planning Code*. American Legal Publishing, 2011. http://www.amlegal.com/nxt/gateway.dll/California/planning/planningcode?f=templates$fn=default.htm$3.0$vid=amlegal:sanfrancisco_ca$sync=1 (accessed July 31, 2011).

_____. *San Francisco Property Information Map*. (Site provides property data, zoning and recent permits on San Francisco real estate parcels.) http://ec2-50-17-237-182.compute-1.amazonaws.com/PIM/ (accessed July 31, 2011).

San Francisco Public Library: Sanborn Fire Insurance Maps: 1886, 1899, 1915 and 1950.

San Francisco Redevelopment Agency. *Redevelopment Plan for the Mission Bay North Redevelopment Project*. Adopted by the Board of Supervisors of the City and County of San Francisco, October 26, 1998. http://www.sfredevelopment.org/Modules/ShowDocument.aspx?documentid=775 (accessed July 31, 2011).

San Francisco Redevelopment Agency & San Francisco Planning Department. *Redevelopment Plan for the Transbay Redevelopment Project Area*. Adopted June 21, 2005. http://www.sfredevelopment.org/ftp/uploadedfiles/Projects/TB%20Redevelopment%20Plan(2).pdf (accessed July 21, 2011).

_____. *Transbay Redevelopment Project Area Design for Development*, October 2003. With contributions by Skidmore, Owings, & Merrill LLP, Alfred Williams Consultancy LLC, BMS Design Group, Peter Bosselmann, Jacobs Macdonald Cityworks, Dowling Associates, Sedway Group, Urban Explorer, and Wilbur Smith Associates. http://www.sfredevelopment.org/index.aspxpage=54#D4D (accessed July 31, 2011).

Scalzo, Julia. "All a Matter of Taste: The Problem of Victorian and Edwardian Shop Fronts." *Journal of the Society of Architectural Historians* 68, no.1 (March 2009): 52–73.

Scharff, Virginia. *Taking the Wheel: Women and the Coming of the Motor Age*. New York: Free Press, 1991.

_____. *Twenty Thousand Roads: Women, Movement, and the West*. Berkeley: University of California Press, 2003.

Sculle, Keith A. "Atlantic Refining Company's Monumental Service Stations in Philadelphia, 1917–1919." *Journal of American and Comparative Cultures* 23 (Summer 2000): 39–52.

Sears, Steven. *The American Heritage History of the*

Automobile in America. New York: American Heritage Publishing, 1977.

Shiva, Vandana. *Earth Democracy: Justice, Sustainability and Peace*. Cambridge, MA: South End Press 2005.

"Should Passenger Stations be Architectural Monuments." *Architect and Engineer* 69, no. 1 (April 1922): 102.

Smallwood, Charles. *The White Front Cars of San Francisco*, revised ed. Glendale: Interurbans, 1978.

"Some of the Work of Wm. H. Crim, Jr., and Earl B. Scott, Architects." *Architect and Engineer* 21, no. 1 (May 1910): 35–49.

"Some Pacific Coast Ideas That Have Helped the Automobile Business." *Motor Age* 40, no. 11 (September 15, 1921): 11.

Starr, George. "Truth Unveiled: The Fair and Its Interpreters." In *The Anthropology World's Fairs: San Francisco's Panama-Pacific International Exposition of 1915*, edited by Burton Benedict, 134–175. Berkeley: Scolar Press, 1983.

Szczygiel, Bonj. "'City Beautiful Revisited: An Analysis of Nineteenth-Century Civic Improvement Efforts." *Journal of Urban History* 29, no. 2 (January 2003): 107–132.

"Tax Payers." *Architectural Forum* 59, no. 1 (July 1933): 86.

"Thirty-two Cars Named for Vanderbilt Cup Race." *The Horseless Age* 35, no. 7 (February 1915): 224b.

Thompson, Gregory Lee. *The Passenger Train in the Motor Age: California's Rail and Bus Industries, 1910–1941*. Columbus: Ohio State University Press, 1993.

Trimble, Paul C., and Emiliano Echeverria. "San Francisco's Omnibuses: Muni's Forerunners." *Argonaut* 20, no. 1 (Spring 2009): 36–47.

Turner, Tom, and John Sparks, with John Goepel and Alison Moore. *The Spirit of the Road: One Hundred Years of the California State Automobile Association*. San Francisco: VIA Books, 2000.

Todd, Frank Morton. *The Story of the Exposition: Being the Official History of the International Celebration Held at San Francisco in 1915 to Commemorate the Discovery of the Pacific Ocean and the Construction of the Panama Canal*. 5 vols. New York: G. P. Putnam's Sons, 1921.

Ullman, Marie R. "We Women." *Motor Land* (May 1926): 18.

Unrau, John. *Looking at Architecture with Ruskin*. London: Thames and Hudson, 1978.

Ute, Grant, Philip Hoffman, Cameron Beach, Robert Townley, and Walter Vielbaum. *San Francisco's Municipal Railway: MUNI*. Charleston, SC: Arcadia Publishing, 2011.

Van Rensselaer, Mariana Griswold. "Recent Architecture in America: Public Buildings." *Century* 28, no. 1 (May 1884): 48–68. http://digital.library. cornell.edu/cgi/t/text/text-idx?c=cent;idno=cent00 28-1.

Venturi, Robert, Denise Scott Brown, and Steven Izenour. *Learning from Las Vegas: The Forgotten Symbolism of Architectural Form*, rev. ed. Cambridge, MIT Press, 1977.

Vieyra, Daniel I. *Fill 'er Up: An Architectural History of America's Gas Stations*. New York: Macmillan, 1979.

Wachs, Martin, and Margaret Crawford, eds., with Susan Marie Wirka and Taina Marjatta Rikala. *The Car and the City: The Automobile, The Built Environment, and Daily Urban Life*. Ann Arbor: University of Michigan Press, 1992.

Wallace, Kevin. "City's Tunnels: When S.F. Can't Go Over, It Goes Under Its Hills," *San Francisco Chronicle*, March 27, 1949. http://www.sfgenealo gy.com/sf/history/hgtun.htm (accessed July 30, 2011).

Ward, Clarence R. "The Housing of a Fire Department." *Architect and Engineer* 50, no. 1 (July 1917): 51–62.

Weeks, Charles Peter. "Monumental Bank Buildings." *Architect and Engineer* 45, no. 3 (June 1916): 39–40.

White, Frank G. "The Embarcadero Subway, San Francisco." *The Architect and Engineer* 76, no. 1 (January 1924): 95.

Wilder, Tom. "The Place of the Garage in Architecture." *Motor Age* 37 (May 1920): 7–9.

——. "Selecting the Site." *Motor Age* 37, no. 15 (April 1920): 7–9.

Willcox, W. R. B. "Architecture and the Architect: The Fancy of Clients and the Attitude of Architects." *Architect and Engineer* 31, no. 2 (December 1912): 67–71.

Wilson, William H. *The City Beautiful Movement*. Baltimore: John Hopkins University Press, 1989.

Woodbridge, Sally B. *San Francisco in Maps and Views*. New York: Rizzoli International, 2006.

Worker of the Writers' Program of the Work Projects Administration in Northern California. *San Francisco: The Bay and Its Cities*. 1940. New York: Hastings House, 1947.

Wright, Gwendolyn. "Sweet and Clean: The Domestic Landscape in the Progressive Era." *Landscape* 20, no. 1 (October 1975): 38–43.

Young, Stanley. *The Missions of California*. Photographs by Melba Levick. 1988. San Francisco: Chronicle Books, 2004.

"Understanding the Green Building Ordinance." *Heritage News* 36, no. 4 (Fall 2008): 7.

"Zoning Regulations." *Architect and Engineer* 50, no. 1 (July 1917): 68.

Unpublished Material

Study

Hardy Holzman Pfeiffer Associates. *40 Theaters*. New York, 1985.

Interviews with Author

Jon Bartunek (garage operator), April 30, 2008, San Francisco.

Mark Luellen (preservation coordinator, San Francisco Planning Department), July 21, 2008.

Sterling Anderson (garage operator), July 28, 2008.

Kaaren Tank (granddaughter of Joseph Pasqualetti), November 12, 2009, Novato, CA.

Archives and Repositories

Environmental Design Archives, UC Berkeley.
- Archival material and architectural drawings:
 — H.C. Baumann
 — G. Albert Lansburgh
 — Panama-Pacific International Exposition
 — Willis Polk

San Francisco Department of Building Inspection.
- Building and alteration permits.

San Francisco Planning Department. *History Files*, n.d.

- Folders on San Francisco resources organized by address.

History Room, San Francisco Public Library.

Photographic Collections

Bancroft Library, UC Berkeley.
- *Charles C. Moore Albums of Panama-Pacific International Exposition*, ca. 1905–1920. http://oac.cdlib.org/findaid/ark:/13030/hb7d5nb8ww/

California Historical Society. San Francisco, California.
- *CHS Collection*. http://www.californiahistoricalsociety.org/collections/photography_coll.html (photos cannot be viewed digitally).

San Francisco Public Library.
- *San Francisco Historical Photograph Collection.* http://sflib1.sfpl.org: 82. (Many but not all photographs can be viewed digitally.)
- Assessor's Negatives.
- Department of Public Works photographs.

Index

Numbers in ***bold italics*** indicate pages with illustrations.
Individual garage buildings are indexed by street name followed by street number.

Abbey Garage *see* O'Farrell, 550–560
academic eclecticism 45, 138; conflicts within movement 149–153; reliance on precedent 140–141; *see also* École des Beaux-Arts; Panama-Pacific International Exposition (PPIE); precedents, architectural
Ackerman, James S. 55
adaptive reuse 259, 266; *see also* garages, as historic resources; preservation, architectural
adaptive reuse projects 258–266, ***260–261***, ***263–264***; Neighborhood Transportation Center proposal 265; *see also* garages, as historic resources; preservation, architectural
Ahnden, John H. 147, 193, ***208***
Alhambra theater ***258***
allegorical art *see* Panama-Pacific International Exposition (PPIE)
Altuna, Richard ***263–264***
American Architect and Architectural Review 117
American Concrete Company 67
American Institute of Architects 206–7
anonymity, garages: causes of 12–13; as countered by typology 55–56, 135, 137, 170; *see also* typology, garages
Apartment Hotel Historic District 148
Arcade Façades (typology category) 44, 57, 88–96
arches *see* portals, arched
Architect and Engineer 34, ***39–40***, ***78***, ***120***, 148, 163, 174, ***175***, ***179***, 203–4
architects, garages: appropriation of train station 141–142; influence of the City Beautiful movement 163, 167; influence of the École des Beaux-Arts 5; intentions 13–14, 47, 57–58, 138; mannered approach 53, 57, 88, 100, 149, 167–168; responsiveness to context 147–148; *see also* architects, San Francisco; Panama-Pacific International Exposition (PPIE)

architects, PPIE *see* Panama-Pacific International Exposition (PPIE)
architects, San Francisco: approach to reconstruction 145; focus on congestion and the garage 203–4; proponents of the City Beautiful movement 146–149, 154, 238; unity of approach 148; use of architectural precedents 151; *see also* architects, garages; architects, PPIE
architectural building program *see* program, garage
architectural graphic analysis 33, 268*c2n*1
architecture vs. *building* 24, 139–142; *see also* dichotomous design organization (garages)
Arguello, 421 131, ***132***, 133
Art Nouveau influence 111, 129
assembly line, Palace of Transportation 188, ***189***, 217
Atwood, Charles B. (train station, World's Columbian Exposition, Chicago) 116, 162, 193
auto ferry service 200–1; *see also* Ferry Building
Auto Row, Golden Gate Avenue 6, 19, ***257***; garages demolished 247; impact of earthquake 144; *see also* Auto Row, Van Ness Avenue
Auto Row, Van Ness Avenue 6, 23, 194, 216–219; automobile parades 188, 192; Closed Car Week 238–239; *see also* Don Lee Cadillac Showroom; Earle C. Anthony Packard Showroom; Panama-Pacific International Exposition (PPIE); Studebaker showroom
Auto Rows 5, 216–217; *see also* Auto Row, Van Ness Avenue; auto showroom buildings
auto showroom buildings 19; compared with garages 216–217, 244–245; compared with skyscraper garages 23; interior design 14–15, 19, 211, 216–217, 223, 236, 238–239; as people — not auto-centric 241–245, ***242–243***; portal motif 239, 241, 244; *see also* Auto Row,

Van Ness Avenue; Auto Rows; Don Lee Cadillac Showroom; Earle C. Anthony Packard Showroom
auto-centric city and the garage 168, 198–199
automobile, rise in San Francisco 142–144, 156–157, 159, 212–213, 217–219; preference for over trains 161, 163; *see also* congestion, parking and the garage; Panama-Pacific International Exposition (PPIE)
automobile industry *see* motordom
automobile parades *see* Auto Row, Van Ness Avenue
automobiles, architectural objects with interior design 14–15, 225–228, ***227***, 230–238, ***232–233***, ***235***, 241; car show, 1918 219, ***220***; closed cab models 223, 226, ***227***, 228, 234, 236; evolution of architectural qualities 212–216, ***214***, 219; as status symbols 6, 167–168, 225–228, ***227***; *see also* Chrysler Six; Closed Car Week; fashion for driving; Ford Model T; garages and automobiles, parallel design objects; women, marketing of automobiles to
automobiles and garages *see* garages and automobiles, parallel design objects
automobiles as miniaturized trains 164, ***165–166***, 189, ***190***, ***214***, 215–216; parable, automobiles as litter of train ***165–166***; 201, 216; *see also* garages, as miniaturized train stations
automobility 237; mastery over time and space 163
auto-use architecture, San Francisco 5–6, 216–217; architects 146; impact of earthquake 144

Bacon, Henry 184
Bakewell & Brown 146–147
band shell, Golden Gate Park *see* Golden Gate Park, band shell
Bank of America, Castro branch 258

Bank of San Francisco, Clement branch 258

Banks & Copeland *130*, 131

Barsotti Garage *see* North Point, 770

Bartunek, Jon (*History of Union Street Garage*) 22

Baumann, H. C. 147

Baumann & Jose 77, *78*, 79

Bay Bridge 201

Beachy, Lincoln 188

Bell Bros. 61, *62*, 63

Bell Garage *see* Turk, 175

Belt Line railway 199

Berger, Michael 167, 237

bike shops 8, 17

Bitter, Karl 187

blight 248, 257; *see also* façades, present state

Blohme, J. Harry *see* Ward & Blohme

Blomfield, Sir Reginald 141

Bohemian Garage *see* O'Farrell, 375

Bottles, Scott 156

Brandi, Richard 156

Brechin, Gray 184–185

Brick Pier Façades (typology category) 57, *128–135*

Bridgeway Garage *see* Fourth St., 145

Broadway Boogie-Woogie (Mondrian) 13

Brown, A. Page *9*, 147

Buckley, Drummond 158, 237

Bugbee, Arthur S. 147

building materials: façades 33, interior 29–30, *31*; structural 25–26, *27*; *see also* sheds

building sheds *see* sheds

building types, dichotomous *see* dichotomous building types

building use, garages *see* program, garage

The Buildings of Main Street (Longstreth) 56

Burnham, Daniel 162, 183, 186–187

Burnham Plan for San Francisco 183, 186–187

Bush, 355 207, *208*, 247; d'Humy Motoramp System 29; lounge accommodations 229

Bush, 1267 *49*

Bush, 1565 *71–72*, 73; compared to 2340 Lombard 73–74; *see also* Pasqualetti, Joseph A.

Bush, 2405 113, *114–115*, 116; as heir to PPIE 193, 217; masonry details 33

C+A Architects (Dennis Gallagher Arts Pavilion, International High School) *97*, 98

cable cars 155

Cahill, B.J.S. 185, 193–194; *see also* Panama-Pacific International Exposition (PPIE)

California Environmental Quality Act (CEQA) 253, 274n8

California missions 104–5; Mission San Luis Rey 108

California Motorist: car show, 1918 *220*; covers 104, 150; organ of California State Automobile Association 159, 218

California Register of Historic Resources 274n8

California State Automobile Association 159, 188, 197–198, 204–5; *see also California Motorist*; *Motor Land*

car barns *171*, 172; *see also* dichotomous building types

car shows: closed cab automobiles 219, *220*; as reminiscent of PPIE 194, *195*; *see also* Panama-Pacific International Exposition (PPIE)

Castro Street car barn *171*, 172

Century Garage *see* Post, 675

CEQA *see* California Environmental Quality Act

chauffeurs 19–21; as comparable to maids 229

Cherny, Robert W. 144, 182

Chestnut, 520 253–256, *254*

Chevrolet (advertisement) 158–159

Chicago World's Fair *see* World's Columbian Exposition, Chicago

Chrysler Six (automobile) 230, *231*

circulation, pedestrian, garages 24, 30

circulation, vehicular: ramps 28–29, *42*, 43; rotation around center 42, *43*, 77, 79–80, 103, 236; in skyscraper garages 29; in Station Façades 113, 193; at 111 Stevenson *102*, 103; *see also* façade composition, ramps and sloping grade; portals, arched

City Beautiful theory: appropriation by motordom 157–159; and electrical substations 172–176, *173*, *175*; and growing automobile use 154–157; influence on garage architects 14, 148, 154, 167; as realized in San Francisco 47, 146; and train stations 162–163; *see also* Panama-Pacific International Exposition (PPIE)

City Hall (Bakewell and Brown) 145–146, 194

Civic Auditorium *see* Exposition Civic Auditorium

Civic Center 146, 191, 193–194, 238

Clement, 2535 *50*, 108

closed car automobiles *see* automobiles

Closed Car Week 238–239; *see also* car shows; women, marketing of automobiles to

Cole, Tom 201

composition, façades *see* façade composition

congestion, parking and the garage: downtown 6, 142, 157, 196–210; as urban phenomenon 137, 155, 163–164; *see also* automobile, rise in San Francisco; expansion and suburbanization

Contemporary Jewish Museum (Libeskind) 172, *173*; *see also* PG & E electrical substations

contextualism, and dichotomous building types 11–12

conversions, garage to residential 248; at 421 Arguello 131, *132*, 133; at 520 Chestnut 253–256, *254*

conversions, livery stable to garage 17, *18*, 19

Corbett, Michael (*Splendid Survivors: San Francisco's Downtown Architectural Heritage*) 269n2

Courtney, Kathleen 265

Cowan, Ruth Schwartz 225

Crim, William H. 147; *see also* Crim & Scott; O'Farrell, 550–560

Crim & Scott 147, 213; *see also* Crim, William H.; Golden Gate, 64; Stanyan, 624

Cunningham Auto Showroom *see* Jackson, 1737

decorated shed (Venturi, Scott Brown and Izenour) 17, 19, 23

dematerialization *see* façades, present state

Denke, E. H. *209*

Dennis Gallagher Arts Pavilion, International High School (C+A Architects) *97*; *see also* Page, 66

dichotomous building types 12, 170–185; car barns *171*, 172; electrical substations 172–176, *173*, *175*; exposition buildings (PPIE) 182–188, *186*, 192–193; firehouses 177–181, *180*; *see also* train stations

dichotomous design organization (garages) 8, *9–11*, 23–24, 45; acknowledgment by McClintock 206–7, 210; as *architecture* vs. *building* 139–142; contextualism of façade 147–148; contributor, auto-centric city 198–199; limits of, as symbol of automobile 211–213, 215–217, 238, 241; link to other dichotomous types 11–12, 139, 142; relationship of façade and interior 53–56; symbolism of 14–15; *see also* dichotomous building types; garages, as miniaturized train stations; Panama-Pacific International Exposition (PPIE)

distribution, San Francisco (garages) 5–8, *7*, 146, 246–247; as symbol of decentralization 169–170; *see also* typology, garages

Divisadero, 650 37–38, 77–*78*, 79; compared to 1745 Divisadero 79–80; compared to 1355 Fulton 118

Divisadero, 1745 *79–82*; widening of entrance bays 44–45, 82; *see also* Pasqualetti, Joseph A.

Don Lee Cadillac Showroom (Weeks and Day) 23, 194, 239–245, *240*, *242–243*

Donovan, Frank 214

Earle C. Anthony Packard Showroom (Maybeck with Powers and Ahnden) 194

earthquake, 1906: automobile in relief effort 144; as complement to PPIE 183, 186, 195; idealism following 47; influence on garage architects 2, 138, 144; *see also* reconstruction, post-earthquake

École des Beaux-Arts 5, 141, 146–147; as distinct influence from City Beautiful 269*n*2

Eddy, 265 *66*, 67; compared to 111 Stevenson 100; ornament 51; *see also* Pasqualetti, Joseph A.

Eddy, 460 122, *123–124*, 125; as epitome, ABA composition 44

Edison, Thomas A. 217

Edmundson, Scott 265

electrical substations *see* PG & E electrical substations

Ellis, 541 *108*, 109

Engine House #17 (Ward & Blohme) 178–179, *180*

expansion and suburbanization 155–157; *see also* automobile, rise in San Francisco; congestion, parking and the garage

Exposition *see* Panama-Pacific International Exposition (PPIE)

Exposition Civic Auditorium 145, 191; car shows 194, *195*; representation in cartoon 231, *232*; *see also* Civic Center

façade composition, and building structure 36–45; brick sheds 37–38; concrete sheds 38–42

façade composition, ornament and style 9, 32, 45, *46*, 47, 51–54, *52*; alternatives to historical styles *150*, 151, *152*; as contributor to auto-centric city 168; as symbol of urban elite 150–151, 157–158, 204–5, 210; *see also* façade elements; façades, lowbrow historicism of; garages, as miniaturized train stations; parapets; portals, arched

façade composition, plasticity and modularity: 460 Eddy *123–124*, 125; 550–560 O'Farrell 98, *99–100*; 66 Page *97*, 98; 3536 Sacramento *130*, 131

façade composition, ramps and sloping grade 40–45, *41–42*; 1565 Bush *72*, 73; 445 Fillmore 42, *43*; 1945 Hyde *91–92*; 525 Jones *93–94*; 818 Leavenworth *85–87*, 88; 750 Post *89–90*; 530–544 Taylor *83*, 84; *see also* circulation, vehicular; ramps

façade composition, rotation around center 42, *43*, 236; in Twin Arch Façades 59–60, 236; in Wide ABCBA Façades 77, 236; *see also* circulation, vehicular; Divisadero, 1745; façades, lowbrow historicism of; Jackson, 1641; Polk, 2120; Stevenson, 111; Turk, 550

façade composition, and signage 36; 415 Taylor 106, *107*

façade elements 33–35, 37; industrial 53, 216; *see also* façade composition, parapets; ramps and sloping grade

façades, as basis of garage classification 12, 55–59, *58*; *see also* façades, lowbrow historicism of

façades, lowbrow historicism of: as antiquated 138; as basis of urban typology 8, 11–12, 170–181, *171-3*, *175*, *179-180*; as caricature of the highbrow 8, 13–14, 111, 118, 159; *historicism*, explanation of term 3; incorporation of industrial elements 53, *62*, 63, 216; internal contradictions 94, 116; as subversive of anthropocentric symmetry 42, *43*, 59–60, 67, 77, *78*, 79, 103–4, 167–168, 236; *see also* dichotomous design organization; façade composition, ornament and style; significance, garages

façades, present state 15; impact of adaptive reuse 259–264, *260-261*, *263*; impact of modifications 15, *107*, 108, 248–249, *250*, 251, *252*; widening of bays 35, 44–45, *79-80*, 82, 116, *117*, 249; *see also* blight

façadism 255, 274*n*12

Fantoni, Charles 262

fashion for driving 219, 223, 226, 239

Ferry Building: cluster of garages around 6; counterweight to garages 201–202; focus of congestion 199–202; port for auto ferry service 200–201; precedent for garage design 8, *9*, 48; regional transit hub 155, 162; starting point, auto parades 188, 192; *see also* congestion, parking and the garage

Fighting Traffic, The Dawn of the Motor Age in the American City (Norton) 196

Filbert, 721 19, *105*, 106

Fillmore, 445 42, *43*, 51, *52*; *see also* Pasqualetti, Joseph A.

fire stations *see* firehouses

firehouse, PPIE 189–190, *191*

firehouses 177–181, *180*; Engine House #17 (Ward & Blohme) 178–179, *180*; *see also* dichotomous building types

Firestone, Harvey 217

Flink, James 157, 161, 203, 230, 244

Ford, assembly line at PPIE 188, *189*

Ford Model T 164, *189*, 213, *214*, 215–217, 219; similarity to garage *214*, 215

Foster, Mark 155

Fourth Street, 145 38, *40*, 247; *see also* Stewart, Joseph L.

Frampton, Kenneth 140

Frickstad, Ivan C. 174

Fulton, 1355 30, *31*, 48, 50–51, 116, *117*, 118; as comment on centralized station 170; compared to 1661

Market 119; as example, lowbrow historicist garage 13

function, garages *see* program, garage

garage, public, defined 17, 19; *see also* program, garage

garage owners, stakeholders in motordom's marketing 159

garages, architectural evolution of 144, 161–162, 236

garages, congestion and parking *see* congestion, parking and the garage

garages, demolished 6, 246–248, *249*; as factor in urban monoculture 256, *257*; 1355 Pacific 251, *252*

garages, as historic resources 30–31, *132*, 133, 251, 253–256, *254*; *see also* preservation, architectural; sustainability

garages, as miniaturized train stations 8, *9-11*, 14–15, 32, 47, 139, 142, 159, 161–170, *166*, *169*, 216; collective expression of decentralization 150–151; symbol, superiority of automobile 111, 116, 118, 151, 153; theme underpinning Station Façades 110–111; *see also* automobiles as miniaturized trains; parable, garages as litter of train station; portals, arched

garages, significance *see* significance, garages

garages and automobiles, as parallel design objects 144, 161–162, 211–217, *214*, 230–237, *231-233*

Gare du Nord (Hittorf) 113

Geary, 855 *121*, 122; compared to 460 Eddy 123

gender stereotypes *see* women, marketing of automobiles to

Golden Gate, 64 94, *95-96*; clubhouse for chauffeurs 19–20; example, early garage 19, 161, 213; influence of Mission architecture 48; programming of bays 44; specialization of use 19, 216; wide brick shed *26*

Golden Gate Park 19, 143; band shell in car ads 231–234, *233*

Gothic Façades (typology category) 57, 96–104

grade, sloping *see* façade composition, ramps and sloping grade

Grand Prix automobile race, PPIE 188

Great Earthquake *see* earthquake, 1906

Green, 1776 *18*, 19, 37, 249

Gropius, Walter 268*c*3*n*3

Grove, 1336 *18*, 19

Gudis, Catherine 163, 167–168, 202

Hamlin, A.D.F. 53, 141

Hardwick, Philip 140, 162

Headman, August G. 146–147; 1945 Hyde 90, *91-92*

Heiman & Schwartz: 855 Geary *121–122*; 242 Sutter 178, *179*

Helbing, William: 1267 Bush 23, *24*; 415 Taylor 106, *107*, 108

historic district 12, 251; Apartment Hotel Historic District 148

historic resources *see* garages, as historic resources

historicism, explanation of term 3

"History of the Union Street Garage" (Bartunek) 22

Hittorf, Jacques-Ignace (Gare du Nord) 113

Hjul, James H. *250*

Hodghead, Beverly L. 188

home and office, termini of commute 158–159, 212

l'Hommedieu, R. R. 143

Horseless Age 20, 200, 215

Howard, John Galen 146; Pierce-Arrow Building 217, *218*

d'Humy Motoramp System 29, *208*

Hyde, 1945 90, *91–92*, 147; compared with 525 Jones 93

interior design, garages 19–21, 228–230; *see also* automobiles, architectural objects with interior design; garages and automobiles as parallel design objects; Post, 675

interior design, home 225; compared to interior, closed cab automobile 234

interior development, garages 19–24, *25–28*, 29–30, *31*; as exclusively male domain 228–230, 234, 236, 244; suitability for adaptive reuse 259; as symbol of early automobile 23, 212, 215–216

Issel, William 144, 182

Ivey, Robert 256

Izenour, Steven 17, 23

Jackson, John Brinckerhoff 14, 17, 32, 157

Jackson, 1600 *20*, 21; as adapted to retail use *260*

Jackson, 1641 37, 51, *111*, 112–113; compared with 2405 Bush 116; example, monumental garage 161, 193, 217

Jackson, 1737 248, *249*

Jacobs, Jane 257

Jerome Garage *see* Jackson, 1600

Jessie Street substation *see* PG & E Electrical Substations

Jewett, Grace 147

Jones, 525 30, *93–94*

Jordy, William H. 141, 184

Kahn, Albert (Packard Showroom, New York) 217, 244, 273*n*84

Kelham, George 146, 184

Kidney, Walter C. 150–151

Kostura, William 144, 146

LaBounty, Woody 156

Lansburgh, G. Albert 146

Larkin, 830 61, *62*, 63

Learning from Las Vegas (Venturi, Scott Brown and Izenour) 17

Lears, T.J. Jackson 225

Leavenworth, 818 *85–87*, 88, 94, 130

Le Corbusier (Villa Savoye) 260*c2n*6

Liebs, Chester A. 8, 17, 137–138, 144, 216–217, 224, 238, 243–244

light, natural (garages) 30, *31*

livery stables 8, 17, *18*, 19; as precedent, dichotomous architecture 148, 213; as undesirable neighbors 206

Lloyd, Bonnie 158, 224

Lombard, 2340 73, *74*; bowstring truss *28*; *see also* Pasqualetti, Joseph A.

Longstreth, Richard 8, 56, 146, 274*n*12

lounge facilities *see* interior design, garages

Loyer, François 140

Lyons, M.J. 105, *106*

Machinery Hall, PPIE (Ward & Blohme) 147, 193

Main Street to Miracle Mile: American Roadside Architecture (Liebs) 137

Market, 1661 51, 118, *119–120*; *see also* Stewart, Joseph L.

Market Street 169, 199–200, 203, 258; *see also* congestion, parking and the garage; Ferry Building

Market Street Railway 171

marketing of automobiles to women *see* women, marketing of automobiles to

materials *see* building materials

Matson Building 203

Maxwell (racecar) 189

Maybeck, Bernard 146–147, 217; Earle C. Anthony Packard Showroom 194; Palace of Fine Arts, PPIE 182

McAllister, 1970 251, *252*; *see also* Pasqualetti, Joseph A.

McCall, Charles W. 35

McClintock, Miller: address to American Institute of Architects 206–7, 210; Traffic Survey for San Francisco (McClintock Report) 200, 203, 205–6

McClintock Report *see* Traffic Survey for San Francisco

McCoy, Esther 194

McDonald, Shannon Sanders 229

McKillop, W.J. *85–87*, 88, 94

McKim, Meade & White 116, 154, 174, 184

Meeks, Carroll L.V. 140, 163

Meusdorffer, Conrad A. *18*, 147

Meyer, Frederick H. 146–147, 174; *see also* Taylor, 530–544

Miller, J.R. 147; *see also* Bush, 2405

Miller & Pflueger (Alhambra theater) *258*

Mission Façades (typology category) 57, 104–110

Mission San Luis Rey 108

missions *see* California missions

Model T *see* Ford Model T

Modern Civic Art (Robinson) 162–163

Mondrian, Piet (*Broadway Boogie-Woogie*) 13

monoculture, urban environment 255–257, 265

Morrow, Irving, architectural reviews by: Don Lee Cadillac Showroom (Weeks and Day) *242*, 243–244; Earle C. Anthony Packard Showroom (Maybeck, with Powers and Ahnden) 194; garages designed by McCall, Charles W. 35

Motor Age, articles and coverage: Closed Car Week 239; "Garage Planning: Service Station Arrangements" 228–229; garage program 19, 29; "The Place of the Garage in Architecture" 151, *152*, 153; 675 Post *126*, 153, 230; South Bend Garage *150*; 111 Stevenson 59

Motor Land: ad, Century Garage (675 Post) *160*, 205; ad, Union Oil 164, *165*; on "car keeping" 225; car show, 1920 *195*; covers 104, 118, 234, *235*; editorial, urban congestion 202; "The Motor Car — A Daily Necessity" 223; organ of California State Automobile Association 159; "The Reign of Feminism" 226, *227*

motordom: architectural expressions of power 19, 23, 143, 194, 216–219, 238–239; marketing during World War I 218–219; response to urban congestion 197–199, 201–210, *208–9*; *see also* Don Lee Cadillac Showroom; McClintock, Miller; women, marketing of automobiles to

Mt. Olivet Cemetery Associates 218

Mullgardt, Louis Christian 184

Municipal Railway (MUNI) 199–200; *see also* streetcars

Narrow ABCBA Façades by Joseph A. Pasqualetti (typology category) 44, 57, 68–76, 136, 211, 236; *see also* Pasqualetti, Joseph A.

Neighborhood Transportation Center 265; *see also* adaptive reuse projects

Nelson, Kevin 143–145, 194, 225, 262

Nelson, Steve *263–264*

Neuhaus, Eugen 184–185

Nordin, August *see* Post, 675

North Central Garage *see* Bush, 355

North Point, 770 51, 236, 262–265, *263–264*, *see also* adaptive reuse projects

Norton, Peter D. 143, 163–164, 168, 196–198, 202, 204, 207, 223

O'Brien Bros. 147; *see also* Jackson, 1641; Jones, 525; Pacific, 240;

Pacific, 1419; Page, 66; Stevenson, 111; Sutter, 840
O'Farrell, 550–560 98, *99–100*; as subversive of anthropocentric symmetry 103, 168; symbolism, Gothic details 45, 53, 103
office and home *see* home and office, termini of commute
Oldsmobile, curved-dash model 213–214
Olmsted, Nancy 200
ornament 51–54, *52*; *see also* façade composition, ornament and style
O'Shaughnessy, Michael 156

Pacific, 240 100, *101*, 103
Pacific, 1355 251, *252*; *see also* Pasqualetti, Joseph A.
Pacific, 1419 37, 109, *110*
Pacific Gas and Electric *see* PG & E Electrical Substations
Packard Auto Showroom, New York (Kahn) 217, 244, 273*n*84
Packard Eight (automobile) 230–231
Page, 66 *25*, 50–51, 53, *97*, 98, 236; compared with 530–544 Taylor 47; vehicular rotation about façade 42, *43*
Palace Garage *see* Stevenson, 111
Palace of Agriculture, PPIE *186*
Palace of Fine Arts, PPIE (Maybeck) 182; backdrop for automobile ads 231–232, 238
Palace of Transportation, PPIE 188, *189*, 217 *see also* Ford Model T
Palazzo Façades (typology category) 57, 120–128
Palladian motif 113, *114–115*, 116
Panama-Pacific International Exposition (PPIE) 182–195, *184*, *186*, *189–191*; affinity with automobiles 188, *189–191*, *233*, 234; architects 12, 182–187; compared with electrical substations 176; as dichotomous architecture 113, 182–188, *186*, 192; as expression of academic eclecticism 149; fire house 189–190, *191*; impact on congestion 199–200; influence of Burnham Plan 183, 186–187; influence on city architecture 191–194, *195*; influence on garage architecture 113, 116, 191–193, 217; palace interiors 183–185, *186*, *189*; as realization of the City Beautiful 182–187, *184*, 192–193; site plan 183–187, *184*
parable, automobiles as litter of train 165, *166*, 201, 216; *see also* automobiles, architectural objects with interior design; parable, garages as litter of train station
parable, garages as litter of train station *166*, 192, 198, 216; *see also* garages, as miniaturized train stations; parable, automobiles as litter of train
parapets 48, *50*, 51; atop Mission Façades 104–109, *105*, *107–8*; *see*

also 2535 Clement; 460 Eddy; 1355 Fulton; 550–560 O'Farrell; 66 Page; 1545 Pine; 4050 Twenty-fourth Street
Parissien, Steven 141–142
parking *see* congestion, parking and the garage
Pasqualetti, Joseph A. 147; approach to composition, 44–45, 68, 98; Narrow ABCBA Façades by 68–76; ornament, ABCBA façades 51, *52*; trusses, bowstring *27–28*; work as typologically significant 136, 236; *see also* Bush, 1565; Divisadero, 1745; Eddy, 265; Fillmore, 445; Lombard, 2340; McAllister, 1970; Pacific, 1355; Turk, 550; Twenty-fourth Street, 4050; Union, 1550
Patagonia clothing company 265; *see also* North Point, 770
Patagonia store *see* North Point, 770
Pennsylvania Station, New York (McKim, Meade & White) 50, 116, 118
Perles, Anthony 199
Pevsner, Nicholas 139
PG & E electrical substations 146, 172–176, *173*, *175*, 179, 181; Electrical Substation C (Willis Polk & Co.) 172–176, *173*, *175*, 270*n*67; Electrical Substation D (Willis Polk & Co.) 174, *175*, 176; *see also* dichotomous building types
Phelan, James Duval 182–183, 186, 271*n*15
Pier 39 *10*
Pierce-Arrow Building (Howard) 146, 217, *218*
Pine, 1545 *129*, 130; compared to 3536 Sacramento 131
Pinkson, Leon J. 143, 197, 213, 217, 239
"The Place of the Garage in Architecture" 151, *152*, 153
Poletti, Therese 146–147
Polk, 2120 63, *64–65*, 66, 236; as adapted to pharmacy 260
Polk, Willis: PPIE 182–183, 185–186, 271*n*15; *see also* PG & E electrical substations; PPIE
portals, arched: as auto-centric 23, 167–168, *169*; and automobiles at PPIE 189, *190–191*; on brick shed garages 33, 37; conferring status on driver 6, 14, 32, 158, 205; on fire houses 177; on Mission Façades 104; and Model T 215; on Station Façades 110, *111*, 112–113, *114–115*, 116, *117*, 118, *119–120*; on Stewart garages *38–40*, 118, *119–120*; train station motif 9, *10–11*, 48, 140, 142, 162–163; *see also* Don Lee Cadillac Showroom; façade composition, ornament and style; façades, lowbrow historicism of; Ferry Building; garages, as miniaturized train stations; Pier 39; Sacramento, 3640;

Southern Pacific Third and Townsend Street Station; Stockton Street Tunnel
Post, 675 125, *126*, 127; advertisements for 159, *160*, 229; article, *Motor Age* 153; as luxury parking facility 21, 153, 205, 229
Post, 750 *89–90*; adapted to art gallery 262; compared to 1945 Hyde 92
Post, 1240 116, *117*, 193
Post Street Garage *see* Post, 750
Post-Taylor Garage *see* Taylor, 530–544
power stations *see* PG & E electrical substations
Powers, John H. 147, 193, *208*
PPIE *see* Panama-Pacific International Exposition
precedents, architectural 8, *9–11*, 12, 17, *18*, 19, 104; *see also* dichotomous building types; garages, as miniaturized train stations; Panama-Pacific International Exposition (PPIE); Station Façades
preservation, architectural 5, 30–31, 135–136, 246–265; *see also* garages, as historic resources; typology, garages
program, garage 17–23, 34; lounge facilities 21, *160*, 205, 228–229
Progressive Era 19, 154–155, 158, 224–225; *see also* women, marketing of automobiles to
public garage 17, 19; *see also* program, garage
public safety 196–198
Purdy, Helen Throop 145

ramps *27*, 28–29; *see also* façade composition, ramps and sloping grade
reconstruction, post earthquake 144–146, 148; *see also* architects, San Francisco; earthquake, 1906; Panama-Pacific International Exposition (PPIE)
Reid, John, Jr. 177
"The Reign of Feminism" 226, *227*
Rickenbacker, Eddie 189, *190*
rise of automobile, in San Francisco *see* automobile, rise in San Francisco
Robinson, Charles Mulford (*Modern Civic Art*) 162–163
Rolph, James 199
Ross, T. Paterson 147; *see also* Ellis, 541
runways *see* ramps
Ruskin, John 24, 139–141
Russian Hill 20, 248, 257, 160
Russian Hill Community Association 265

Sachs, Wolfgang 202, 215, 224
Sacramento, 3536 37, *130*, 131
Sacramento, 3640 *133–134*, 135
San Francisco, historical context 142–145; *see also* automobile, rise

in San Francisco; congestion, parking and the garage; earthquake, 1906; Panama-Pacific International Exposition (PPIE)
San Francisco Architectural Club 146–147
San Francisco Car Dealers Association 201
San Francisco–Oakland Bay Bridge 201
San Francisco Planning Code 251, 253, 256; *see also* garages, as historic resources
San Francisco Planning Department 133, 253; *see also* garages, as historic resources
San Francisco Traffic Survey 200, 203, 205–6; *see also* congestion, parking and the garage; McClintock, Miller
Sansome, 825 38, *39*, 119
saturation, automobile market 223–224
Scalzo, Julia 139
Scharff, Virginia 139, 226, 238
Schnaittacher, Sylvain 13, 116, *117*, 147
Schwartz, Mel I. 13, *31*, 116, *117*, 147; *see also* Fulton, 1355
Scott, Earl B. 147; *see also* Crim & Scott
Scott Brown, Denise 23
sheds 23–24, *25–28*; *see also* interior development, garages; train stations
showroom buildings *see* auto showroom buildings
Shrader, 636 260, *261*
signage *see* façade composition and signage
significance, garages: accessory to automobile 6, 32, 150–151, 158, 167, 204–5, 213; contributor, auto-centric city 6, 167–170, *169*, 198–199; counterweight to Ferry Building 192–193, 195; loss of 15, 95, 170, 193, 212, 223, 238, 240–241, 246; male domain 228–230, 234, 236, 244; relief valve for parking 6, 203–210, *208–9*; representative of urban elite 6, 14, 204–5, 210, 213; source of urban diversity 5, 255–256, *257*, 265; symbol of dichotomous automobile 23, 215–216; *see also* City Beautiful theory; garages as miniaturized train stations
skyscraper garages 5, 23; as McClintock's desirable neighbors 206–7, *208–9*; vehicular circulation in 29; *see also* Eddy, 265; Stevenson, 111
sloping grade *see* façade composition, ramps and sloping grade; ramps
Smallwood, Charles 171
Smith, Art 188
Smith, Henry C. 147; 265 Eddy *66*, 67
Southern Pacific railroad stations

95, 104; Third and Townsend Street Station 8, *10*, 11, 48, 106, 155, 162, 191, 201
Splendid Survivors: San Francisco's Downtown Architectural Heritage 172, 174
Stadtbahn station, Karlsplatz (Wagner) 111, *112*, 113
Standard Oil (advertisement) 168, *169*
Stanyan, 624 33, *34*, 148, 161; *see also* Crim & Scott
Station Façades (typology category) 57, 110–120; as heir to PPIE 193, 195
Stevenson, 111 100–103, *102*; in *Motor Age* 59; as subversive of anthropocentric symmetry 103, 168, 236
Stewart, Joseph L. 147, 247; 145 Fourth Street 38, *40*, 247; 1661 Market 51, *119–120*; 825 Sansome *39*; 150 Turk *38*, 51; use of ornament 51; use of super-scaled portals *38–40*
Stockton Street Tunnel *11*, 156, 192
streetcars 155–157, 171, 196, 199–203
Studebaker showroom 183, 239
Substation C *see* PG & E electrical substations
Substation D *see* PG & E electrical substations
suburbanization *see* expansion and suburbanization
sustainability 256–259, *257–258*; *see also* garages, as historic resources; preservation, architectural
Sutter, 242 38, 178, *179*, 193
symbolism *see* significance, garages

Table 1 (typology summary) *58*
Taylor, 415 106, *107*, 108; *see also* façade composition and signage
Taylor, 530–544 41, 82, *83–84*, 236, 268c3n6; as ABCBA composition 47; compared to 818 Leavenworth 85, 87; *see also* façade composition, ramps and sloping grade
Tenderloin (neighborhood) 6, 8, 19, 95, 148, 191, 247–248
Tenth Avenue Garage, San Diego *166*; *see also* garages, as miniaturized train stations
Tharp, Newton J. 177
Todd, Frank Morton 187–188
Tower of Jewels, PPIE 189, *190*
Town Talk 144, 197, 201, 203, 222
Traffic Ordinance, 1924 204, 206
Traffic Survey for San Francisco (McClintock Report) 200, 203, 205–6
train station: in City Beautiful theory 162–163; evolution of type 139–142; Mission style 48, 95, 104; World's Columbian Exposition, Chicago (Atwood) 116, 162, 193; *see also* Ferry Building; garages, as miniaturized train stations; portals, arched; Southern Pacific railroad stations

Transportation Ordinances, 1915 196
Transportation Palace *see* Palace of Transportation, PPIE
trusses, bowstring *27–28*
Turk, 150 *38*, 51, 119; *see also* Stewart, Joseph L.
Turk, 175 207, *209*, 229
Turk, 550 *60–61*; compared to 265 Eddy 66–67, 100; compared to 830 Larkin 61, 63; eclectic ornament 53; *see also* Pasqualetti, Joseph A.
Twenty-fourth Street, 4050 51, 74, *75*, 76; *see also* Pasqualetti, Joseph A.
Twin Arch Façades (typology category) 56, 59–67, 80, 236; integration of ramps *41*; 111 Stevenson *102*, 103; *see also* façade composition, rotation around center
Twin Peaks Tunnel 156
typology, garages 55–136; classification criteria 55–59, *58*; as counter to anonymity 12–13, 55–56, 135, 137, 170, 192, 265; as criterion for architectural significance 251, 255; as decentralized collective 168–170; *see also* preservation, architectural

underutilization 247–248, 251, 255; *see also* preservation, architectural
Union, 1550 68, *69–70*, 71, 98, 236; compared to 1565 Bush 71–73; compared to 1745 Divisadero 79; compared to 2340 Lombard 73–74; "History of the Union Street Garage" (Bartunek) 22; as pure public garage 21–23; *see also* Pasqualetti, Joseph A.
Union Oil (advertisement) 164, *165*
Union Street Garage *see* Union, 1550
United Railroads 155

Valencia, 623 *172*
Valencia, 1220 *48*
Van Ness Avenue *see* Auto Row, Van Ness Avenue
Van Rensselaer, Mariana Griswold 141
Vanderbilt Cup automobile race, PPIE 188
Venturi, Robert 17, 23, 47
Villa Savoye (Le Corbusier) 260c2n6
Vitruvian triad 141, 183–184, 211; *see also* architecture *vs.* building

Wachs, Martin 156–157, 225
Wagner, Otto (Stadtbahn station, Karlsplatz) 111, *112*, 113
Ward, Clarence R. 147, 178; *see also* Ward & Blohme
Ward & Blohme 147; firehouses 177–179, *180*; Machinery Hall, PPIE 147, 193; Pacific Automobile Show, 1920 *195*; *see also* Ward, Clarence R.
Weaver, Chester 237

Weeks & Day (Don Lee Cadillac Showroom) 194, 239–245, *240, 242–243*

Wide ABCBA Façades (typology category) 44, 57, 76–88, 236

Wilder, Tom 19, 151

Willis Polk & Co. *see* Polk, Willis

Wilson, William H. 270*n*28

winged wheel ornament 118

women, marketing of automobiles to 211, 219–229, *221, 227*; Closed Car Week 238–239; during World War I 222–223; impact on garage interior 228–230, 241, 244–245; interior design, color and finish 219, 222–228, *227*, 234; Progressive Era stereotypes 158–159, 224–225; as solution to saturation 223, 224; *see also* automobiles, architectural objects with interior design; Don Lee Cadillac Showroom

Woodbridge, Sally 156

World War I 217–218, 222–223, 225–226

World's Columbian Exposition, Chicago 116, 149, 154, 162, 183, 193

Wright, Gwendolyn 158, 224–225

Zoning Ordinance, 1921 8